PHOTOGRAPHY SPEAKS
150 PHOTOGRAPHERS ON THEIR ART

PHOTOGRAPHY SPEAKS
150 PHOTOGRAPHERS ON THEIR ART

BROOKS JOHNSON

APERTURE FOUNDATION

CHRYSLER MUSEUM of ART

Library of Congress Control Number: 2004109816

Hardcover ISBN: 1-931788-50-2

The staff for this book at Aperture Foundation includes:
 Ellen S. Harris, Executive Director; Roy Eddey, Director of Finance and Administration; Lesley Martin, Executive Editor, Books; Andrew Hiller, Acting Managing Editor, Books; Lisa A. Farmer, Production Director; Andrea Smith, Director of Publicity; Linda Stormes, Director of Sales & Marketing; Diana Edkins, Director of Special Projects

The purpose of Aperture Foundation, a not-for-profit organization, is to advance photography in all its forms and to foster the exchange of ideas among audiences worldwide.

Aperture Foundation, including Book Center and Burden Gallery:
 20 East 23rd Street, New York, New York 10010
 Phone: (212) 505-5555, ext. 300. Fax: (212) 979-7759
 E-mail: info@aperture.org

Aperture Foundation books are distributed outside North America by:
 Thames & Hudson Distributors, Ltd.
 44 Clockhouse Road
 Farnborough
 Hampshire, GU14 7QZ
 United Kingdom
 Phone: 44 (0) 1252 541602
 Fax: 44 (0) 1252 377380
 Web: www.thamesandhudson.co.uk

To subscribe to Aperture magazine write Aperture, P.O. Box 3000, Denville, New Jersey 07834, or call toll-free: (866) 457-4603. One year: $40.00. Two years: $66.00. International subscriptions: (973) 627-2427. Add $20.00 per year.

Visit Aperture Foundation's website: www.aperture.org

Printed and bound in China by Everbest Printing Co.
First Edition
10 9 8 7 6 5 4 3 2 1

CONTENTS

Foreword 7

Preface 8

Introduction 11

Photography Speaks 14

Bibliography 315

Index 319

FOREWORD

The first edition of *Photography Speaks* was published in 1987 to celebrate the opening of the Chrysler Museum's Alice R. and Sol B. Frank Photography Galleries. That publication, focusing on a selection of works from a private family collection, provided not just high-quality illustrations of major landmarks in the history of photography, but also brief biographies of the photographers, and a selection of statements by the artists themselves. Some of these statements dealt with the specific images, others with technical matters, still others with the nature of photography itself. All provided the photographers with a chance to speak directly and in their own words about themselves and their art. The public response to this publication was enthusiastic and a second volume of *Photography Speaks*, this time focusing on works in the Chrysler Museum's own collection, was produced in 1995.

The Chrysler is now proud to be joining once again with Aperture Foundation to produce a new combined edition of *Photography Speaks*. This book includes the full contents, revised and updated, of the first two volumes plus sixteen new entries on recent additions to the Chrysler Museum's collection.

The museum is grateful to Aperture for its continuing partnership. And we express our sincere thanks to The Horace W. Goldsmith Foundation, which has provided crucial underwriting for this project, along with generous continuing support for the museum's photography program. From the start the *Photography Speaks* project has been guided by the vision of the Chrysler's Curator of Photography, Brooks Johnson. We salute him for his long service and join him in thanking our colleagues on the museum staff for their own hard work and commitment.

William J. Hennessey
Director, Chrysler Museum of Art

PREFACE

This newly revised and expanded book, published fifteen years after the initial *Photography Speaks* and nine years since its sequel *Photography Speaks II*, presents a kind of history of the medium as seen from a twenty-first-century perspective—A history told through the words and images of those who have made lasting contributions since the invention of photography in the early nineteenth century. In the years since the publication of those earlier books, the history of photography has continued to evolve in myriad ways. Image-makers who had slipped—or were slipping—through the cracks in the history of photography have emerged and been resurrected. (Undoubtedly, there are still discoveries to materialize.) Equally exciting, some photographers have developed entirely new ways to use this wondrous and malleable medium.

This volume is not intended to be simply a picture book on the history of photography or on one museum's collection. Each photograph is accompanied on the opposite page by a statement from the artist and a brief biography placing that artist within an historical context. Some of the texts deal with the specific image reproduced, while others take a broader approach, commenting on the art of photography in general. A few texts are technically oriented, and some consider the intricacies of art creation. Taken as a whole, this collection of statements provides a wide range of thinking on photography.

From the living artists I requested a statement on working methods or philosophy. The responses varied. Some artists sent previously written statements while others wrote something specifically for this project. With the passage of time, some of the photographers who wrote statements for the first book have since gone to that well-furnished darkroom in the sky. Their statements are reprinted unchanged, while other deceased artists' statements have been culled from previously published materials, notebooks, and letters.

Upon publication of the first book in 1989 it was the collectors' and my hope that it would provide the uninitiated with an enjoyable, meaningful introduction to the history of photography. We wanted to help people understand how this powerful medium of photography has shaped our world and why it occupies such a vital and important place in our society to this day. It is my hope that this combined and expanded edition of *Photography Speaks* will continue to be an informative and delightful addition to the literature on photography, guiding readers to a better understanding of this remarkable medium that has enriched and inspired the lives of so many.

There have been many people who have assisted in the preparation of this book and to each of them go my sincere thanks. Naturally, thanks must begin with the photographers who created the images and kindly agreed to allow them to be reproduced. All of the objects in this book are drawn from The Chrysler Museum of Art's collection or from the family of Alice R. and Sol B. Frank. My thanks to the Frank family, individual donors, and members of the Photography Alliance of The Chrysler Museum who, through gifts of objects and funds, have helped build this collection. I am forever grateful to Joyce F. and Robert B. Menschel for their generous support and continuing guidance over these many years.

I am grateful to my colleagues at Aperture, Andrew Hiller and Lesley Martin, for their assistance and support throughout this project. This project could not have been realized without the dedication of Georgia Young who attended to the many details required to assemble this book. In addition, thanks to all of our colleagues on the Museum staff who have in some way assisted us with this project.

We acknowledge with many thanks the individuals, agencies, and institutions that granted text and/or photograph reproduction permissions:

Nichole Frocheur and Hans P. Kraus, Jr.; Tilly Abbe, Estate of James Abbe; Cindy Johnson, Commerce Graphics Ltd.; Claudia Kishler, Ansel Adams Publishing Rights Trust; Cristin O'Keefe and Janet Hicks, Artists Rights Society; Bob Calle, Christian Boltanski Archives; Jonathan Toby White, Estate of Margaret Bourke-White; Edwynn Houk, Edwynn Houk Gallery; Susan Ehrens and Ellen D. Nott, Estate of Anne W. Brigman; Sarah Morthland, Archive Consulting & Management Services; Russell Burrows, Estate of Larry Burrows; Peter MacGill and Kay Broker, Pace MacGill Gallery; Michael Shulman, Magnum Photos; Jill Quasha, Estate of Marjorie Content; Howard Read and Paul Moreno, Cheim & Read; Camilla Costello, Country Life Picture Library; Jeff L. Rosenheim, The Metropolitan Museum of Art; Katharina Hohenhörst, Thomas Struth Studio; Barbara McCandless, Callie Morfeld Vincent, and John B. Rohrbach, Amon Carter Museum; Dianne Nilsen and Denise Gosé, Center for Creative Photography; Steve Bello, Halsman Estate; Karen S. Kuhlman, The David Hockney Trust; Bill McMorris, Oakland Museum of California; John Lawrence and John T. Magill, The Historic New Orleans Collection; Mason E. Turner, Jr.; Robert Knodt, Museum Folkwang; Zachary Buchanan, Art + Commerce; Joree Adelman, Robert Mapplethorpe Foundation; Falkland Road, Inc., Mary Ellen Mark Library; Christopher Meatyard, Estate of Ralph Eugene Meatyard; Bettina Schwartz, Sheila Metzner Studio; Daniel Gersen, Gersen, Blakeman & Ackert LLP; Hattula Moholy-Nagy, Estate of Moholy-Nagy; Lloyd Morgan, Printing & Graphic Services, Inc.; Stephen Porter, Estate of Eliot Porter; Andrea Mihalovic-Lee, VAGA; Susanne Lange and Rajka Knipper, Die Photographische Sammlung; Charles Traub, Aaron Siskind Foundation; Kevin Eugene Smith, Estate of W. Eugene Smith; Naomi Lyons and Jeremy Cox, Frederick & Frances Sommer Foundation; Laurie Winfrey, Carousel Research, Inc.; Agapita Judy Lopez, Georgia O'Keeffe Foundation; Anthony Montoya, Paul Strand Archive; Anna Fárová, Estate of Josef Sudek; Michael John Shaw, The Sutcliffe Gallery; Donna Mussenden VanDerZee; Cynthia Young, International Center of Photography; Joseph Mulholland; Marla Dowers, Brett Weston Archive; Peter C. Bunnell, Minor White Archive, Princeton University Art Museum; Jeffrey Fraenkel, Estate of Garry Winogrand; Linda Wolcott-Moore, Estate of Marion Post Wolcott; Anita Duquette, Whitney Museum of American Art; Susan Snyder, The Bancroft Library, University of California, Berkeley; Katie Halliday/Taylor and Francis Group; Sara F. Stevenson, Scottish National Portrait Gallery; Iain G. Brown, National Library of Scotland; Maia-Mari Sutnik.

Thanks to the many colleagues and friends who have helped in so many ways:

Bodo von Dewitz, Museum Ludwig; Keith F. Davis, Hallmark Collection; Kim Sichel, Boston University; Karen Sinsheimer and Kim Beil, Santa Barbara Museum of Art; Joseph Bellows, Joseph Bellows Gallery; Larisa Dryanski; George Tice; Joe R. Struble, George Eastman House; Janet Lehr; Christopher Cardozo Fine Art; Sara Macel; Robert Hershkowitz; Anne Fourcroy; Gerd Sander; Jeannie Freilich-Sondik and Catherine Belloy, Marian Goodman Gallery; Joseph Kraeutler, Janet Borden Gallery; W. M. Hunt and Sarah Hasted-Mann, Ricco/Maresca Gallery; Laurence Miller and Vicki Harris, Laurence Miller Gallery; Howard Greenberg, Margit Erb, and Parker Stephenson, Howard Greenberg Gallery; Catherine Edelman, Catherine Edelman Gallery; Johanna Fiore; Pierre Apraxine, Gilman Paper Company Collection; Tom Beck, Kuhn Library, University of Maryland; Paula Richardson Fleming, National Anthropological Archives, Smithsonian Institution; Violet Hamilton, Michael Wilson Collection; Mark Haworth-Booth, Victoria and Albert Museum; Ann N. Paterra, Harry Ransom Humanities Research Center; Lori Pauli, National Gallery of Canada; Barbara Tannenbaum, Akron Art Museum; Karyl Winn, University of Washington Libraries; Evelyne Z. Daitz, Witkin Gallery; Catherine Edelman; Charles Isaacs; Ingrid Raab; Noya Brandt; Edna Bullock; Sonja Bullaty; Howard Chapnick; Paula Stewart; John Szarkowski; Beaumont Newhall; Phillip S. Block; Jeffrey Hoone; William A. Ewing; William Clift; Janet Dewan; Anne Horton; Carol Nigro; Naomi Rosenblum; George Slade; Deborah Marquardt; Michelle Lamunière; Ronald Crusan; Thomas W. Southall.

FASHIONING THE HISTORY AND SOUL OF PHOTOGRAPHY

As photographers, we turn our attention to the familiarities of which we are a part. So turning, we in our work can speak more than of our subject—we can speak with them; we can more than speak about our subjects—we can speak for them. They, given tongue, will be able to speak with and for us. And in this language will be proposed to the lens that with which, in the end, photography must be concerned—time, and place, and the works of man.

—Dorothea Lange

Photography is an international language. Unlike verbal language in which a sound represents a specific meaning, a photograph—because of its pictorial quality—communicates a concept visually. In her quote, Lange suggests that a subject speaks through the photographer and that the photographer speaks through the photograph. Thus, this symbiotic relationship results in a collaboration between photographer and subject. Although some do not, many photographs do speak of time and place. Regardless of the message communicated by the photograph, those that are timeless continue to sustain our interest as viewers.

The immediate and realistic nature of photography does something that no other medium can do: record and present an accurate impression of what was before the lens. Of course, it is a subjective truth, depending upon what the photographer included or excluded from the picture frame. Some would go so far as to argue that the photograph is never truthful because a person with a specific viewpoint makes it, and the image can be manipulated to support that individual's prejudices. In the early twentieth century, Lewis Hine made the prescient comment: "While photographs may not lie, liars may photograph."

Little could Hine have imagined the complicated predicament that now exists, thanks to the development of digital technology. In the late 1970s, artist Nancy Burson began to explore the possibilities of manipulating photographic images with a primitive computer program. In the present day, the easy access to manipulative computerized programs such as Photoshop extends this power to anyone with minimal computer skills. The meaning and integrity of a photograph may be further compromised by the text that accompanies it. Thus, the entity that determines the circumstances of a photograph's presentation controls the power of the image. Considering all of these variables, we must then question the truthfulness of even the most benign photographs.

The anthology of photographs presented in this book offers yet another history of photography. Because the story of photography continues to evolve, it is still far from being complete. As artists push through seemingly imposed boundaries, they achieve new applications through which this malleable medium continues to influence humanity. The artists in this book have earned a place in the history of photography because they have created a unique body of work. The nature of photography is such that anyone might make a great photograph at some time in his or her life. The gift of an accomplished photographer is to continue making those kinds of images.

At the dawn of photography, much effort was expended to learn techniques that would produce an accurate representation of the subject. Indeed, this continues to be a concern for many of the medium's

current practitioners. Yet, the uses for photography have shifted and evolved over the years to the point whereby some contemporary artists do not even create an original image, but instead re-introduce an existing photograph. This practice, known as appropriation, lends new meaning to an image according to the context in which it is used.

Today, it is hard to imagine a world without photography. Every day we experience a bombardment of photographic images from books, television, magazines, newspapers, billboards, and all manner of advertising propaganda. If one asks a room full of people if they have seen the Sphinx of Egypt, most would answer: "Why, yes, of course." Further questioning, however, might reveal that few of those who claimed to have seen the Sphinx had actually been to Egypt. Rather they have seen photographic images that created the visual memory of seeing the genuine object. Because photography replicates the experience of vision, we assume an object seen in a photograph represents one that exists in reality. Albeit an interpretation of a subject through the photographer's eyes, the image nonetheless maintains an indexical relationship to the world.

Prior to the invention of photography in 1839, the only way to have seen the distant lands of the Middle East with a sense of verisimilitude was to actually go there. Unlike today, one could not board a plane and arrive in Cairo the next afternoon. With the invention of photography, photographers flocked to such faraway parts of the world, eager to give people who could not make the expensive, arduous, and time-consuming journey to such remote places the chance to see them in the comfort of their own homes. Naturally, they were motivated not only by the desire to record mysterious lands, but by the chance to earn legal tender as well.

Another early and important use for photography was to accurately preserve the human likeness. An artist could draw or paint a satisfactory interpretation, perhaps even doing away with a few wrinkles or an unruly cowlick, much to the appreciation of the sitter. However, this kind of rendering was available only to those who could afford the services of an artist. Photography, especially the daguerreotype, offered immortality to the masses for a minimal investment. Thus, photography became the first truly egalitarian means for preserving one's likeness and for seeing the world. In this era of digital photography and the internet, the tools to make and show photographic images are more widely accessible than at any other time, although not all of the resulting images are of enduring interest.

From the early days of photography, there was much discourse about capturing the soul of the sitter. Likewise, some have feared the medium because of their belief that it might steal one's soul or because of religious prohibitions against graven images (see Roman Vishniac, p. 154). Perhaps it is no surprise that certain spiritual characteristics are attributed to photography as many who practice it do so with a religious zeal. The writings in this book may strike readers by the continual use of such emotion-laden words and phrases such as "soul," "faith," "truth," "beauty," "magic," and "the mystery of light." Clearly, many of the speakers in this book do have strong, deeply felt emotions about what they are attempting to accomplish with their work. This then touches on the soul of photography: It is that passionate desire to communicate a concept, or to reveal a new way of experiencing the world.

Much of the photograph's success depends upon the quality of the light and an oft-recited axiom says that a photographer "lives or dies by the light." Again, the spiritual connotations proliferate, as light is a frequent symbolic representation for a higher entity. To the casual viewer, photography may seem like a mechanical process because of the manufactured camera and lens. However, the process of photography might be more easily likened to that of a magician at work. The photographer embraces a little black box and massages the lens with a sleight of hand, perhaps uttering a few incantations like "hold it—say cheese." Vanishing into the darkroom, the photographer plunges the film into a series of intoxicating brews, before emerging with the final print after a choreographed sequence of shaking and stirring movements.

With the digitization of the image eliminating the alchemy of the darkroom, the magical process that we know as photography is rapidly being transformed into an even more mysterious and intricate technology. Although based on the same concept, the machinery of the medium is profoundly different in ways unimaginable to earlier practitioners. Consider the thoughts of Peter Henry Emerson on the fiftieth anniversary of the invention on photography in 1889:

> It must not be forgotten that water-colour drawing and etching have both been despised in their time by artists, dealers, and the public, but they have lived to conquer for themselves places of honour. The promising boy, photography, is but fifty years old. What prophet will venture to cast his horoscope for the year 2000?

Although photography has proved its worth as art and as a method of communication many times over, it would have been beyond Emerson's wildest imagination to comprehend the many roles of photography in today's twenty-first-century world. Its qualities are so immense that it is beyond even our generation's grasp as to what the meduim's ultimate potential may be. Who would dare to speculate as to the roles photography might play by the time of its 200th anniversary in 2039? There is no doubt that artists will find many answers, but we will have to wait to see where they shall lead.

Albert Sands Southworth
American, 1811–1894

Josiah Johnson Hawes
American, 1808–1901

Southworth and Hawes worked in partnership from 1843 to 1862. They are widely recognized as being among the finest daguerreotypists. Catering exclusively to a wealthy clientele, they used the term "artists' daguerreotype room" for their fashionable studio, located at 19 Tremont Row, Boston. Southworth and Hawes studied the romantic ideals prevalent in American art and literature of the time and developed artistic innovations in the photographic process to suit the prevailing tastes. Southworth and Hawes were justifiably proud of their hand-coloring, much of it done by Nancy Hawes, Josiah's wife. This text is drawn from a speech that Southworth delivered to the National Photographic Association in 1870.

We appreciate the perfection of the lenses with which we make the images of nature or art in our cameras; the perfection in the manufacture of our chemicals, glass, and paper; the variety and beauty in the style of our mountings and frames; but that which is necessary and requisite to fit one for the disposition of light and shade, the arrangement of the sitter, and accessories for the design and composition of the picture, is of a far higher order in the scale of qualifications, demands more observation and comprehensive knowledge, a greater acquaintance with mind in its connection with matter, a more ready and inventive genius, and greater capacity for concentrated thought and effort with prompt accompaniment in action. What is to be done is obliged to be done quickly. The whole character of the sitter is to be read at first sight; the whole likeness, as it shall appear when finished, is to be seen at first, in each and all its details, and in their unity and combinations. Natural and accidental defects are to be separated from natural and possible perfections; these latter to obliterate or hide the former. Nature is not all to be represented as it is, but as it ought to be, and might possibly have been; and it is required of and should be the aim of the artist-photographer to produce in the likeness the best possible character and finest expression of which that particular face or figure could ever have been capable. But in the result there is to be no departure from truth in the delineation and representation of beauty, and expression, and character.

Observation is the locomotive to be attached to the train of thought and engineered under your own conductorship; the power which turns the revolving wheels must be created by fuel from your own stores; your freight is to be truth, and knowledge, and wisdom, in all their purity, from the overflowing treasuries of the infinite Creator of Nature. For your harvesting he has sown with a lavishing hand. But not all is gold that glistens; truth lies at the bottom of the well, whilst straws float on the surface. For the truth we are to dig as for hidden treasures—truth, so rare, so often counterfeited or disguised by the glittering tinsel of falsehood, so often mixed with error—truth always withstanding assaults, defending itself, now here, now there; almost overwhelmed by the dust and rubbish of delusion or the blatant effrontery of impudence, empiricism, and quackery. The question, what is truth? began to be asked more than eighteen hundred years ago, and will continue to be asked as long as human nature exists.

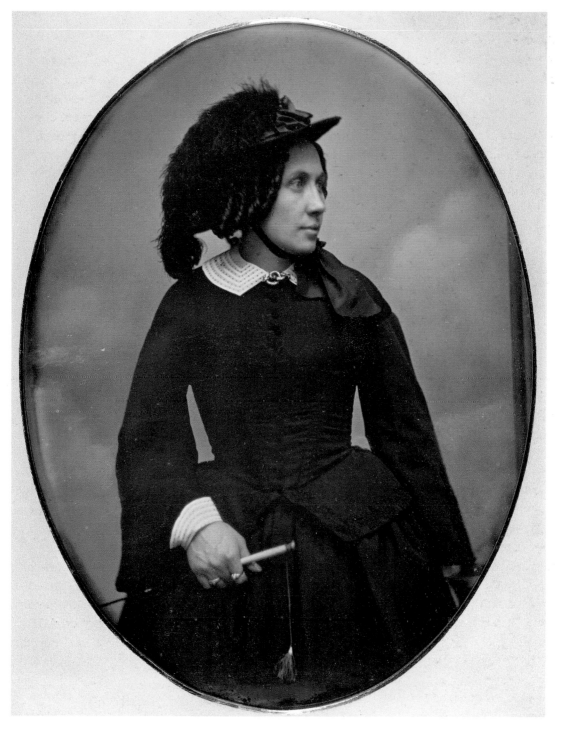

The Equestrienne, ca. 1850

Daguerreotype with applied color, 7¾ x 5⅞ inches
Purchase, in memory of Alice R. and Sol B. Frank, 99.15

William Langenheim
American (b. Germany), 1807–1874

Frederick Langenheim
American (b. Germany), 1812–1879

The Langenheim brothers immigrated to America in the 1830s, and by the early 1840s were operating a successful daguerreotype studio in Philadelphia; some of their more illustrious clients included Henry Clay, Andrew Jackson, and Martin Van Buren. A contract to procure exclusive U.S. rights to William Henry Fox Talbot's calotype invention—the first negative/positive process—led to near financial disaster in 1849. However, the Langenheims quickly recovered with their introduction of glass transparencies (lantern slides), stereoscopic paper prints, and slides. The following two advertisements from Philadelphia newspapers illustrate their sales strategies:

NOTHING can be more affecting and exciting to the feelings of our hearts than to take to hand an excellent Daguerreotype portrait of a parent, a brother or sister, a child, a friend or anyone else we love, after they are "far away" or dead. No limner's brush, no engraver's steel, no lithographer's ink is able to produce a likeness so striking, pleasing and lifelike as the Daguerreotype, which is not done by the hand of an artist, but by the *Pencil of Nature*. Everyone knows that in this process the artist has merely to follow Nature's unchangeable laws in preparing the plates, and that Light, the first created Element, draws the picture. It is true, that not every operator knows how to apply these laws, and in consequence not every picture is what it ought to be; but if you want to procure one good in every respect go to the old reliable establishment of LANGENHEIM DAGUERREOTYPE EXCHANGE.

I F YOU WANT A REALLY GOOD PICTURE of yourself, your relations or friends—if you want a family group well arranged—if you want the picture of small children taken in the quickest possible time—if you want a portrait set in a breastpin, bracelet, locket or finger ring—if you want a copy of a Daguerreotype, painting, engraving, or other artistical production—if you want a portrait of a deceased or sick person taken at home—in short, if you want anything superior in the Daguerreotype line, go to the old and far-famed establishment of W. & F. LANGENHEIM.

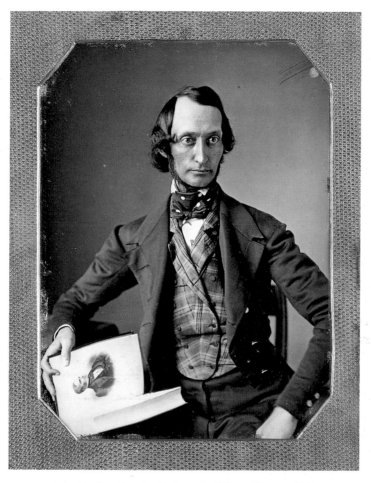

Man Holding Book with Portrait of Henry Clay, ca. 1848

Daguerreotype, 4¾ x 3½ inches
Horace W. Goldsmith Fund, 89.77

Mathew Brady
American, 1823–1896

One of the most well-known photographic entrepreneurs of the nineteenth century, Brady became famous for his portraits of politicians and celebrities. He owned galleries in New York and Washington in which he employed accomplished operators who maintained a high level of quality. Brady personally took few, if any, of the photographs that bear his studio name. However, he achieved much notoriety for financing the first comprehensive photographic documentation of the Civil War. In the following passage taken from an 1891 interview with George Townsend, Brady reminisces about his days of glory and how he managed to photograph the "Swedish Songbird," Jenny Lind:

"How old are you, Mr. Brady?"

Never ask that of a lady or a photographer; they are sensitive. I will tell you, for fear you might find it out, that I go back to near 1823–24; that my birthplace was Warren County, N.Y., in the woods about Lake George, and that my father was an Irishman....

I entered at last into business, say about 1842–43. My studio was at the corner of Broadway and Fulton streets, where I remained fifteen years, or till the verge of the Civil War. I then moved up Broadway to between White and Franklin, and latterly to Tenth street, maintaining also a gallery in Washington City. From the first I regarded myself as under obligation to my country to preserve the faces of its historic men and mothers. Better for me, perhaps, if I had left out the ornamental and been an ideal craftsman!

"What was the price of daguerreotypes forty-five years ago?"

Three to five dollars apiece. Improvements not very material were made from time to time, such as the Talbotype and the ambrotype. I think it was not till 1855 that the treatment of glass with collodion brought the photograph to supersede the daguerreotype. I sent to the Hermitage and had Andrew Jackson taken barely in time to save his aged lineaments to posterity. At Fulton street, bearing the name of the great inventor before Morse, I took many a great man and fine lady....

"Jenny Lind?"

Yes, Mr. Barnum had her in charge and was not exact with me about having her sit. I found, however, an old schoolmate of hers in Sweden who lived in Chicago, and he got me the sitting. In those days a photographer ran his career upon the celebrities who came to him, and many, I might say most, of the pictures I see floating about this country are from my ill-protected portraits. My gallery has been the magazine to illustrate all the publications in the land. The illustrated papers got nearly all their portraits and war scenes from my camera....

My wife and my most conservative friends had looked unfavorably upon the departure from commercial business to pictorial war correspondence, and I can only describe the destiny that overruled me by saying that, Like Euphorion, I felt that I had to go. A spirit in my feet said, "Go," and I went. After that I had men in all parts of the army, like a rich newspaper. They are nearly all dead, I think. One only lives in Connecticut. I spent over $100,000 in my war enterprises. In 1873 my New York property was forced from me by the panic of that year. The Government later bought my plates and the first fruits of my labors, but the relief was not sufficient and I have had to return to business.

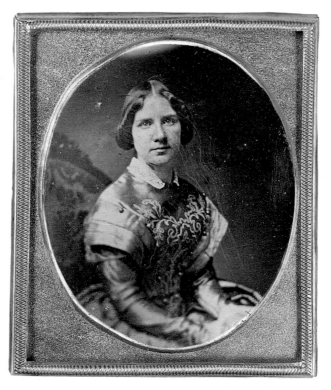

Jenny Lind, 1852

Daguerreotype, 3¼ x 2¾ inches
Purchase, partial gift of Kathryn K. Porter, and Charles and Judy Hudson, 89.75

Antoine François Claudet
French (worked in England), 1797–1867

An innovator and champion of photography as an art form, Claudet learned the daguerreotype process from its inventor Louis J. M. Daguerre. He opened London's second daguerreotype studio and, in 1853, became the official photographer to Queen Victoria. Credited as the inventor of the daguerreotype stereograph, Claudet is recognized for his exquisite hand-colored portraits. He was a prolific writer on the technical problems and artistic attributes of photography. In the following text from the American publication *Humphrey's Journal of Photography*, he expounds on photography as art:

When the present state of photography was considered, and the vast strides it had made during the last four years, it would seem that a more perfect process could scarcely be wished. The highly sensitive plates on which even such subjects as the waves of the sea could be fixed, were results which only a few years ago would appear difficult to have attained; and supposing photography to make no further progress, it was in its present state a most valuable auxiliary to the artist, as an agent in the hands of whom its application required taste and discrimination.

In taking a picture the first care was to select a fine subject, and that attained, the next point was the selection of a proper point of view from which to take it, and, lastly, the hour of the day at which the lights and shades would be most effectively rendered; for, by taking the same view under different conditions of light, very important changes were apparent. All these points having been attended to, the photographer should then never leave the place until he had obtained as perfect a picture as possible. He must seize his subject at precisely the right moment, otherwise, although he might obtain a perfect photograph, it would not be an artistic picture.

Photography was an art in which only genius and talent could rise to a high position. In the immense number of photographs exhibited during the past five years, how small was the number meriting the designation of really fine photographic pictures! There was neither pleasure nor merit in doing that which did not cost trouble or talent.

Photography would increase the taste for the productions of art; and, reciprocally, art would increase a taste for photography. Photography was the imitator of nature—the drawing was perfect, and the perspective correct. It was the image of the objects depicted in the retina which, if transitory, still was susceptible of leaving on gifted minds an impression capable of being continually recalled by the powers of memory. Photography was to the fine arts what logarithms were to mathematics; by its means work was more easy and was more rapidly accomplished. It was to the artist a vocabulary which guides him as the handbook of nature.

Since photography had been invented because fine art was in want of it, was it not ridiculous to suppose that art could be injured by it? In miniature painting it had been of the most signal advantage, as it very materially shortened the sittings. A photographer of taste, feeling, and judgment, although not a painter, might yet know how to place a model so as to give the greatest possible grace to a picture, and a painter could not fail to find among the productions of such many excellent models for study, as photographers arrange and pose many subjects daily, while the painter only arranges what he can paint.

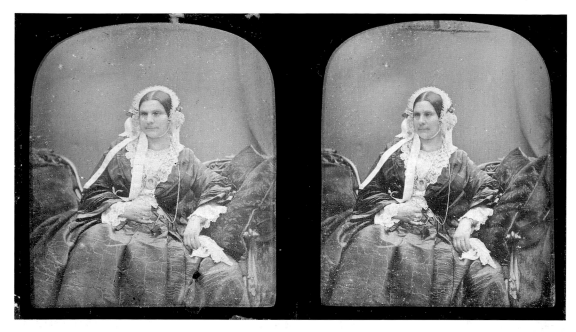

Portrait of a Woman, ca. 1855

Daguerreotype stereograph with applied color; 3¼ x 7 inches overall
Gift of Robert W. Lisle, 91.101

William Henry Fox Talbot
English, 1800–1877

Talbot's display, on January 25, 1839, of prints from the negative/positive process he formulated is generally regarded as the birth of conventional photography. Talbot patented his discovery in 1840 as the "calotype" process, and in 1844 he published *The Pencil of Nature*, the first book illustrated with actual photographic prints. His photographs were generally made in bright sunlight, which allowed exposure times of under one minute; despite this relatively fast exposure, most of Talbot's work consists of still lifes, architectural renderings, and rural scenes. His reflection on how he came to invent this photographic process was originally published in *The Pencil of Nature*.

One of the first days of the month of October 1833, I was amusing myself on the lovely shores of the Lake of Como, in Italy, taking sketches with Wollaston's Camera Lucida, or rather I should say, attempting to take them: but with the smallest possible amount of success. For when the eye was removed from the prism—in which all looked beautiful—I found that the faithless pencil had only left traces on the paper melancholy to behold.

After various fruitless attempts, I laid aside the instrument and came to the conclusion, that its use required a previous knowledge of drawing, which unfortunately I did not possess.

I then thought of trying again a method which I had tried many years before. This method was, to take a Camera Obscura, and to throw the image of the objects on a piece of transparent tracing paper laid on a pane of glass in the focus of the instrument. On this paper the objects are distinctly seen, and can be traced on it with a pencil with some degree of accuracy, though not without much time and trouble…

Such, then, was the method which I proposed to try again, and to endeavour, as before, to trace with my pencil the outlines of the scenery depicted on the paper. And this led me to reflect on the inimitable beauty of the pictures of nature's painting which the glass lens of the Camera throws upon the paper in its focus—fairy pictures, creations of a moment, and destined as rapidly to fade away.

It was during these thoughts that the idea occurred to me…how charming it would be if it were possible to cause these natural images to imprint themselves durably, and remain fixed upon the paper!

And why should it not be possible? I asked myself.

The picture, divested of the ideas which accompany it, and considered only in its ultimate nature, is but a succession or variety of stronger lights thrown upon one part of the paper, and of deeper shadows on another. Now Light, where it exists, can exert an action, and, in certain circumstances, does exert one sufficient to cause changes in material bodies. Suppose, then, such an action could be exerted on the paper; and suppose the paper could be visibly changed by it. In that case surely some effect must result having a general resemblance to the cause which produced it: so that the variegated scene of light and shade might leave its image or impression behind, stronger or weaker on different parts of the paper according to the strength or weakness of the light which had acted there.

Such was the idea that came into my mind. Whether it had ever occurred to me before amid floating philosophic visions, I know not, though I rather think it must have done so, because on this occasion it struck me so forcibly.

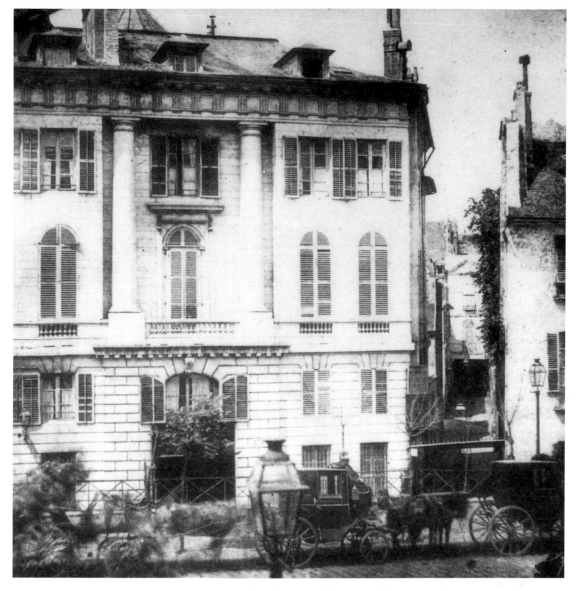

Building with Carriages, Paris, May 1843

Salted paper print from paper negative, 6½ x 6¾ inches
The Family of Alice R. and Sol B. Frank

David Octavius Hill
Scottish, 1802–1870

Robert Adamson
Scottish, 1821–1848

Hill and Adamson are celebrated as the first successful painter/photographer collaborative team. Hill, a landscape and genre painter, wanted to produce a massive group portrait (when finished in 1866, it measured 11-by-5 feet, and included 474 people), and he enlisted the photographic skills of Adamson to provide individual portraits from which he could paint. Hill posed and arranged the sitters, while Adamson handled the technicalities. The photographs remain excellent examples of the early use of William Henry Fox Talbot's calotype process; the close description of faces in bright sunlight demonstrates a prescient and clear understanding of the medium. In several of his letters, and in a prospectus for the photographs that Thomas Annan made of the painting, Hill gave his thoughts and aspirations for the calotype.

It is worthy of notice, in passing, that the Portraits made chiefly for this Picture, in 1843...by the then newly discovered Photographic Process of Mr Fox Talbot, called the Calotype or Talbotype,—Until then almost unknown or unapplied as a vehicle of artistic thought and expression,—were mainly the means of first raising the process to the rank of a Fine Art, or rather to that of one of its most magical and potent auxiliaries.

...The one selfish object I had in view in presenting them is gained, in their being in your library to demonstrate that we had at an early period of the art done it some service. I need not say I am otherwise more gratified in believing I have caused any gratification to the members of the Academy.

...The rough surface and unequal texture throughout of the paper is the main cause of the Calotype failing in details before the process of Daguerreotypes —and this is the very life of it. They look like the imperfect work of man—and not the much diminished perfect work of God.

...Our Academy have been making [illegible] important additions to their Library of late and I think this department will begin to receive more attention. They have received with [acceptance?] a project of mine to form a Calotype department of the Library of which I have formed the basis with 500 of my own. I think I have influence enough with not a few of the Calotypists to get copies of their best. These we propose to preserve in [beautiful?] volumes. Look one day to see this an important feature of our collection.

...I shall also see to your having a batch of calotypes—it may be some little time ere I can get them looked out—but it is a promise which shall gladly be redeemed. I am glad you have not tired of them. I had some hope the Chrystal Palace Fine Arts Jury would have awarded me a medal for my artistic application of this process—and I am still of the opinion they should have done so—it would have been some consolation for much time and money spent, I hope not foolishly, in making the art respectable.

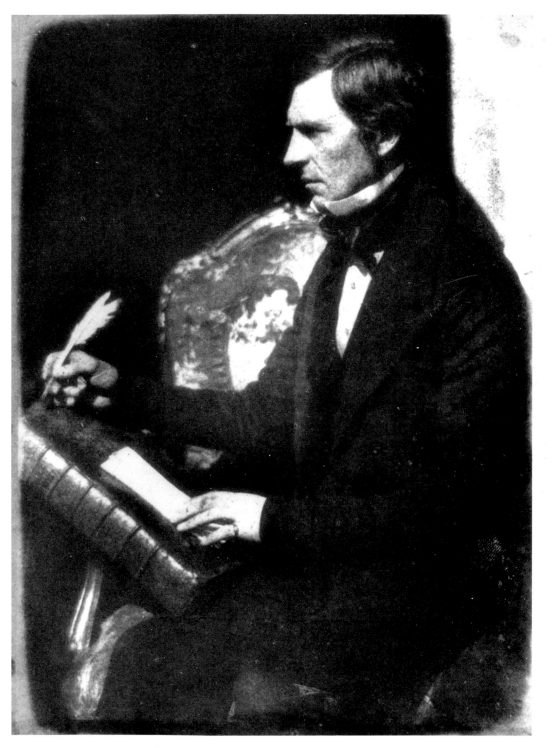

Rev. Dr. William Maxwell Hetherington (1803–65)
Professor of Apologetics and Systematic Theology at New College, Glasgow, ca. 1845

Salted paper print from paper negative, 8 x 5¾ inches
The Family of Alice R. and Sol B. Frank

Anna Atkins
English, 1799–1871

Atkins is recognized as the first woman photographer. Before hearing of Fox Talbot's photographic reproduction process, Atkins made use of drawings, etchings, and paintings to depict her interest in plant life. By using light-sensitized papers Atkins was able to obtain precisely registered contact prints of botanical specimens, which she used to produce *Photographs of British Algae: Cyanotype Impressions* (1843) in a small edition—the first illustrative use of photographic images. Atkins, using handwritten text, explained her use of the new medium of photography:

The difficulty of making accurate drawings of objects so minute as many of the Algae and Confervae has induced me to avail myself of Sir John Herschel's beautiful process of Cyanotype, to obtain impressions of the plants themselves, which I have much pleasure in offering to my botanical friends.

I hope that in general the impressions will be found sharp and well defined, but in some instances/ such as the Fuci/the thickness of the specimens renders it impossible to press the glass used in taking Photographs sufficiently close to them to insure a perfect representation of even part. Being however unwilling to omit any species to which I had access, I have preferred giving such impressions as I could obtain of these thick objects, to their entire omission. I take this opportunity of returning my thanks to the friends who have allowed me to use their collections of Algae on this occasion.

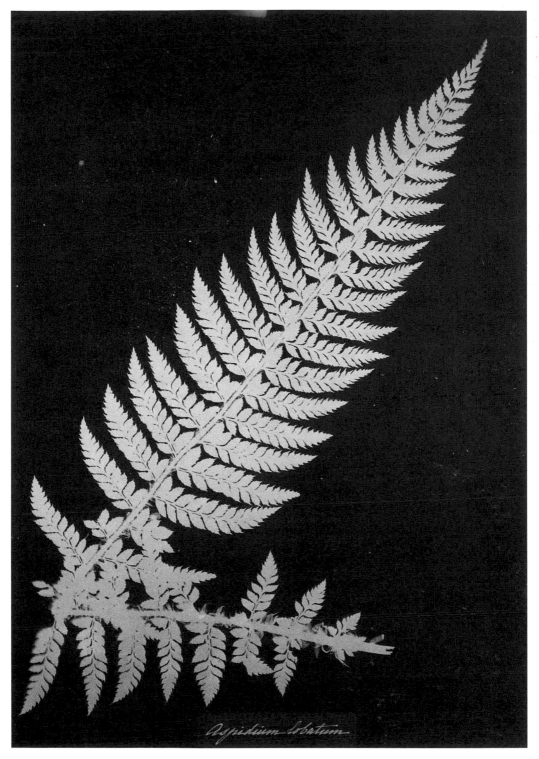

Aspidium lobatum

Aspidium Lobatum from *Cyanotypes of British and Foreign Flowering Plants and Ferns*, 1851–54

Cyanotype print, 13 x 9¼ inches
The Family of Alice R. and Sol B. Frank

Thomas Rodger
Scottish, 1833–1883

Rodger learned the mechanics of photography from his medical professor Dr. John Adamson, in Glasgow, Scotland. Dr. Adamson was also responsible for instructing his brother Robert Adamson, who entered into a famed photographic collaboration with the painter David O. Hill. Rodger operated his own photographic studio in St. Andrews, Scotland, and according to his obituary published in *The British Journal of Photography*, he was, "a born artist, and…gained for himself a name and fame which became known throughout every region of the globe." The obit also notes that "with children he was particularly successful." In this text, Rodger discusses his techniques, especially his use of various formulas to achieve different results according to the subject:

I can say little about the time the plate must be exposed in the camera, further than that, with my lenses, which are by Ross and Lerebours, and have moderate diaphragms, and with the chemicals prepared according to the formula given, my usual time of exposure (in shade) for negatives is in summer from five to thirty seconds, according to the hour of the day; and that at the present season, in the early part of a good day, it is about the same.

The quarter from which I have almost always managed to receive my light is the north-east. The steady character of light coming from this direction renders it a matter of consequence, in taking a portrait especially. To develop the image, I have long employed two different solutions; using either according to the character of the object, and the quality of the light. I shall first give the formula, and then make a remark or two regarding their application…. For a landscape No. 1 is excellent, bringing up, as it does, the parts in deep shadow, which would with many other developers be utterly lost. In portraits of gentlemen, No. 1 is also specially applicable and I always prefer it for such, as without approaching to hardness,

I obtain by it a very pleasing decisiveness of light and shadow. But, for ladies, I think too much care cannot be taken to avoid a rapid passage from lights to shadows in photographs. Therefore, to obtain that delicate and softened effect so suitable and necessary to the subject, I certainly prefer the latter solution. Very often, however, in fine light and warm weather, I as readily make use of No. 1.

The spirit is employed merely to ensure a ready mixture between the bath on the plate and the developer.

When I develop a picture, I pour on the developer and give the plate a little motion, so as to mix whatever nitrate of silver is on the surface with the developing solution, to secure uniform action; and, after the image seems pretty decided and intense, I raise the plate and examine for an instant by transmitted light. If there should happen to be a thinness or want of intensity in the deposit, I mix half a dram of a weak solution of nitrate silver with what was poured off, and pour it off and on the plate several times, or until I obtain the opacity which I desire; after which I immediately wash in the ordinary way before fixing.

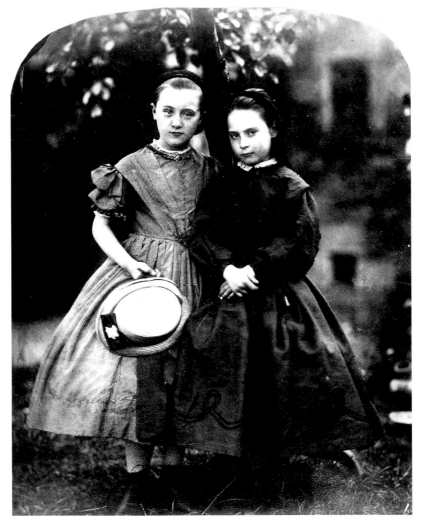

Cousins, ca. 1855

Albumen print from glass negative, 7½ x 6⅛ inches
Horace W. Goldsmith and Art Purchase Funds, 91.29

Nadar (Gaspard-Félix Tournachon)
French, 1820–1910

Nadar began working with photography in 1854 and became one of the finest portrait photographers in mid-nineteenth-century France. His clientele included numerous authors, actors, artists, composers, and celebrities. In his gallery, he hosted the first exhibition by a group of artists advocating a new style of painting known as Impressionism. It was also the meeting place for The Society for the Encouragement of Aerial Locomotion by Heavier than Air Machines. The group's secretary was the author Jules Verne, who was so enthralled by Nadar's adventurousness that the photographer became the protagonist in Verne's science fiction novel, *From the Earth to the Moon*. Navigating his own enormous hot air balloon named "The Giant," Nadar's photographic firsts included aerial views of Paris in 1868, and the use of electric lights to photograph in the catacombs and sewers of that city in 1861. In this text he clarifies the difference between the science and the art of photography.

What can't be learned, I will tell you: it's the sense of light, it's the artistic appreciation of the effects produced by different and combined qualities of light, it's the applying of this or that effect according to the nature of the face that you have to reproduce as an artist.

What can be learned still less is the moral intelligence of your subject, it's the swift tact that puts you in communion with the model, makes you size him up, grasp his habits and ideas in accordance with his character, and allows you to render, not an indifferent plastic reproduction that could be made by the lowliest laboratory worker, commonplace and accidental, but the resemblance that is most familiar and most favorable, the intimate resemblance. It's the psychological side of photography, that word doesn't seem too ambitious to me.

What also can't be learned is integrity of work: in a genre as delicate as portraiture, it's zeal, the search, an indefatigable perseverance in the relentless pursuit of the *best*; it is, in a word, the commercial honesty which I make bold to say I have inherited from our father.

The whole question is summarized for you in "doing good work." Always strive for the best, and be preoccupied day and night with the perfection of your work, and be harsher with yourself than anyone. Be sure that nothing emerges from your establishment that cannot defy the criticism of a rival.

Look for the honor before the profit—that is the surest means to find the profit with the honor.

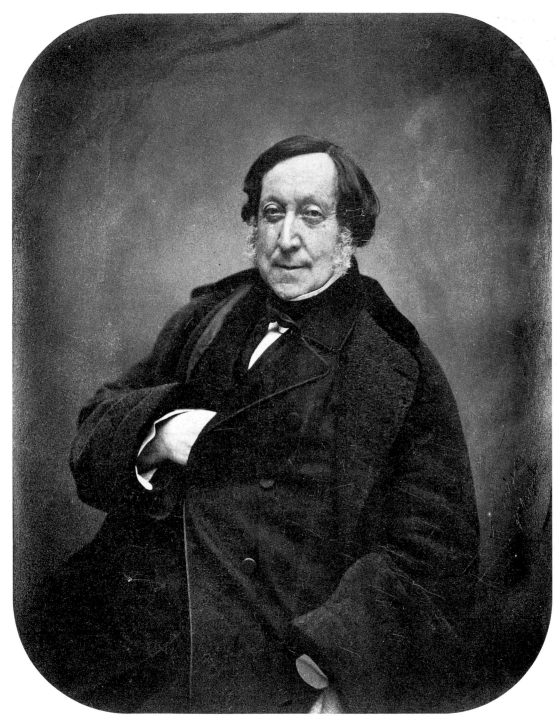

Gioacchino Antoni Rossini, 1856

Lightly albumenized salted paper print from glass negative, 9¾ x 7⅝ inches
Purchase, in memory of Alice R. Frank with funds contributed by the
Board of Trustees of The Chrysler Museum of Art and the Art Purchase Fund, 95.40

Guillaume-Benjamin Duchenne (de Boulogne)
French, 1806–1875

The founder of electrotherapy, Duchenne used photography between 1852 and 1856 to record the effects of electrical stimulation of muscles in order to determine their role in facial expression. He learned the rudiments of photography from his colleague Adrien Tournachon (also knows as Nadar Jeune; French, 1825–1903), who assisted in making some of Duchenne's physiognomic studies. In 1862, Duchenne published *Méchanisme de la Physionomie Humaine ou Analyse Électro-Physiologique de L'Expression des Passions* (The Mechanism of Human Facial Expression or an Electrophysiological Analysis of the Expression of the Emotions), illustrated by photographs taken with Tournachon's assistance. The following statement is a translation from Duchenne's book:

Photography, as true as a mirror, can illustrate my electrophysiological experiments and help to judge the value of the deductions that I have made from them.

From 1852, convinced of the impossibility of popularizing or even publishing this research without the aid of photography, I approached some talented and artistic photographers. These first trials were not, and could not be, successful. In photography, as in painting or sculpture, you can only transmit well what you perceive well. Art does not rely only on technical skills. For my research, it was necessary to know how to put each expressive line into relief by a skillful play of light. This skill was beyond the most dexterous artist; he did not understand the physiological facts I was trying to demonstrate.

Thus I needed to initiate myself into the art of photography.

I photographed most of the 73 plates that make up the Scientific Section of this Album myself, or presided over their execution, and so that none shall doubt the facts presented here, I have made sure that not one of the photographs has been retouched.

The spirit is thus the source of expression. It activates the muscles that portray our emotions on the face with characteristic patterns. Consequently the laws that govern the expressions of the human face can be discovered by studying muscle action.

I sought the solution to this problem for many years. Using electrical currents, I have made the facial muscles contract to speak the language of the emotions and the sentiments. "Experimentation," said Bacon, "is a type of question applied to nature in order to make it speak." This careful study of isolated muscle action showed me the reason behind the lines, wrinkles, and folds of the moving face. These lines and folds are precise signs, which in their various combinations result in facial expression. Thus by proceeding from the expressive muscle to the spirit that set it in action, I have been able to study and discover the mechanism and laws of human facial expression.

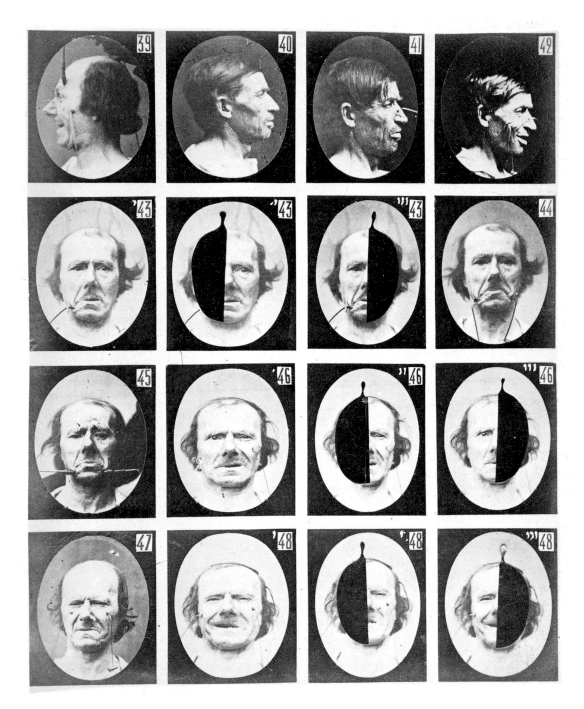

Plate 5 from *Méchanisme de la Physionomie Humaine ou
Analyse Électro-Physiologique de L'Expression des Passions*, 1862

Albumen print from glass negative, 5⅛ x 4¼ inches
Horace W. Goldsmith and Art Purchase Funds, 93.19.2

Roger Fenton
English, 1819–1869

A seminal artist in the history of British photography, Fenton studied art in France with Gustave Le Gray, Charles Nègre, and Henri LeSecq. He was instrumental in the founding of the Photographic Society of London in 1853 and was renowned for his own photographic work including architectural views, still lifes, and landscape. In 1852 he was commissioned to photograph architecture and construction projects in Russia; the same year he assembled eight hundred pictures into the first exhibition of photographs in Great Britain. Later he waged a successful campaign for the extension of copyright protection to photography. Fenton is best-known as being the first to extensively photograph a war during the Turkish and Russian conflict on the Crimean Peninsula. Woodcuts of his photographs of the Crimean War (1854–56), were published in the *Illustrated London News*. Fenton's 1855 letters report his difficulties in managing the act of photography in the harsh war environment:

Lord Raglan [Commander-in-the-Field of the British Army and Master-General of the Ordnance] was in town this morning with his staff. The soldiers have nothing but good words to say about him; one of them told me that when the weather was at the worst he was constantly sitting about amongst the men....

I am now at Headquarters taking a few portraits I am yet in want of, Lord Raglan gave me a sitting this morning and I have obtained a very good likeness of him. General Pèlissier, with whom I breakfasted this morning, is coming the day after tomorrow at five in the morning. It is impossible to work after nine or ten from the intense heat, which sends the stoppers flying out of my bottles, and spoils every picture. I am almost at the end of my materials, having only 1 oz. of nitrate of silver left....

I have found a much better way of getting my van conveyed to the site I select than by applying to the authorities. As soon as a few of the prints had been seen, I was overwhelmed with applications to go here and there to take a portrait or a view of some tent or camp. If it is a place where I want to go, I go if they will drag the van up, and if it does not take me out of my way to Headquarters. For any very heavy pull the Artillery give me six horses for small distances; the men turn out in the hope of getting photographed in a group. This way I have travelled during the past week a great part of the way up, and had it not been pouring with rain I should have got there this evening. All the heavy part of my baggage not immediately needed I leave in my hut down here [Balaclava] where I print; the rest will be sent up by one of the railway wagons to the top of the hill and I shall have to cart it from there if I can borrow a cart, or carry it piecemeal on my horses by pack saddle.

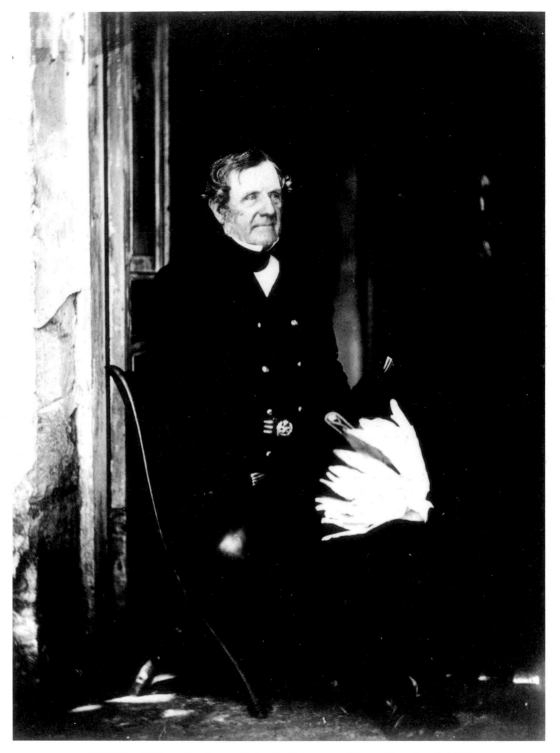

Field Marshall Lord Raglan, published by T. Agnew and Sons, November 1, 1855

Salted paper print from glass negative, 7 x 5⅞ inches
The Family of Alice R. and Sol B. Frank

Maxime DuCamp
French, 1822–1894

DuCamp, a Parisian journalist and man-of-letters, made his only known photographs while travel-ing with the writer Gustave Flaubert through Greece, Egypt, Palestine, and Turkey between 1849 and 1851. Multiple sets of 125 albumen prints, made by the French photo-technician Louis Dèsirè Blanquart-Evrard from DuCamp's negatives, were assembled into a travel album titled *Egypte, Nubie, Palestine et Syrie* (1852). This album, the first of its kind in France to use actual photo-graphic prints in its presentation, brought DuCamp's straightforward impressions of far away and fantastic regions home to the French public. While on his photographic expedition with Flaubert, DuCamp recorded his experiences in extensive notes.

Gustave gives a loud cry, and I am pale, my legs trem-bling. I cannot remember ever having been moved so deeply.... When we reached the Sphinx...Flaubert reined in his horse and cried, "I have seen the Sphinx fleeing toward Libya; it was galloping like a jackal." And he added: "That's from *Saint Anthony*...."

Every time I visited a monument I had my photo-graphic apparatus carried along and took with me one of my sailors, Hadji Ismael, an extremely handsome Nubian, whom I had climb up on to the ruins which I wanted to photograph. In this way I was always able to include a uniform scale of proportions. The great difficulty was to get Hadji Ismael to stand per-fectly motionless while I performed my operations; and I finally succeeded by means of a trick whose success will convey the depth of naiveté of these poor Arabs. I told him that the brass tube of the lens jut-ting from the camera was a cannon, which would vomit a hail of shot if he had the misfortune to move—a story which immobilized him completely, as can be seen from my plates.

The day I was returning from Dendera I overheard the following conversation between him and Raïs Ibrahim—a curious account of a photographic expedi-tion: "Well, Hadji Ishmael, what news?" asked the *raïs* as we boarded the *cange*. "None," the sailor answered. "The Father of Thinness ('Abu Muknaf,' as I was called by my crew) ordered me to climb up on a column that bore the huge face of an idol; he wrapped his head in the black veil, he turned his yellow cannon towards me, then he cried: 'Do not move!' The cannon looked at me with its little shining eye, but I kept very still; and it did not kill me." "God is the greatest," said Raïs Ibrahim, sententiously. "And our Lord Mohammed is his prophet," replied Hadji.

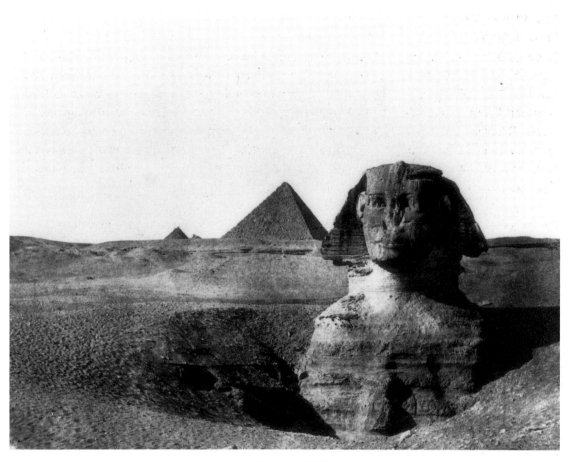

Le Sphinx, 1849

Salted paper print from paper negative, printed by Blanquart Evard, 6⅛ x 8⅛ inches
The Family of Alice R. and Sol B. Frank

Félix Teynard
French, 1817–1892

In 1851 and 1852 Teynard, a civil engineer, traveled throughout Egypt recording the country's landscape and architectural monuments. Teynard was interested in capturing the patterns created by the contrasts of light and shadow, and his photographs display a unique balance of information and design. Originally issued beginning in 1853 Teynard's salted paper prints were published in two volumes under the title *Égypte et Nubie: Sites et monuments* (1858), a travel album considered to be one of the masterpieces of nineteenth-century photography. Teynard's description of the voyage, excerpted from *Égypte et Nubie*, follows:

The plates included in this work were photographed as souvenirs during a voyage that we made in the years 1851 and 1852. The edifices of the different eras, the banks of the Nile, the wretched dwellings of the fellahin, were taken one after another to recall the sensations experienced during the many months that we passed, alone, among the inhabitants of Egypt and Nubia. The monuments of ancient Egypt deserved the larger share of the photographs, since, from the historical and architectural points of view, they represent an account of the most ancient civilization that has come down to us. It is regrettable that the complete gloom that reigns inside the tombs and temples cut into the flanks of the cliffs does not permit the photographing of the exceedingly harmonious and remarkable paintings that decorate their walls. The absence of windows in Egyptian buildings also prevents the possibility of obtaining interior views unless collapsed ceilings allow the penetration of the sun's rays.

We brought back photographs of all the buildings of any importance that still stand in the Nile valley. When the monuments were numerous, and when the distribution of locations permitted, we took an overall view, detail views, and examples of the sculpture. Many of the photographs are far from being irreproachable, but the traveler perhaps has the right to some indulgence when his meticulous work is carried out in a country like Egypt. Isolated in a region without resources, he can count on himself alone; pressed for time, the slowness of the means of transportation does not permit him to retrace his steps; as a nomad, his installation is always temporary, and the delicate preparations for photography must be done, sometimes with the lurching of a sail boat, sometimes beneath a tent set up in the middle of the desert.

These statues…represent [Amenophis III].… They are 18 meters apart and face the southeast. Their height is approximately 16 meters from the tops of the partially buried bases which are 4 meters high. The left colossus is a monolith of very hard crystalline sandstone, brought from the southern Thebaïd. The one on the right, given the name Memnon by the Greeks, was also a monolith, but…it was broken across the center during an earthquake. When it was hit by the rays of the rising sun, the part that remained in place gave off sounds which Pausanias compared to those produced by a lyre string when it breaks. A large number of travelers, among them the Emperor Hadrian, witnessed this phenomenon. These sounds came from the disintegration of the stone caused by the heat of the sun vaporizing the humidity absorbed during the night. These conditions were changed by Septimius Severus, who had the colossus repaired. Since that time, its melodious voice has ceased.

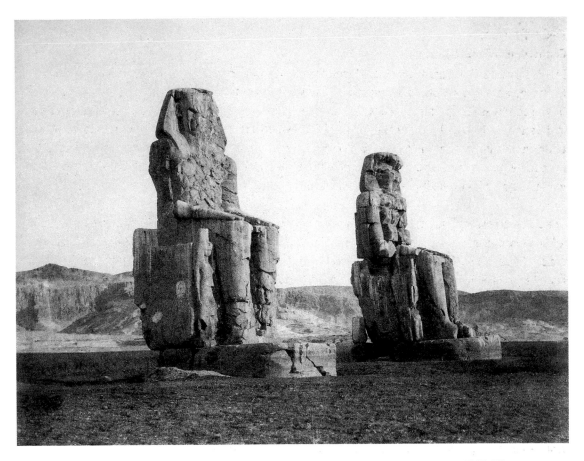

Colossi (The one on the right called the Colossus of Memnon), Qurna (Thebes), 1851–52

Salted paper print from a waxed paper negative, 9¼ x 12 inches
Purchase, gift of Alice R. Frank, 93.47

Francis Frith
English, 1822–1898

Frith traveled and photographed extensively in Northern Africa and the Near East in the mid-nineteenth century. His recollections of his adventures, which were intended to inform and delight the armchair traveler, were visually descriptive scenes of exotic lands. Between 1855 and 1870, he made or published over 100,000 views, many in book form. Originally published as the introduction to his 1858–59 book *Egypt and Palestine*, the following passage clearly shows Frith's wry sense of humor:

Salaam!—Peace be with thee, oh, thou pleasant Buyer of my book!

It is my intention, should my life be spared, and should the present undertaking prove successful, to present to the public, from time to time, my impressions of foreign lands, illustrated by photographic views.

I have chosen, as a beginning of my labours, the two most interesting lands of the globe—Egypt and Palestine. Were but the character of the pen for severe truthfulness as unimpeachable as that of the camera, what graphic pictures might they together paint! But we scarcely expect from a traveller "the truth, the whole truth, and nothing but the truth."

...I hold it to be impossible, by any means; fully and truthfully to inform the mind of scenes which are wholly foreign to the eye. There is no effectual substitute for actual travel; but it is my ambition to provide for those to whom circumstances forbid that luxury faithful representations of the scenes I have witnessed, and I shall endeavour to make the simple truthfulness of the camera a guide for my pen.

Now we shall see (if my bungling does not spoil the match) what sort of chance Fact has with Fiction in the race for popularity.... A man sitting quietly at home in London or New York may write even a Book of Travel, and an artist may compose for it a series of illustrations, with every chance of success upon the most scanty materials, and with the cost and labour of travelling. It is an artist's privilege to "make a picture" of his subject; but, alas for the poor photographer! and alack for the man who will write the truth, if he can, at all hazards!—they must be dull.

A photographer only knows—he only can appreciate the difficulty of getting a view satisfactorily into the camera: foregrounds are especially perverse; distance too near or too far; the falling away of the ground; the intervention of some brick wall or other commonplace object, which an artist would simply omit; some or all of these things, (with plenty others of a similar character) are the rule, not the exception. I have often thought, when manoeuvring about for a position for my camera, of the exclamation of the great mechanist of antiquity—"Give me a fulcrum for my lever, and I will move the world." Oh what pictures we would make if we could command our points of view!

The difficulties which I had to overcome in working collodion in those hot and dry climates, were also very serious. When, at the second cataract; one thousand miles from the mouth of the Nile, with the thermometer at a hundred and ten degrees in my tent, the collodion actually boiled when poured upon the glass plate, I almost despaired of success. By degrees, however, I overcame this and other difficulties; but I suffered a good deal throughout the journey from the severe labour rendered necessary by the rapidity with which every stage of the process must be conducted in climates such as these, and from excessive perspiration, consequent upon the suffocating heat of a small tent, from which every ray of light, and consequently every breath of air, was necessarily excluded.

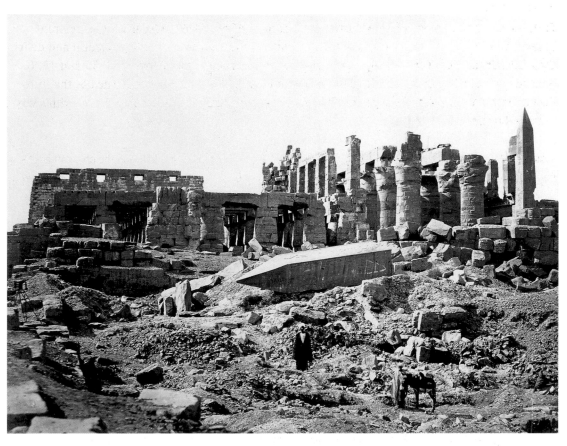

The Temple of El Karnak, from the South East, 1857, from *Egypt, Sinai, and Jerusalem*, 1858

Albumen print from glass negative, 15 x 19¼ inches
Horace W. Goldsmith and Art Purchase Funds, 91.94

Linnaeus Tripe
English, 1822–1902

Prior to being hired to photograph antiquities by the British East India Company in 1855, Captain Tripe was photographer to the British mission at the court of Ava in Burma. For thirty-six days he battled unfavorable working conditions and weather to produce a series of Burmese views published for the Madras Photographic Society in 1857. These images, as well as a group of stereoscopic views taken in 1858, reveal Tripe's interest in picturesque representations of monuments in natural settings. The following passages, which are excerpted from letters and a brief text written by Tripe, describe the difficulties he met in completing his assignment for the Government and his resultant frustrations:

The accompanying views, taken by the undersigned when attached to the Embassy to Amerapoora in 1855, in justice to him as a photographer employed by the Government of India, should not be looked upon as a challenge to Photographic criticism; but as a series of views of subjects interesting on account of their novelty; many having been retained solely on that account when they would certainly have been otherwise discarded. As excuses, too, for these defective photographs he would wish it known, that he was working against time; and frequently with no opportunities of replacing poor proofs by better. Also that, from unfavourable weather, sickness and the circumstances unavoidably attending such a mission, his actual working time was narrowed to thirty six days....

If during the hot season at Madras those accustomed to it feel exertion in common duties irksome, what must become of his [the photographer's] energy who, instead of a well ventilated office with all appliances for banishing heat and discomfort, has a room where no air in movement is allowed because of dust, and no ventilation because of white light, the temperature higher than outside, the atmosphere a mass of chemical evaporations. This is his Workroom; what does his Work become? All the better because carried on under such difficulties? By no means. Perspiration, impatience, failure, mutually act and react on each other. If at all successful, it can only be partially so because of deteriorated chemicals....

Two causes have retarded [printing] work—sickness among my assistants from working in close rooms, during the hot weather; and rain experiments, to enable me to work during the monsoon, have also tended to retard progress.

One cause of the amount of failures [unsatisfactory prints], has been the newness of the work to those assisting me, and also the fact, that (in this country especially), the wax, used to render the negatives transparent, is melted out, by the heat of the sun, in printing and spots the first-positives so as to spoil them....

I have had no leave of any kind since December 1854, but have been closely at work for most of the interval. It is not to be supposed, that, because Photography is taken up as an amusement by so many, that when pursued zealously as a duty, that duty is slight. On the contrary, I declare seriously, that I have never had such hard work, as I have had during the last two years of my life....

There is scarcely a duty more easily perverted to private pleasure or advantage than mine has been, and I feel it almost necessary to assure His Excellency the Governor in Council that I have not done so: and further that economy both of time and materials has been my anxious care from first to last.

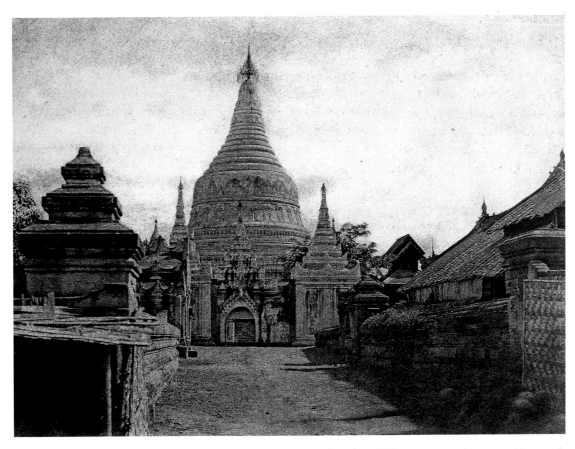

Amerapoora Bodan Pagoda, Burma, 1855

Salted paper print from waxed paper negative, 11 x 13¾ inches
Horace W. Goldsmith and Art Purchase Funds, 93.312

Gustave Le Gray
French, 1820–1882

Trained as a painter, Le Gray was among the earliest to perceive the artistic potential of the new medium of photography. He is recognized as one of the pioneers of photography as art. His seascapes of the 1850s illustrated how light—at its most brilliant moment—could define a scene and that this depiction of light could be the focal point for a work of art. This concept was later realized in color by the Impressionist painters. Constantly striving to improve the technical shortcomings of the medium, this 1850 English translation of Le Gray's *Practical Treatise on Photography* offers some advice:

The extensive application that I have been enabled to make for several years of the art of Photography, as a means of obtaining an exact re-production of nature in all its aspects, Landscapes, Monuments, Pictures, & c., has opened to view its immense importance, and urges the necessity of a sure method, without restriction, which will facilitate its employment by the Artist and Amateur.

I wish to be useful, both to one and the other, in the publication of this process, which my research and experience has made known to me as the most certain and practicable.

The future and extensive application of this art will, doubtless, be confined to the paper process, and I cannot too much engage the amateur to direct his attention and study to it.

The negative proof upon glass, it is true, is finer, but I think it is a false road, and it would be much more desirable to arrive at the same results, with the negative on paper.

Glass is very difficult to prepare, fragile, and inconvenient to travel with, and less rapidly operated upon by the light.

Thus, though its results are extremely delicate, I would strenuously urge the perfection of paper fabrication, as a means to arrive at the same delicacy of detail which is produced upon glass.

That this is possible, I am certain, from some perfect results that I have obtained.

Nevertheless, by the application of a coat of albumen on paper, we can obtain results which are equally perfect with those upon glass.

All will agree that paper is more convenient for travelling, as glass is weighty, fragile, and, if broken, may be difficult to procure in some places.

It is for this reason that I would wish Artists not to be dazzled by the beautiful results upon glass, and not to be discouraged in their pursuits upon paper. It should be, on the contrary, a subject of emulation to perfect the results upon that material.

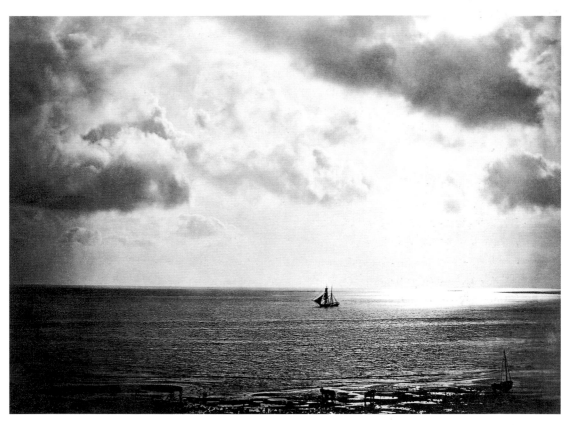

Brig on the Water, ca. 1855

Albumen print from glass negative, 12 x 16 inches
Purchase, gift of Mr. and Mrs. Calvin H. Childress, Mr. and Mrs. Chris A. Crumley, Mrs. Alice R. Frank,
Dr. and Mrs. George M. Kemp, Mr. and Mrs. Harry Lester, Mr. and Mrs. Arnold B. McKinnon, Dr. Patricia L. Raymond,
P. L. Wilds, Landmark Communications Art Trust, Art Purchase Fund, and an Anonymous Donor; 94.33

Adolphe Braun
French, 1812–1877

Originally a textile designer, Braun began photographing flower and still-life compositions in 1853. Turning to landscape imagery, he created many photographs of Alpine, Black Mountain, and Vosges scenery, and supplied prints in a variety of formats, including stereoscopic and panoramic views, to subscribers throughout Europe and the United States. In the late 1860s he built a photographic printing plant that produced reproductions of artistic masterpieces. Braun refers to these reproductions as publications in the following letters to art critic and journalist Paul de St. Victor:

My establishment has a few exceptional features and I do not believe many of my colleagues have seen the need for a steam engine such as I use to operate many of the machines in my workshops.

I have always regretted the fact that the French government had never so much as condescended to acknowledge the importance or influence of our publication, in spite of the many difficulties I had to overcome in order to lower its price to make the riches of our great masters available to everyone.

M. Von Zahn, director of the Museum of Dresden, has recently asked me to approach the Commission Royale for permission to photograph their Musée de la Peinture, assuring me of his unconditional support. He also advised me to emphasize to them the lack of interest of the French government in our outstanding publication. He also added that he was quite prepared to pull the most powerful levers so that we could be granted this great privilege.

As you can image I let my dignity as an Alsatian guide me in this matter and I sent in my request but chose not to allude to the French government's attitude; so I do hope you approve of my decision.

I have felt extremely gratified by this call to the public's attention, written by a man who is not only the most competent but also a master of language. This has been the greatest boost to me and no sooner are your articles published than I receive the most flattering letters from unknown correspondents.

So please accept my most sincere thanks for this latest evidence of your friendship.

You may have already seen the "Collection des Statues du Louvre." I must admit I am not entirely satisfied with it. I feel my technician has not quite captured the best angles of their faces; however, you might find some of the most famous ones quite satisfactory, considering the incoherence of the lighting as well as the numerous stains on some of the marbles....

My younger son will be in Paris for a few days and will of course call on you to pay his respects. He knows M. Ch. Blanc personally, having traveled with him to Egypt. He can pay him a professional visit and discuss with him my wish to work on some paintings. He will no doubt follow your advice on this matter.

Please accept my gift of a cask of wine from Alsace. I remember how much you had enjoyed it when you visited me in Dornach. It comes from my own vineyards and I harvest it myself. It dates from the days when the Vosges did not separate us from France.

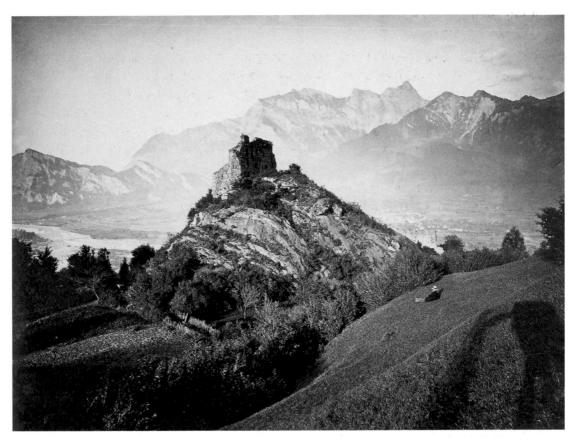

Alpine Landscape, ca. 1860

Albumen print from glass negative, 7⅝ x 10¼ inches
Purchase, gift of Alice R. Frank, 93.20

Adalbert Cuvelier
French, ?–1871

Eugène Cuvelier
French, 1837–1900

Adalbert was a businessman, amateur painter, and photographer. His son Eugène was a painter and photographer. Both worked in the forest of Fontainebleau and were friendly with many of the Barbizon painters. Their photographs, which capture the beauty in nature's inherent simplicity, are quite similar and frequently indistinguishable. Although father and son used both glass plate and paper negatives, the imperfections and absorptive qualities of the paper reveal the mystical atmosphere of the forest and the smoky effects of filtered sunlight. In this excerpt, Adalbert urges his colleagues to study the artistic sensitivities of painting to become good photographers:

Many people who have never taken up either painting or drawing and know absolutely nothing about either one, imagined that the discoveries of Niepce and Daguerre would enable just about anyone who could afford a darkroom with all the Daguerreian paraphernalia, including a how to brochure, to produce wonders.

They were mistaken.

I am not saying there that one must be an expert at painting or drawing in order to become a good photographer, but what I am saying is that one must be an artist. You must have sensitivity to painting, understand its effect and composition.

Those are crucial matters if you do not want to spend your life turning out, without realizing it, a lot of ridiculous pictures, and there are too many of those out there already.

To those who wish to become decent photographers and acquire those skills, if they do not yet have them, I would say this: Get acquainted with an elite painter, someone serious, ask him for his advice and then put it to good use.

Most photographers who do only portraits might think that it is not really necessary to know how to compose a scene in order to do something so simple.

Well, those are precisely the ones I want to understand that being knowledgeable is essential, because, to me, nothing appears quite so difficult as to pose a model well and light him correctly, for the very reason that it seems so simple to do.

In the interest of photography and photographers I cannot urge amateurs enough to understand that photography is not a trade but an art and that, as a consequence, their feeling and their knowledge must be reflected in their works just as the feeling of a painter is reflected in his paintings.

In order to prove this point, one needs only to examine the work of several photographers who operate equally well and use the same techniques. Their finished products are all very different. Each one of them will have a distinctive style and it is almost as easy to recognize them as to tell a Delacroix from a Decamp or a Corot from a Troyon.

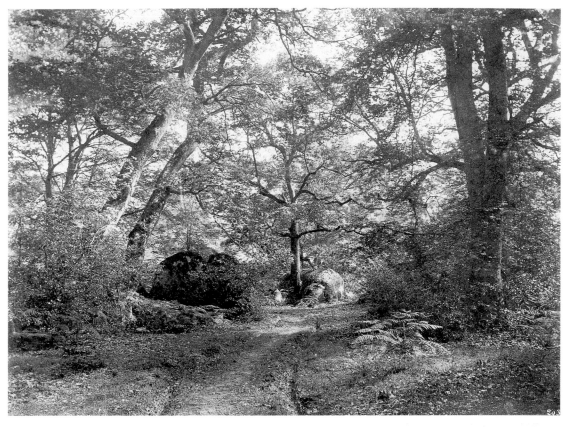

View in a Forest, probably Fontainebleau, ca. 1860

Albumen print from paper negative, 9⁷⁄₈ x 13³⁄₈ inches
Horace W. Goldsmith and Art Purchase Funds, 90.328

Charles Nègre
French, 1820–1880

A respected painter, Nègre exhibited in many of the Paris salons, yet he was far more adventurous with his photography. His first well-known photographs, which were genre studies of people on the streets of Paris, were considered remarkable because of the long exposure times required in the 1850s. Because of the ordering of the space, the image *Landscape with Chapel* was considered to be quite revolutionary. Rather than a formal, straightforward presentation of the hillside, the composition has a diagonal orientation. The work could even be thought of as a precursor to the style of painting that Cézanne, working in the same area of France, was to accomplish later. The following text comes from an unpublished manuscript probably meant to serve as an introduction to Nègre's 1854 album entitled *The Midi de la France Photographed*. Commenting on the exactitude of photographs, Nègre says:

Henceforth, photography will replace that category of drawing requiring rigorous accuracy.

If art is the poetic interpretation of nature, photography is the exact translation; it is exactitude in art or the complement of art.

In giving us perspective and geometric precision, however, photography does not destroy the personal feeling of the artist: he must always know how to choose his subject; he must know how to choose the most advantageous point of view; he must choose the effect that will be most in harmony with his subject.

Photography is not a remote and barren art; it is, in fact, a rapid, sure, and uniform means of working, which is at the artist's service, and which can thus reproduce with mathematical precision the form and the effect of objects as well as that poetry which is the immediate result of all harmonious combinations.

It is not only the varied and picturesque nature of the sites, the brightness of the sun, the purity of the atmosphere that I wished to show in my photographs; in addition to the beauties with which the Creator has endowed our climes and which stem from completely physical causes, I have searched for beauty of another order which also should be of importance to us because it relates to the study of art and history. Each generation has left a visible trail of its passage across the face of the earth—such as religious monuments, public or private—and it is through the study of these monuments that, today, we may form an exact idea of the various civilizations.

Being a painter myself, I have kept painters in mind by following my personal tastes. Wherever I could dispense with architectural precision I have indulged in the picturesque; in which case I have sacrificed a few details, when necessary, in favour of an imposing effect that would give to a monument its real character and would also preserve the poetic charm that surrounded it.

Landscape with Chapel, near Cannes, ca. 1865

Albumen print from glass negative, 10 x 13 inches
Horace W. Goldsmith and Art Purchase Funds, 92.47

Alexander Gardner
American (b. Scotland), 1821–1882

A pioneering photojournalist and master of portraiture, Gardner made numerous portraits of Abraham Lincoln and other notables, including Native Americans. Gardner documented the Civil War and photographed the Westward expansion of the railroad. In 1866, he published the first photographically-illustrated book on the war, *Gardner's Photographic Sketch Book of the War*. The passage that follows is drawn from that book and comes from the introduction and commentary accompanying *Home of a Rebel Sharpshooter*. In it, Gardner presents an emotional verbal portrait as a companion to the photograph:

In presenting the *Photographic Sketch Book of the War* to the attention of the public, it is designed that it shall speak for itself. The omission, therefore, of any remarks by way of preface might well be justified; and yet, perhaps, a few introductory words may not be amiss.

As mementoes of the fearful struggle through which the country has just passed, it is confidently hoped that the following pages will possess an enduring interest. Localities that would scarcely have been known, and probably never remembered, save in their immediate vicinity, have become celebrated, and will ever be held sacred as memorable fields, where thousands of brave men yielded up their lives a willing sacrifice for the cause they had espoused.

Verbal representations of such places, or scenes, may or may not have the merit of accuracy; but photographic presentments of them will be accepted by posterity with an undoubting faith. During the four years of the war, almost every point of importance has been photographed, and the collection from which these views have been selected amounts to nearly three thousand.

On the Fourth of July, 1863, Lee's shattered army withdrew from Gettysburg, and started on its retreat from Pennsylvania to the Potomac. From Culp's Hill, on our right, to the forests that stretched away from Round Top, on the left, the fields were thickly strewn with Confederate dead and wounded, dismounted guns, wrecked caissons, and the debris of a broken army. The artist, in passing over the scene of the previous days' engagements, found in a lonely place the covert of a rebel sharpshooter, and photographed the scene presented here. The Confederate soldier had built up between two huge rocks, a stone wall, from the crevices of which he had directed his shots, and, in comparative security, picked off our officers. The side of the rock on the left shows, by the little white spots, how our sharpshooters and infantry had endeavored to dislodge him. The trees in the vicinity were splintered, and their branches cut off, while the front of the wall looked as if just recovering from an attack of geological small-pox. The sharpshooter had evidently been wounded in the head by a fragment of shell which had exploded over him, and had laid down upon his blanket to await death. There was no means of judging how long he had lived after receiving his wound, but the disordered clothing shows that his sufferings must have been intense. Was he delirious with agony, or did death come slowly to his relief, while memories of home grew dearer as the field of carnage faded before him? What visions, of loved ones far away, may have hovered above his stony pillow! What familiar voices may he not have heard, like whispers beneath the roar of battle, as his eyes grew heavy in their long, last sleep!

Home of a Rebel Sharpshooter, Gettysburg, July 1863
from *Gardner's Photographic Sketch Book of the War*, 1866

Albumen print from glass negative, 6¾ x 8⅞ inches
Purchase, partial gift of Carol L. Kaufman and Stephen C. Lampl in memory of their parents Helen and Carl Lampl, 91.23.41

Thomas Roche
American, ?–1895

Roche was primarily known for his Civil War photography. By 1862, he had become part of the photographic team of Anthony & Co., and was traveling with the Union Army. He was among the first to photograph in the occupied cities of Petersburg and Richmond, Virginia. Roche was a prolific maker of landscape views and spent much of the 1870s photographing throughout California and the South. This description of Roche's working methods is excerpted from "Landscape and Architectural Photography," which was published in the September 1873 issue of *The Philadelphia Photographer*:

For general outdoor photography it will be necessary to have plenty of lenses, and the most improved camera box. Attempting to do work of all kinds with a single lens and an old-fashioned box will not answer. For instance, with an old-fashioned rigid, portrait camera box and a 4-4 portrait tube, trying to take a view of a five or six story building in a narrow street, or a view of a fine dwelling inside of a row of trees, the front of the camera not sliding up and down, the box has to be pointed upwards at a sharp angle, and the result is a picture without parallel vertical lines. No wonder that customers complain that there is something wrong, or, as one remarked to me, that his house looked as if all his cider barrels in the cellar had burst, and the picture was taken as the house was going over. Another instance I have seen this summer, viz., a professional photographer taking stereoscopic views with a rigid portrait box cocked up as usual and but one lens. This mode is, I believe, about the first used in making stereoscopic views, but has been long discarded for the twin tubes.

In going but a short distance from home, you will only require a dark box or tent with all necessary chemicals, camera, tripod, and negative box; but for an extended trip you will need a chemical box or miniature stock depot, divided up into square compartments, to pack your bottles and extra stock in, as on railroads they are handled rather roughly. In travelling over mountains on mule-paths, you will require boxes long and narrow. They can be packed readily on each side of the mule, and can be well tied, so that, in case the mule should roll over, he cannot hurt anything. It is always best to make out a careful list of everything needed, for if you wish to do good work, go prepared for it—do not begin to make excuses about this or that article. Take all inconveniences you may meet with in good part, and keep your temper and powder dry. It is better, if you have the time, to reconnoitre the place on some day previous to working. Pick out your standpoints, and look out for what will make good stereo views and 8 x 10 or larger sizes; mark down the time of day the light is most suitable.

My latest mode of working is to give a good exposure for details; and, in developing, get out all you can, but do not overexpose or develop so as to get a foggy or flat negative. For general work a well-lighted picture will not require, if your chemicals are in good working condition, any redeveloping or intensifying, by using Anthony's new negative collodion.

Some of our best landscape photographers have been for some time developing in the field, and finishing up at home in the evening or next morning....

If the above may be of some benefit to those who are working in the field by the wet process, I shall be abundantly rewarded.

The Petersburg Courthouse, Virginia, April 3, 1865

Albumen print from glass negative, 10 x 8⅜ inches
Horace W. Goldsmith and Art Purchase Funds, 93.19.6

Carleton E. Watkins
American, 1829–1916

One of the most accomplished ninteenth-century photographers, Watkins created awe-inspiring views of the western American landscape and received world-wide acclaim after exhibiting at the Paris International Exposition of 1867. He began as a daguerreotypist in San Francisco and soon mastered the wet collodion glass plate process as well. Enduring the difficulties of cumbersome equipment and rough terrain he became the preeminent photographer of Yosemite. Watkins's photographs of that magical Eden were among the first to cross the continent to be seen in the East. In 1864 his imagery was used to help convince Congress to preserve Yosemite Valley. In order to settle a debt, Watkins endured the indignity of losing his precious negatives to a competitor in 1875. Phoenix-like, he remade many of his earlier views of Yosemite with an even more refined artist's eye. Undoubtedly, his earlier financial troubles weighed heavily on his mind, as revealed in the following excerpts from letters to his wife Frances:

Anaconda, Saturday, July 5th, n.y.: Yesterday, "the glorious fourth," I started in to do some work and did do some altho the day was not satisfactory and today it is cloudy and raining, you can imagine in what humor I am in. Nearly a month gone and nothing done—the oldest inhabitant here never saw anything like it, but those that are not so old say the rainy season generally lasts until the 4th of July. This year is certainly no exception. If it was good weather I should have a tough job ahead of me and as it is it makes me pretty nearly sick and there is provocation enough without the weather.

Portland, Oregon, September 19, 1882: I never had the time seem so long to me on any trip that I ever made from home, and I am not half done my work, in fact barely commenced. It drags along awful slow, between the smoke and the rain and the wind, and as if the elements were not enough to worry me, a spark from an engine set fire to my [dark] tent last week and burned it half up, and it was the merest chance that it did not ruin the whole outfit. I was where I could not see it but some men working near called out to me and I got to it in time to prevent it doing any damage except to the tent. It took a couple of days to repair damages, and of course money. Talking about money....

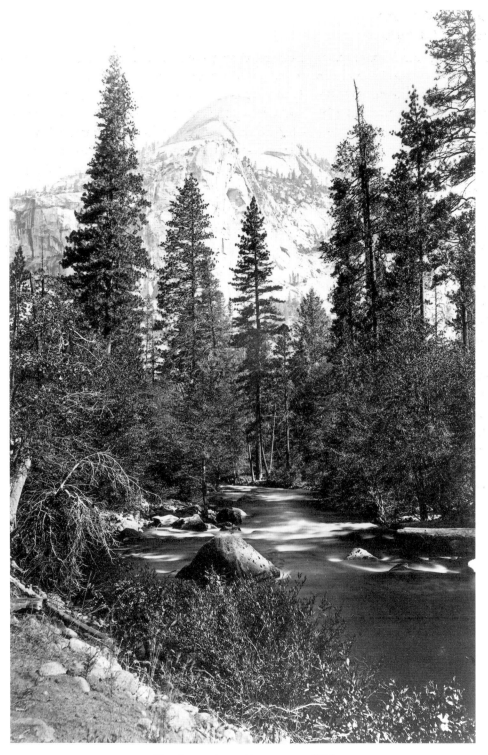

The North Dome, Yosemite, ca. 1866

Albumen print from glass negative, 21¼ x 17⅜ inches
The Family of Alice R. and Sol B. Frank

William Bell
American (b. England), 1830–1910

After operating a daguerreotype studio in Philadelphia, Bell joined the Union Army in 1862. In 1865, he was appointed chief photographer for the Army Medical Museum in Washington, D.C., where he documented the injuries suffered by Civil War soldiers. In 1872, he accompanied Lieutenant George M. Wheeler on a geographical survey west of the 100th meridian for the War Department. In the January 1873 issue of *The Philadelphia Photographer*, Bell published "Photography in the Grand Gulch of the Colorado River" which comments on his arduous trek:

Since my last communication to you I have had some rough experience in this far western country, where few white men have trod, and where the camera never before perhaps has had a "shot" at the wild beauties about us.

I will give you a little idea of our routine work, day by day, that you may know that it is not all ease and comfort.

I arise at 4 A.M.; feed the mule; shiver down my breakfast; mercury at 30 degrees, candle dim, cup and plate tin; my seat, the ground. After breakfast I roll up my bedding, carry it up to the property line to be loaded on the pack mule, water and saddle my riding mule, and by that time it is broad daylight. If negatives are to be taken on the march the photographic mule is packed with dark-tent, chemical boxes and camera, and out we start ahead of our exploring party on the lookout for views.

Having found a spot from whence three to four can be had, we make a station, unpack the mule, erect the tent, camera, &c. The temperature has risen from 30 to 65 degrees. One finds difficulty in flowing a 10 by 12 [inch] plate with thick enough collodion to make a sufficiently strong negative without redevelopment, and to have a plate ready for development that has not dried, on account of the distance the plate has been carried, and time intervening between sensitizing and development.

These troubles are constant, with occasional gusts of wind and fine white alkali dust, which often covers the plate, while being coated with collodion, as though it had been sifted on it from a dredging-box. Excepting these difficulties, along with the precipitation of half the iron in solution by the addition of the alkaline water (most met with), everything may be said to work as smoothly as could be expected under the circumstances, but the ultimate inspection of the now dried negatives is most disheartening.

They are covered with dust and sand. A blender is used to remove most of it, and the negative is varnished and packed up. Having got all we can here, everything is repacked. Meantime the whole party have passed on and are several miles ahead.

We start again, and repeat our work at another station, which, when done, brings us late in the day, and from eight to ten miles in the rear of the main party. We endeavor now to reach camp in good season, but it is generally about dark and very cold. Arriving in camp, we water, unsaddle, and feed the mules; then to supper; and, if it is not one's turn on guard, make our bed and retire, with our loaded carbine and pistol handy.

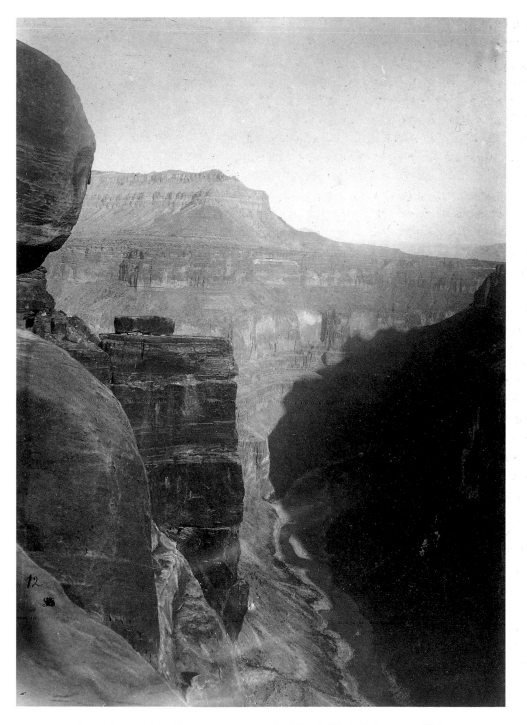

Grand Cañon of the Colorado River, mouth of Kanab Wash, looking east, 1872

Albumen print from glass negative, 11 x 8 inches
Horace W. Goldsmith Fund, 84.271

William Henry Jackson
American, 1843–1942

Working for the United States Geological and Geographical Survey (1870–78), and others, Jackson documented the western American frontier. His photographs from this period were instrumental in the U.S. Congress passing legislation preserving the Yellowstone, Grand Teton, and Mesa Verde areas as national parks. During his long life, which extended from the early years of the daguerreotype into the widespread use of the 35mm camera, Jackson became known for his wide-ranging work including his portraits of Native Americans and his commissioned images of railroad expansion in the West. In 1894–96, he photographed sites around the world on behalf of the World Transportation Commission. In these passages, from his autobiography *Time Exposure*, Jackson describes the difficulty in working with the unwieldy technology necessary to make his enormous images, especially in sustaining the required dampness of the wet collodion glass-plate negatives during this challenging process.

I wanted to have a large camera for certain pictures, and I picked a 20x24, that is, one taking a plate of 480 square inches—exactly twelve times the area of my 1874 negatives. No such camera was stocked in Washington; but I found one in New York, either at E. & H.T. Anthony's or the Scovill Manufacturing Co., as I remember. By late May of 1875 it was ready for me, and in the first week of June, I was on my way to Colorado with the largest camera I have ever handled outside of a studio. I can add that my 20x24—although used only for exceptional shots—was worth all the extra labor it cost....

[We] proceeded to Tower Creek. At the point where that stream drops into the gorge the view is magnificent—but recording it on a glass plate from the bed beneath turned out to be my biggest photographic problem of the year. Clambering down, and even up, the steep sides of the canyon was not an insuperable task. Neither was moving the camera over the same precipitous route. But getting the heavy dark box within working distance was a stickler. In fact, in the absence of mechanical aid, it couldn't be done.

Since the mountain could not be brought to Mohammed, another method had to be worked out, and finally I solved the situation. After setting up and focussing my camera at the bottom of the gorge, I would prepare a plate, back the holder with wet blotting paper, then slip and slide and tumble down to my camera and make the exposure. After taking my picture, I had to climb to the top carrying the exposed plate wrapped up in a moist towel. With Dixon to help, cleaning and washing the plates, I succeeded in repeating the procedure four or five times. The end of the day found us exhausted but very proud; and we had reason to be pleased with ourselves, for not a single one of our plates had dried out before being developed....

Besides the riding horses I had six pack mules, four to carry grub, utensils, and tents, the remaining two to tote my cameras, chemicals, plates, and the same little orange-calico tent I had used in the Yellowstone. Everything was carried on aparejos, the stuffed-leather pack saddles commonly used in that country and farther south.

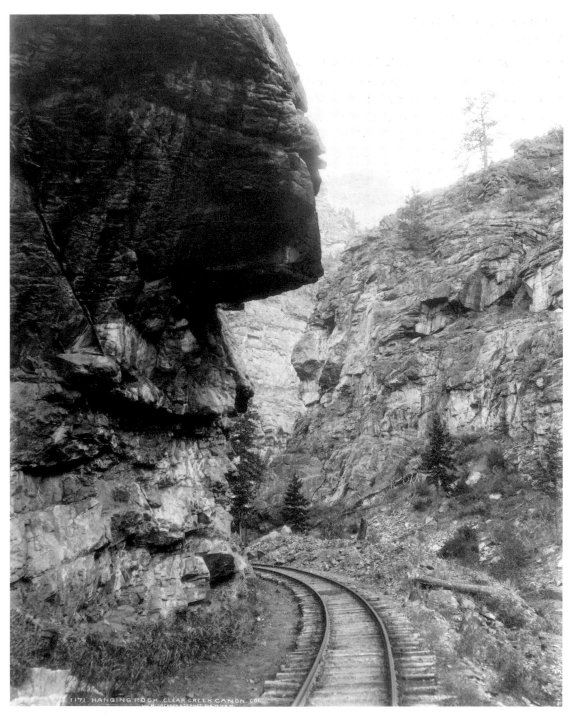

Hanging Rock, Clear Creek Canyon, Colorado, ca. 1875

Albumen print from glass negative, 12¼ x 8 inches
The Family of Alice R. and Sol B. Frank

Timothy H. O'Sullivan
American, 1840–1882

After learning his trade while working in Mathew Brady's New York studio, O'Sullivan became one of the most prolific photographers of the Civil War. Later, he worked as a photographer on geological and mapping expeditions in the American West and Panama. O'Sullivan made more photographs of Shoshone Falls than of any other single subject, visiting in 1868 and 1874. Using John Samson as his pen name, O'Sullivan published an article in *Harper's New Monthly Magazine.* Following is an excerpt from that 1869 article in which O'Sullivan expounds on the sometimes adventurous nature of photography and the resultant rewards:

Places and people are made familiar to us by means of the camera in the hands of skillful operators, who, vying with each other in the artistic excellence of their productions, avail themselves of every opportunity to visit interesting points, and take care to lose no good chance to scour the country in search of new fields for photographic labor.

During our late war we had photographic representations of battle-fields, which are now valuable as historical material, both for present and for future use.

The battle of Bull Run would have been photographed "close up" but for the fact that a shell from one of the rebel field-pieces took away the photographer's camera. In 1863, while photographing Fort Sumter and the Confederate batteries in the vicinity of Charleston, a courageous operator saw his camera twice knocked over by fragments of shell, his camera-cloth torn, and the loose white sand of Morris Island scattered over plates and chemicals. The veteran artillerists who manned the battery from which the views were made wisely sought refuge in the bomb-proofs to secure themselves from the heavy shell fire which was opened upon their fortification; but the photographer stuck to his work, and the pictures made on that memorable occasion are among the most interesting of the war. Many of the best photographs of events that occurred during the war were made by the adventurous artist who now furnishes pictures of scenes among the High Rockies, and nar-

rates the adventures incident of the long journey during which the photographs were made.

The volume of water pouring over the Shoshone Falls is small compared with the great flood which gives grandeur to Niagara. Neither is the width of the river greater than that portion of Niagara known as the American Fall. In the Shoshone we have fall after fall to view as a preliminary exhibition. Each cascade is a splendid fall of itself, and the vast walls of rock are worn into weird forms by the constant action of rushing water.

The surroundings of the main fall are such that any number of views may be had of the scene. Standing upon the craggy rocks that jut out from and form the walls of the tableland below the falls, one may obtain a bird's-eye view of one of the most sublime of Rocky Mountain scenes....

There is in the entire region of the falls such wildness of beauty that a feeling pervades the mind almost unconsciously that you are, if not the first white man who has ever trod that trail, certainly one of the very few who have ventured so far. From the island above the falls you may not see the great leap that the water takes, but you will certainly feel sensible of the fact that you are in the presence of one of Nature's greatest spectacles as you listen to the roar of the falling water and gaze down the stream over the fall at the wild scene beyond.

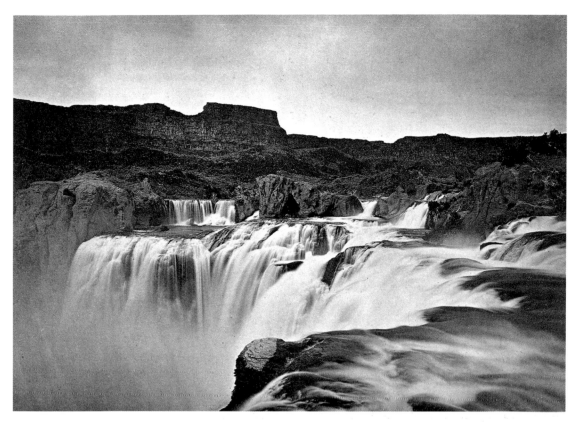

Shoshone Falls, Snake River, Idaho, 1874, from *Wheeler Survey West of the 100th Meridian*

Albumen print from glass negative, 11 x 14 inches
Horace W. Goldsmith Fund, 90.63

Frank Jay Haynes
American, 1853–1921

Following in the footsteps of the great recorders of the West, Haynes established a place for himself in photographic history as the photographer of Yellowstone. He built a lucrative business through the sale of mammoth-plate prints, smaller prints, and eventually, postcards to tourists. After apprenticeships in Wisconsin, Haynes began his photographic career in 1876 when he was contracted by the Northern Pacific Railroad to make views of farm life and the progress of technology along the railroad lines. In 1884, he opened a seasonal studio on the grounds of Yellowstone and spent most of the next thirty-two years preserving the wonders of the park. On August 29, 1881, Haynes wrote to Sam J. Kirkwood, Secretary of the Interior, that "I shall endeavor to illustrate this wonderland to the satisfaction of all." In the following statement to Emerson Hough, Haynes comments on the technicalities of lighting and lenses.

All amateurs...think they have to have the sun at their backs. You'll find this is wrong: if you get the sun to one side and catch the shadows, you get a "Rembrandt-lighted" picture with good contrasts. If you try to photograph a geyser in action, you get nothing with the sun at your back because there is no contrast between the steam and the background. Better squarely face the sun and the light shining in against the cloud of vapor will give you a sharp clear negative.

As to focus...with the right lens you can forget focus. My Ross lens cuts sharp and clear from twenty-five feet to half a mile and gets relative perspective. It pays to get the best lens you can afford. And don't go snapping at everything. Be patient and wait till you have a good subject.

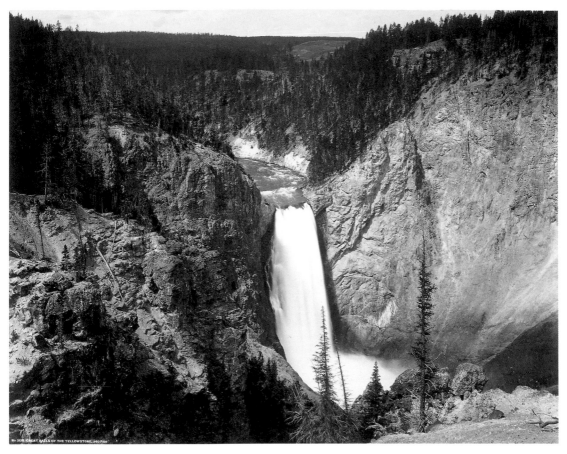

Great Falls of the Yellowstone, 1884

Albumen print from glass negative, 17⅛ x 21½ inches
Art Purchase Fund, partial gift of Mr. and Mrs. John F. Marshall, Jr., Mr. and Mrs. Calvin H. Childress,
Mr. and Mrs. Chris A. Crumley, Dr. and Mrs. George M. Kemp, Dr. Patricia L. Raymond, and Ms. Germaine Clair, 94.17

Julia Margaret Cameron
English (b. India), 1815–1879

Born into a prominent British family, Cameron lived much of her life in India. However, she did not begin her photographic careeer until the age of forty-eight, after receiving a camera from her daughter. Cameron knew and photographed many of the famous creative individuals of her time, among them Frederick Watts, Dante Gabriel Rossetti, Sir John Herschel, and Charles Darwin. In 1874 Cameron created illustrations for Alfred Lord Tennyson's *Idylls of the King and other Poems*. Her soft-focus style was caused by long exposures, which she believed allowed more of the true personality of the sitters to reveal itself. This somewhat whimsical text, entitled "The Annals of My Glass House," was first published in *Photo Beacon* in 1890:

I longed to arrest all beauty that came before me, and at length the longing has been satisfied. Its difficulty enhanced the value of the pursuit. I began with no knowledge of the art. I did not know where to place my dark box, how to focus my sitter, and my first picture I effaced to my consternation by rubbing my hand over the filmy side of the glass.

I turned my coal-house into my dark room, and a glazed fowl-house I had given to my children became my glass house! The hens were liberated, I hope and believe not eaten. The profit of my boys upon new laid eggs was stopped, and all hands and hearts sympathised in my new labour, since the society of hens and chickens was soon changed for that of poets, prophets, painters and lovely maidens, who all in turn have immortalized the humble little farm erection.

I believe that…my first successes in my out-of-focus pictures were a fluke. That is to say, that when focussing and coming to something which, to my eye, was very beautiful, I stopped there instead of screwing on the lens to the more definite focus which all other photographers insist upon….

Artists, however, immediately crowned me with laurels, and though "Fame" is pronounced "The last infirmity of noble minds," I must confess that when those whose judgment I revered have valued and praised my works, "my heart has leapt up like a rainbow in the sky," and I have renewed all my zeal.

Personal sympathy has helped me on very much. My husband from first to last has watched every picture with delight, and it is my daily habit to run to him with every glass upon which a fresh glory is newly stamped, and to listen to his enthusiastic applause. This habit of running into the dining-room with my wet pictures has stained such an immense quantity of table linen with nitrate of silver, indelible stains, that I should have been banished from any less indulgent household.

Thomas Carlyle, 1867

Albumen print from glass negative, 12⅛ x 9¾ inches
Gift of Mrs. Louis I. Jaffé, 50.45.6

Lewis Carroll (Charles Lutwidge Dodgson)
English, 1832–1898

Although known primarily as the author of *Alice's Adventures in Wonderland* and *Through the Looking Glass*, Carroll is also regarded as one of the nineteenth century's greatest photographers of children. Like many of his contemporaries, Carroll found the new art of photography to be a stimulating avocation. In addition to his imaginative tableaux with children, Carroll proved himself as a highly capable photographic portraitist, depicting both adolescent and adult subjects. This satirical statement is excerpted from "A Photographer's Day Out," originally published in the *South Shields Amateur Magazine* in 1860.

They say that we Photographers are a blind race at best; that we learn to look at even the prettiest faces as so much light and shade; that we seldom admire, and never love. This is a delusion I long to break through—if I could only find a young lady to photograph, realizing my ideal of beauty above all, if her name should be—(why is it, I wonder, that I dote on the name Amelia more than any other word in the English language?)—I feel sure that I could shake off this cold, philosophic lethargy.

The time has come at last. Only this evening I fell in with young Harry Glover in the Haymarket— "Tubbs!" he shouted, slapping me familiarly on the back, "my Uncle wants you down tomorrow at his Villa, camera and all!"

"But I don't know your Uncle," I replied, with my characteristic caution. (N.B. If I have a virtue, it is quiet, gentlemanly caution.)

"Never mind, old boy, he knows all about *you*. You be off by the early train, and take your whole kit of bottles, for you'll find lots of faces to uglify and—"

"Ca'n't go," I said rather gruffly, for the extent of the job alarmed me, and I wished to cut him short, having a decided objection to talking slang in the public streets.

"Well, they'll be precious cut up about it, that's all," said Harry, with rather a blank face, "and my cousin Amelia—"

"Don't say another word!" I cried enthusiastically, "I'll go!"

Xie Kitchin, ca. 1870

Albumen print from glass negative, 5½ x 4 inches
The Family of Alice R. and Sol B. Frank

Étienne Carjat
French, 1828–1906

In addition to his talents as a caricaturist, journalist, and editor, Carjat was a popular French portraitist who photographed many of the artistic and literary personalities of his time. He opened a studio in 1860 and continued to photograph through 1875, contributing his images to periodicals and publications such as the *Galerie Contemporaine.* Carjat's cartes-de-visite and albumen portraits were noted for their directness; this ability to capture the essential characteristics of his sitters may be attributed in part to his skill as a caricaturist. "The Lament of the Photographer," written in 1875, reveals Carjat's sardonic view of photography as a life's work:

More than six months my friend
I have been waiting for you in vain.
I dream of beautiful days gone by,
They so swiftly flew by....

What has happened, pray tell?
A new Delilah, a new belle?
Are you under some spell?
Who might this woman be, do tell!

Could she be angel, or could she be demon?
Is her hair fair, or is she darker?
Goes she to Mabille or to sermon?
Is she in money or is she a pauper?

And you, bright chameleon
Will your heart finally change color?
Will you follow our Leon later
Down the aisle to the altar?

I want to know, dear wanderer
Tell me what is the matter?
What has made you pounce and leap?
Was it riches and gold to reap?

Are you now investing?
Is a Rothschild helping?
Have you turned magic banker
Making shares higher and lower?

Must be brewing some liqueur
To make chilblains better

Or cooking up some lotion
That will grow hair to perfection.

Is it money you are seeking?
Do you want to stop painting?
Put that big lens away?
'tis only torture, I say!

Those two lenses of crystal
Inside that long tube of copper
Will lead you straight to hospital
Don't you follow me there, ever!

Become a spy or a clerk in court
Tamer of bears, wrestler, a circusman in short,
If in some attic you won't be put away
Still waiting for the money.

Be a Quaker or a Mormon.
Support the Emperor.
Don't be a photographer, ever
For 'tis worse than hard labor.

The photographer my dear Ernest
Is like a pariah at best.
He is a leper, he is Saint Genest.
Men flee from him like a pest.

And you cold-hearted being,
Through your life you go floating.
Uncaring, you go your merry way
With not even a look in my door way.

Émile Zola, 1875, from the *Galerie Contemporaine*, 1877

Woodburytype, 8¾ x 7¼ inches
Horace W. Goldsmith Fund, 83.225

Frank Meadow Sutcliffe
English, 1852–1941

Sutcliffe opened a portrait studio in the late 1870s in Whitby, England, where he lived until his death in 1941. Fascinated by photographic technology such as the new Kodak cameras, he experimented with many different printing processes, including albumen, platinum, and silver. Although he earned his living as a commercial photographer, he is best known for his personal work, which reflects the influence of Peter Henry Emerson in its choice of village life as subject matter and its spontaneous, naturalistic style. The following text is excerpted from a paper entitled "How to Look at Photographs," which Sutcliffe read before the Photographic Convention of the United Kingdom in 1892:

Photographs are generally said to show either technical or artistic excellence. Sometimes both qualities are visible in the same piece of work, sometimes they are not. There is another quality which ought to be present in all photographs without which no photograph can be considered perfect; and, until this quality has been recognized, the photographer should stop before he pats himself on the back and says, "What a good boy am I," after he has taken what he may look upon as a perfect piece of work, as an example of technical skill or an attempt at picture-making; it may be clever, yet for all that it is a failure if it cannot speak to those who look at it.

There has been, as you all know, a lot of strife between what has been called the old school and the new, and the sharp and the unsharpened; it seems to me that, if both these parties had looked at their work and at that of others in the right way, all this bickering would not have been. It would almost appear as if many consider their photographs as an end rather than a means to an end, and as if all that is expected of the spectator is that he should admire the skill of the worker as shown in his work; sometimes even it appears to be the author of the work who expects to be admired.

The person who looks at a photograph as a complete picture, unable to say anything about anything except the facts which existed at the moment of exposure, does not see very far. You may contend that, if this is true, it will depend more upon the spectator than upon the photograph, for what will give pleasure to one will say nothing to another. To be sure if the spectator is blind to everything except the mechanical part of the work, the loss is his alone; but he need not, as he often does, call attention to his own ignorance by denouncing a picture a failure because his mind happens to be blank except so far as a knowledge of a certain kind of mechanics may go.

If a photographer thinks he can tell his tales better by making his works microscopically sharp, let him do so by all means; if any one's hobby is the study of mosses and fungi, no pinhole or spectacle-lens view will remind such a one of the happy days he has spent in pouring over damp walls in musty nooks and corners. To some an extremely sharp picture may be positively painful, for it will perhaps disturb and break the train of thought, whereas a less-defined one would allow the mind to wander at its own sweet will.

May I say that a photograph gives us the naked truth, which has to be clothed by the imagination.

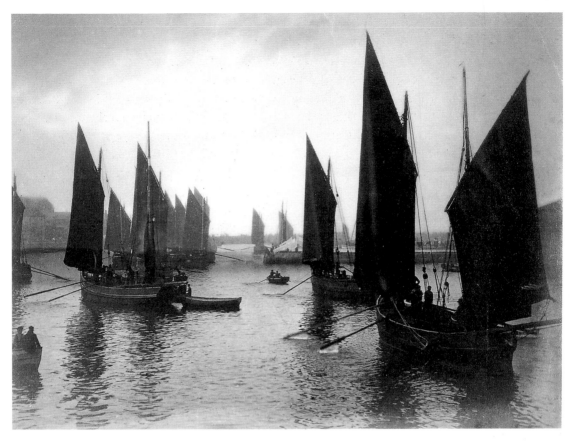

Harbor View, ca. 1880s

Albumen print, 5¾ x 8 inches
Horace W. Goldsmith and Art Purchase Funds, 85.155

Peter Henry Emerson
English (b. Cuba), 1856–1936

Emerson was an early and ardent champion of photographic purity; his 1889 book *Naturalistic Photography* argued for pictures that would replicate the in-person visual experience of a place. Emerson considered photography to be a blend of art and science, and his platinum prints and gravures of natural landscapes and rural genre scenes supported this theoretical stance. By 1899, however, he had tempered his views; a new edition of his book appeared with a final chapter entitled "Photography—Not Art," in which he recanted his previous stance and acquiesced to the popular preference for painterly manipulations. This statement appeared in the 1889 edition of *Naturalistic Photography*.

"A photograph," it has been said, "shows the art of nature rather than the art of the artist." This is mere nonsense, as the same remark might be applied equally well to all the fine arts. Nature does not jump into the camera, focus itself, expose itself, develop itself, and print itself. On the contrary, the artist, using photography as a medium, chooses his subject, selects his details, generalizes the whole in the way we have shown, and thus gives his view of nature. This is not copying or imitating nature, but interpreting her; and this is all any artist can do, and how perfectly he does it, depends on his technique, and his knowledge of this technique; and the resulting picture, by whatever method expressed, will be beautiful proportionately to the beauty of the original and the ability of the artist. These remarks apply equally to the critics who call pictures "bits of nature cut out." There is no need to slay the slain, and give any further answer to the objection that photography is a mechanical process, if there were, it would be enough to remind the objectors that if twenty photographers were sent to a district of limited area, and told to take a given composition, the result would be twenty different renderings. Photographs of any artistic quality have individuality as much as any other works of art....

Photography has been called an "irresponsive medium." This is much the same as calling it a mechanical process, and, therefore, disposed of, we venture to think. A great paradox which has to be combatted, is the assumption that because photography is not "hand-work," as the public say,—though we find there is very much "hand-work and head-work" in it—therefore, it is not an Art language. This is a fallacy born of thoughtlessness. The painter learns his technique in order to speak, and as more than one painter has told us, "painting is a mental process," and as for the technique they could almost do that with their feet. So with photography, speaking artistically of it, it is a very severe mental process, and taxes all the artist's energies even after he has mastered his technique. The point is, *what you have to say*, and how to say it. It would be as reasonable to object to a poet printing his verse in type instead of writing it in old Gothic with a quill pen on asses' skin. Coupled with this accusation, goes that of want of originality. The originality of a work of art, it should be needless to say, refers to the originality of the thing expressed and the way it is expressed, whether it be in poetry, photography, or painting, and the original artist is surely he who seizes new and subtle impressions from nature, "tears them forth from nature," as Durer said, and lays them before the world by means of the technique at his command. That one technique is more difficult than another to learn, no one will deny, but the greatest thoughts have been expressed by means of the simplest technique—namely writing.

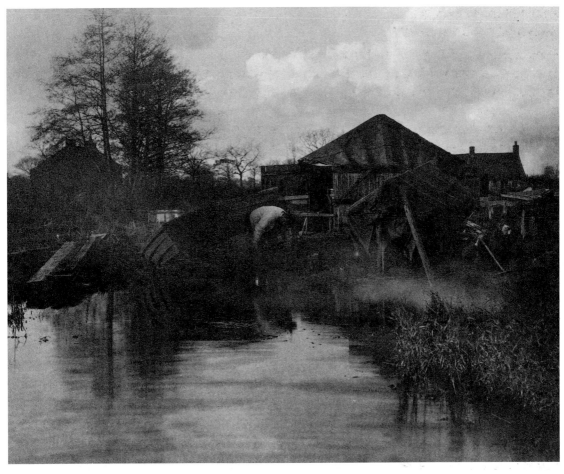

A Norfolk Boat-Yard from *Life and Landscape on the Norfolk Broads*, October 1886

Platinum print, 8¾ x 11¼ inches
The Family of Alice R. and Sol B. Frank

Henry Peach Robinson
English, 1830–1901

Arguably, Robinson was the most widely-known photographer of the latter half of the nineteenth century. His method of working required assembling many negatives to create a seamless image that could be viewed and regarded using the same criterion as was used for academic painting. A prolific writer, he authored several volumes on the merits of pictorial photography, primarily treatises on technical aspects. This passage, which comes from his 1896 book *The Elements of a Pictorial Photograph*, discusses the merits of photography as art:

Photography is becoming so very useful that it is a question whether it will not in time be forgotten that it was originally intended as a means of representing the beautiful, and become known only as being the humble helper in everybody's business except its own, from that of the astronomer, who uses it to discover unsuspected worlds, down to that of the "brewer and baker and candlestick maker." It may be said that there is scarcely anything our art cannot accomplish, even to seeing things invisible to ordinary senses and photographing the living bones of which our frames are made. The only impossibility to the art—if we are to believe some art critics who appear to have had little opportunity of observation—is that it can produce art; this little treatise contends that the camera is only a tool in the sense that the brush is a tool, and one capable in the hands of an artist of conveying thought, feeling, expressing individuality, and also of the usual attributes of art in their degree.

From the earliest times photography was intended to produce pictorial results. The first photographers devoted all their attention to making pictures, and there has always been a few who have endeavoured to keep the sacred lamp of art alight, but the adaptability of the processes to every purpose under the sun, has interfered greatly with its fitness for finer issues. Another cause of decadence has been the curious fondness of the public for meretricious untruthfulness, such as mistaking smoothness and polish for beauty, and venerable wrinkles for ugliness. Still another, and perhaps the chief cause, is that there are many men who can understand an obvious fact to one who has a feeling for the sentiment of beauty. The former find that the hard nuts of science (whether they crack them or only break their own teeth) easily satisfy their aspirations, and at the same time they cannot feel much conviction about a thing they so little understand as art. The efforts, however, of the promoters of the Photographic Salon during the later years, have met with very great success in inducing photographers and the public to take a more serious view of the art.

This is not intended to be so much a serious treatise on art, as a book of hints and suggestions supplementing, but distinct from, a former volume—*Pictorial Effect in Photography.* I want to help the amateur to recognise that there is much more in the art than the taking of a simple photograph, that its materials are only second in plasticity to those of the painter and draughtsman, and that if they are more difficult to manage, there are effects to which they are even more adapted than any other means of art. Much of the volume will be found useful for suggesting subjects which are possible to those means.

When The Day's Work Is Done, 1890, from *Sun Artists*, January 1890

Photogravure, 5⅞ x 7⅛ inches
Horace W. Goldsmith and Art Purchase Funds, 93.19.5d

Eadweard Muybridge
American (b. England), 1830–1904

Between 1868 and 1873, demonstrating a dramatic and expressive style, Muybridge made roughly two thousand photographs rendering the beauty of the American western landscape, including Alaska. But the bulk of his reputation lies in his work making sequences of stop-motion photographs of animals in motion. He launched into this enterprise by making a series of photographs proving that a running horse lifts all four hooves off the ground simultaneously. He went on to make hundreds of these sequences depicting humans and all types of animals in various phases of activity. These photographs were published in the eleven-volume *Animal Locomotion* (1887), ostensibly as a guide to artists. Viewing these sequences on moving devices recreated the original movements and essentially signaled the birth of motion pictures. An abridged version of his massive work was published in 1899 as *Animals in Motion*. In the preface of that book Muybridge wrote about his early experiments.

In the spring of the year 1872, while the author was directing the photographic surveys of the United States Government on the Pacific Coast, there was revived in the city of San Francisco a controversy in regard to animal locomotion, which we may infer, on the authority of Plato, was warmly argued by the ancient Egyptians, and which probably had its origin in the studio of the primitive artist when he submitted to a group of critical friends his first etching of a mammoth crushing through the forest, or of a reindeer grazing on the plains.

In this modern instance, the principal subject of dispute was the possibility of a horse, while trotting—even at the height of his speed—having all four of his feet, at any portion of his stride, simultaneously free from contact with the ground.

The attention of the author was directed to this controversy, and he immediately resolved to attempt its settlement.

The problem before him was, to obtain a sufficiently well-developed and contrasted image on a wet collodion plate, after an exposure of so brief a duration that a horse's foot, moving with a velocity of more than thirty yards in a second of time, should be photographed with its outlines practically sharp....

Having constructed some special exposing apparatus, and bestowed more than usual care in the preparation of the materials he was accustomed to use for ordinarily quick work, the author commenced his investigation on the racetrack at Sacramento, California, in May, 1872, where he in a few days made several negatives of a celebrated horse named Occident, while trotting, laterally, in front of his camera, at rates of speed varying from two minutes and twenty-five seconds to two minutes and eighteen seconds per mile.

The photographs resulting from this experiment were sufficiently sharp to give a recognizable silhouette portrait of the driver, and some of them exhibited the horse with all four of his feet clearly lifted, at the same time, above the surface of the ground.

So far as the immediate point at issue was concerned, the object of the experiment was accomplished, and the question settled for once and for all time in favour of those who argued for a period of unsupported transit.

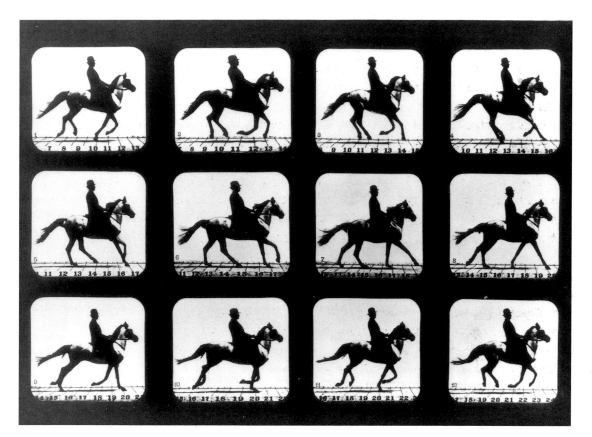

Horse Trotting from *Animals in Motion*, 1881

Albumen print from glass negative, 5½ x 9 inches
The Family of Alice R. and Sol B. Frank

Thomas Eakins
American, 1844–1916

Best known as a painter, Eakins made photographs primarily for his own enjoyment, although some were used as documents and studies for his paintings. He was very interested in the study of anatomy, and was excited by the motion analysis photographs of Eadweard Muybridge. Eakins's photographs date from the 1880s to around 1900, and consist mainly of family snapshots, portraits, genre scenes, and images of moving people and animals. While living in Europe, Eakins wrote letters to his father in which he discusses his thoughts on the creation of art. This text is excerpted from two of those letters:

The big artist does not sit down monkey-like and copy a coal-scuttle or an ugly old woman like some Dutch painters have done, nor a dung pile, but he keeps a sharp eye on Nature and steals her tools. He learns what she does with light, the big tool, and then color, then form, and appropriates them to his own use. Then he's got a canoe of his own, smaller than Nature's, but big enough for every purpose.... With this canoe he can sail parallel to Nature's sailing. He will soon be sailing only where he wants to...but if ever he thinks he can sail another fashion from Nature or make a better-shaped boat, he'll capsize or stick in the mud, and nobody will buy his pictures or sail with him in his old tub....

The big artists were the most timid of themselves and had the greatest confidence in Nature, and when they made an unnatural thing they made it as Nature would have made it, and thus they are really closer to Nature than the coal-scuttle painters ever suspect. In a big picture you can see what o'clock it is, afternoon or morning, if it's hot or cold, winter or summer, and what kind of people are there, and what they are doing and why they are doing it. The sentiments run beyond words. If a man makes a hot day he makes it like a hot day he once saw or is seeing; if a sweet face, a face he once saw or which he imagines from old memories or parts of memories and his knowledge, and he combines and combines, never creates —but at the very first combination no man, and least of all himself, could ever disentangle the feelings that animated him just then, and refer each one to its right place....

Then the professors, as they are called, read Greek poetry for inspiration and talk classic and give out classic subjects, and make a fellow draw antique, not to see how beautiful those simple-hearted big men sailed, but to observe their mud marks, which are easier to see and measure than to understand. I love sunlight and children and beautiful women and men, their heads and hands, and most everything I see....

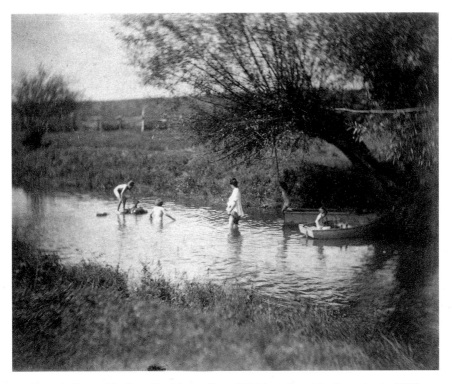

Hannah Susan MacDowell with the Crowell Children, Avondale, Pennsylvania, 1883

Albumen print, 3½ x 4½ inches
Horace W. Goldsmith and Art Purchase Funds, 92.48

Adam Clark Vroman
American, 1856–1916

Born in La Salle, Michigan, Vroman began making landscape photographs upon his move to Pasadena, California, in 1892. He made his first visit to a Hopi village in 1895 and spent the next fifteen years photographing the daily lives and rituals of Native Americans throughout the southwestern United States. Unlike other photographers of his day who exploited these cultures, Vroman created thoughtful and respectful studies, in which he sought to preserve this vanishing lifestyle. Vroman spoke out against attempts to assimilate the Native Americans into mainstream culture. He also describes his approach to photographing Native Americans in this excerpt from an article in the February 1901 issue of *The American Journal of Photography:*

But we hasten along, making a few exposures around the pueblo and try to get acquainted with the natives. If you are a little patient and do not try to hurry matters you will have but little trouble in getting what you want. The Indian must always have plenty of time to think over anything he is to do, and you cannot rush him a particle; sit down with him, show him the camera inside and out, stand on your head (on the ground-glass) for him, or anything you want him to do, and he will do the same for you. One trouble is a lack of background if you take the time to improvise one. The subject may change his mind and your time is wasted.

Another trouble is the promises of the white man. If an Indian promises to do a thing he will do it, but we promise to send the Indian prints, little thinking how difficult it is to get them to him, if we are successful with the negative. You must arrange to send in care of some one whom you know will take the trouble to take them to the Indian. To break your word once, ends it with him. He will never overlook it, and this failure of some to keep their word has made him doubt us all.

It is much the best way to pay him at the time, and then if your negative is satisfactory, send him a print, and if you should go a second time to the same pueblo, you will find one "Quatse," at least.

I recall the past summer, sitting one evening at Capt. Keams, a young Indian kept looking at me, when suddenly he rushed up, put his arm around me, and said he was "Ongha," who I remembered five years ago at my first visit at the Moki Towns had been with me several days.

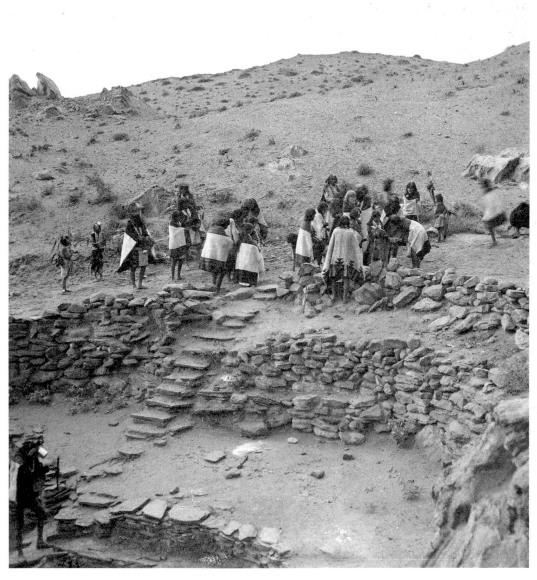

Hopi Towns, Snake Dance, Oraibe, 1898

Platinum print, 6¼ x 5½ inches
Horace W. Goldsmith and Art Purchase Funds, 86.196

Edward S. Curtis
American, 1868–1952

For more than thirty years Curtis was obsessed with his comprehensive photographic documentation presenting "every phase of life among all tribes yet in primitive condition." From 1907 to 1937, he published twenty volumes of his photographs, with accompanying text entitled, *The North American Indian*. His romanticized views of Native American life have led to questions of the validity of Curtis's work as true ethnographic record. In this speech delivered at the University of Washington, Curtis tells of the difficulties he endured to perform his work:

You ask me to tell you something of my work that would be of interest to photographers. I question anything in connection with it or information in regard to it being of much help to my fellow photographers, unless it would be to convince him that his life is one of comparative ease and comfort. To begin with, for every hour given to photography two must be given to the word picture part of this record of the vanishing Indian. True, many of the hours given to the writing are those of the night time, and the light is not a 32-candlepower stand lamp, but most likely two or a half dozen tallow candles fastened with their own wax to a scrap of plate or grub box. The everlasting struggle to do the work, do it well and fast, is such that leisure and comfort are lost sight of. To the oft-asked question, "What camera or lens do you use?" I can only reply "I couldn't tell to save my soul—it is enough for me to know that I have something that will make pictures and that it is in working order." And as to chemicals, I have almost forgotten that they are a necessary part of photography. With us it is seven days in a week, twenty-four hours in each day and thirty-one days in most months. We sleep when we can't work, and here is one place where we are most particular. Our beds must be as comfortable as human ingenuity can make a camp bed, for while we do rest we want to rest well. Most likely the roof to our apartment is the blue sky dome, but to sleep in the open is real rest.

The field season of 1906 was nine months long....We have worked with fourteen languages and no end of dialects. Our camp equipment weighing from a thousand pounds to a ton, depending upon distance from a source of supplies; in photographic and other equipment there were several 6½ x 8½ cameras, a motion-picture machine, phonograph for recording songs, a typewriter, a trunk of reference books, correspondence files covering over a year of business affairs, as being always on the move it is necessary to keep up my regular correspondence in connection with the work, its publication and the lectures all from the field. Tents, bedding, our foods, saddles, cooking outfit, four to eight horses—such was the outfit....

Each tribe visited is a new situation to be taken up and mastered, and that quickly. Every phase of their life must be noted and, as far as possible, pictured, and the gathering of this lore, logic and myth must go hand-in-hand with the picturemaking, as without the knowledge of their life, ceremony, domestic, political and religious, one cannot do the picture work well.

How do I manage the portraits and the handling of the life? In every way. Conditions cannot be changed. I must fit myself to them. Some of the portraits can be made in my tent, which is a fair sized one made for photographic work. More are made in the open, in the soft light of the morning or in the intense glare of the midday sun. The subject secured, it matters not the time or conditions. The picture must be made.

Prayer to the Stars, ca. 1909

Orotone, ca. 1916, 16½ x 13⅜ inches
Gift of Robert W. Lisle, 91.114

Eugène Atget
French, 1857–1927

An extraordinary photographer, Atget's intention was to photograph everything that was beautiful in and around Paris and his images are now considered early masterpieces of photographic realism. He began photographing at age forty and worked until the year of his death. During that time he made approximately ten thousand glass-plate negatives of turn-of-the-century Paris and its rural environs. He made a living selling his photographs to French institutions such as the Bibliothéque Nationale, the Museé Carnavalet, and to artists to be used as reference works. His work was admired by the Surrealists and, in the 1920s, was reproduced in their publications. His fame as a photographic artist has accrued entirely in retrospect, thanks to the efforts of Berenice Abbott and, more recently, the Museum of Modern Art. In his writings, Atget referred to himself not as a photographer, but as an *artistie dramatique* or *auteur editeur*. In 1920, concerned about the final disposition of his negatives, Atget wrote a letter to Monsieur Paul Léon, the Director of Fine Arts at Les Monuments Historiques, offering to sell his collection.

For more than twenty years, through my own labor and individual initiative, in all the venerable streets of Old Paris, I have been making photographic negatives measuring 18 x 24 cm, artistic documents of beautiful civil architecture from the 16th to the 19th century: the old mansions, houses historical or curious; beautiful facades, doorways, wainscots; door knockers, old fountains, period staircases (in wood and wrought iron); the interiors of all the churches of Paris (overall and artistic details: Notre-Dame, Saint-Gervais et Protais, Saint-Séverin, Saint-Julien-le-Pauvre, Saint-Etienne-du-Mont, Saint-Roch, Saint-Nicolas-du-Chardonnet, etc., etc.).

This enormous artistic and documentary collection is today complete. I can truthfully say that I possess all of Old Paris.

Now that I am approaching old age—that is to say, 70 years—and have neither heir nor successor, I am worried and tormented about the future of this beautiful collection of negatives, which could fall into hands unaware of its import and ultimately disappear, without benefitting anyone. I would be very happy Monsieur, if you could interest yourself in this collection.... I hold at your disposal, Monsieur, and with a simple word from you, my references on Old Paris and all the explanations you might wish to have from me.

Hotel de Parliamentarier, 3 Rue du Lions, ca. 1905

Albumen print from glass negative, 8½ x 7 inches
The Family of Alice R. and Sol B. Frank

Frederick Evans
English, 1853–1943

Although Evans joined the Linked Ring Brotherhood in 1900, his work is more closely identified with photographic purism than with that group's Pictorialist aesthetic. The Linked Ring was formed in London to promote photography as a fine art. They believed in making painterly photographs, which, because they looked like art, would be considered art. As a writer he campaigned for straight, unmanipulated images and his luminous photographs of English and French architecture, influenced by J.M.W. Turner watercolors, have established Evans as perhaps the greatest architectural photographer. This statement is from a lecture given at the opening of Evans's exhibition at the Royal Photographic Society in London on April 25, 1900, as reprinted in *The Photographic Journal* of April 30, 1900.

My chief aim has always been to try for such effects of light and shade as will give the irresistible feeling that one is in an interior, and that it is full of light and space. Realism in the sense of true atmosphere, a feeling of space, truth of lighting, solidity and perfection of perspective (in the eye's habit of seeing it), has been my ambitious aim; and to say that I have not achieved it, but only hinted at it, would be praise enough, considering the really great difficulties in the way of a full achievement, and how few examples of such even the great "art world" can point to....

I do not want to venture among those quicksands, the endless discussions as to whether photography can be considered in any degree art or fine art; but I would like just to hint that perhaps a more useful and a humbler way of looking at it would be as to why it should not be considered worthy a place among the crafts. A clever artistic photographer has a full claim I think to the cognomen craftsman. The great difficulty I have is in getting handworkers in any art to allow that I have any right to say or think that photography can be a means of expression. It is of course a very complete means of recording or copying, but of a personal art *expression* (which at times amounts to creative effort) they will hear nothing. They say that even though it may not always be done, yet it would be possible for six men to be sent to the same spot and to bring back the same camera record. This I deny. I contend there is as much individuality exercised in photographic as in any other work; those who oppose this could of course easily prove it for themselves by experimenting with a camera and half-a-dozen lenses, but this they will not do, and so the discussion gets limited to intelligent assertion on my part and ignorant assertion on theirs, and there is nothing so impossible or hopeless to combat as willful ignorance. I have often tried to repeat certain negatives, but have invariably failed, most so of course in out-of-door work: but even in interiors I think I might challenge any one to go to any of my subjects on these walls and bring away an exact replica, in print as well as negative of course: he may easily do better (or worse), but to repeat it with the so-called mechanical accuracy of the box with a glass in it is, I say, impossible, and if this does not mean individuality it means nothing, and individuality is the basis of all art....

But now, to conclude this essay in the obvious, permit me to say, that even were I an artist in the accepted sense of the word, and making "art" my profession, I would rather be the producer of a good photograph than of a poor or indifferent painting or drawing; and I hope I shall never come to say, in parody of the proverb, "I cannot draw or paint, and to photograph I am ashamed."

Le Puy, Church of St. Michael D'Aiguilla, 1906–07

Platinum print, 9⅞ x 7¾ inches
The Family of Alice R. and Sol B. Frank

Léonard Misonne
Belgian, 1870–1943

Misonne discovered photography while pursuing a degree in engineering, which he received in 1895. Financial independence enabled him to pursue his interests in painting, music, and photography, which he practiced exclusively beginning in 1896. By 1900, he had developed a distinctive Pictorialist style, and soon gained international recognition for his atmospheric landscapes depicting the Belgian countryside. Misonne describes the importance of light for the pictorial photographer:

If I were asked what I have learned during my 40 years experience as a Photographer, I should reply:

"The most important thing I have learned is to observe the beautiful effects of atmosphere and light."

Many Photographers are concerned only with the subject and they seek to render it as it is. Often they fail to observe that the lighting and the atmosphere adorn and transform even the most humble and common-place objects.

It is the effect that should be depicted, and not the subject only. To do this successfully, the Photographer should seek continually to develop his powers of observation so that he may acquire the ability to "see" well.

These are the qualities that every successful Pictorialist must possess.

Untitled, Bruges?, after 1900

Toned silver-chloride print, 3⅛ x 4¼ inches
Purchase, 83.224

Edward Steichen
American (b. Luxembourg), 1879–1973

After the first exhibition of his photographs in 1899, Steichen became a leading pictorial photographer. In collaboration with Alfred Stieglitz, he was a founding member of the Photo-Secession, was instrumental in the publication of *Camera Work*, and suggested exhibitors for the gallery known as 291. Later, he became a fashion photographer and was photographically active in both World Wars. In this text, Steichen relates his experience of making a photograph of J. P. Morgan in 1903 from which Fedor Encke was to make a painting. Obviously, this sitting with Morgan made a lasting impression on Steichen:

Morgan arrived with Encke, took off his large hat, laid a foot-long cigar on the edge of a table...and took his habitual Encke portrait pose. After a hasty look at the ground glass I said, "Still," and made the two- or three-second exposure required. Then, I took over the making of a negative for myself. I suggested a different position of the hands and a movement of the head. He took the head position, but said, in an irritated tone, that it was uncomfortable, so I suggested he move his head to a position that felt natural. He moved his head several times and ended exactly where it had been "uncomfortable" before, except that this time he took the pose of his own volition. But his expression had sharpened and his body posture became tense, possible a reflex of his irritation at the suggestion I had made. I saw that a dynamic self-assertion had taken place, whatever its cause, and I quickly made the second exposure, saying, "Thank you, Mr. Morgan," as I took the plate holder out of the camera.

He said, "Is that all?"

"Yes, sir," I answered.

He snorted a reply, "I like you, young man. I think we'll get along first-rate together." Then he clapped his large hat on his massive head, took up his big cigar, and stormed out of the room. Total time, three minutes.

Over the years people have referred to the insight into Morgan's real character that I showed by photographing him with a dagger in his hand. But this was their own fanciful interpretation of Morgan's hand firmly grasping the arm of the chair. It is not only photographers who read meanings into their photographs.

The experience of photographing J. P. Morgan taught me an important lesson. In Milwaukee, I had found that capturing the mood and expression of the moment was more important than photographing the twigs, the leaves, and the branches of the trees. And in photographing the dynamic personality of Morgan, I found that, when he sat in the pose he habitually took for the painter, all I saw was the map of his face, blank and lifeless. But when he was irritated, even by a trifle, something touched the quick of his personality and he reacted swiftly and decisively. The lesson was that a portrait must get beyond the almost universal self-consciousness that people have before the camera. If some moment of reality in the personality of the sitter did not happen, you had to provoke it in order to produce a portrait that had an identity with the person. The essential thing was to awaken a genuine response. This was one of the most valuable lessons I ever learned, and it stood me in good stead later when I worked for *Vanity Fair* and was doing portraits almost daily.

J. P. Morgan, 1903

Gelatin-silver print, 16½ x 13½ inches
Gift of Walter P. Chrysler, Jr., 71.2207.41

Gertrude Käsebier
American, 1852–1934

Käsebier turned to photography at the age of thirty-six, and in 1897 opened a studio in New York where she introduced natural poses to commercial portraiture. Käsebier worked in the soft focus style of the Pictorialist movement, and was a founding member of the Photo-Secession in 1902. Käsebier is known for her photographs of womanhood and the relationship between mothers and daughters, and she did much to encourage women to pursue photography. In this 1898 passage, Käsebier speaks about her innovative approach to composition:

I feel diffident in speaking to you about photography, because I have not followed the beaten paths, and because I have had to wade through seas of criticism on account of my heretical views....

Why should not the camera as a medium for the interpretation of art as understood by painters, sculptors and draughtsmen, command respect? Why should it not be required of the photographer, desiring to be known as an artist, that he serve an apprenticeship in an art school? Masterpieces can never be understood, or appreciated, or produced by one whose sense of beauty has not been awakened and educated. There is more in art, with an apology to that much abused word, as applied to photography, than startling display lines, on mounts and signs announcing "Artist Photographer," "Artistic Photographic Studio," etc., and the lower the standard the more frantic the claim....

An artist must walk in a field where there is something more than chemical formulae, theatrical effects, affected and monotonous posing. He must see nature through the medium of his own intellectual emotions, and must guard that they be not led into artificial channels. Technique is not art, but manual skill; a proficiency of labor, which can be acquired...without a glimmer of artistic feeling....

There is, however, a growing, cultured public, whom we are bound to take into consideration. There is a far cry for more art in photography. It has to come; and it will come through the amateurs. They are not hampered by the traditions of the trade and are not forced to produce quantity at the expense of quality. They go at their work in a more natural, simple and direct way, and they get corresponding results. One of the most difficult things to learn in painting is what to leave out. How to keep things simple enough.

The same applies to photography. The value of composition cannot be over estimated; upon it depends the harmony and the sentiment. Instruments and mediums can be had for a price; originality, creative faculty, poetic feeling, can come from only one source, but they can be lost if they be not cherished....

The key to artistic photography is to work out your own thoughts, by yourselves. Imitation leads to certain disaster.

New ideas are always antagonized. Do not mind that. If a thing is good it will survive. I earnestly advise women of artistic tastes to train for the unworked field of modern photography. It seems to be especially adapted to them, and the few who have entered it are meeting with gratifying and profitable success. If one already draws and paints, so much the better the equipment. If one has wrestled with the subtle lines of the human form; if one has experienced the feeling of trying to produce color from simple pigments, their enjoyment of the exquisite pictures thrown upon the ground glass will be enhanced, and their artistic growth and color sense will not suffer.

Besides, consider the advantage of a vocation which necessitates one's being a taking woman.

Happy Days, from *Camera Work, No. 10*, April 1905

Photogravure, 8½ x 6½ inches
Horace W. Goldsmith and Art Purchase Funds, 89.1114

Alfred Stieglitz
American, 1864–1946

Both as photographer and advocate, Stieglitz was one of the most important figures in early twenti-eth-century photography and art in general. Through his own work, his periodical *Camera Work*, and his influential New York gallery 291, he was the primary activist for photography's acceptance as an art form. Stieglitz founded and edited *Camera Work*, published quarterly from 1902 until 1917. It featured high-quality photogravures, criticism, and later, artists working in media other than photography. Through 291 and *Camera Work*, Stieglitz introduced the American audience to many European and American avant-garde artists and African art. In 1902, Stieglitz formed the Photo-Secession group to promote his Pictorialist style consisting of the emulation of painterly effects. He soon abandoned that approach evolving into a clearer, less manipulative style, essen-tially shepherding photography into the modern era. His photograph, "The Steerage" (reproduced here), was a pivotal image in his personal transformation. Stieglitz wrote the following statement for an exhibition of his photographs held at the Anderson Galleries, New York, in 1921:

My teachers have been life——work—continuous experiment. Incidentally a great deal of hard thinking. Any one can build on this experience with means available to all.

Many of my prints exist in one example only. Negatives of the early work have nearly all been lost or destroyed. There are but few of my early prints still in existence. Every print I make, even from one nega-tive, it's a new experience, a new problem. For, unless I am able to vary—add—I am not interested. There is no mechanicalization, but always photography.

My ideal is to achieve the ability to produce num-berless prints from each negative, prints all significantly alive, yet indistinguishably alike, and to be able to circulate them at a price not higher than that of a popular magazine, or even a daily paper. To gain that ability there has been no choice but to follow the road I have chosen.

I was born in Hoboken. I am an American. Photography is my passion. The search for Truth is my obsession.

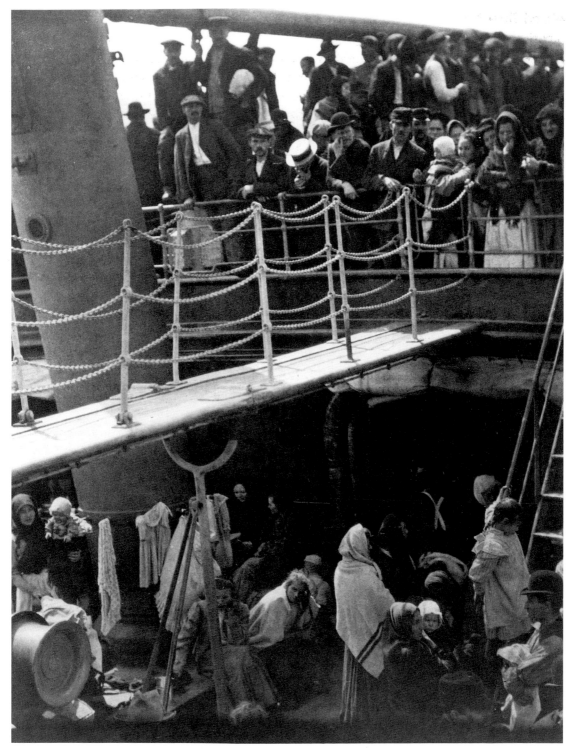

The Steerage, 1907

Photogravure, 12½ x 10¼ inches
The Family of Alice R. and Sol B. Frank

Alvin Langdon Coburn
English (b. America), 1882–1966

Mostly known for his mid-career Cubist-inspired "Vortographs" (regarded as the first purely abstract photographs), Coburn was also a prolific portraitist and urban landscape photographer. He produced more than 40,000 gravure prints for his books, which include *Men of Mark* (1913; British artists and literati), *New York* (1910), and *London* (1909). Coburn associated with both the English Pictorialist group, The Linked Ring, and Alfred Stieglitz's Photo-Secession group in New York. Coburn was strongly affected by Whistler's paintings, Japanese rendering of tone and perspective, and the urban imagery of Stieglitz. This statement is excerpted from "The Relation of Time to Art," originally published in *Camera Work* in 1908.

Photography is the most modern of the arts, its development and practical usefulness extends back only into the memory of living men; in fact, it is more suited to the art requirements of this age of scientific achievement than any other. It is, however, only by comparing it with the older art of painting that we will get the full value of our argument plainly before us; and in doing so we shall find that the essential difference is not so much a mechanical one of brushes and pigments as compared with a lens and dry plates, but rather a mental one of a slow, gradual, usual building up, as compared with an instantaneous, concentrated mental impulse, followed by a longer period of fruition. Photography born of this age of steel seems to have naturally adapted itself to the necessarily unusual requirements of an art that must live in skyscrapers, and it is because she has become so much at home in these gigantic structures that the Americans undoubtedly are the recognized leaders in the world movement of pictorial photography.

Just imagine anyone trying to paint at the corner of Thirty-fourth street, where Broadway and Sixth avenue cross! The camera has recorded an impression in the flashing fragment of a second. But what about the training, you will say, that has made this seizing of the momentary vision possible? It is, let me tell you, no easy thing to acquire, and necessitates years of practice and something of the instinctive quality that makes a good marksman. Just think of the combination of knowledge and sureness of vision that was required to make possible Stieglitz's "Winter on Fifth Avenue." If you call it a "glorified snapshot" you must remember that life has much of this same quality. We are comets across the sky of eternity.

The Two Trees, Rothenbergh, 1908

Photogravure, 14¾ x 11 inches
The Family of Alice R. and Sol B. Frank

Anne W. Brigman
American, 1869–1950

Brigman was an ardent feminist who separated from her husband to seek her destiny. Best known for her allegorical nudes made outdoors in the natural environment, Brigman became a member of the Photo-Secession, and her work was published in three issues of *Camera Work*. In 1909, she spent eight months in New York, at which time she met Alfred Stieglitz at his art gallery known as 291. This text, which was published in the *Camera Work* issue "What is 291?" describes her first meeting with Stieglitz whom she refers to here as the Man, with a capital M:

Don't you remember trying, in your youth, to sit still on a haircloth sofa during long Sunday morning prayers? Of the ache in your legs for flight; of the hunger for air in your nostrils; of the wild, wonderful need to stampede?

Never mind. All this belongs to the impressions that gather themselves around those first spaces called a few minutes which were the beginnings of the real 291.

Another time, after going over many folios of photographs, my own among them, I said, I hoped when I first came, that you would show some of my things. Now I'm deadly afraid you will.

"Why?" asked the Man.

Because, I answered, the longer I look at the intelligent beauty of the work in these folios, the muddier and hotter looking my sepia bromides grow. How did you ever care to show them?

The Man's short gray moustache twitched. He shuffled reams of papers, magazines, and envelopes.

I had begun to think he hadn't heard the question, or perhaps forgotten.

Then he adjusted for the hundredth time, with thumb and finger his pince-nez glasses and glancing over the edges of them said, staccato—

"The way you did them was rotten, but they were a new note—they were worth while."

Then he walked out of the liliputian room, and I sat humped up on the arm of the big chair and stared down Fifth Avenue, trying to focus the unarrested lens of my thoughts.

"Rotten—but worth while."

I was beginning to understand!

Nothing in this place was final (nothing ever is) but things that stayed for a time were worth while....

You remember too, the long steep trails that lead zig-zag, mile after mile, away from trees and brooks, up, up into the heat of rocks blessed by the sun, where your lungs ache and your heart hurts from the struggle—and then you find it—the Vision!—the glory of the things beyond.

The memory and the wonder of it goes with you to the lowlands, into the daily life, and you are glad that you had the courage.

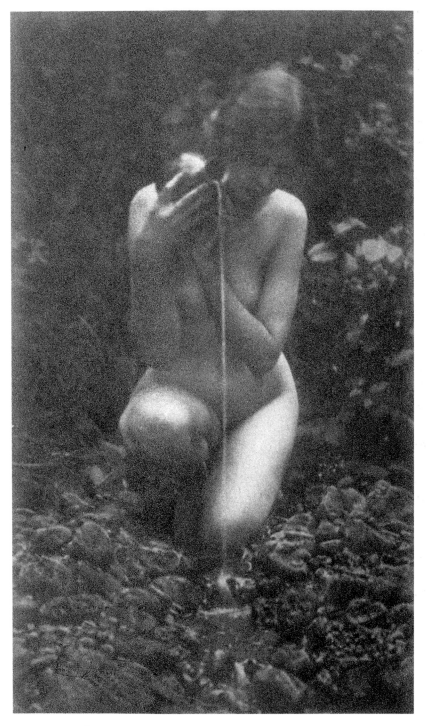

The Source from *Camera Work, No. 25*, January 1909

Photogravure, 9³/₈ x 5½ inches
Horace W. Goldsmith and Art Purchase Funds, 89.125.4

Clarence H. White
American, 1871–1925

Although a bookkeeper by trade, White began photographing in 1898 and soon became a widely known pictorial photographer. In 1907 he began teaching at Columbia University and in 1914 founded the Clarence H. White School of Photography. Many of his students became well-known photographers; among them were Margaret Bourke-White, Margaret Watkins, Dorothea Lange, and Paul Outerbridge. This text is from an interview published in the *Annual Report of the Pictorial Photographers of America*:

The development of modern art, I think, is in the direction of construction; and construction, picture construction, applies to photography as definitely as it applies to painting and other art. Indeed, a great feeling of the need of this has expressed itself in connection with photography....

The rules of composition as usually understood have been too narrow. We might say there are no rules, but there are certain fundamentals. These fundamentals have been made to apply in a great variety of ways. Take this print, for instance. [Mr. White took up a photograph showing some peculiar architectural effects.] Here is a little of what we might call cubism in modern photography. We first look at it and we get pleasure from the play of light and dark on the object. It produces a sense of satisfaction to the eye, and yet when we examine it more closely we feel that the artist has violated the rules of what might be called composition. We must construct our rules of composition from examples, rather than make the construction that is demanded by our art out of formal rules....

[The photographer] should go out into the fields with an open eye and open mind to be moved to an expression of his appreciation of pattern, his appreciation of tone, of values, etc. Let him leave the mind open and that will tell him what to express. He gets his inspiration from nature and he contributes to nature just so much as he has of knowledge of photography, knowledge of composition, knowledge of tone values—he expresses himself that way. I do not believe he should go with a preconceived idea of what he is going to get. He should be moved by his subject. If he is not, he will become blind to the most beautiful aspects of nature. That is the interesting thing of nature; the changing light and shadow are never twice the same. The light is continually changing, and he has combinations and variations that a man with a preconceived idea will miss, and in photography that is the most impressive thing—that it can record these subtleties.

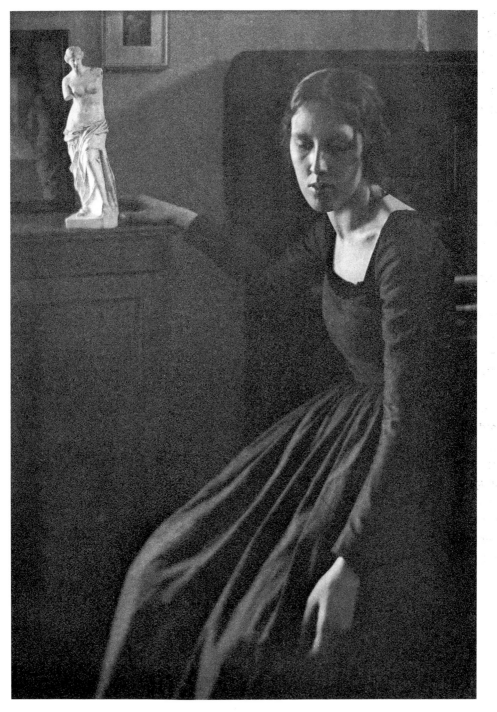

Lady in Black with Statuette from *Camera Work*, No. 23, 1908

Photogravure, 7⅝ x 5⅜ inches
Purchase, 84.734

James VanDerZee
American, 1886–1983

One of the first major African American photographers, VanDerZee's career spanned over seventy years. In 1907 and 1908 VanDerZee lived for a brief period in Phoebus, Virginia, where he photographed the town's activities as well as the students and teachers of Hampton Institute, an instructional school for African and Native Americans founded in the 1860s. After returning to New York, he opened Guarantee Photo Studio in 1916, where he photographed the celebrities of the Harlem Renaissance and middle-class African Americans. A musician and self-taught artist, VanDerZee commented that music and art all seemed to work in conjunction. In the following he reminisces about the early days of photographic technology:

I was a big professor [a common title of respect for musicians] down there, and yet I was myself trying to get an education. Of course, I was never too hot at the piano or the violin, but at the same time, I was so much better than the rest. There was one professor at the school who was very good, and I couldn't understand why they thought I was so much better than he until I figured it out one day. I figured it must be that the stuff he was playing was so difficult that their untrained ears couldn't follow him. I played pieces like Ave Maria and Mendelssohn's Spring Song, simple pieces that had an even, flowing melody that was easy to follow. But he'd be playing something that would be too much for them. They could appreciate my work, so they liked my work much better.... Music and art, they all seemed to work in conjunction, to my way of thinking....

We were obliged to use flash powder in those days. It produced very good illumination, but there were technical difficulties. If you put too much powder in, why, you were liable to blow your head off, or at least your hand. I knew people who got burned pretty bad. I burned my hand sometimes, trying to light the powder. Then I noticed an advertisement; it showed a tray and a partition with a hole in it, so you lighted the powder with a match that you put through the hole. I started using that. There were others where you lit the powder with a gun.

You'd open the lens of the camera, let the powder go off—bang!—and close the camera up. Course there was a great deal of smoke to it afterwards. If there was a high ceiling it was all right, because it took a little time for the powder to go up and come down. I'd try to make a second shot quick, because when all that smoke came down everyone would start coughing and choking. With a low ceiling, the powder would go up and spread around and come down, and there was no time for a second shot. We had to get out of there before they started coughing!

Some big concerns had flash bags they put the powder in, and had it connected up with electricity. Flash went off, and it wasn't so bad. Then later on, they came up with the flash bulbs and that was a great improvement. There wasn't any smoke. But with the flash powder you could make the illumination as bright as you wanted....

Being an artist, I had an artist's instincts. Why, you have an advantage over the average photographer. You can see the picture before it's taken; then it's up to you to get the camera to see it.

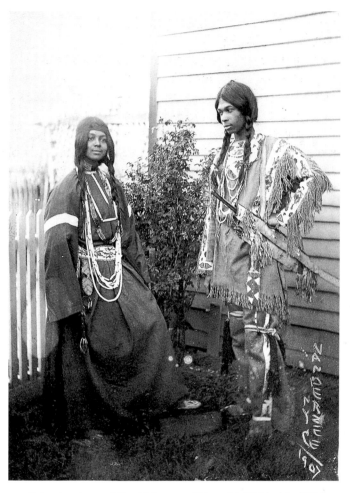

Schoolteachers, Miss Holmes and Harry McGill, Virginia, 1907

Gelatin-silver print, 4⅝ x 3½ inches
Purchase, 88.66

Lewis Wickes Hine
American, 1874–1940

Educated as a sociologist, Hine employed photography for the cause of social reform. His most influential work was carried out in service of the National Child Labor Committee; his images of juveniles and children at work (1911–16) were instrumental in changing labor regulations. In this work, and in photographs of Ellis Island immigrants, Red Cross efforts in Europe during World War I and the construction of the Empire State Building, Hine demonstrated respect and genuine personal concern for the conditions of his subjects; Hine's work stands as a model for social documentary photography. The following, entitled "Social Photography, How the Camera May Help in the Social Uplift," is excerpted from the Proceedings of the National Conference of Corrections, June 1909.

Whether it be a painting or a photograph, the picture is a symbol that brings one immediately into close touch with reality. It speaks a language learned early in the race and in the individual—witness the ancient picture writers and the child of today absorbed in his picture book. For us older children, the picture continues to tell a story packed into the most condensed and vital form. In fact, it is often more effective than the reality would have been, because, in the picture, the nonessential and conflicting interests have been eliminated. The picture is the language of all nationalities and all ages. The increase, during recent years, of illustrations in newspapers, books, exhibits and the like gives ample evidence of this.

The photograph has an added realism of its own; it has an inherent attraction not found in other forms of illustration. For this reason the average person believes implicitly that the photograph cannot falsify. Of course, you and I know that this unbounded faith in the integrity of the photograph is often rudely shaken, for, while photographs may not lie, liars may photograph. It becomes necessary, then, in our revelation of the truth, to see to it that the camera we depend upon contracts no bad habits.

Not long ago, a leader in social work, who had previously told me that photographs had been faked so much they were of no use to the work, assured Editor Kellogg that the photographs of child labor in the Carolinas would stand as evidence in any court of law.

Moral: Despise not the camera, even though yellow-photography does exist.

With several hundred photos like those which I have shown, backed with records of observations, conversations, names and addresses, are we not better able to refute those who, either optimistically or hypocritically, spread the news that there is no child labor in New England?

Perhaps you are weary of child labor pictures. Well, so are the rest of us, but we propose to make you and the whole country so sick and tired of the whole business that when the time for action comes, child-labor pictures will be records of the past.

The artist, Burne-Jones, once said he should never be able to paint again if he saw much of those hopeless lives that have no remedy. What a selfish, cowardly attitude!

How different is the stand taken by Hugo, that the great social peril is darkness and ignorance, "What then," he says, "is required? Light! Light in floods!"

The dictum, then, of the social worker is "Let there be light;" and in this campaign for light we have for our advance agent the light writer—the photograph.

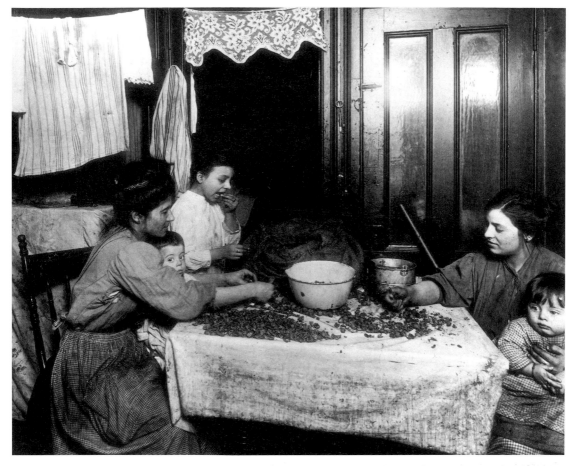

Picking Nut Meats, New York City, 1911

Gelatin-silver print, 10¼ x 13¼ inches
The Family of Alice R. and Sol B. Frank

Margaret Watkins
Canadian, 1884–1969

Watkins began her professional career as a photographer in 1916 when she opened a studio in New York's Greenwich Village. In the 1920s she became one of the first women to be employed by a major advertising firm. A strong sense of design permeated both her personal and commercial work, transforming objects from ordinary life into abstract compositions. In this excerpt from "Advertising and Photography," published in the 1926 volume of *Pictorial Photography in America*, Watkins discussed the merging roles of artistic and commercial photography:

To fix the image projected in the camera obscura, that was a scientific problem. When it was solved we had the foundation of a new art medium. Soon Daguerre's work appeared, depicting the quaintness and decorum of our grandparents with charming precision. And D.O. Hill, seeking at first for aid in his work, became fascinated by the discovery, producing a series of portraits whose vigor and vitality hold their place today when his paintings are outdated and forgotten. Research brought technical refinements, the corrected lens, the delicate detail of the collodion plate; but when Julia Margaret Cameron photographed the celebrities of a later generation, she disdained delicacy, preferring means which gave her sitters the strength of characterization worthy of their personalities.

Then for a time force and sincerity were smothered by stilted Mid-Victorian sentiment. Landscapes were self-consciously rustic, facts obscured. Truth, acres of sweetly obvious anecdote covered the gallery walls, and photography followed the elder arts. Followed, and came to life. The ferment of the Photo-Secession seethed through the exhibitions. Repelled by the cold eye of the anastigmat, some sought to give the Impressionist sense of vibrating light, and reacted to an extreme of emotional mistiness. Others were moved by the remote aestheticism of the Pre-Raphaelites, or the fine, if somewhat conscious figure placing of Whistler; and with everyday scenes, a live realism succeeded the old deadly literalness.

And commercially? From the beginning there was a parallel and separate development. To the neat-minded scientist the accuracy of the photographic process was a god-send. Where a map of the object sufficed, here was a truthful and adequate record. Later, with half-tone, photography became the chief medium of reproduction, yet ever kept as a sedate handmaid of the graphic arts. For in the days of the Photo-Secession the artistic and commercial photographers were mutually unaware. No devout pictorialist would have deigned to descend to advertising. In their desire to establish photography as an art they became a bit precious; crudeness was distressing, materialism shunned.

With Cézanne, Matisse, Picasso, came a new approach. Soulfulness was taboo, romance derided, anecdote scorned; beauty of subject was superseded by beauty of design, and the relation of ideas gave place to the relation of forms. Weird and surprising things were put upon canvas; stark mechanical objects revealed an unguessed dignity; commonplace articles showed curves and angles which could be repeated with the varying pattern of a fugue. The comprehending photographer saw, paused, and seized his camera! And while the more conservative workers still exhibited photographs beautiful in the accepted sense, strange offerings startled the juries; prints original perhaps, but hardly pretty, and showing an apparent queerness of choice most painful to the orthodox.

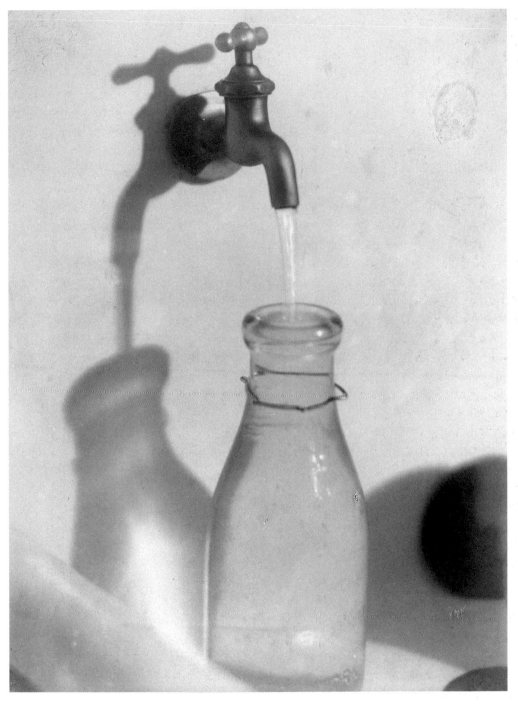

Milk Bottle, 1919

Silver-chloride print, 8¼ x 6¼ inches
Horace W. Goldsmith Fund, 84.77

Paul Outerbridge
American, 1896–1958

After training as an illustrator and painter, Outerbridge began taking photography classes in 1921. His early work consisted of still life abstractions of ordinary objects, reflecting his interest in design. By 1924, Outerbridge had become a successful advertising photographer, freelancing for *Harper's Bazaar* and *Vanity Fair*. After living and working in Paris in the late 1920s, Outerbridge set up a studio outside of New York where he experimented with carbro color photography; his mastery of this process earned him further commercial success. The following discussion on photography and still life is taken from Outerbridge's 1940 publication *Photographing in Color:*

There is always the distinction between fine and applied art to be borne in mind. Fine art exists for itself alone; applied art as an adjunct to or quality of something else—for a use, as it were. Now, whereas we do not find it hard to accept the beauty of a flower for itself alone, in present-day, mechanical-industrial civilization, people will usually question the use of a picture. Things are estimated much more for what they do or will do than for what they are or will become....

To appreciate photography one must disassociate it from other forms of art expression. Instead of holding a preconceived idea of art, founded upon painting (painting is cited because, in general, the word "art" seems to be somewhat synonymous with painting), it must be considered as a distinct medium of expression, and one must first of all realize that it is a medium capable of doing certain things which can be accomplished in no other way. No one condemns architecture because it does not look like a painting or a painting because it is not done in stone.

Of those who say that photography is too mechanical to produce works of art—and this category includes many otherwise competent art critics—it may be safely said that such an attitude denotes a lack of knowledge. The camera and the various apparatus and materials used in photography are, after all, merely tools, as are the paints, brushes, and chisels of other arts. And the result is bounded, not by the limitations of the tools, but by those of the man.

If the test of artistic worth is that an object be the means of aesthetic enjoyment, who will deny that through photography such objects may be and have been created?

Still life subjects will often reflect a clearer picture of a photographic artist's imaginative vision than landscape work, which is usually more dependent upon the choice of a point of view than upon anything else; or portraiture, in which the photographer must somewhat subordinate his own personality to that of his sitter.

Still life takes up less space and does not move; therefore less light is required. It stays where you put it, so that you can come back to it and make whatever changes in the composition or arrangement, lighting, or exposure, that you have found necessary to a better result....

What makes still life good instead of mediocre is the quality of vision and imagination employed by the photographer, and especially his reaction to his subject material. Though this subject may be, from one point of view, much more impersonal than many others, from still another viewpoint it may be intensely personal and quite a revealing expression of its creator's mind.

A sound knowledge of chiaroscuro and a passionate interest in and reaction to the shape of objects devoid of sentimental association is essential to producing the best results.

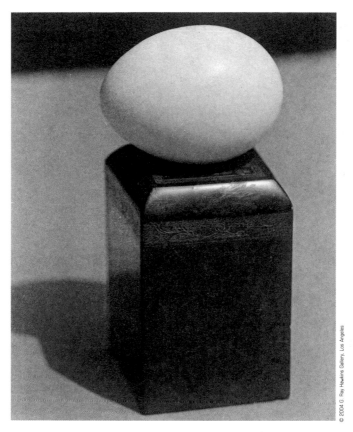

Egg on an Ebony Block, 1923

Platinum print, 4¼ x 3½ inches
Purchase, gift of Robert B. and Joyce F. Menschel, 80.223

Aleksandr Rodchenko
Russian, 1891–1956

Originally trained as a painter, Rodchenko, who was active in the artistic development following Russia's 1917 revolutions, was a pioneer of new processes and ideas. Mainly self-taught, he began experimenting with photomontage in 1923, and worked as a magazine photographer and photo-reporter. His abstract images eliminated unnecessary detail and emphasized dynamic compositions; he often photographed scenes from odd angles in order to challenge the viewer's perception and delay recognition. In the following statement published in 1928, Rodchenko strongly urges his colleagues to create photographs that go beyond imitation of painting:

We struggle against easel painting not because it is an aesthetic form of painting, but because it is not modern, for it does not succeed in bringing out the technical side, it is a redundant, exclusive art, and it cannot be of any use to the masses.

Hence, we are struggling not against painting but against photography carried out according to the models of painting as if it were an etching, a drawing, a picture in sepia or watercolour.

Struggling for "what" to photograph means nothing. Examples must be provided. That is what we are all doing.

A "fact" photographed badly does not represent a cultural phenomenon, and still less a cultural value for photography....

Revolution in the photographic field consists in photographing in such a way that photography will have enough strength not just to rival painting, but also to point out to everyone a new and modern way of discovering the world of science, of technology and of everyday life....

We are obliged to make experiments.

Photographing facts as mere description is not an innovation. Behind a simply photographed fact painting can be concealed, and behind a simply described fact, a romance. You may be advocates of the "fact," but you do not describe it so simply.

Comrades, you will soon end up confusing left and right.

A Leftist is not someone who photographs facts, but someone who, through photography, is able to struggle against "the imitations of art," with images of high quality, and to do this he experiments until he obtains a perfect "easel" photograph.

What is this easel photograph...? It is the experimental photograph.

Do not study theoretically without taking advice from those with experience and do not be the worst friends of your enemies.

For those who are doing actual work, abstract theories based on the aesthetics of asceticism are highly dangerous....

It is said: Rodchenko's photographs have become a bore: always looking down from above, looking up from below.

But everyone has been photographing "from centre to centre" for years; not just I but the majority of photographers ought to be taking pictures looking up from below or down from above....

Damn it, nobody knows what is beautiful and what is not. They do not understand new things.

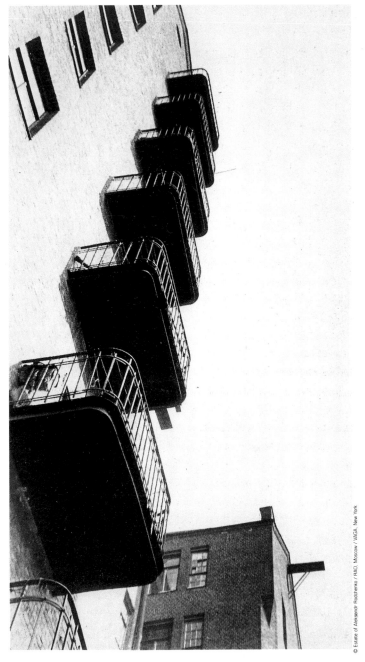

Balconies, 1925

Gelatin-silver print, 1930s, 8¾ x 4½ inches
Walter P. Chrysler, Jr., Photography Fund, 95.14

André Kertész
American (b. Hungary), 1894–1985

One of the earliest to fully avail himself of the small-format camera, Kertész's work reflects a curiosity and passion for serendipitous moments. His earliest images lyrically epitomized everyday life in his native Hungary. As a soldier in WWI, Kertész continued photographing and during recuperation from a war wound, photographed a man in a swimming pool whose body was distorted by the water. This image began his close affiliation with the development of surrealism. Living in Paris from 1925 to 1936, Kertész sold work to the major French, German, and English magazines with a range of photography including reportage, portraits, still lifes, and nude distortions. Although widely respected as an influence and a mentor in France, he was enticed to move to New York in 1936. His artistic recognition in the United States however, was long delayed as publishers during the 1940s and 1950s considered his images too subtle and eloquent. This statement is taken from a May 1982 unpublished interview.

I am not surrealist. I am only realist. All this group—surrealists—use my name. No, no, I am realist. Not surrealist. You can give any explanation [that] you want, this is a normal realist thing that I do.... I did the same in Budapest before the surrealist.... All the so-called element [that] you find later, the so-called modern business...I did before, without knowing surrealism: [there] was no surrealism in this time. I lived in Paris in this day, but I had material before. People give [it] a new name, that's all....

And come a crazy photographer...you know, in the infantry you have everything in your rucksack. Very heavy. Lose my glass plate, lose my metal holder, you can imagine. The idea was if I stay alive.... Fine with me and that's that. Now in the end I stay alive.... And in Esztergom made my first distortion, underwater...we [were] sitting around in the pool, talking before lunch...everybody was wounded...we [were] the wounded men. And we [were] sitting around talking and in the water [was] the leg. The hand. And I began shooting this. "You are crazy; what you are doing?" [they asked me.] I made I don't know how many [photographs] for the girlfriends; for your girlfriend the face is interesting.... We make the joke [that] I am crazy. And this was effectively the beginning of distortion photography....

And the *Pipe and Glasses*. It was between talk. Between talk over these things I make the photo, that's all. Something like that. Look I don't make again very little. Except one photo or two. No really, this is what is going around now, shooting a thousand for one, but I didn't make [*Pipe and Glasses*] that way. If you know what you want to do, you don't make thousand. Or a hundred.... If you feel exactly what you want and you have your technique, [and you are] not playing around, [it] is unnecessary *Pipe* was one shot. We worked in glass plate, you don't go around with [a] hundred.

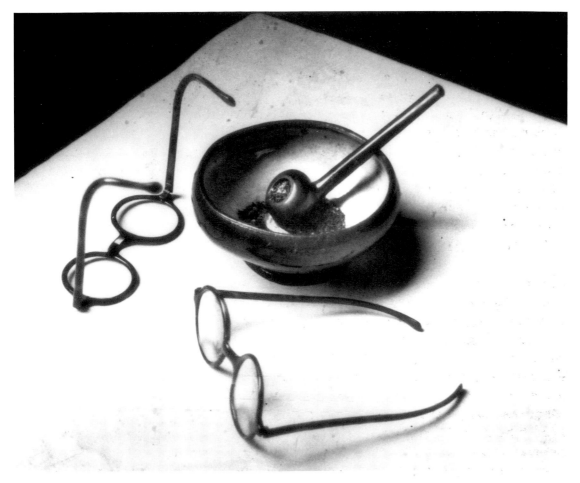

Pipe and Glasses, Paris, 1926

Gelatin-silver print, 7¾ x 9¾ inches
The Family of Alice R. and Sol B. Frank

Marjorie Content
American, 1895–1964

Content's still lifes, portraits, and landscapes reveal exquisite delicacy and formal beauty; her most ambitious work dates from the 1920s and early 1930s. Although never exhibited publicly during her lifetime, her work was reproduced in *Photographie*, an annual published in Paris that showcased the photography of many of the most innovative photographers of the era. Alfred Stieglitz, Georgia O'Keeffe, and Maxwell Anderson were included among her intimate friends. During the summers of 1931 through 1933, Content traveled throughout the southwest photographing Native Americans and making abstract landscapes. After the late 1930s she photographed sporadically, devoting most of her time to her fourth husband, writer Jean Toomer. This statement is excerpted from a journal entry dated November 18, 1936:

How to see more than one does see? Struggle with a physical object is without doubt struggle. You know it by the undeniable testimony of the strain on your muscles. It is a known experience—trying to push or lift a heavy weight. But psychological struggle is an experience not so recognizable to me. I am sure I have had it. Circumstances have produced situations against which I have struggled and also against the effects of those situations on me. But in the struggle to see more than I now see, there is nothing to come to grips with. One either can or cannot see. But what happens in that area between can and can't I do not know. It may be struggle but gives me no sensation recognizable as such. Am I struggling to extract now? I do not know.

Struggle with a particular property in oneself is more easily understandable and recognizable. It is a definite task. And progress or lack of it can be seen and measured. Progress in enlarging vision and extracting meaning could also be noticed if it were there but the way to do it is still obscure to me.

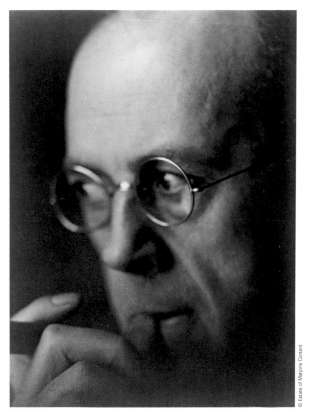

© Estate of Marjorie Content

Bruce Christen, ca. 1926

Gelatin-silver print, 3⅞ x 2⅞ inches
Horace VV. Goldsmith and Art Purchase Funds, 93.9.2

René Magritte
Belgian, 1898–1967

A well-known Surrealist painter, Magritte began experimenting with photography and photomontage around 1929. His photographs, which can be viewed more as snapshots, document the private lives of his friends and family; however, despite their informality, it is evident that Magritte acted as director, manipulating his subjects, including himself, to create controlled compositions that often reflect the imagery in his paintings. As this statement from the 1960s suggests, Magritte regarded everyday life as the source for mystery:

Mystery—without which no world, no thought, would be possible—corresponds to no doctrine, and does not deal with possibilities. Thus, a question such as "How is mystery possible?" is meaningless because mystery can be evoked only if we know that any possible question is relative only to what is possible.

Some mediocre or absurd things do not really cast doubt on the concept of mystery; nothing beautiful or grandiose can affect it. Judgment as to what is, was, or will be possible does not enter into the concept of mystery. Whatever its manifest nature may be, every object is mysterious: the apparent and the hidden, knowledge and ignorance, life and death, day and night. The attention we give to the mystery in everything is deemed sterile only if we overlook the higher sensibility that accompanies that attention, and if we grant a supreme value to what is possible. This higher sensibility is not possible without freedom from what we call "the laws of the possible."

Freedom of thought alert to mystery is always possible if not actually present, whatever the nature of the possible: atrocious or attractive, mean or marvelous. It has power to evoke mystery with effective force.

The term Surrealism gives rise to confusion, and the term Realism is not suitable for the direct apprehension of reality. Surrealism is the direct knowledge of reality: reality is absolute, and unrelated to the various ways of "interpreting" it. Breton says that Surrealism is the point at which the mind ceases to imagine nothingness, not the contrary. That's fine, but if I repeat this definition I'm no more than a parrot. One must come up with an equivalent, such as: Surrealism is the knowledge of absolute thought.

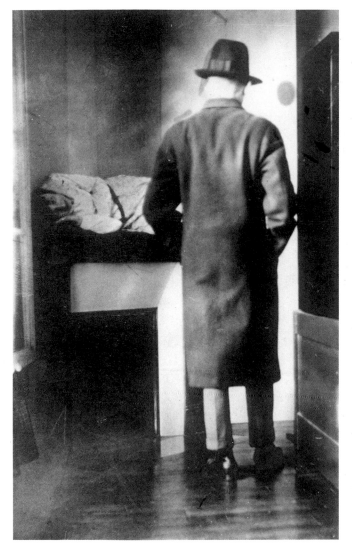

Tableau (self-portrait with Jacqueline Nonkels), ca. 1927

Gelatin-silver print, 5½ x 3½ inches
Horace W. Goldsmith and Art Purchase Funds, 93.19.1

Imogen Cunningham
American, 1883–1976

Through an active career spanning sixty-five years, Cunningham emerged from a Pictorialist attitude—chiefly influenced by Gertrude Käsebier—to become one of the pioneers of West Coast modernism. After graduation from the University of Washington she worked in the Seattle studio of Edward S. Curtis. Her work includes portraits, nudes, and voluptuously detailed close-up renditions of plants and flowers. A founding member of the Group f/64, she was included in their first exhibition (1932) held at the M.H. de Young Memorial Museum in San Francisco. At the time of her death she was involved in a portraiture project on elderly people, published as *After Ninety* (1977). In a 1961 interview conducted by Edna Tartaul Daniel for the Regional Cultural History Project at the University of California, Berkeley, Cunningham said:

Of course I think a good many people go into photography because they think it's easy. The ones who succeed don't think that, but people go into it thinking like the old slogan that Eastman Company put out, "You press the button and we do the rest."

For one thing, I think that people like the freedom of photography whether they are women or men. You can be your own boss....

I wasn't very ambitious. I think that's the solution. I just took things as they came. I wouldn't say I didn't have any problem, but I didn't care. I didn't think I was going to save the world by doing photography as some of these people do. I just was having a good time doing it, and so I still had a good time no matter what I had to photograph, so I photographed the plants in my garden and steered my children around at the same time.

But I can think of the times we went into the mountains and into the Southwest when, if I had had a little camera, I would have done a lot more work than I did. I didn't have anything but a big camera, and the big camera and the children were just too much for me....

I have no ambition, never did have any ambition to be a reporter. That is something different. I still feel that my interest in photography has something to do with the [a]esthetic, and that there should be a little beauty in everything.

Triangles, 1928

Gelatin-silver print, 3¾ x 2¾ inches
The Family of Alice R. and Sol B. Frank

Ansel Adams
American, 1902–1984

One of the world's most renowned photographers, and an impassioned spokesperson for both photography and nature preservation, Adams's early training as a musician voiced itself in the eloquent photographic orchestrations of landscape. Using a musical analogy, Adams likened the negative to the composer's score and the print to the performance. His work in the early 1930s with the California-based Group f/64 helped develop and affirm photography as an autonomous medium. Adams published numerous books on both the technical aspects and aesthetics of photography, and, in 1952, along with Minor White, Beaumont and Nancy Newhall, and others co-founded *Aperture*, a journal of creative photography. In the late 1970s Adams played a significant role in establishing the modern photography market by taking final orders for his prints, thereby creating rarity. In his 1985 autobiography, Adams recalled the experience of producing his *Parmelian Prints of the High Sierras* portfolio in the spring of 1926:

I was ushered into Albert's [Bender] office at 311 California Street. He was a partner in a leading insurance firm in the city, not large, but possessed of a remarkable clientele. His desk was a chaotic mass of letters, envelopes, postcards, books, and pamphlets: an ever-accumulating mound of memorabilia into which he could delve and immediately find whatever he sought. He greeted me warmly, talked a minute with his staff, made a phone call, then took me to a small table, pushed aside some books and periodicals, and said, "Let's look at them again." During his thorough inspection of my photographs he received at least two visitors and six phone calls, but nothing disturbed the intensity of his concentration on my work. After he finished, he looked me squarely in the eye and said, "We must do something with these photographs. How many of each can you print?"

I replied, "An unlimited number, unless I drop one of the glass plates."

He then said, "Let's do a portfolio." I remained outwardly calm, but was electrified by his decision.

We quickly established the probable costs and the time required to do the job. He called Jean Chambers Moore, a respected publisher and dealer in fine books, and arranged for her to publish the portfolio and the Grabhorn Press to do the typography as well as the announcement. Edwin and Robert Grabhorn had developed a worldwide reputation for their incredibly beautiful typographic design and printing. Having decided upon an edition of one hundred portfolios (and ten artist's copies) of eighteen prints each, Albert suggested a retail price of fifty dollars for each portfolio. It was a whirlwind morning. This was my first experience with such decisive organization; red tape was not a part of Albert's world....

Jean Chambers Moore decided she dare not publish the portfolio if it had the term *photographs* in the title. She was adamant against my objections; she was the experienced publisher, not I. We needed to sell the remaining half of the portfolios, and at that time creative photography was not considered commercially viable, as hardly anyone considered it to be a fine art. Hence, we coined a bastard word to take the place of photograph—*Parmelian Prints*. I am not proud at allowing this breach of faith in my medium. And then, to add to my chagrin, when I saw the finished title page I found an error, *Parmelian Prints of the High Sierras*. The name *Sierra* is already a plural. To add an *s* is a linguistic, Californian, and mountaineering sin.

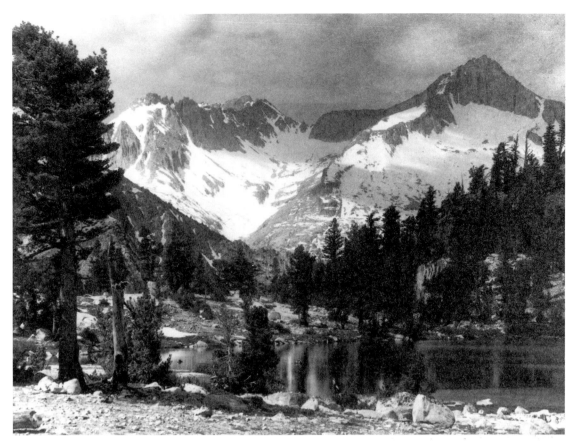

Mount Brewer and Bullfrog Lake, Kings Canyon National Park
from *Parmelian Prints of the High Sierras*, ca. 1925

Gelatin-silver print, 5¾ x 7¾ inches
The Family of Alice R. and Sol B. Frank

Edward Weston
American, 1886–1958

One of photography's greatest artists, Weston was acclaimed both for his groundbreaking attention to the medium's innate qualities and for his commitment to aesthetic purity. Weston's significant work began in the early 1920s after a decade's worth of Pictorialist imagery. By the end of the 1920s, however, Weston had concluded that his task as an artist was to "render the substance and quintessence of the thing itself." In his images he was obsessed with clear, sharp description of objects (particularly vegetables), landscapes, nudes, and portraits. In 1932 along with Ansel Adams, Imogen Cuningham, and others Weston founded the Group f/64. F/64 refers to the small lens aperture which causes maximum sharpness and depth of field in the photograph. The group's other tenets included the use of a large-format camera, glossy photographic paper, and previsualization of the image so that no cropping was necessary in the final print. In his *Daybooks*, Weston wrote:

July 16, 1931: Artists (fine ones) don't copy nature, and when they do record quite literally the presentation is such as to arouse connotations quite apart from the subject matter. The camera recording nature exactly can yet be used to convey an abstract idea. Peppers are reproduced in seed catalogues, but they have no relation to my peppers.

No—nature cannot be improved upon considered physically. No use to exactly copy a butterfly—better to see it floating in summer sky: but to find a dead pelican, photograph a few inches of its wing so that white quills dart from black barbs like rays of light cutting a night sky—this is not copying nature, but using her with imaginative intent, to a definite end.

February 1, 1932: Photography as a creative expression—or what you will—must be seeing plus. Seeing alone means factual recording. Photography is not at all seeing in the sense that the eyes see. Our vision is binocular, it is in a continuous state of flux, while the camera captures but a single isolated condition of the moment. Besides, we use lenses of various focal lengths to purposely exaggerate actual seeing, we "overcome" color for the same reason. In printing we carry on our willful distortion of fact. This is all legitimate procedure: but it is not seeing literally, it is seeing with intention, with reason.

An idea just as abstract as could be conceived by sculptor or painter can be expressed through "objective" recording with the camera, because nature has everything that can possibly be imagined by the artist: and the camera, controlled by wisdom, goes beyond statistics.

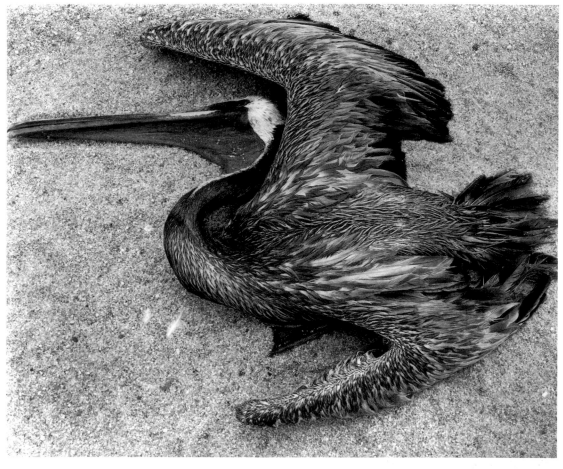

Pelican, Point Lobos, 1942

Gelatin-silver print, 7½ x 9½ inches
The Family of Alice R. and Sol B. Frank

Frederick Sommer
American (b. Italy), 1905–1999

In 1935, after showing Alfred Stieglitz his watercolors, Sommer began photographing. Much of his work consists of spatially ambiguous images of southwestern American desert landscape; however, he is also known for his metaphoric, surreal still-life constructions, cameraless abstractions, and his troubling photographs of decomposing animals found in the desert. Sommer's work is deeply thoughtful and prevents easy reading. Although he worked in a secluded area of Arizona for more than half a century, his fine printing technique and abstract theoretical stance have been widely influential.

Design reaches for the complimentary in aesthetic
fields, the splendor of design is display of pictorial logic.

Art is perception of design structured in the per-
ceived, memorized images are the beginning of
linguistic logic.

There would be no music without structure and
memory, nature and logic are incapable of iconoclasm.

Jack Rabbit, 1939

Gelatin-silver print, 7½ x 9¼ inches
The Family of Alice R. and Sol B. Frank

Paul Strand
American, 1890–1976

One of the principal exponents of modernism, Strand was among the earliest twentieth-century photographers to adopt the straightforward precise vision that would soon become the mantra of Group f/64. Strand learned photography from Lewis Hine, while a student at the Ethical Culture School. In the 1910s and 1920s, he was closely associated with Stieglitz, who devoted the last two issues of *Camera Work* to Strand's undiluted images of architecture, still lifes, and candid street portraiture. During the 1930s Strand was active as a filmmaker, but returned full-time to photography in the 1940s, extending his reputation as a master photographer and impeccable printer. He produced many books, and his *Time in New England* (1950), with text by Nancy Newhall, is considered one of the great publications of American photography. Strand's statement was originally published in *Seven Arts*, 1917.

Photography, which is the first and only important contribution thus far, of science to the arts, finds its *raison d'être*, like all media, in a complete uniqueness of means. This is an absolute unqualified objectivity. Unlike the other arts which are really anti-photographic, this objectivity is of the very essence of photography, its contribution and at the same time its limitation. And just as the majority of workers in other media have completely misunderstood the inherent qualities of their respective means, so photographers, with the possible exception of two or three, have had no conception of the photographic means. The full potential power of every medium is dependent upon the purity of its use, and all attempts at mixtureo end in such dead things as the color-etching, the photographic painting and in photography, the gum-print, oil-print, etc., in which the introduction of hand work and manipulation is merely the expression of an impotent desire to paint. It is this very lack of understanding and respect for their material, on the part of photographers themselves which directly accounts for the consequent lack of respect on the part of the intelligent public and the notion that photography is but a poor excuse for an inability to do anything else.

The photographer's problem therefore, is to see clearly the limitations and at the same time the potential qualities of his medium, for it is precisely here that honesty, no less than intensity of vision, is the prerequisite of a living expression. This means a real respect for the thing in front of him, expressed in terms of chiaroscuro (color and photography having nothing in common) through a range of almost infinite tonal values which lie beyond the skill of human hand. The fullest realization of this is accomplished without tricks of process or manipulation, through the use of straight photographic methods. It is in the organization of this objectivity that the photographer's point of view toward Life enters in, and where a formal conception born of the emotions, the intellect, or of both, is as inevitably necessary for him, before an exposure is made, as for the painter, before he puts brush to canvas. The objects may be organized to express the causes of which they are the effects, or they may be used as abstract forms, to create an emotion unrelated to the objectivity as such. This organization is evolved either by movement of the camera in relation to the objects themselves or through their actual arrangement, but here, as in everything, the expression is simply the measure of vision, shallow or profound as the case may be. Photography is only a new road from a different direction but moving toward the common goal, which is Life.

Iris, Georgetown, Maine, 1928

Gelatin-silver print, 9½ x 7½ inches
The Family of Alice R. and Sol B. Frank

Laura Gilpin
American, 1891–1979

Gilpin created an unparalleled body of work as a female landscape photographer and as a cultural geographer. From her birthplace in Colorado Springs, she developed a dedication to the landscape and native people of the American Southwest. In 1916 she went to New York to attend the Clarence White School, returning in 1917 to open a commercial studio. Her first book, published in 1941, *The Pueblos: A Camera Chronicle*, was followed by many others. In 1946 she relocated to Santa Fe, New Mexico and began to focus on the Navaho Indians and the Canyon de Chelly region, supporting her project with portrait commissions and commercial assignments. This statement was originally published in the journal *Ninety-Eight-Six*, in May 1928.

Since the invention of the [K]odak, photography has become immensely popular. And here lies one grave danger. Everybody thinks it is easy! Two well known advertisements have not in the least helped matters. "It's all in the lens" and "You push the button we do the rest" sound marvelous. But—is it all in the lens? The quickest answer to this would be to show you some wonderful examples of pin hole photography when the negatives were made without any lens at all, just a fine needle hole in a piece of black paper. After all is said and done it isn't what kind of a lens or camera you have, it is what kind of a picture you make with that lens and camera. This requires much thought, much study, much knowledge. It has often been said that the camera is a machine therefore its results must be mechanical. This is far indeed from the truth. The photographer makes his negative not with his hand but with his brain. As a matter of fact there is nothing so extremely sensitive as the camera. It can record the greatest delicacies of line and tone, and in portraiture the most subtle expressions. When photography gains artists who are equally sensitive, are skilled in their technique, and big in their perceptions, then we will have monumental works of art.

Every great work of art is fundamentally a fine design in its arrangement of light and dark, of line and form. All of us are sensitive to this, some of [us] consciously, some unconsciously. The photographer can arrange his picture just as the painter does, only sometimes he must go about it in a different way. The greatest tool at our command is the very thing that IS photography. LIGHT. Light is our paint brush and it is a most willing tool in the hands of the one who studies it with sufficient care. It seems to me that too often this all important factor of our work is overlooked. Choosing the right light for a given subject is vital to the success of your picture. Failing to do this, you simply have a record of facts. These are the elements of your photograph and on them rests your success, the lighting you choose, and the way you arrange your masses of dark and light tones on the plate.

Then we come to the making of the print, skipping momentarily the intermediate technical step of developing the negative. The highest ideals of a print are one of quality. Quality of tone, of texture…. One of the great allurements of photography is the many different kinds of printing processes from which we may choose. You can take the same negative and secure a half a dozen different effects by the use of a different process…. In fact one of the greatest problems is finding time to do all the many interesting things there are to do in this work.

Bryce Canyon #2, 1930

Platinum print, 9¼ x 7¼ inches
The Family of Alice R. and Sol B. Frank

Francis J. Bruguière
American, 1879–1945

Although his earliest works reveal a Pictorialist heritage, Bruguière was an instrumental catalyst in the acceptance of photography as a modern art form. He began his career as a studio portraitist in San Francisco in 1906, but after travels to Europe in 1912 and 1913, he soon recognized the abstract possibilities of photography. In the late 1920s Bruguière created a group of images called light abstractions, which captured the effects of light cast onto cut paper patterns. These images and others helped to establish Bruguière as an important contributor to the development of American Surrealism. In this 1935 statement written for *Modern Photography Annual*, Bruguière speaks of creating his own subject matter:

The application of design to the photograph is entirely in the hands of the photographer. It means that he must be equipped both technically and aesthetically. The photographer ultimately will have to be trained with as much care as those who practice the other arts. It will not be a haphazard pursuit as it is now, but will depend on the creative capabilities of the individual. Photography is not easily mastered. One's attitude to it should be one of continual questioning and dissatisfaction. Its progress depends on striving to preserve it from easy pitfalls....

It is possible for photographers to make or design objects that can be treated with light, thereby creating a world of their own which is in many ways as interesting as the visible, external world. The same laws of composition of light and shade and line govern this personal world, only it has not the so-called aspect of nature that is termed documentary.

By many practitioners of photography it is not considered "legitimate" to create a personal world: they limit the photograph to the documentary, and seem to be satisfied that it shall remain a document for ever. Human beings like to think of things in secure and proper places, to which they alone hold the key; if anyone tampers with the lock, he is a pariah! I have seen it stated by well-known photographers, and heard it from their own lips, that the photograph must be exactly the document they have defined, and that nothing else must exist in the medium!...

In making subjects of my own, I have used paper-cut designs brought into low relief, and lit, generally, by one small spot lamp of 250 watts: the same lamp has been placed in different positions through a series of exposures. The field is not limited to paper; any plastic material will answer the purpose. Then you can have the pleasure of making your own "unnatural" world, to which it is not unpleasant to return if you are a photographer, and have been working daily with fashions, portraits, or advertising!

Cut-Paper Abstraction, 1927

Gelatin-silver print by George Tice, 1977, 7⅜ x 9⅜ inches
Gift of George A. Tice, 91.85.3

Man Ray (Emmanuel Radnitsky)
American, 1890–1976

Just as Man Ray was influenced by his associations with Duchamp, Dadaism, Cubism, and Surrealism, so were his own artworks difficult to categorize. He made photographs, film, paintings, and found-object sculptures with interchangeable fluency and innovative skill. Within photography, his series of "Rayograms"—objects placed on photographic paper and exposed to light—and solarized portraits distinguished him as one of the medium's unique, iconoclastic talents. His most significant work was created while living in Paris in the 1920s and 1930s. In 1931, a French electric company commissioned him to create a portfolio of Rayograms promoting the use of their product. Entitled "Électricité," the portfolio contained ten photogravure plates in an edition of 500. This excerpt is from "Photography is Not Art," published in the book *Man Ray Photographs*.

I ask you, how can we ever get together on the question of beauty? This dilemma fortunately no longer troubles a self-respecting Artist. In fact, to him the word beauty has become a red rag, and with reason. I am not being sarcastic, but mean it in all sincerity, when I say that the Artist even when copying another, works under the illusion that he is covering ground which he imagines no one has covered before him. He is then necessarily discovering a new beauty which only he can appreciate, to begin with. (In this respect he really returns to nature, because he employs her time-honored mode of repetition, unconsciously. Only the desire to make a permanent work is conscious.) Aside from this, *the success with which the Artist is able to conceal the source of his inspiration, is the measure of his originality*. The final defense is, of course, "I paint what I like," meaning he paints what he likes most, or he paints that which he fears, or which is beyond his attainments, in the hope of mastering it....

It was a mere hazard that photography began with the black-and-white image, perhaps it was even fortunate for the possibilities of a new art, or that a new art might become possible. The violent attacks by painters on photography were mitigated by its lack of color of which they still had the monopoly, and they could afford a certain indulgence. Just as in writing, "l'humeur noir" had been considered the bastard child, a new black-and-white graphic medium could never be feared as a serious competitor. But, if this humor should assume all the colored facets of a serious form, like the present discourse, or if a photograph should break out into all the colored growths accessible to the painter, then the situation would indeed become serious for the exclusive painter. Then the danger of photography becoming a succeeding art, instead of simply another art, would be imminent.

Or rather, the danger of photography becoming simply Art instead of remaining AN art. To complete this result, a little research and some determination could prove that whatever was possible in the plastic domain, was equally feasible in the optical domain. The trained human eye, guiding one of glass, could capture as wide a field as had been controlled by a more or less trained hand guided by a half closed eye.

To conclude, nothing is sadder than an old photograph, nothing so full of that nostalgia so prized by many of our best painters, and nothing so capable of inspiring us with that desire for a true Art, as we understand it in painting. When photography will have lost that sourness, and when it will age like Art or alcohol, only then will it become Art and not remain simply AN art as it is today.

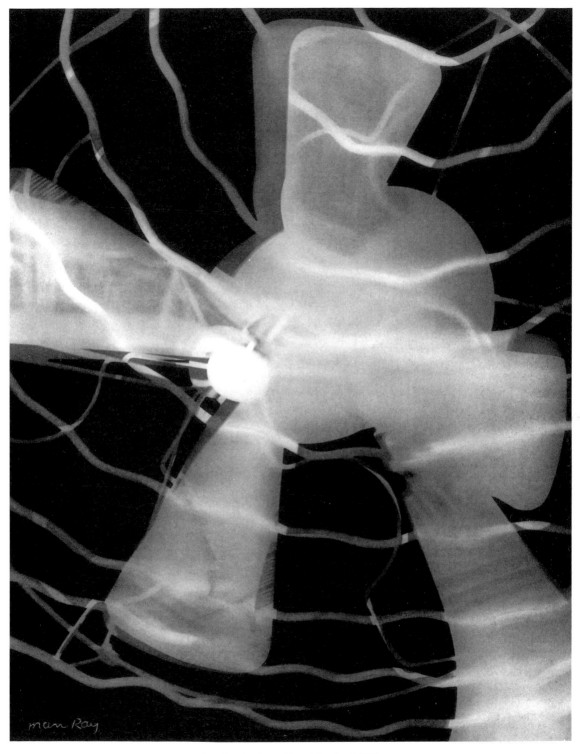

Le Souffle, from *Electricite*, April 1931

Photogravure, 10¼ x 8 inches
The Family of Alice R. and Sol B. Frank

László Moholy-Nagy
American (b. Austria-Hungary), 1895–1946

Although he didn't commonly refer to himself as a photographer (he was also involved in painting, sculpture, film, typography, graphic and stage design), Moholy-Nagy influenced both the practice and the conception of the medium. His photography explored new perspectives through the use of both high and low viewpoints and experimental methods of collage and montage. He was also active as a theoretician and in 1923 joined the faculty of the German Bauhaus in Berlin. In 1937 he immigrated to Chicago to become director of the New Bauhaus school which in 1944 became the Institute of Design in Chicago. This statement is from a much longer text entitled "From Pigment to Light" originally published in *Telehor* in 1936. It is entitled "The New Vision."

All interpretations of photography have hitherto been influenced by the aesthetic-philosophic concepts that circumscribed painting. These were for long held to be equally applicable to photographic practice. Up to now, photography has remained in rather rigid dependence on the traditional forms of painting; and like painting it has passed through the successive stages of all the various art "isms"; though in no sense to its advantage. Fundamentally new discoveries cannot for long be confined to the mentality and practice of bygone periods with impunity. When that happens all productive activity is arrested. This was plainly evinced in photography, which has yielded no results of any value except in those fields where, as in scientific work, it has been employed without artistic ambitions. Here alone did it prove the pioneer of an original development, or of one peculiar to itself.

In this connection it cannot be too plainly stated that it is quite unimportant whether photography produces "art" or not. Its own basic laws, not the opinions of art critics, will provide the only valid measure of its future worth. It is sufficiently unprecedented that such a "mechanical" thing as photography, and one regarded so contemptuously in an artistic and creative sense, should have acquired the power it has, and become one of the primary objective visual forms, in barely a century of evolution. Formerly the painter impressed his own perspective outlook on his age. We have only to recall the manner in which we used to look at landscapes, and compare it with the way we perceive them now! Think, too, of the incisive sharpness of those camera portraits of our contemporaries, pitted with pores and furrowed by lines. Or an airview of a ship at sea moving through waves that seem frozen in light. Or the enlargement of a woven tissue, or the chiseled delicacy of an ordinary sawn block of wood. Or, in fact, any of the whole gamut of splendid details of structure, texture, and "factor" of whatever objects we care to choose.

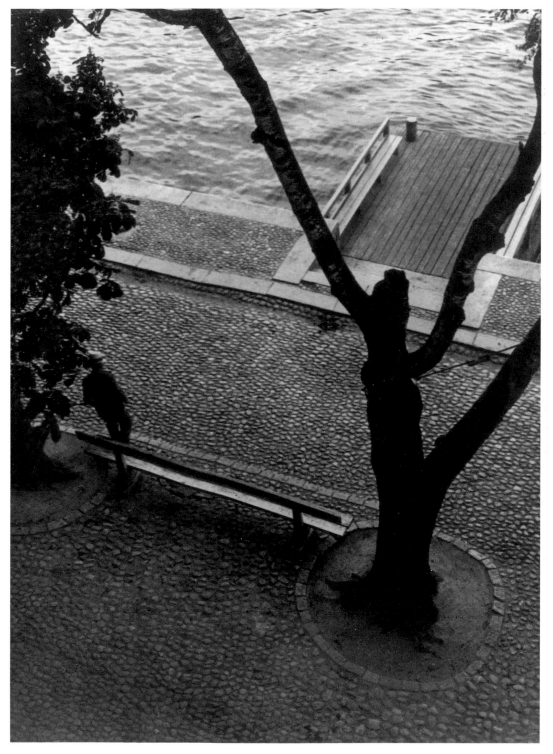

Waterfront, Turku, Finland, early 1930s

Gelatin-silver print, 9¼ x 7 inches
The Family of Alice R. and Sol B. Frank

Germaine Krull
German (b. Poland), 1897–1985

Krull studied in both Paris and Munich, and received her M.A. in photography in 1918. After operating her own studio and doing freelance photography in Holland and Germany in the early 1920s, Krull settled in Paris from 1924 to 1932 where she made her reputation documenting industrial architecture and machinery. During this period she also shot fashion and advertising work and created numerous portraits of her friends, including Colette and Jean Cocteau. Over the course of her long career Krull traveled widely throughout Europe and Asia and published her photographs in over twenty books. This statement, entitled "Thoughts on Art," is from a 1931 monograph, *Photographes Nouveaux: Germaine Krull.*

Photography is an artisan's field of work. A métier for which one shows more or less talent, like all craftsmanship.

Art is found in all métiers done well because art is a choice.

The most important skill of the photographer is to know how to see. Yes, one sees through one's eyes, but the same world seen through different eyes is no longer the same world; it's the world seen through that individual's eye. With just one click, the lens captures the exterior world at the same time as it captures the photographer's inner world.

The lens is designed more efficiently than the human eye. It therefore has the ability to see the world in a better light, or in a different light, which is its true function and is a pretty good one. Every new angle offers the world multiple reflections on itself.

The camera need not invent, manipulate, or fool. It does not paint, nor does it imagine. The photographer is a witness, the witness of his time. The true photographer is the witness of the everyday; he reports. That his eye does not always focus on what he sees three feet above ground is natural. But that he focuses consistently on the ground, on today's ground, on this morning's ground, on this Thursday morning's ground, or on the ground of this day so beautiful that he forgets what day it is. The world. The world of his time. And man, who has become nothing more than yet another mobile object in his world and in his time. And man, who is morally identical throughout time.

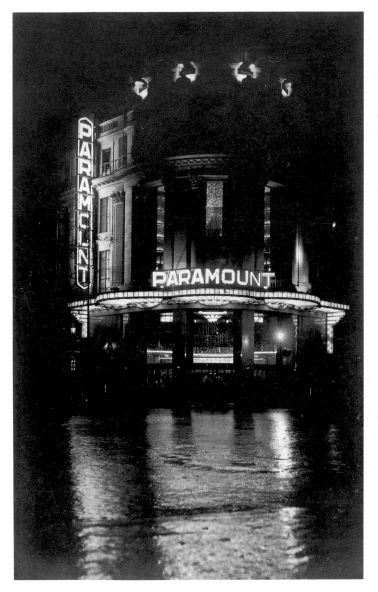

La Cinéma Paramount, Paris, ca. 1930

Gelatin-silver print, 5⅜ x 3½ inches
Horace W. Goldsmith and Art Purchase Funds, 95.15.1

Walker Evans
American, 1903–1975

Evans was responsible for the emergence in 1930s American photography of a new, more literary and less dramatic conception of documentary description. Drawing upon the work of Atget, Evans made head-on, highly detailed images of Americans and the material manifestations of their indigenous cultures. He was employed by the Farm Security Administration from 1935 to 1937, and in 1938 published his now classic book, *American Photographs* in conjunction with a solo exhibition at the Museum of Modern Art, New York. During the summer of 1936 he photographed an Alabama sharecropper's family that resulted in a 1941 collaborative book with James Agee entitled, *Let Us Now Praise Famous Men*. Other important books included photographs for Carleton Beals's *The Crime of Cuba*, 1933, and images of New York subway riders entitled *Many Are Called*, 1966; he additionally photographed for *Time* and *Fortune* magazines from 1943 to 1965.

It's logical to say that what I do is an act of faith. Other people might call it conceit, but I have faith and conviction. It came to me. And I worked it out. I used to suffer from a lack of it, and now that I've got it I suppose it seems self-centered. I have to have faith or I can't act. I think what I am doing is valid and worth doing, and I use the word *transcendent*. That's very pretentious, but if I'm satisfied that something transcendent shows in a photograph I've done, that's it. It's there, I've done it. Without being able to explain, I know it absolutely, that it happens sometimes, and I know by the way I feel in the action that it goes like magic—this is it. It's as though there's a wonderful secret in a certain place and I can capture it. Only I can do it at this moment, only this moment and only me. That's a hell of a thing to believe, but I believe it or I couldn't act. It's a very exciting, heady thing. It happens more when you're younger, but it still happens, or I wouldn't continue. I think there is a period of esthetic discovery that happens to a man and he can do all sorts of things at white heat. Yeats went through three periods. T.S. Eliot was strongest in his early period, I think. E.E. Cummings seemed to go on without losing much. After all, poetry is art and these fields are related. It's there and it's a mystery and it's even partly mystical and that's why it's hard to talk about in a rational, pragmatic society. But art goes on…. The unappreciated artist is at once very humble and very arrogant too. He collects and edits the world about him. This is especially important in the psychology of camera work. This is why a man who has faith, intelligence, and cultivation will show it in his work. Fine photography is literate, and it should be. It does reflect cultivation if there is cultivation. This is also why, until recently, photography has had no status, as it's usually practiced by uncultivated people. I always remember telling my classes that the students should seek to have a cultivated life and an education: they'd make better photographs. On the other hand, Eugène Atget was an uneducated man, I think, who was a kind of medium, really. He was like Blake. His work sang like lightning through him. He could infuse the street with his own poetry, and I don't think he even was aware of it or could articulate it. What I've just been saying is not entirely true. Since I'm a half-educated and self-educated man, I believe in education. I do note that photography, a despised medium to work in, is full of empty phonies and worthless commercial people. That presents quite a challenge to the man who can take delight in being in a very difficult, disdained medium.

Untitled, ca. 1930

Gelatin-silver print, 4⅝ x 3 inches
The Family of Alice R. and Sol B. Frank

Doris Ulmann
American, 1882–1934

While drawn to subject matter of a documentary nature, Ulmann's consistent use of a soft focus reflects her roots in the Pictorialist aesthetic. Although a well-known portraitist of literary and medical figures, Ulmann's interest in preserving isolated cultures compelled her to travel in the 1920s throughout the rural areas of the Appalachian region. A later project to photograph African Americans in the South resulted in the book *Roll, Jordan, Roll* (1933), which discusses the lives of the Gullah people of South Carolina. Ulmann discussed her relationship with her sitters in a 1930 interview with Dale Warren, which was published in the literary periodical, *The Bookman*. This excerpt reveals Ulmann's technique of connecting with those she photographed:

The faces of men and women in the street are probably as interesting as literary faces, but my particular human angle leads me to men and women who write. I am not interested exclusively in literary faces, because I have been more deeply moved by some of my mountaineers than by any literary person, distinguished as he may be. A face that has the marks of having lived intensely, that expresses some phase of life, some dominant quality or intellectual power, constitutes for me an interesting face. For this reason, the face of an older person, perhaps not beautiful in the strictest sense, is usually more appealing than the face of a younger person who has scarcely been touched by life....

Men are usually less self-conscious and women often have preconceived notions of how they want to look. However, if a man is self-conscious he is a hundred times worse than the most self-conscious woman. Whenever I am working on a portrait, I try to know the individuality or real character of my sitter and, by understanding him, succeed in making him think of the things that are of vital interest to him. My best pictures are always taken when I succeed in establishing a bond of sympathy with my sitter. When there is the slightest suggestion of antagonism, then my best efforts are of no avail....

I see my finished print in the proof.... But I cannot expect others to see anything beyond what the proof presents. I avoid retouching, but prints always require spotting before they are ready. I believe that I become better acquainted with my sitter while working at the pictures, because the various steps provide ample time for the most minute inspection and contemplation. Sometimes I wonder about thought transference. If it exists, my patients must sense my preoccupation when I think intensely of them while working on their portraits.

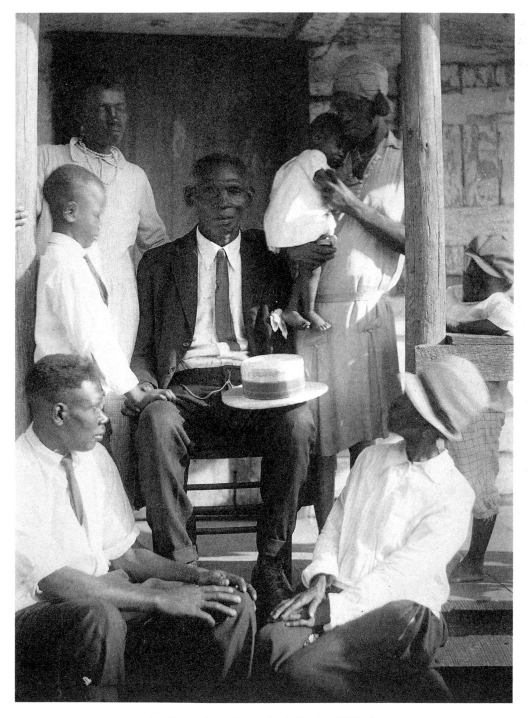

The Preacher's Family, South Carolina, 1929–31

Platinum print, 8⅛ x 6⅛ inches
Horace W. Goldsmith Fund, 84.176

August Sander
German, 1876–1964

Sander's portraits were intended to provide a cross-section of German society during the 1920s. His book *Antlitz der Zeit* (Face of our Time, 1929) was the first volume of an extended series which provided an exhaustive catalog of all classes and types in Germany; however, his factual documentation contradicted the Aryan ideals of the rising Nazi Party, and his book *Antlitz der Zeit* was banned in the early 1930s. This statement comes from an essay written in 1927 to formally announce Sander's project, "People of the Twentieth Century." The occasion was an exhibition of modern painting, sculpture, and photography in the Cologne Kunstverein.

I am often asked how I came upon the idea of creating this work: Look, Observe and Think and the question is answered. Nothing seemed more appropriate to me than to render through photography a picture of our times which is absolutely true to nature. Every period of the past has left us documents and books with pictures, but photography has given us new possibilities and different problems from painting. It can reproduce things with impressive beauty, or even with cruel accuracy, but it can also be outrageously deceptive. In order to see truth we must be able to tolerate it, and above all we should pass it down to our fellow men and to posterity, whether it is in our favour or not. If I, as a normal person, can be so immodest as to see things as they are and not as they should or could be, please forgive me, but I cannot do otherwise. I have been a photographer for thirty years, and have devoted myself to photography with all seriousness. I have been down good paths and bad and I have acknowledged my mistakes. The exhibition in the Cologne Kunstverein is the result of my quest and I hope I am on the right path. I hate nothing more than sugary photographs with tricks, poses and effects. So allow me to be honest and tell the truth about our age and its people.

Businessman, Linz, Rhine, 1930

Gelatin-silver print, 9⅛ x 6¾ inches
The Family of Alice R. and Sol B. Frank

Brassaï (Gyula Halász)
French (b. Transylvania), 1899–1984

American writer Henry Miller christened Brassaï "the eye of Paris," and his images of street and night life, populated with underworld and underground characters, do indeed epitomize that darkly romantic capital of the 1930s. After studying art, Brassaï moved to Paris in 1924 and supported himself as a journalist. He was encouraged by his friend André Kertész to take up photography after finding painting lacking in immediacy. Brassaï associated with the Surrealists, and his book *Paris de Nuit* (1933) has become a classic example of personal, interpretive documentation. Brassaï wrote of his experiences photographing for that book:

During my first years in Paris, beginning in 1924, I lived at night, going to bed at sunrise, getting up at sunset, wandering about the city from Montparnasse to Montmartre. And even though I had always ignored and even disliked photography before, I was inspired to become a photographer by my desire to translate all the things that enchanted me in the nocturnal Paris I was experiencing. So *Paris de Nuit*, published in 1933, was born....

The real night people, however, live at night not out of necessity, but because they want to. They belong to the world of pleasure, of love, vice, crime, drugs. A secret, suspicious world, closed to the uninitiated. Go at random into one of those seemingly ordinary bars in Montmartre, or into a dive in the Goutte-d'Or neighborhood. Nothing to show they are owned by clans of pimps, that they are often the scenes of bloody reckonings. Conversation ceases. The owner looks you over with an unfriendly glance. The clientele sizes you up: this intruder, this newcomer—is he an informer, a stool pigeon? Has he come in to blow the gig, to squeal? You may not be served, you may even be asked to leave, especially if you try to take pictures.... And yet, drawn by the beauty of evil, the magic of the lower depths, having taken pictures for my "voyage to the end of night" from the outside, I wanted to know what went on inside, behind the walls, behind the façades, in the wings: bars, dives, night clubs, one-night hotels, bordellos, opium dens. I was eager to penetrate this other world, this fringe world, the secret, sinister world of mobsters, outcasts, toughs, pimps, whores, addicts, inverts. Rightly or wrongly, I felt at the time that this underground world represented Paris at its least cosmopolitan, at its most alive, its most authentic, that in these colorful faces of its underworld there had been preserved, from age to age, almost without alteration, the folklore of its most remote past.

Une Fille de Joie, Boulevard Rochechouart, Montmartre, 1932

Gelatin-silver print, 8⅞ x 6⅞ inches
The Family of Alice R. and Sol B. Frank

Henri Cartier-Bresson
French, 1908–2004

Cartier-Bresson's spontaneous photographs, cross-sections of life framed with a hand-held camera, embody his concept of "the decisive moment"—images made in a fraction of an instant that would otherwise be unobserved. Although he was a founder of the cooperative photojournalistic agency Magnum (1947), his work in China, India, France, the United States, and elsewhere is concerned more with a singular photographic beauty than with specific reportage. His photographs have been reproduced in virtually all of the major magazines. Cartier-Bresson has also been deeply interested in painting and film and has pursued these media along with his influential photography. This statement is from the introduction to Cartier-Bresson's 1952 book *The Decisive Moment*:

The photographer's eye is perpetually evaluating. A photographer can bring coincidence of line simply by moving his head a fraction of a millimeter. He can modify perspectives by a slight bending of the knees. By placing the camera closer to or farther from the subject, he draws a detail—and it can be subordinated, or he can be tyrannized by it. But he composes a picture in very nearly the same amount of time it takes to click the shutter, at the speed of a reflex action.

Sometimes it happens that you stall, delay, wait for something to happen. Sometimes you have the feeling that here are all the makings of a picture—except for just one thing that seems to be missing. But what one thing? Perhaps someone suddenly walks into your range of view. You follow his progress through the view-finder. You wait and wait, and then finally you press the button—and you depart with the feeling (though you don't know why) that you've really got something. Later, to substantiate this, you can take a print of this picture, trace on it the geometric figures which come up under analysis, and you'll observe that, if the shutter was released at the decisive moment, you have instinctively fixed a geometric pattern without which the photograph would have been both formless and lifeless.

Composition must be one of our constant preoccupations, but at the moment of shooting it can stem only from our intuition, for we are out to capture the fugitive moment, and all the interrelationships involved are on the move. In applying the Golden Rule, the only pair of compasses at the photographer's disposal is his own pair of eyes. Any geometrical analysis, any reducing of the picture to a schema, can be done only (because of its very nature) after the photograph has been taken, developed, and printed—and then it can be used only for a post-mortem examination of the picture. I hope we will never see the day when photoshops sell little schema grills to clamp onto our viewfinders; and the Golden Rule will never be found etched on our ground glass.

If you start cutting or cropping a good photograph, it means death to the geometrically correct interplay of proportions. Besides, it very rarely happens that a photograph which was feebly composed can be saved by reconstruction of its composition under the darkroom's enlarger; the integrity of vision is no longer there. There is a lot of talk about camera angles; but the only valid angles in existence are the angles of the geometry of composition and not the ones fabricated by the photographer who falls flat on his stomach or performs other antics to procure his effects.

Seville, Spain, 1933

Gelatin-silver print, 1940s, 9¾ x 14½ inches
Purchase, in memory of Alice R. and Sol B. Frank, 2002.12

Bill Brandt
English, 1904–1983

After studying with Man Ray in Paris in 1931, Brandt moved to England and, over the next forty years, created a singular body of work that has identified him as one of Britain's most important photographers of the twentieth century. Brandt's moody, evocative landscapes, portraits, and domestic tableaux reveal a unique sensibility imbued with inventive and iconoclastic romanticism. Although best known for his documentation of the stark social contrasts in Britain between the World Wars he also created innovative surrealistic nude studies that resulted in a book published in 1961 as *Perspective of Nudes*. In his 1948 book, *Camera in London*, Brandt delivered his Photographer's Credo:

I did not always know just what it was I wanted to photograph. I believe it is important for a photographer to discover this, for unless he finds what it is that excites him, what it is that calls forth at once an emotional response, he is unlikely to achieve his best work. For me it was not easy. Simply because my response was so much a matter of instinct that consciously I could not formulate it. In fact I did not try to do so. I now have through experience a more conscious knowledge of what it is that excites me—or would it be more exact to say of what does not excite me? Yet instinct itself should be a strong enough force to carve its own channel. Too much self-examination or self-consciousness about it or about one's aims and purposes may in the early stages be a hindrance rather than a help.

If his instinct did not guide him, either consciously or subconsciously, a photographer might work for years without experiencing the excitement of creative work with his camera. To discover what it is that quickens his interest and emotional response is particularly difficult for the photographer today because advances in technical equipment have made it possible to take such a wide variety of subjects under such varying conditions that the choice before him has become immense in its scope. The good photographer will produce a competent picture every time whatever his subject. But only when his subject makes an immediate and direct appeal to his own interests will he produce work of distinction....

It is part of the photographer's job to *see* more intensely than most people do. He must have and keep in him something of the receptiveness of the child who looks at the world for the first time or of the traveller who enters a strange country. Most photographers would feel a certain embarrassment in admitting publicly that they carried within them a sense of wonder, yet without it they would not produce the work they do, whatever their particular field. It is the gift of seeing the life around them clearly and vividly, as something that is exciting in its own right. It is an innate gift, varying in intensity with the individual's temperament and environment....

By temperament I am not unduly excitable and certainly not *trigger-happy*. I think twice before I shoot and very often do not shoot at all. By professional standards I do not waste a lot of film; but by the standards of many of my colleagues I probably miss quite a few of my opportunities. Still, the things I am after are not in a hurry as a rule. I am a photographer of London.

Parlormaid and Under-Parlormaid Ready to Serve Dinner, ca. 1933

Gelatin-silver print, 9 x 7¾ inches
The Family of Alice R. and Sol B. Frank

James E. Abbe
American, 1883–1973

During the 1920s and 1930s, James Abbe was among the best-known and most widely published photographers on the international scene. He photographed the most renowned theater and film celebrities, as well as the dictators of Europe. During his prime years, his reputation was such that *Vanity Fair* magazine nominated him to their "hall of fame" in February 1934. Working under the moniker "the tramp photographer," Abbe paved the way for today's freelance photojournalists by earning his living on the road making photographs, writing accompanying stories, and selling them to magazines and newspapers throughout the world. Based in Paris, Abbe traveled throughout Europe working for various magazines and newspapers such as the *Berliner Illustrirte Zeitung* in Germany, and *VU* in France. Traveling to Russia in 1928, and again in 1932, Abbe published a book of text and photographs entitled *I Photograph Russia* in 1935. Photographing Stalin was undoubtedly Abbe's biggest scoop, and the pictures were published in the newspapers and magazines of many countries.

Here I was inside the Kremlin, Communism's Holy of Holies, first foreign photographer ever to have an appointment with its forbidding recluse.

What would I find to say to him with my limited command of Russian? Should I address him as "Your Highness" as I once had the King of Sweden, or by his Christian name as I had Jack Dempsey when he was champion of the world?

Mr. Stalin—"Just call him Mr. Stalin," Neumann [Abbe's escort] advised....

There was nothing of the fanatic about him; his whole appearance registered strength. Pockmarks on his face reminded one he had fought a deadly disease and won, and somehow the pockmarks were becoming. In Russian, Stalin asked Neumann: "Why does he want to photograph me?" Then without waiting for an answer, turned back to me. "Scurry, scurry." Anna Pavlova had told me to "scurry, scurry" on occasion, but never had she expected me to get it over with in five minutes! My professional pride was stung. Indiscreetly, I exclaimed that I could hardly be expected in five minutes to photograph the man with a five-year plan to industrialize Russia. Stalin sensed the feeling behind my words and turned to Neumann for a translation. Luckily my feeble joke appealed to him; he offered me ten minutes. And, in fact, he wound up giving me twenty-five.

Stalin's eyes were impressive. My years of photo experience had persuaded me that the eyes are seventy-five percent of a face....

When I had jockeyed Stalin into position for my first shot, and set up my little Kodak on a tripod, I got an awful shock. The finder was missing from the side of the camera! I turned and bolted from the room. The finder must be in the adjoining office. Why I was not shot as an assassin making his getaway I will never know. But before such a thought could occur to anyone I had snatched up the finder and was back in Stalin's room. Stalin still sat where I had put him; over his head a portrait of Karl Marx, in front of him carafes, ink bottles, and cigarette boxes. As I hooked the finder to my camera, I murmured "A-a-h!" I can remember Stalin mimicking me, "A-a-h!" then laughing out loud. I waved Neumann aside and recorded Stalin for posterity.... I asked Stalin if I could release my photos without retouching. His answer was an amused "nitchevo" (it doesn't matter). Nor did he ask to see the proofs. He did, however, call my attention to the fact we had taken twenty-five minutes of his time. Quickly Neumann and I gathered up the litter of films, cameras, tripods and flash-lamps scattered all over the office. I volunteered to send him a set of photos, to which he politely said, "Spasibo" (thank you).

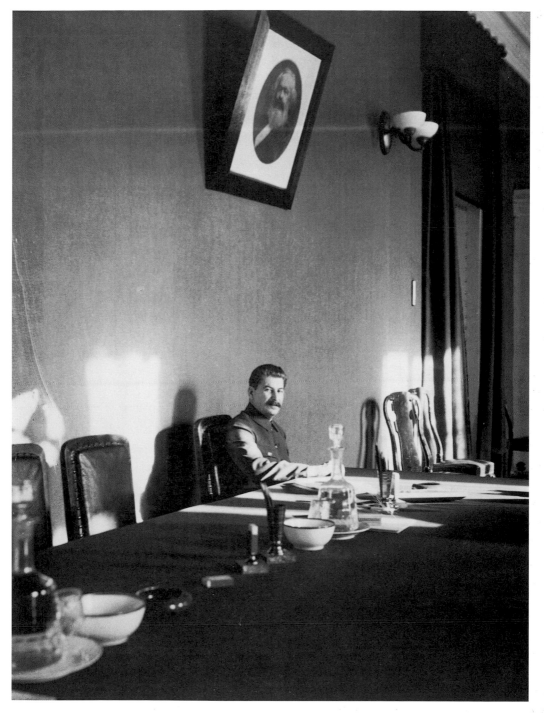

Joseph Stalin in the Kremlin, Moscow, April 13, 1932

Gelatin-silver print, 9¾ x 7¾ inches
Gift of Tilly Abbe for the Abbe Family, 2004.1

Roman Vishniac
American (b. Russia), 1897–1990

Although trained as a medical doctor, in 1933 Roman Vishniac embarked on a self-imposed mission to photograph the Jews living in Eastern Europe. His motivation was the belief—certainly unbelievable at the time—that the Nazis planned to eliminate all Jewish culture from Europe. By 1939 he had covered more than 5,000 miles in Poland, Ukraine, Czechoslovakia, Romania, Hungary, Latvia, and Lithuania. The photographs serve as an invaluable resource, documenting the lives of people who were soon to vanish from this earth.

From earliest childhood, my main interest was my ancestors. My Grandfather Wolf and my parents told me about the activities of my forefathers following the establishment of the Pale of Settlement by the pseudo-liberal tsarina, Catherine II. They told me of the restrictions against Jews, and how Nicholas I forced the conscription of Jewish boys with the intention of converting them to Christianity. My great-grandparents "bought" these child-soldiers from the Russian officers for the weekends and taught them how to remain Jews. By doing so, my great-grandparents were risking persecution and exile to Siberia, but they persisted.

My own activities began when I was eighteen, early in the First World War. The Jews of the Pale who resided in the battle zone were declared German spies and were forcibly transported to the Russian interior in cattle cars, without food or water, and without any provision for housing once they arrived. Together with a few other Jewish students— I was in medical school at the time—I collected money in Jewish communities and tried to save these unjustly accused Jews. Hundreds of thousands were affected, and thousands died. This was but a prelude to what was to come two decades later.

I was living in Germany in the thirties, and I knew that Hitler had made it his mission to exterminate all Jews, especially the children and the women who could bear children in the future. I was unable to save my people, only their memory.

None of my colleagues was ready to join me. Rather, they warned me of the danger and called my project impossible. A man with a camera was always suspected of being a spy. Moreover, the Jews did not want to be photographed, due to a misunderstanding of the prohibition against making graven images (photography had not been invented when the Torah was written!). I was forced to use a hidden camera, and there were other problems as well. The technical aspects of photography were in their infancy. The sophisticated cameras of today were, of course, not available then. My means were meager, but my will was unbreakable. I was thrown into prison, but still I persisted.

During my journeys, I took over sixteen thousand photographs. All but two thousand were confiscated and, presumably, destroyed—although perhaps they will reappear someday. I hope my photographs enable the reader to envision a time and place that are worthy of remembrance.

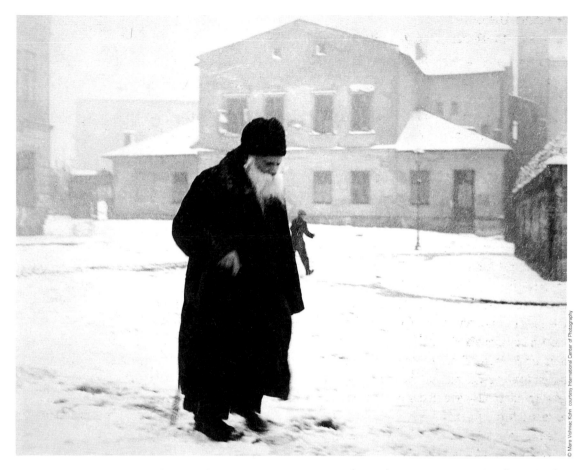

A Square in Kazimierz, Cracow, 1936–39

Gelatin-silver print, 11 x 13⅝ inches
Purchase, gift of Dr. and Mrs. Paul A. Mansheim, Mr. and Mrs. Richard M. Waitzer, Mr. and Mrs. Arthur Diamonstein,
Mr. and Mrs. Arnold S. Goldin, Mr. and Mrs. Paul O. Hirschbiel, Mr. and Mrs. Arnold McKinnon, Mr. and Mrs. David R. Goode,
Mr. Calvin Childress and Ms. Lydia Martin, Anonymous, Norfolk Southern Foundation, and in memory of Alice R. and Sol B. Frank, 2003.1

Hans Bellmer
German, 1902–1975

A technical artist and graphic designer, Bellmer merged the detail-orientation of these disciplines with a fantasy realm derived from childhood escapism and the darkly Expressionist art and theater of early 1930s Europe. In Germany, 1933 saw the ascendancy of the Nazi party to power; it was also the year that Bellmer began to create and photograph a bizarre series of dolls, entitled "poupée." The contorted dolls were his political statement in opposition to the ideal of the perfect human as espoused by the Nazis. In 1934, Bellmer self-published his first book of ten photographs entitled *Die Puppe* (The Doll). Emigrating to Paris in 1938, Bellmer affiliated himself with the Surrealist movement, and his images were often used as illustrations in Surrealist publications. In a 1962 edition of *Die Puppe*, Bellmer outlined his theories for this style of working:

Like everyone, I was born with a very pronounced need for "comfort," for a paradisiacal and limitless indolence. But limits were very quickly laid down for me, in the form of "father" and a little later in the form of "policeman." Beyond the warm and delicate presence of my mother, there was the hostile masculine authority: the enemy, the frustrator (detainer) of power....

The body is like a phrase that invites us to disjoint it (to pull it apart), so that it can be recomposed through an infinite series of anagrams [which is] its true content...an artificial woman of anatomical possibilities [which are] capable of reshaping the giddiness of passion into the invention of desire....

Like the gardener who compels the boxwood to take the shape of a ball, cone, cube, so man imposes on the image of woman his elementary certainties, the geometric and algebraic habits of his thought.

La Poupée, 1935

Gelatin-silver print, 9¾ x 9⅜ inches
The Family of Alice R. and Sol B. Frank

John Gutmann
American (b. Germany), 1905–1998

Originally a painter, Gutmann claimed to be a photojournalist in 1933 in order to escape the German government under Hitler. Upon his arrival in the U.S., Gutmann photographed scenes of everyday life during the devastation of the Depression, as well as other troubling episodes in American history, including the National Guard occupation of San Francisco during the General Strike of 1934. Between 1940 and 1962 Gutmann's photographs were published in many magazines and periodicals, including *Life*, *Time*, and *National Geographic*. The following text, selected by the artist, is excerpted from a 1983 interview and from a statement written by Gutmann in 1979 in which he discusses how the interpretation of photographs is often open-ended at best:

Content to me is very important, but I like it when [the photograph] is also enigmatic. If you don't know what it is you begin to speculate, and that is what I want. I want people to be interested in my pictures, to say: "What does it mean? Is there anything else?" And I don't feel there are any absolutes in life…. In my philosophy in life, everything is related to something else. Every experience is relative…which I find very exciting, because of the contrasts and affinities….

Titles or captions are important to me. I try to either state a fact of reality, give information to the curious viewer or direct attention to what the picture means to me. As a rule I do not like to explain my photographs. I want my pictures to be read and explored. I believe a good picture is open to many individual (subjective) associations. I am usually pleased when a viewer finds interpretations that I myself had not been aware of. I believe that some of my best images have this ambiguity which is an essence of life. In this sense I am not interested in trying desperately to make Art but I am interested in relating to the marvelous extravagance of Life.

Omen, San Francisco, 1934

Gelatin-silver print, 13 x 10⅜ inches
Purchase, 81.193

Arthur Rothstein
American, 1915–1985

Rothstein began a long and prolific career in photojournalism as the first photographer hired by Roy Stryker to document the effects of the Depression for the Farm Security Administration. Rothstein's first assignment for the FSA was to photograph people who were being relocated from an area that was to become the Shenandoah National Park in Virginia. Between 1935 and 1940, Rothstein traveled to the South and the West, recording daily life in rural America. During World War II Rothstein worked for the U.S. Office of War Information and the Army Signal Corps. In 1946 he became director of photography for *Look* magazine, and by 1971 held the same position at *Parade* magazine. In a 1985 exhibition catalogue, Rothstein commented on his assignments for the FSA. This passage is part of his commentary:

You see this man in his environment and by studying the picture a little bit you get to learn a great deal about the kind of complex personality that he is. He's not just an ordinary hillbilly postmaster— he's a man who reads books as you can see by the fact that there are several books on the table as well as the one he has in his hand. He also is a religious man—you can see that by the sign "As Christ is the head of the house, the unseen guest at every meal, the silent listener to every conversation" and also he obviously has either traveled to Europe or he is familiar with places in Europe because he has a large picture of the Colosseum of Rome above the table on the wall. But then there is a frivolous side to his nature which is indicated by the coy picture of a half clad beautiful young lady hanging behind him on the wall with a party wreath thrown over it. He obviously is a man who knows how to have fun. And this man who seems to be a small town postmaster is really a complex person and you learn all of that from studying this picture....

My technical problems resulted from long periods on location, the need for high quality, and maintenance of flexibility and mobility. My first camera was the Leica. I also used the Contax, Super Ikonta B, Rolleiflex, and Linhof. I used flashbulbs to illuminate the interiors of rural homes and barns. High aperture lenses on 35mm cameras stopped action and revealed poses, expressions, and scenes that had never been recorded before. The small unobtrusive cameras made photographs possible where complicated equipment would have created antagonism. My five years with the FSA were ones of change, evolution, tension, and sometimes, frustration and despair. They were active, exciting, creative, and stimulating. During these five years, I participated in an educational experience that has influenced my life ever since.

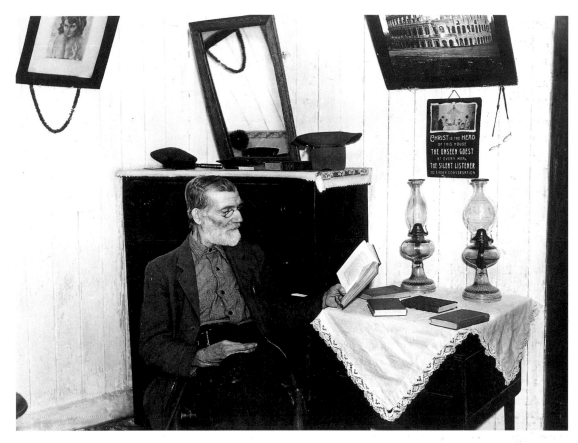

Home of Postmaster Brown, Old Rag, Virginia, Shenandoah National Park area, October 1935

Gelatin-silver print, 7⅜ x 9⅝ inches
Horace W. Goldsmith and Art Purchase Funds, 93.31.1

Marion Post Wolcott
American, 1910–1990

Wolcott took her first photographs in 1933. Not one to be deterred by gender bias, Wolcott firmly believed that women had made great strides but still faced "formidable hurdles." In 1935 she began freelancing for *Life, Fortune*, and the Associated Press, and in 1937 and 1938 Wolcott was staff photographer for the *Philadelphia Evening Bulletin*. From 1938 to 1941, Wolcott worked for the Farm Security Administration photographing government-sponsored programs for those suffering from the effects of the Depression. Throughout her life, she was interested in exposing social inequalities, and was the first FSA photographer to contrast images of the poor and wealthy classes as a way to inform the public of the dignity and courage of the underprivileged. In the following quote, Wolcott asserts the necessity of photography as a medium for social commentary: "Speak with your images from your heart and soul. Give of yourselves. Trust your gut reactions; Suck out the juices—the essence of your life experiences. Get on with it; it may not be too late." This passage elaborates on her feelings:

My formal education had focused on child psychology. Thus, when I moved to Washington to begin the FSA job, I brought with me, not only bags and baggage, but also a significant measure of experience that definitely influenced my work—my photographs. I had warm feelings for blacks, could communicate effectively with children, had deep sympathy for the underprivileged, resented evidence of conspicuous consumption, felt the need to contribute to a more equitable society....

As a documentarian in whatever medium, one cannot perform beyond her or his personal capacities, qualifications; of the individual's comprehension, based upon experience, research, and general ability to understand the subject and, most important, to empathize with the people directly and indirectly involved....

My principal concern is to challenge photographers to document, in mixed media if they wish, or even just record, in still photographs as well as film and video, our present quality of life, the causes of the present malaise in our society—and the world—the evidences of it. History, which will affect this and many generations, is being made, is right out there. A record of it might help, be useful in an old, new world....

Perhaps now, today, there is more opportunity for social commentary through photography because the scope of documentary photography has broadened, and the use of varied techniques to achieve the final image, or series of images, is widely accepted. It is no longer so controversial. It is accepted as Art. However, there are more photographers out there now who, in their earlier work, were acclaimed as Art photographers, who are focusing their cameras, eyes, talents, and interests on issues relevant to their sensitivity—contemporary issues—their special concerns aesthetically presented. Is it a symptom of a renewal of social consciousness? And, are they finally incorporating it into their concept of Art?

Biscuit Lady, a member of the Wilkins family making biscuits for dinner on corn shucking day at the home of Mr. and Mrs. Fred Wilkins, near Stem and Tallyho, North Carolina, 1939

Gelatin-silver print, ca. 1984, 8⅞ x 12 inches
Gift of Paul Messick Jones, 94.13

Margaret Bourke-White
American, 1904–1971

One of the first female photojournalists, Bourke-White's 1928 photographs of the Otis Steel Mill in Cleveland earned her a job as staff photographer at *Fortune.* In 1936, her image of Montana's Fort Peck Dam appeared on the cover of the first issue of *Life* where she was one of the original staff photographers. In 1936 and 1940 Bourke-White traveled through the South with writer Erskine Caldwell; their collaborative projects resulted in two books exploring rural life: *You Have Seen Their Faces* (1937) and *Say, Is This the U.S.A.?* (1941). Bourke-White wrote of these experiences in her 1963 autobiography, *Portrait of Myself,* from which the following reflections have been taken:

Whether he was aware of it or not, Erskine Caldwell was introducing me to a whole new way of working. He has a very quiet, completely receptive approach. He was interested not only in the words a person spoke, but in the mood in which they were spoken. He would wait patiently until the subject had revealed his personality, rather than impose his own personality on the subject, which many of us have a way of doing. Many times I watched the process through which Erskine became acquainted with some farmer and the farmer's problem.

Erskine would be hanging over the back fence, and the farmer would be leaning on his rake, the two engaged in what I suppose could be called a conversation—that is, either Erskine or the farmer made one remark every fifteen minutes. Despite the frugal use of words, the process seemed productive of understanding on both sides. While this interchange went on, I lurked in the background with a small camera, not stealing pictures exactly, which I seldom do, but working on general scenes as unobtrusively as possible. Once Erskine and a farmer had reached a kind of rapport, I could close in quite freely for portraits, and perhaps we would be invited into the tiny one-room sharecropper's home, which gave me a chance to photograph an interior.

Erskine had a gift, over and above the Southern tongue with which he was born, for picking up the shade and degree of inflection characteristic of the state in which we were working. His proficiency surprised me because he was uninterested in music. But in this he had a musician's ear. This was a useful talent in an area in which you are considered an alien and treated with appropriate distrust if you come from only as far away as across the state line. The people we were seeking out for pictures were generally suspicious of strangers. They were afraid we were going to try to sell them something they didn't want and fearful we were taking their pictures only to ridicule them. Reassuring them was a very important part of our operations, and a reassuring voice in their own mode of speech eliminated many a barrier. Of course, no amount of doctoring could disguise my mode of speech. I was unmistakably a Yankee, "down South on her vacation," Erskine would say. I could be labeled only as a foreigner, and sometimes I am afraid I acted like one....

I know of nothing to equal the happy expectancy of finding something new, something unguessed in advance, something only you would find, because as well as being a photographer, you were a certain kind of human being, and you would react to something all others might walk by. Another photographer might make pictures just as fine, but they would be different. Only you would come with just that particular mental and emotional experience to perceive just the telling thing for that particular story, and capture it on a slice of film gelatin...

Of course, I am at the very core a photographer. It is my trade—and my deep joy.

Lucky Stop Garage, 1936

Gelatin-silver print, 7¼ x 9⅝ inches
Purchase, gift of Alice Frank, 95.13

Ilse Bing
American (b. Germany), 1899–1998

During the 1930s, Ilse Bing was a pioneering avant-garde photographer in Paris, working for magazines such as *VU*, *Arts et Metiers Graphiques*, and *Le Monde Illustre* and shooting fashion for *Harper's Bazaar* and Schiaparelli. Working exclusively with a Leica, she was a pioneer in the use of the small handheld camera. In 1936, during a visit to New York, she declined an offer to work for *Life* magazine and instead returned to France to marry. In 1940, the Vichy government interned her and her husband as enemy aliens. A year later they immigrated to New York where she remained for the rest of her life. She was included in the Museum of Modern Art's first landmark exhibition of photography in 1937 as well as the Louvre's in 1936. This statement is drawn from her unpublished manuscript entitled, "The Camera as My Artistic Tool."

Not the fact that photography deals with reality, but the question of how an artist makes each picture deal with it, has always appeared to me the essential denominator in a photographer's work. Here is indeed where photography can elevate itself far beyond mechanical snapping. Here was my incentive to work in this art form. My goals were determined by the free choice regarding three of the constituents of all reality: Time, Space, and Chance. I recognized the possibility of combining them so that, instead of a blank statement, the result became an artistic message—that is, one in which the subject of the picture was made to relate to life in general....

The pointing out of differences in style should not lead to misunderstanding: I was always the same ME. Therefore, my work comprises essential permanent characteristics, and the whole of it bears, more or less latently, qualities of its different periods: features of my late work are integral parts of earlier photographs, and vice versa. New experiences made me change emphasis, and thus led to a new style. Yet, there was never a sudden break, only an evolution....

I must explain that when speaking of abstract composition, I do not refer to the Bauhaus style, in which an object can be used as a device to create a new shape leading away from the traditional nature of that object. The abstract I intend to show is inherent in the object itself, or lies in the natural position of different objects.

Historic events were not exclusively responsible for the change in me and my work. The place where we live also influences our approach to life. And, as I said before, all such influences operate with "delayed reaction." I lived in Paris before the War, and since 1941 I have lived in New York. Paris has that shimmery silver light, its streets are built so that they embrace everything, everyone in harmony. Walking in Paris, I feel roots growing from my feet down into the pavement. I feel part of my surroundings.

New York has a clear and differentiating light, which makes me see things in sharp detail. The streets in which I walk do not "integrate" me like the Paris streets; the architecture with its inhuman proportions makes me feel isolated and, as it were, living in a vacuum. Here I see the wonders of the world as if from inside a space capsule.

This shows in my photographs.

New York, The Elevated, and Me, 1936

Gelatin-silver print, 7³⁄₈ x 11 inches
Purchase, Walter P. Chrysler, Jr., Photography Fund, 2001.3

Berenice Abbott
American, 1898–1991

While living in Paris in the 1920s Abbott assisted the artist Man Ray and made portraits of the major literary and artistic figures of the time, including the great French photographer Atget just before his death. It is largely due to her efforts that his work came to public attention. Abbott brought Atget's uninflected documentary style to bear on New York City and from 1935 to 1938 she made some 300 negatives with an 8-x-10-inch view camera. She documented the rapidly changing architectural environment of both the old and the new New York City. The work was published in 1939 as *Changing New York*. This statement comes from Abbott's proposal to the Federal Arts Project of the Works Progress Administration which funded her project.

To photograph New York City means to seek to catch in the sensitive and delicate photographic emulsion the spirit of the metropolis, while remaining true to its essential fact, its hurrying tempo, its congested streets, the past jostling the present. The concern is not with an architectural rendering of detail, the buildings of 1935 overshadowing everything else, but with a synthesis which shows the skyscraper in relation to the less colossal edifices which preceded it. City vistas, waterways, highways, all means of transportation, areas where peculiarly urban aspects of human living can be observed, crowds, city squares where the trees die for lack of sun and air, narrow and dark canyons where visibility fails because there is no light, litter blowing along a waterfront slip, relics of the age of General Grant or Queen Victoria where these have survived the onward march of the steam shovel; all these things and many more comprise New York City in 1935 and it is these aspects that should be photographed.

It is important that they should be photographed today, not tomorrow; for tomorrow may see many of these exciting and important mementos of eighteenth- and nineteenth-century New York swept away to make room for new colossi. Already many an amazing and incredible building which was, or could have been, photographed five years ago has disappeared. The tempo of the metropolis is not of eternity, or even time, but of the vanishing instant. Especially then has such a record a peculiarly documentary, as well as artistic, significance. All work that can salvage from oblivion the memorials of the metropolis will have value. Something of this purpose has been carried out as the exigencies of a busy life and the physical difficulties of the undertaking have permitted, but more could be done with ample leisure to devote wholly to the project and with more systematic assistance.

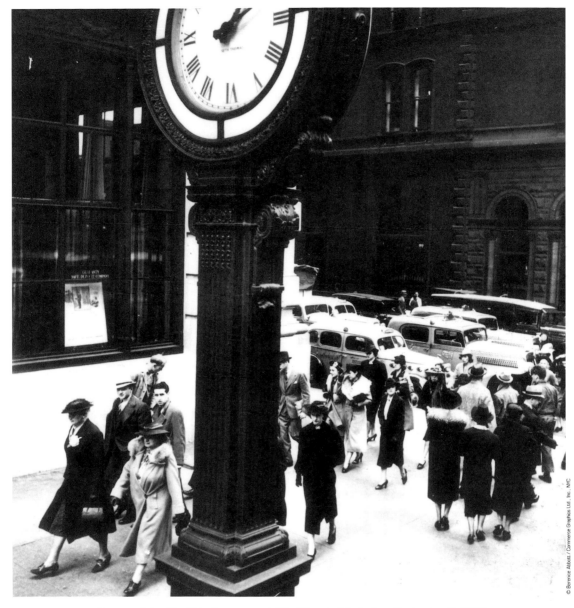

Tempo of the City, Fifth Avenue and 42nd Street, Manhattan, September 6, 1938

Gelatin-silver print, 8½ x 7¾ inches
The Family of Alice R. and Sol B. Frank

Barbara Morgan
American, 1900–1992

Originally trained as a painter, Morgan became interested in photography while teaching art at UCLA in the 1920s. She moved to New York and became an avid photographer in 1935, and throughout her career Morgan experimented with photomontage and abstraction. Best known for her dance photographs, Morgan became interested in this form of expression after observing American Indian dance rituals in the Southwest. This statement comes from a 1940 essay:

Americans dance not only with their feet and their bodies but with automobiles and airplanes. This delightful control of motion and transition of tempo gives dance sensations that are true to the American concept of freedom. Born into this love of space and movement, dance pioneers are distilling characteristic tempos and gestures out of modern life and building them into modern American dance forms. These movements are too thrilling and vital to lose, and as it is possible from the very nature of photography to capture the evanescent image of motion, I have undertaken the arduous, expensive, but engrossing work of photographing the dance.

Primarily, I am after that instant of combustion, when all the energies of the spirit are wonderfully coordinated with the action of the body. How to get that onto a negative! There is a photographic "no man's land" between a dancer's stage performance and the photographic expression of a dance that is hard to bridge. But to make a literal photograph of a dance in a bare documentary spirit is to come out empty-handed. A body in action may be calisthenics or sex appeal, but it is not necessarily dance. Something has to happen. The photograph must show an aesthetic state or the result is less than dance. On the flat, still, small rectangle of paper, how to create an illusion of a sculptural body impelled by certain emotions, moving in certain rhythmic tempo through space with convincing memorable beauty? To reach the good negative many bad ones are thrown out.

The most difficult, but also the most creative and exciting, part of dance photography is not so much the eventual picture as the groping and shaping toward a conception of what the picture ought to be. As one watches the rhythmic movements succeeding one another in time, they tend to merge in the memory—so that the memory of a dance is usually not made up of the literal moments of the dance. Therefore, to give the real essence of a dance or the real quality of a dancer, some sort of transformation has to take place before the "time" dance can become a "time-less" photograph. I have no formula for this.

Sometimes after seeing a dance in rehearsal and in performance I can visualize very clearly the photograph I want to make; the precise placing, the gradation of lights and darks, the entire expression. But when I try to execute these preconceived pictures they almost always end up as rigid lifeless images. My most fertile and rewarding manner of working is to be very familiar with the character of movement of a dancer and with the dance, until I automatically react to what is vital photographically, and reject what is insignificant. In this frame of mind, the dancer dances and always something happens which suggests a composition.

Finally, I am photographing the work of modern dancers as something organically American that must be preserved. Something as creatively of the generous American Spirit as Walt Whitman, and as inevitably a product of the forces of our continent as Rainbow Bridge or a sahuaro growing in the space of the desert.

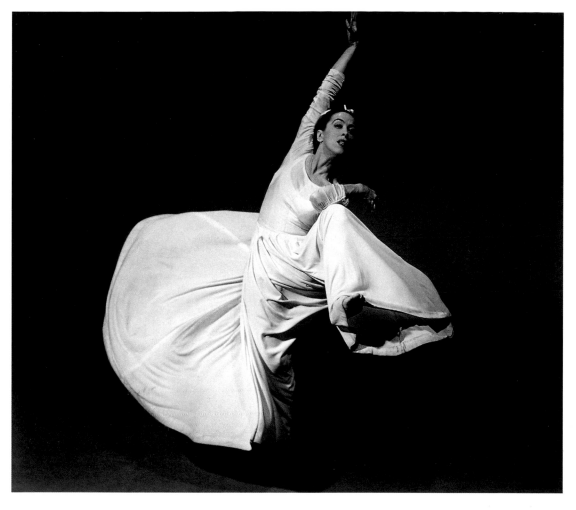

Martha Graham: Letter to the World, Swirl, 1940

Gelatin-silver print, 14⅞ x 17¼ inches
Horace W. Goldsmith Fund, 86.198

Helen Levitt
American, 1918–

With understated, elegant depictions of 1940s street life, mostly of children in her native New York City, Levitt shared with James Agee and Walker Evans a desire for direct expression of feelings in art. Her photographs of children allow access to their games and fantasy worlds as expressed in urban circumstances. Attracted to her work, Agee wrote an appreciation of her photographs that was published in her 1965 book entitled *A Way of Seeing*. In collaboration with Agee and others, she made a film about children playing in the street and another on a ten-year-old runaway from Harlem. Levitt supported herself with freelance magazine work and made pioneering color photographs in New York in the late 1950s and again in the early 1970s. More recently, she has produced numerous books and exhibitions of her work. Known as a photographer of few words, she did submit this statement for this book:

All I can say about the work I try to do,
is that the aesthetic is in reality itself.

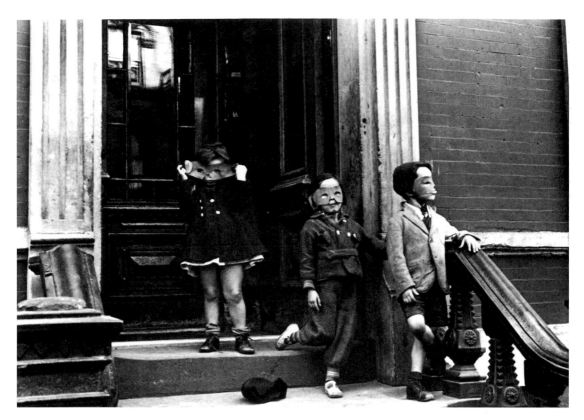

Untitled, New York City, 1942

Gelatin-silver print, 6¾ x 10¼ inches
The Family of Alice R. and Sol B. Frank

Weegee (Usher H. Fellig)
American (b. Austria-Hungary), 1899–1968

Usher H. Fellig's first name change was to the Americanized *Arthur* H. Fellig. Later, Fellig derived his "nom de foto" from his uncanny Ouija board-like ability (abetted by a police radio) to sense and be present at scenes of urban calamities almost as they happened. "Weegee the Famous," as his credit line read, became known in the 1930s and 1940s for his raw, spontaneous photographs of victims, survivors, and onlookers at crime scenes and fires in New York City. Weegee was also concerned with documenting more humane, humorous urban situations; after the publication of his New York work in *Naked City* (1945) he turned to photographs of Hollywood culture and experiments with distorting lenses. His egocentric personality is revealed in this statement from *Weegee by Weegee: An Autobiography*, 1961.

On my safaris and lecture tours all over the world, people were always asking for the secret of my success. (Thanks for the compliment.) It's very simple. I've just been myself. Besides, I was born with a great inferiority complex and just had to make good, giving all my life and energy to my work. I'm no part-time dilettante photographer, unlike the bartenders, shoe salesmen, floorwalkers, plumbers, barbers, grocery clerks and chiropractors whose great hobby is their camera. All their friends rave about what wonderful pictures they take. If they're so good, why don't they take pictures full-time, for a living, and make floor-walking, chiropractics, etc., their hobby? But everyone wants to play it safe. They're afraid to give up their pay checks and their security...they might miss a meal....

The camera is the modern Aladdin's lamp. It has given me all the things I've wanted...fame, fortune and friends. It is the easiest profession to get into because editors are always looking for something human, something different. The doors are always open to beginners and unknowns. Other photographers think the magic name of Weegee hypnotized the editors into buying my pictures. That's not so. To prove it, I tried a little experiment in London. Unannounced, and without an appointment, I went to *The Times*. They, had never heard of me, much to my amazement (I amaze easily). I

showed them some of my kaleidoscopic pictures. The editor stopped drinking his tea, and said, "By Jove, it's something new! Original. Refreshing." And they bought my pictures and gave them a half-page spread. Then the Beaverbrook Group, who publish the *Daily Express* and the *Sunday Express*, picked them up and syndicated them all over the world. They were used for greeting cards and for calendars. It proved my point that good pictures will sell themselves....

There are photographic fanatics, just as there are religious fanatics. They buy a so-called candid camera...there is no such thing: it's the photographer who has to be candid, not the camera....

Life is better than ever now. There are new presidents...kings...queens...starlets...public enemies...Hello! Hello! Who's calling? (I wish the phone would stop ringing.) This is the White House...this is Buckingham Palace...this is the Warden of Sing Sing Prison...this is Alcatraz. Oh, so you want pictures? Have you got an appointment? Guess I'd better pack up my typewriter (I wish it had an attachment that could spell and write English for me) and my camera and get going to...Paris...London...Berlin...Rome...Tokyo... Hong Kong...the world is calling, and I'm on my way...any mail for me? Here's my passport, dearie. Just call me Weegee.

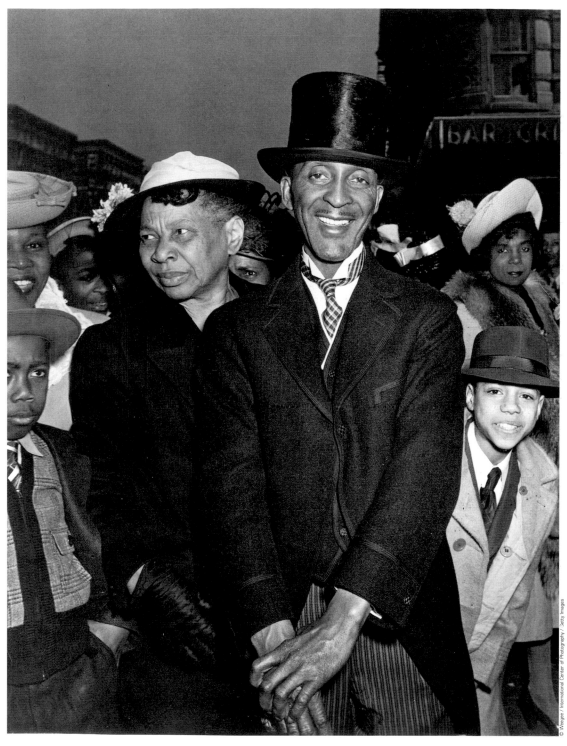

Easter Sunday in Harlem, 1940

Gelatin-silver print, 13½ x 10½ inches
The Family of Alice R. and Sol B. Frank

Lisette Model
American (b. Austria), 1906–1983

As a young woman, Model's passion was music, but she took up photography as a way of earning a living in Paris in the 1930s. Her first major photographs were images of the wealthy taken along the Promenade des Anglais in Nice on the eve of World War II. The strength of these images secured her freelance work for *Harper's Bazaar* upon moving to New York in 1938. Model photographed life in lower Manhattan and was particularly interested in the city's nightlife; she also did several series of abstract images entitled "Reflections" and "Running Legs." An accomplished teacher, Model defines creative photography in the following excerpt from a 1951 *New York Times* article:

To define the term creative is to define art; both words mean the same thing. If the photographer believes his print to be worthy of evaluation on artistic grounds, as one may assume all photographs are that are submitted to salons and exhibitions, then the print is by that token creative. For the only purpose of art is to be creative. If a picture is good it is creative; if it is bad, it is not creative....

The term creative is extremely misleading. People look for creativeness either way up on ivory towers or way down in the depths of the subconscious. The fact is that creativity is just a matter of purposeful living, regardless of one's activities; anyone who achieves meaningful results is a creative person, whereas he who lives an unproductive life is not creative.

I do not believe in talent for the few; everybody has it. All depends on how much interest a person has in a specific medium, and how much effort he is willing to expend in achieving whatever goal in life he sets himself. In working with a camera, when a photographer is in contact with life and in contact with himself, that is, understands himself for what he really is, then he can use the medium creatively....

It is of importance for photographers to realize that a photograph should be a product of today, not of yesterday. It should be concerned with everything in life that is meaningful for us today. Otherwise it is merely an imitation of something that happened yesterday, and lacks meaning today....

A knowledge of photography in itself represents a difficult task; so-called creative photography makes it even more confusing. Let photography be the scientific eye that captures life and creates life and art. Placed between the eye of the photographer and the world, the camera reveals both man and the outside world. This in effect is the main photographic situation.

Percy Pape, The Living Skeleton, 1945

Gelatin-silver print, 10 x 13¾ inches
Horace W. Goldsmith Fund, 84.33

Philippe Halsman
American (b. Latvia), 1906–1979

After operating a studio in Paris between 1931 and 1940, Halsman immigrated to America with the help of Albert Einstein and became a freelance photographer for numerous magazines, including *Life*, *Time*, and the *Saturday Evening Post*. Beginning in 1942, his work graced the cover of *Life* over one hundred times, more than that of any other photographer. An interest in psychology led him to focus on photographic portraiture; in his sharply focused images Halsman attempted to capture the essence of his subjects' personality. In his 1972 book *Sight and Insight* Halsman described his sitting with Albert Einstein. This text reveals the intimacy with which Halsman approached portraiture:

If the photograph of a human being does not show a deep psychological insight it is not a true portrait but an empty likeness. Therefore my main goal in portraiture is neither composition, nor play of light, nor showing the subject in front of a meaningful background, nor creation of a new visual image. All these elements can make an empty picture a visually interesting image, but in order to be a portrait the photograph must capture the essence of its subject.

Herein lies the main objective of portraiture and also its main difficulty. The photographer probes for the innermost. The lens sees only the surface....

I admired Albert Einstein more than anyone I ever photographed, not only as the genius who singlehandedly had changed the foundation of modern physics but even more as a rare and idealistic human being....

The question of how to capture the essence of such a man in a portrait filled me with apprehension. Finally, in 1947, I had the courage to bring on one of my visits my Halsman camera and a few floodlights. After tea, I asked for permission to set up my lights in Einstein's study. The professor sat down and started peacefully working on his mathematical calculations. I took a few pictures. Ordinarily, Einstein did not like photographers, who he called *Lichtaffen* (Light monkeys)....

Suddenly, looking into my camera, he started talking. He spoke about his despair that his formula $E=mc^2$ and his letter to President Roosevelt had made the atomic bomb possible, that his scientific search had resulted in the death of so many human beings. "Have you read," he asked, "that powerful voices in the United States are demanding that the bomb be dropped on Russia now, before the Russians have the time to perfect their own?" With my entire being I felt how much this infinitely good and compassionate man was suffering from the knowledge that he had helped to put in the hands of politicians a monstrous weapon of devastation and death.

He grew silent. His eyes had a look of immense sadness. There was a question and a reproach in them.

The spell of this moment almost paralyzed me. Then, with an effort, I released the shutter of my camera. Einstein looked up, and I asked him, "So you don't believe that there will ever be peace?"

"No," he answered, "as long as there will be man there will be wars."

It is difficult for a photographer to judge the truth or the force of a photograph he has produced. I showed it first to Einstein's daughter Margot. Tears came to her eyes and she said, "I cannot tell you how much this portrait moves me." The professor was more detached: "I dislike every photograph taken of me. However, this one I dislike a little bit less."

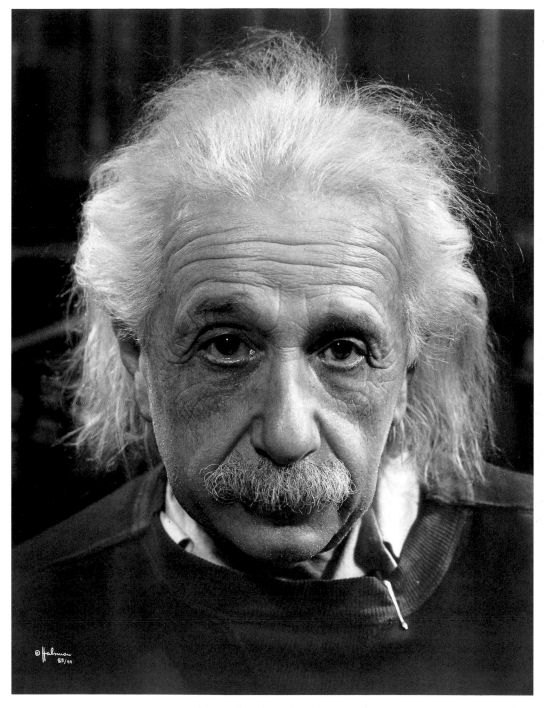

Albert Einstein, 1948

Gelatin-silver print, 20 x 16 inches
Gift of Joyce F. and Robert B. Menschel, 89.94

Clarence John Laughlin
American, 1905–1985

Laughlin—"The Baudelaire of the Bayous"—is considered the foremost American exponent of the 1930s French Surrealist movement. Laughlin lived in New Orleans for 75 years, and his portraits, abstractions, still lifes, architectural work, and multiple-exposure allegories reflect a deep engagement with the romantic mysticism of the area. In the 1940s he made photographs for the U.S. Engineer Corps, the Army Signal Corps, and *Vogue* magazine. His catalog of decaying plantation homes, *Ghosts Along the Mississippi*, was published in 1948. His 1973 monograph, *Clarence John Laughlin: The Personal Eye*, contained an overview of his photography as well as his prodigious writing illuminating his work.

In our society, most of us wear protective masks (psychological ones) of various kinds and for various reasons. Very often the end result is that the masks grow to us, displacing our original characters with our assumed characters. This process is indicated in visual, and symbolic, terms here by several exposures on one negative—the disturbing factor being that the mask is like the girl herself grown harder, and more superficial....

One of my basic feelings is that the mind, and the heart alike, of the photographer must be dedicated to the glory the magic, and the mystery of light. The mystery of time, the magic of light, the enigma of reality—and their interrelationships—are my constant themes and preoccupations. Because of these metaphysical and poetic preoccupations, I frequently attempt to show in my work, in various ways, the unreal in, of the "real" and the reality of the "unreal." This may result, at times, in some disturbing effects. But art should be disturbing; it should make us both think and feel; it should infect the subconscious as well as the conscious mind; it should never allow complacency nor condone the status quo.

My central position, therefore, is one of extreme romanticism—the concept of "reality" as being, innately, mystery and magic; the intuitive awareness of the power of the "unknown"—which human beings are afraid to realize, and which none of their religious and intellectual systems can really take into account. This romanticism revolves upon the feeling that the world is far stranger than we think; that the "reality" we think we know is only a small part of a "total reality"; and that the human imagination is the key to this hidden, and more inclusive, "reality."

As a corollary, I attempt, through much of my work, to animate all things—even so-called "inanimate" objects with the spirit of man. I have come, by degrees, to realize that this extremely animistic projection rises, ultimately, from my profound fear and disquiet over the accelerating mechanization of man's life; and the resultant attempts to stamp out individuality in all the spheres of man's activity—this whole process being one of the dominant expressions of our military-industrial society.

The physical object, to me, is merely a stepping-stone to an inner world where the object, with the help of subconscious drives and focused perceptions, becomes transmuted into a symbol whose life is beyond the life of the objects we know and whose meaning is a truly human meaning. By dealing with the object in this way, the creative photographer sets free the human contents of objects; and imparts humanity to the inhuman world around him.

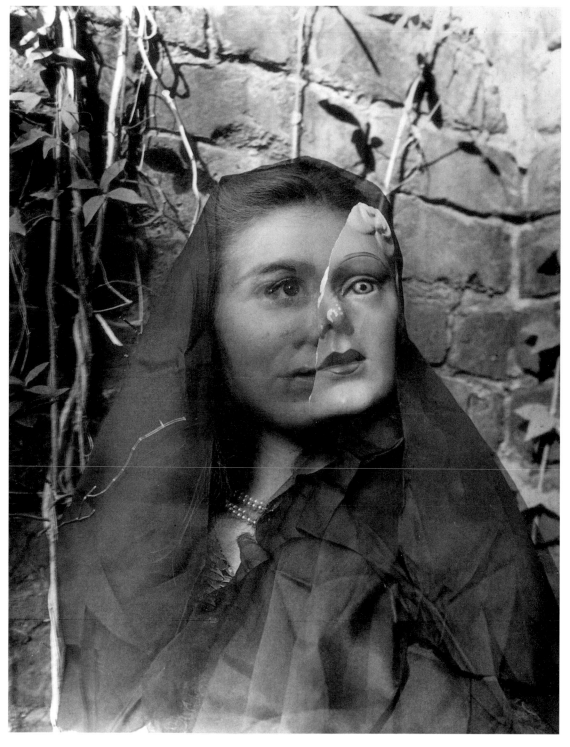

The Masks Grow To Us, 1947

Gelatin-silver print, 13¼ x 10¼ inches
The Family of Alice R. and Sol B. Frank

Aaron Siskind
American, 1903–1991

Although his planar, abstract work from the late 1940s on is recognized as some of the greatest twentieth-century American photographic art, Siskind began his photographic career in a documentary style. From 1932 to 1935 he was active in the New York Workers' Film and Photo League and from 1936 to 1941 he was involved with the reorganized New York Photo League, organizations whose collective mission was the advancement of socially engaged documentary work. Siskind's departure from the League symbolized a decisive shift in his work (and in mid-century American photography in general) away from the primacy of subject matter per se toward the dominance of individual vision. Siskind has had great influence as a teacher, both at the Chicago Institute of Design and the Rhode Island School of Design. In the exhibition catalog, *Aaron Siskind: Photographer*, 1965, Siskind states:

When I make a photograph I want it to be an altogether new object, complete and self-contained, whose basic condition is order—(unlike the world of events and actions whose permanent condition is change and disorder).

The business of making a photograph may be said in simple terms to consist of three elements: the objective world (whose permanent condition is change and disorder), the sheet of paper on which the picture will be realized, and the experience which brings them together. First, and emphatically, I accept the flat plane of the picture surface as the primary frame of reference of the picture. The experience itself may be described as one of total absorption in the object. But the object serves only a personal need and the requirements of the picture. Thus, rocks are sculptured forms; a section of common decorative iron-work, springing rhythmic shapes; fragments of paper sticking to a wall, a conversation piece. And these forms, totems, masks, figures, shapes, images must finally take their place in the tonal field of the picture and strictly conform to their space environment. The object has entered the picture, in a sense; it has been photographed directly. But it is often unrecognizable; for it has been removed from its usual context, disassociated from its customary neighbors and forced into new relationships.

What is the subject matter of this apparently very personal world? It has been suggested that these shapes and images are underworld characters, the inhabitants of that vast common realm of memories that have gone down below the level of conscious control. It may be they are. The degree of emotional involvement and the amount of free association with the material being photographed would point in that direction. However, I must stress that my own interest is immediate and in the picture. What I am conscious of and what I feel is the picture I am making, the relation of that picture to others I have made and, more generally, its relation to others I have experienced.

New York 1, 1947

Gelatin-silver print, 13¼ x 10 inches
The Family of Alice R. and Sol B. Frank

Harry Callahan
American, 1912–1999

A self-taught photographer, Callahan has been highly influential as a teacher—first at the Chicago Institute of Design (1946−61) and then at the Rhode Island School of Design, where he was a full-time professor until 1977. Callahan's photography deals extensively with portraiture of his family (particularly his wife, Eleanor), natural landscapes and, recently, color images or urban scenes. This extemporaneous statement comes from the 1983 film *Harry Callahan: Eleanor and Barbara.*

...to photograph was so strong that it made me take a lot of directions. During that time I was making a lot of multiple exposures. I used a four by five camera with cut film holders. I photographed the egg on a piece of glass with a white background and then I would go out and photograph a landscape and then I'd come back and I'd photograph Eleanor within the egg. I had my studio light shining on the wall and made her silhouette so that made her out of branches and things. So that's what I wanted. I was always trying different ways of printing, different lenses, and printing dark. I found out something by printing dark. I found what I consider different ways of seeing....

I very rarely start photographing immediately. I like to walk and walk and walk. And the beach was nice because I can walk and unwind and then after awhile start photographing. You can go to the sea where it's beautiful and you want a part of it and I guess you want to let somebody else know about it. I think I must have felt the same way with Eleanor.

I felt very natural photographing Eleanor. I didn't feel like there were any obstacles of any kind. When I started photographing, I started photographing nature because Ansel Adams came and he'd been photographing nature and I thought well, this is eternal. Then, I ran out of gas, so to speak. I got tired of photographing nature. So I started photographing buildings. And then I ran out of gas there and then I started photographing people. And all of this is because I wanted to keep on photographing. I wanted to photograph so bad. I would go from one to another. And I think all of this has blended in with my photographing Eleanor...

I think I've mainly been naive all my life and I never knew much about what was going on. Maybe if I knew too much I would be too influenced or maybe if I knew the history of art, you know, I might have been stifled by it.

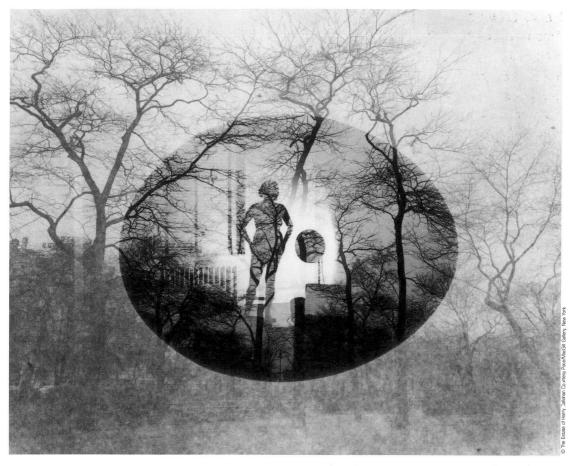

Eleanor, Chicago, 1953

Gelatin-silver print, 6 x 7 ½ inches
Gift of Joyce F. and Robert B. Menschel, 87.433

Wynn Bullock
American, 1902–1975

Bullock invoked the purist aesthetics of the Group f/64 tradition in his fine prints of nudes, nature scenes and buildings; however, he extended the tradition to account for his conception of photography as an abstracting medium, one that should "express the fourth-dimensional structure of the real world." Trained extensively in music, Bullock experimented with techniques for registering and reproducing light, which he considered as pervasive and pliable as sound. Some of his writings were published posthumously in *Photographing the Nude*.

The urge to create, the urge to photograph, comes in part from the deep desire to live with more integrity; to live more in peace with the world, and possibly to help others do the same....

As I became aware that all things have unique spatial and temporal qualities which visually define and relate them, I began to perceive the things I was photographing not as objects but as events. Working to develop my skills of perceiving and symbolizing these event qualities, I discovered the principle of opposites. When, for example, I photographed the smooth, luminous body of a woman behind a dirty cobwebbed window, I found that the qualities of each event were enhanced and the universal forces which they manifested were more powerfully evoked. Out of these experiences, I embarked on some of my most productive years of working.

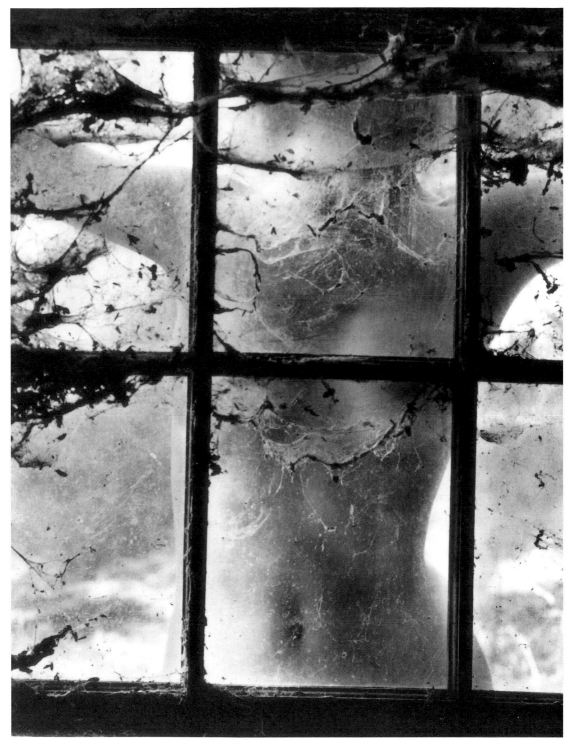

Nude Behind Cobwebbed Window, 1955

Gelatin-silver print, 9¼ x 7¼ inches
The Family of Alice R. and Sol B. Frank

Albert Renger-Patzsch
German, 1897–1966

Renger-Patzsch was a major contributor to the German Neue Sachlichkeit (new objectivity) move-
ment of the 1920s and 1930s. This European movement endorsed the same kind of imagery
espoused by the American Group f/64. Renger-Patzsch was concerned with precise descriptions
of machinery, flora, and architecture in the Ruhr district of Germany. His book, *The World is
Beautiful* (1928) demonstrated his obsession with pure, natural forms. After World War II he con-
centrated his energies on landscape photography. This statement comes from "Photography and
Art" in *Das Deutsche*.

There was a time when one looked over one's
shoulder with an ironical smile at the photographer
and when photography as a profession seemed
almost invariably a target for ridicule. That time is
now over. A whole number of people of cultivated
taste, technical ability and well-developed formal
talent have made photography into a matter of seri-
ous artistic concern.

The question of whether photography can be
regarded as art or not has given rise to much verbal
and written discussion. However, it seems pointless
to me to attempt to determine the question either
way. After all, one can prove everything: that it is
art and that it is not, that it assumes an intermedi-
ate position, that one must extend the concept of
art to take account of photography, and so on.
Basically that is a question which, for reasons of
organization, might interest the editor of an ency-
clopedia of conversation, but it has nothing to do
with the real issues. Therefore we shall refrain
from any attempt at classification.

But photography exists and has done so for
nearly a hundred years now. It has acquired an
immense significance for modern man, many thou-
sands of people live from it and through it, it exerts
an immense influence on wide sections of the popu-
lation by means of film, it has given rise to the
illustrated press, it provides true-to-life illustrations
in most works of a scientific nature, in short, modern
life is no longer thinkable without photography.

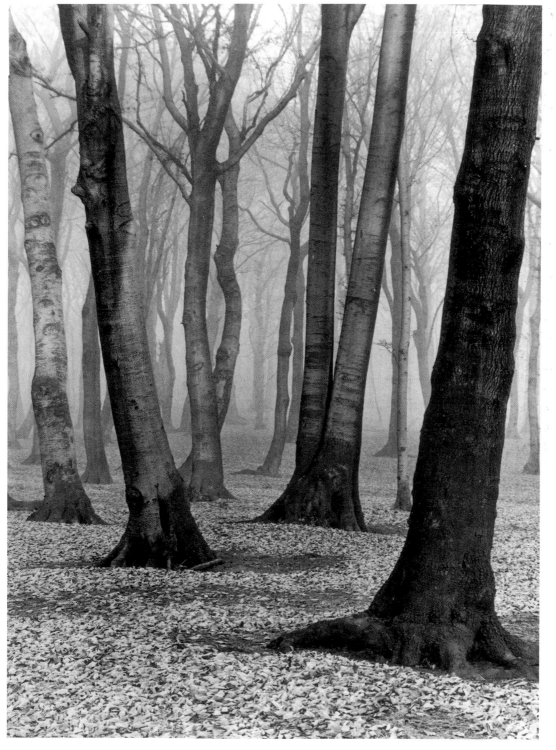

Zierlen, ca. 1955

Gelatin-silver print, 9 x 6¾ inches
The Family of Alice R. and Sol B. Frank

Brett Weston
American, 1911–1993

Like his father Edward, Brett Weston demonstrated in his work an obsession with precise, clear photographs of natural forms, landscapes, textures, and bodies. His photographs were first shown at the important "Film und Foto" exhibition in Stuttgart when Weston was eighteen. He was also invited to show with Group f/64 in their first exhibition in 1932. Although the impact of his images was somewhat preempted by the strength of his father's, the younger Weston's work indicates a greater interest in abstraction, atmosphere, and graphic formalism. This statement from March 1975 was originally published in *Dialogue with Photography*.

I photograph man-made things a great deal. It's true, I am a modern man in many ways. I love modern architecture, modern machines and tools....

I don't limit myself. I hope I'm not too stylized or too much in a rut. I use various types of cameras and photograph anything, anytime. It could be something modern or an ancient rock, it doesn't matter. But, unless a landscape is invested with a sense of mystery; it is no better than a postcard....

My whole life is photography, but I love music. I have dear friends who are musicians and writers as well as photographers. I also love traveling....

When I photograph, I don't have anything in mind except the photograph. I don't think in terms of magazines, books, or promotions. I photograph for the love and the excitement. It's just a self-centered, dedicated thing...a dedication to photography and freedom. That's all I want. I don't want a lot of money. Freedom is the paramount thing—the freedom to work. Its very hard in our times, with all the material abundance around us, to have it. We're distracted—we want this and we want that....

I don't photograph for other people. I love an audience, mind you. Once I've got them there, then I love an audience. Not a big audience, though. I'd rather please ten people I respect than ten million I don't. But I don't play to an audience, I do it for myself.

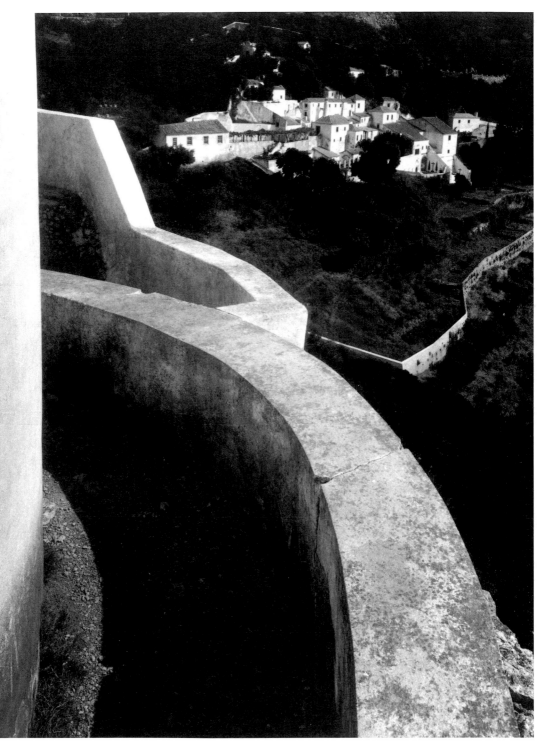

Portugal, 1960

Gelatin-silver print, 9½ x 7½ inches
The Family of Alice R. and Sol B. Frank

Minor White
American, 1908–1976

White served photography as a teacher, a critic, an innovative publisher, and an influential image-maker. In all of his pursuits, including *Aperture* magazine (which he founded in 1952 and edited until 1975), he sought to infuse his work with spiritual aspects of creativity and lessons derived from Oriental thought and Gestalt psychology. He felt that his photographs—fine black-and-white prints, often of natural subjects—should be viewed as metaphors for human experiences. This statement was originally published in *Minor White: Rites and Passages*.

The path my feet took was lined with images, whole gardens of pictures. With exposures I picked bouquets, each more vivid than the previous...finally a gathering of gem-like flames in the low tide...I thought I had forgotten how to use my camera, so I counted each step of the process aloud...shutter speed, aperture, cock the shutter.... Though I feared to lose the sense of beauty, no loss occurred; the sense of rapport was strong beyond belief.

While rocks were photographed, the subject of the sequence is not rocks; while symbols seem to appear, they are pointers to the significance. The meaning appears in the space between the images, in the mood they raise in the beholder. The flow of the sequence eddies in the river of his associations as he passes from picture to picture. The rocks and the photographs are only objects upon which significance is spread like sheers on the ground to dry.

Moencopi Strata, Capitol Reef, Utah, 1962

Gelatin-silver print, 12 x 9¼ inches
The Family of Alice R. and Sol B. Frank

W. Eugene Smith
American, 1918–1978

One of the most important American photojournalists, Smith conducted his work under the principle "let truth be the prejudice." His famous photo-essays ("Spanish Village," "Nurse-Midwife," "Country Doctor," "Schweitzer in Africa") helped define the look of *Life* magazine in the 1940s and 1950s, and established a model for subsequent work in the essay form. Smith was compassionate toward his subjects and uncompromising about the use of his images, maintaining control over editing and even layout of his stories. Other notable extended photo-essays include: "The city of Pittsburgh," in 1955–57, and in the early 1970s "Minamata, Japan." This statement is from "The World's Greatest Photographers," in the May 1958 issue of *Popular Photography*.

I doubt the existence of any perfection, although I am for trying the rise to this the impossible and would take measure from such failure rather than from the convenience of a safe but mundane success. (I do not deplore success.) I would experience even deeper, and endeavor to give out from this experience. My photographs at best hold only a small strength, but through them I would suggest and criticize and illuminate and try to give compassionate understanding. And through the passion given into my photographs (no matter how quiet) I would call out for a spiritualization that would create strength and healing and purpose, as teacher and surgeon and entertainer, and would give comment upon man's place and preservation within the new age—a terrible and exciting age. And with passion. Passion, yes, as passion is in all great searches and is necessary to all creative endeavors—whether of statesman, or scientist, or artist, or freedom, or devil—and Don Juan may have been without passion, for sex and sentiment and violence can very much be without passion. Question this? Take note of the values around you, everywhere thrust upon you—and wade awhile, with this question in thought, through publications and publications from cover to cover.

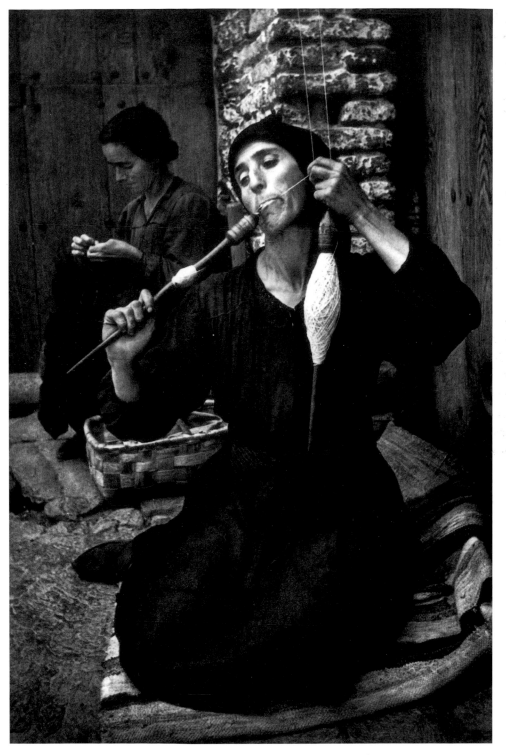

The Thread Maker, 1951

Gelatin-silver print, 13⅜ x 9⅛ inches
The Family of Alice R. and Sol B. Frank

Bob Lerner
American, 1926–

Working as a staff photographer for *Look* magazine from 1951 to 1971, Lerner traveled to fifty countries on five continents and to each of America's fifty states. His photojournalist work included sports greats, political giants, talented celebrities, peace rallies, poverty-stricken and mentally-challenged individuals and families, street scenes from around the world, and glamour. Historically, the photographers at *Look* have been overshadowed by its primary competitor magazine, *Life*. Because the photographers at *Look* worked as a team with writers, the culture of the magazine did not encourage individuals to be stars.

The years I spent as a staff photographer for *Look* Magazine were the height of my career in photo-journalism. As a teenager I dreamt of working on a picture magazine like *Look* or *Life*. Being asked to join the *Look* staff at the age of twenty-one was an unforgettable stroke of luck. *Look* was a great picture magazine that had implicit trust in their photographers, and gave all of us great opportunities to do a variety of assignments in every corner of the world. I am and always will be most grateful to *Look*—for their patience and support over those exciting years. I found joy in my work early on, and always hoped—and still do—that one of my images could motivate people to right a wrong. I know that, for me at least, I have to cover as many facets of life that I can.

In 1962 I was assigned by *Look* to do a picture essay on the current state of affairs in Haiti. The government at that time was headed by a dictator who was being noticed in the world press. He was a physician named Papa Doc Duvalier (François Duvalier, 1907–71, dictator of Haiti 1957–71). Under his regime of brutal terror, political opponents were summarily executed and the country maintained an illiteracy rate of 90 percent. On arrival in Port au Prince I hired a driver so that I could get around and to serve as an interpreter. He turned out to be very helpful—I later learned that he was a member of the secret police. I tried to cover every aspect of Haitian life—the awful poverty, Voodoo, the wealthy, hospitals, and an insane asylum are just some examples. Over the

two weeks of shooting, one subject was missing. I never had a chance to photograph Papa Doc—even though I made a number of requests. Of course, this was very frustrating. At close to the end of my coverage, I learned from a Haitian friend that Papa Doc was going to make a rare public appearance. He was to rename a small village "Duvalierville." The *Look* editor I was working with and I decided to attend the ceremony without telling our driver escort. We arrived early and found hundreds of Haitians, police and military awaiting the arrival of Papa Doc. He arrived with a large entourage including a group of cheering Haitians. He emerged from a long black Cadillac wearing a white suit and black Homburg. I had already made many good pictures of the security people—so I concentrated on Duvalier and the officers around him. Most of the images were made with a telephoto lens—even though I still stood out in the crowd. His thick glasses, black hat, and dead pan face fascinated me. Intuition told me I had enough, the crowd was getting restless, and so we slipped away. Shortly after we returned to our hotel we received by government correspondence that we were no longer welcome, and we should leave the country in forty-eight hours. Since I had been able to get the "missing picture" there was no reason to stay. The July 3, 1962 issue of *Look* ran the story for six pages, entitled: "Haiti, a Sad Sad Neighbor." The Haiti pictures were syndicated worldwide.

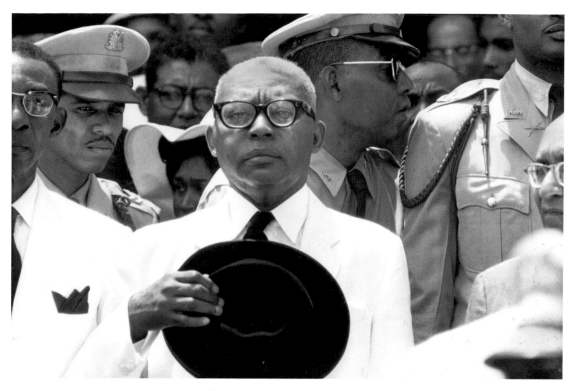

Papa Doc, Duvalierville, Haiti, 1962

Digital pigment print, 2004, 11½ x 17¾ inches
Gift of the Artist, T2004.15

William Klein
American, 1928–

Though his mastery of the 35mm medium may be compared to Cartier-Bresson's, Klein was much more interested in the photographer's effect on situations. Klein's provocative and grittily engaging "street photography" challenged traditions of elegance, discretion, and formal quality. His books— *New York* (1956), *Rome* (1958), *Moscow* (1962), and *Tokyo* (1964)—resemble psychological portraits of cities more than photojournalistic documentation. Alexander Liberman, art director for *Vogue*, commissioned Klein to photograph New York which resulted in his book on that city. It also led him to photograph regularly for *Vogue* (1955–65) where he expanded the boundaries of fashion photography. This statement is from Klein's book *Rome*.

All roads lead to Rome, even mine, and all Romes exist, even mine. You might not have found my Rome looking for yours—but you might have also failed to find other Romes, the pretty, miserable white-color Rome, or the hopeless Rome of the unemployed, or Holy Rome, or Ancient Rome, or Café Society Rome. This book is a result of several months spent in Rome, several visits and something of several Romes, what I have seen and what I think I have seen. I might be wrong but if I am wrong, then, I am wrong....

Sunday dinner at the sea-shore is quite an affair. An Italian pointed out to me that the social equivalent of these families in France would probably be picnicking on the beach. Aside from the fact that macaroni boiling is difficult in the sand, it would seem to be beneath Italian dignity to eat below table level. If you are going to take your family out for a day you can damn well sit them down in a restaurant, call a waiter and be a sport—even half naked, peeling, and sand-caked in any one of the twenty, noisy, 500-lire trattorie on the Ostia beach.

But, very important, note that the whole family, including prospective sons and daughters-in-law, is together, because they want to be, around this table. Here, exhibit A, is the secret of Italian Happiness and Equilibrium. The family in Italy is not a No Man's Land as it is elsewhere but a mutual admiration society where parents and children adore each other unselfconsciously. Children are free, spoiled, and listened to. Parents are indulgent and contrary to all logic, inducible from American experience, children are well-adjusted, and—so help me—parents are respected.

Every holiday is also a family holiday where the old are as spoiled as the young. Family solidarity thus becomes a form of old-age insurance.

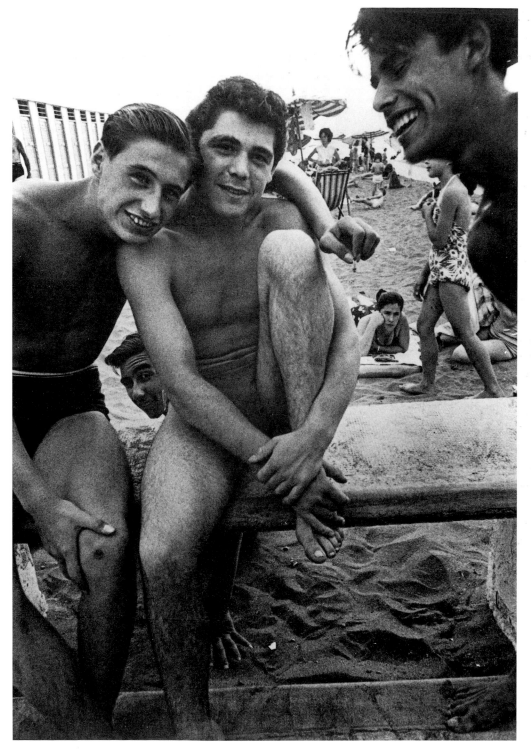

Ostia Beach, Rome, 1956

Gelatin-silver print, 13½ x 9⅝ inches
The Family of Alice R. and Sol B. Frank

Robert Frank
American (b. Switzerland), 1924–

From his non-native observer's position, Frank made incisive photographs exposing the underside of 1950s American culture. In 1955, Frank was awarded a Guggenheim Fellowship which he used to explore America with his camera. In two years he made some twenty thousand images that were published in his landmark book *The Americans*. First published in France in 1958, and then in the United States in 1959, this book confirmed the emergence of a new subjectivity in American photography and established Frank as one of the most important and influential small-camera photographers in the medium's history. After the publication of the book, Frank began to make films and is now widely recognized for his directorial innovation. Before the publication of *The Americans*, Frank wrote an essay for *U.S. Camera Annual 1958* discussing his approach to photography. From that essay, he selected a statement for this book.

Above all, I know that life for a photographer
cannot be a matter of indifference. Opinion often
consists of a kind of criticism. But criticism can
come out of love. It is important to see what is
invisible to others. Perhaps the look of hope or the
look of sadness. Also, it is always the instantaneous
reaction to oneself that produces a photograph.

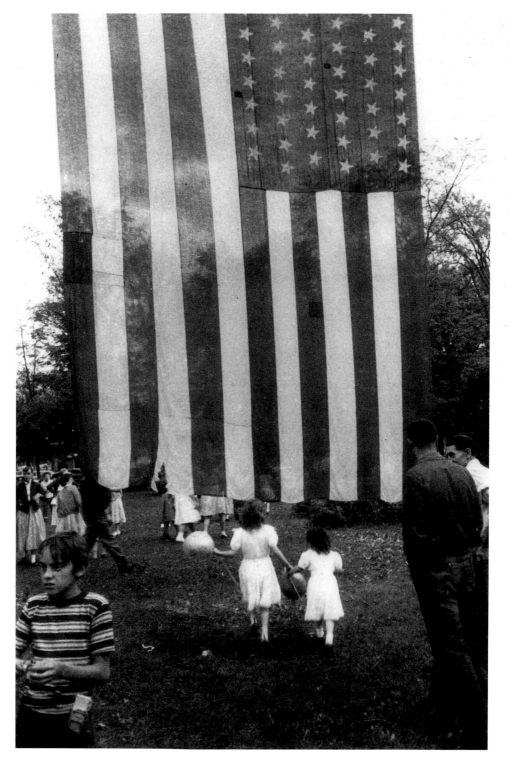

Fourth of July, Jay, New York, 1955–56

Gelatin-silver print, 13⅜ x 9 inches
The Family of Alice R. and Sol B. Frank

Bruce Davidson
American, 1933–

In numerous documentary photo-essays, on subjects including a traveling circus, a gang of Brooklyn youths, the Civil Rights movement and the New York subway system, Davidson has proved himself as a compassionate observer of the lives of common Americans. Associated with Magnum Photos since 1958, his extended projects have come to epitomize the agency's notions of personally motivated, concerned photography. Davidson published *East 100th Street*, a study of a stricken Harlem neighborhood, in 1970, and he has also directed a number of films. This statement was written for his 1978 book *Bruce Davidson Photographs*.

The man who headed the picture library at Magnum told me about a small circus that had pitched its tent at Palisades Amusement Park in New Jersey. I began to photograph the circus every day during the weeks it was there; then I traveled with it along its route. I took pictures of the circus acts—the girl riding the elephant, the lion tamer, the man shot from the cannon and the clowns. I rode with the cannon man and his family in a silver truck that carried his cannon. The roustabouts helped me climb the rim of the tent to the top, where I saw the circus far below.

I first saw the dwarf standing outside the tent in the dull mist of a cold spring evening. His distorted torso, normal-sized head and stunted legs both attracted and repelled me. He stood sad and silent, smoking a cigarette outside the tent.

Loud music played and he disappeared into the lights and laughter of the tent. His name was Jimmy, but he called himself "Little Man," and sometimes after the last show we went into a diner together where people snickered and laughed at us. When I finished the photographs of him, I gave Jimmy a small camera that could fit into his hands.... I finished the dwarf essay in the summer of 1959.

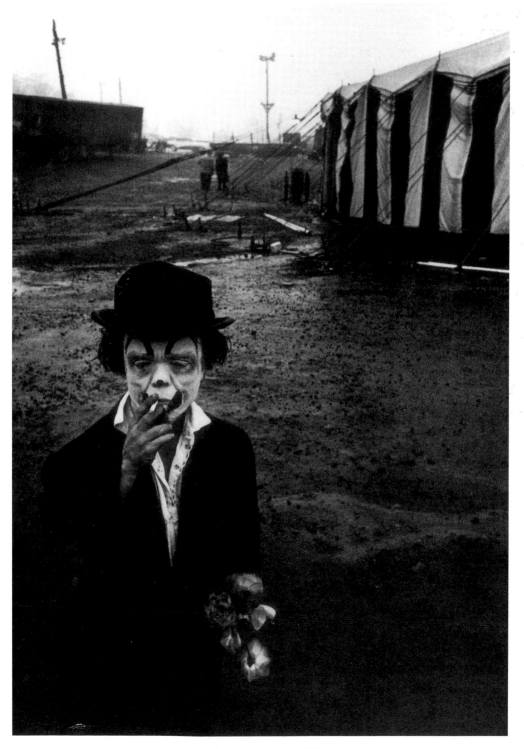

Jimmy Armstrong, 1958

Gelatin-silver print, 12 x 8 inches
The Family of Alice R. and Sol B. Frank

Diane Arbus
American, 1923–1971

For Arbus, one of the most influential American artists of the 1960s, photography was a process of confrontation. Her direct, uncompromising portrayals of individuals out of the social mainstream reveal her fascination with experience beyond her urban, upper-class, sheltered upbringing. Arbus's work refigures both traditional portraiture and the nature of documentary photography. A collection of her writings was published posthumously in the 1972 monograph *Diane Arbus*.

If I were just curious, it would be very hard to say to someone, "I want to come to your house and have you talk to me and tell me the story of your life." I mean people are going to say, "You're crazy." Plus they're going to keep mighty guarded. But the camera is a kind of license. A lot of people, they want to be paid that much attention and that's a reasonable kind of attention to be paid....

What I'm trying to describe is that it's impossible to get out of your skin into somebody else's. And that's what all this is a little bit about. That somebody else's tragedy is not the same as your own....

Freaks was a thing I photographed a lot. It was one of the first things I photographed and it had a terrific kind of excitement for me. I just used to adore them. I still do adore some of them. I don't quite mean they're my best friends but they made me feel a mixture of shame and awe. There's a quality of legend about freaks. Like a person in a fairy tale who stops you and demands that you answer a riddle. Most people go through life dreading they'll have a traumatic experience. Freaks were born with their trauma. They've already passed their test in life. They're aristocrats....

I never have taken a picture I've intended. They're always better or worse.

For me the subject of the picture is always more important than the picture. And more complicated. I do have a feeling for the print but I don't have a holy feeling for it. I really think what it is, is what it's about. I mean it has to be of something. And what it's of is always more remarkable than what it is.

I do feel I have some slight corner on something about the quality of things. I mean it's very subtle and a little embarrassing to me, but I really believe there are things which nobody would see unless I photographed them.

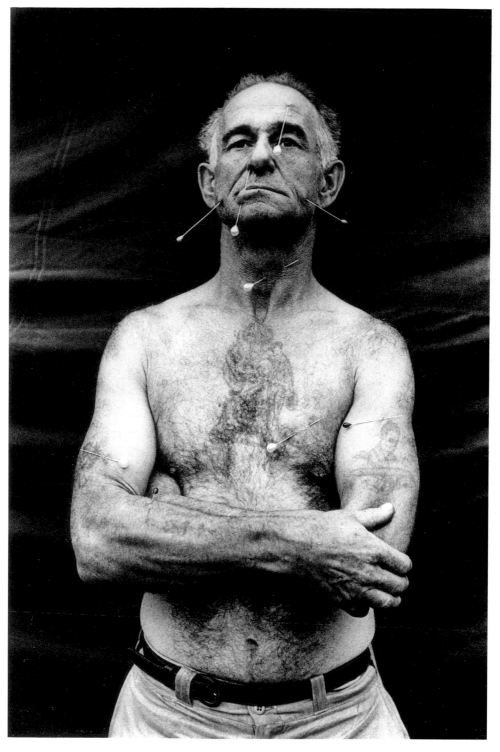

The Human Pincushion, 1962

Gelatin-silver print, 10 x 6⅝ inches
The Family of Alice R. and Sol B. Frank

Ralph Eugene Meatyard
American, 1925–1972

Meatyard became interested in photography in the 1950s while living a relatively isolated existence in Lexington, Kentucky, where he worked as an optician. His images of people wearing masks and inhabiting decayed structures have been characterized as haunting, enigmatic, and macabre. Meatyard also made abstract images, experimenting with multiple exposures and capturing blurred movement. An avid reader of modernist literature and philosophy, Meatyard occasionally collaborated with writers such as Wendell Berry; his last major project, *The Family Album of Lucybelle Crater* (1974), was based on a story by Gertrude Stein. The following comments, written for a 1962 exhibition in Boston, are as cryptic as his photographs are surreal:

From the beginnings of my participation in photography I have always felt that it was a form of Fine Art.

I have believed that we must be true to our medium. That we must know where we have been and where we are going in order to make something original out of our art.

I have always tried to keep truth in my photographs. My work, whether realistic or abstract, has always dealt with either a form of religion or imagination. In this exhibition I deal mainly with the "surreal," which I feel is the especial province of photography.

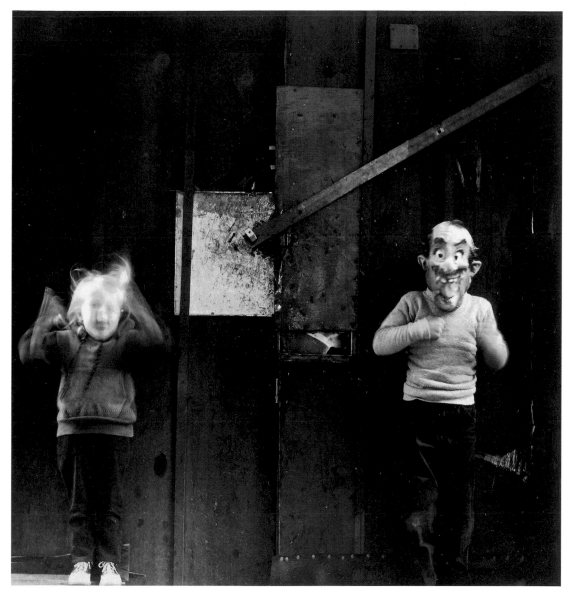

Occasion for Diriment, 1962

Gelatin-silver print, 7⅝ x 7⅝ inches
Purchase, 83.614

Ray K. Metzker
American, 1931–

Metzker's inventive photography is rooted in his early training in the Bauhaus philosophy as taught by Harry Callahan and Aaron Siskind at the Chicago Institute of Design. His work, a series of formal visual experiments, including "Composites," "Sand Creatures," "Pictus Interruptus," "City Whispers," and "Landscapes," poses and seeks to resolve questions about the medium's descriptive potential. Though frequently abstract in appearance, Metzker's images reveal, on closer inspection, an acute, carefully defined essence of a place. Originally written in his journal, this statement was published in *Unknown Territory: Photographs by Ray K. Metzker* 1984.

For some time, I have found myself discontented with the single, fixed-frame image, the isolated moment that seemingly is the dominant concern of still photography today. Instead, my work has moved into something of the composite, of collected and related moments, employing methods of combination, repetition, and superimposition as I find the opportunity in the camera, the darkroom, and the final presentation. Where photography has been primarily a process of selection and extraction, I wish to investigate the possibilities of synthesis.

...I began thinking of the entire roll of film as one negative. Ten-inch sections of film were printed onto long strips of photographic paper and then mounted in rows, forming a final constructed piece which I called a composite. You can deal with the whole or you can deal with just one part. To me there is a richer experience if the two can operate together. What I am talking about is com-plexity. When you approach one of the large composites, you see it more as an abstract design, and when you come in closer, you see a wealth of everyday information. There is no particular point of entry or procedure to the seeing; it is a multiplicity of elements operating in an aleatory manner.

Simultaneity was a key factor—ongoing, continuous interaction of one element or form with another. My need was to integrate the variety of experience, to fashion a form that pulled diverse parts together without stripping the parts of their vitality.

At this time I was reaching into music and into flux. I was working with kinetic sculpture, building toys that would flip-flop. I didn't have the expertise for these because they needed to be electrical. So I said to myself, I know photography. Why can't I take these ideas and bring them back into photography? Percussion, the playing of one beat against the next, began to translate into the photographs.

Composite: Car and Street Lamp, 1966

Gelatin-silver print, 25¼ x 17½ inches
The Family of Alice R. and Sol B. Frank

Jerry N. Uelsmann
American, 1934–

Uelsmann's photographs are widely admired as much for their innovative technical form as for their surreal content. His perfection of printing techniques combining multiple negatives creates seamless images with an almost mythical blend of style and substance. Uelsmann's on-going concern in his work is for the relationship between natural and manmade worlds. Immediately upon receiving his MFA from Indiana University in 1960, Uelsmann took his first job offer and taught photography at the University of Florida in Gainesville until he retired in 1998. His most recent monograph, *Referencing Art*, pays homage to the artists, art, and art trends that have influenced his own photography. For this book, Uelsmann reflects on his working methods:

I try to begin working with no preconceived ideas. Each click of the shutter suggests an emotional and visual involvement and contains the potential of establishing greater rapport with some quintessential aspect of the subject and my feelings toward it, both conscious and preconscious. My contact sheets become a kind of visual diary of all the things I have seen and experienced with my camera. They contain the scenes from which my images grow. Before entering the darkroom, I ponder these sheets, seeking fresh and innovative juxtapositions that expand the possibilities of the initial subject matter. Ultimately, my hope is to amaze myself. The anticipation of discovering new possibilities becomes my greatest joy.

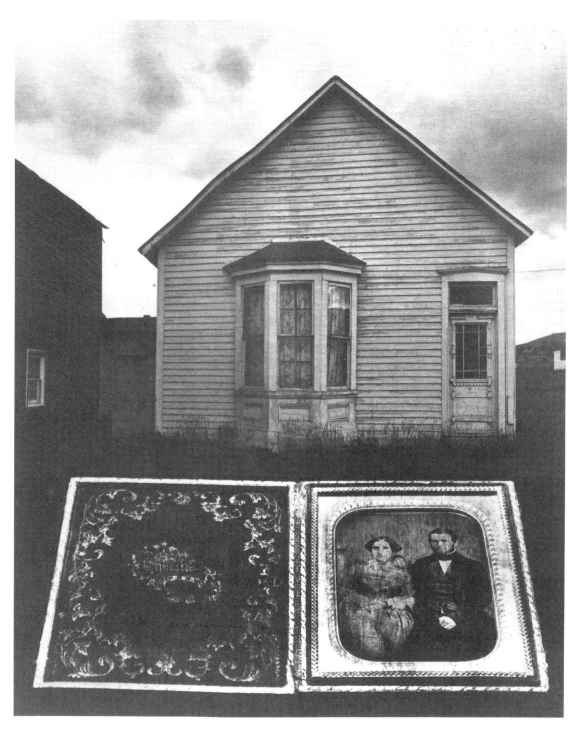

House and Daguerreotype, 1969

Gelatin-silver on metal plate, 6⅜ x 5¼ inches
The Family of Alice R. and Sol B. Frank

Eikoh Hosoe
Japanese, 1933–

The second son of a Buddhist priest, Eikoh Hosoe was born in Yonesawa, Japan and brought to Tokyo shortly thereafter. He first came to prominence with his 1961 book *Man and Woman*, but it was his body of work known as "Ordeal by Roses," or "Barakei," that solidified his position as the best known contemporary Japanese photographer. Portraying the acclaimed Japanese author Yukio Mishima as the central figure in a complexly orchestrated photographic drama, this work was first published in 1963 as *Killed by Roses*. In 1971, a new edition of the book changed the name to *Ordeal by Roses*. This statement comes from the 2002 publication of that book.

Barakei began one day in September 1961 as a result of an assignment from the Japanese publishers, Kodansha. I was asked to photograph Yukio Mishima for the jacket and frontispiece of Mishima's first book of critical essays, which Kodansha were about to publish.... I was curious as to why I had been given such an important assignment and was told by the editor over the telephone that I had been chosen at Mishima's specific request....

Some of the photographs from *Barakei* were first exhibited in January 1962 in the group show *Non* which was held at the Matsuya Department Store in Tokyo.... [When] the exhibition was about to take place I asked Mishima to provide a title. The next day he sent me a letter with eight possibilities...[among them] *Barakei*.

The word *Barakei* immediately impressed me. Each of the word's Chinese characters or *kanji* was beautiful in form and sound, and moreover the title fully expressed the content. *Bara* means rose and *kei* means punishment. Translated literally, the title would be *The Punishment of a Rose*. When the work was first published as a book in 1963, I decided after consulting with Mishima, that the English title would be *Killed by Roses*.

I wanted to explore a theme of life and death through Mishima's body and flesh, but the idea was never concrete at the start. However, as Mishima wrote in his preface, the most significant element of the theme was established in the final section of the book. In fact the early sections were photographed as the shooting sessions were coming to an end and my concept had already been clearly established. This whole process of shooting and making the concept explicit had lasted from the fall of 1961 until the spring of 1962. When the project was crystalized I realized I needed an infant to symbolize birth. I really wanted to photograph Mishima's young son, but knew he would never allow this. However, he did permit me to bring an anonymous child into his house to use as a model.

Despite the fact that *Barakei* was a document of life and death, I had a taboo about actually mentioning the word death in regard to the theme of the book until the fall of 1970. At the end of the summer of 1970 we had changed the sequence and the layout of the work for publication of a second edition. Mishima chose the titles for each section and called the final chapter *Death*, then asked for my approval. I accepted the suggestion at once, having known all along that the essence of the last section was morbid. Shortly after this decision, on 25 November 1970, he committed suicide by *seppuku* at Ichigaya Heights.

Recalling that day now, I have no doubt he was exercising an absolute will. The publication of *Barakei* in a new edition is my requiem to Yukio Mishima, who revealed his gorgeous flesh and supremely powerful body at the age of thirty-eight. Here is the perfect body of Mishima, who never admitted the decay of the flesh.

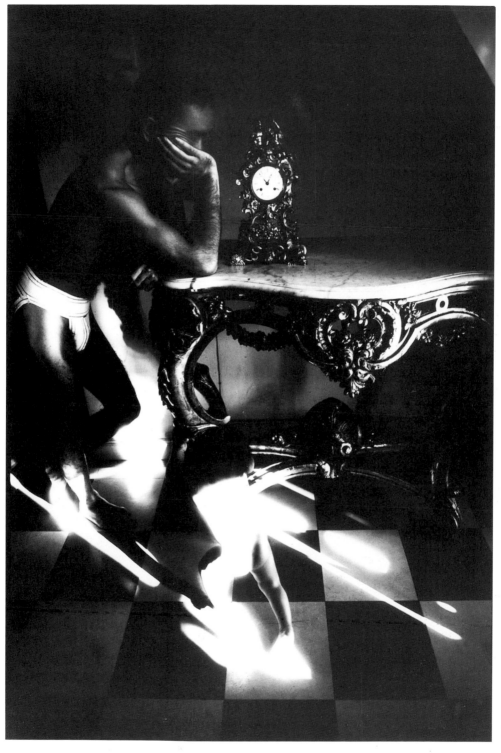

Ordeal by Roses #3, 1961

Gelatin-silver print; before 1970, 11⅝ x 7¾ inches
Purchase, in memory of Alice R. and Sol B. Frank, 2003.15

Gordon Parks
America, 1912–

Self-taught, Parks began his photographic career working for African-American newspapers and documenting poverty on Chicago's South Side. He worked under Roy Stryker at the Farm Security Administration and later as a correspondent in World War II. Earning renown for his sensitive photo-essays for *Life* magazine, Parks went on to become an accomplished writer, composer, musician, and filmmaker. His mantra has been "I chose my camera as a weapon against all the things I dislike about America—poverty, racism, discrimination." This text was written as the prologue for his 1975 book, *Moments Without Proper Names*.

Covering some of the stories of the past three decades was like reporting from the darkness. During that period I saw men in incomprehensible actions against their fellow men. I witnessed jagged moments of brutality and terror. I came to understand the implications of bigotry, poverty, and war. During some unbelievable hours I doubted that another morning would arrive; each day seemed sufficient to bring the world to a stop.

Nonetheless I have been in awe of what remained to be admired. For while evil and corruption suited certain men, there were others inclined toward greatness, good men who refused to be squashed under the heels of others. These were men who, when the sky threatened to fall upon us, raised their voices and guaranteed another sunrise. And there were beautiful things to see—so beautiful they defied description. I recall an aged Norwegian guide pointing from a mountaintop down toward the splendor of a fjord, saying simply, "God did a good job on that one."

...I feel it is the heart, not the eye, that should determine the content of the photograph. What the eye sees is its own. What the heart can perceive is a very different matter. For me at least, the camera is a technical device, used as a writer uses his typewriter or as a painter uses his brush.

I was born to a black childhood of confusion and poverty. The memory of that beginning influences my work today. It is impossible for me now to photograph a hungry child without remembering the hunger of my own childhood. Time has taught me that it is not enough to look, condemn, or praise—to be just an observer. I must attempt to transcend the limitations of my own experience by sharing, as deeply as possible, the problems of those people I photograph. There are still a lot of deplorable things happening around me. If, when I see these things happening, nothing happens inside me, I will know I have touched bottom. I hope always to feel the responsibility to communicate the plight of others less fortunate than myself, to show the abused and those who administer the abuses, to point up the pain of the underprivileged as well as the pleasures of the privileged—somehow to evoke the same response from a house wife in Harlem as I would from a seamstress in Paris or a butcher in Vladivostok.

In helping one another we can ultimately save ourselves. We must give up silent watching and put our commitments into practice. We need miracles now, I am afraid. If only we could understand the needs of our past, then perhaps we could anticipate our future. We cannot get too comfortable in our houses. Wolves still roam the woods. The hawk still hangs in the air. And restless generals still talk of death in their secret rooms.

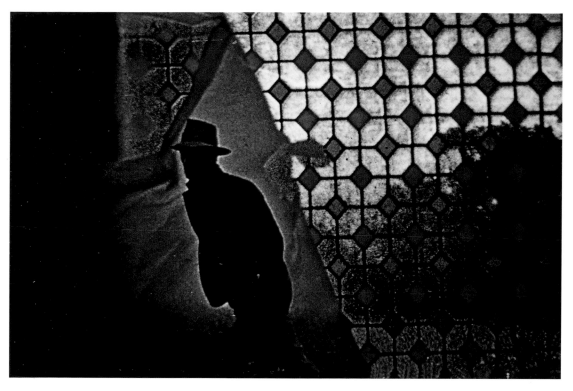

The Stranger, 1958

Dye transfer print, 12¼ x 18¾ inches
Purchase, 84.269

Robert F. Heinecken
American, 1931–

An influential educator regarding the use and theory of mixed materials, Heinecken demonstrates in his collage works an interest in media commentary and, often, in the consideration of explicit sexuality. He describes his works as being not "pictures of" something, but "objects about" a theme, combining elements of sculpture, drawing, and print-making to elaborate on the basic photographic message. In the early 1960s, Heinecken was responsible for introducing photography studies into the University of California at Los Angeles art department. Heinecken explains his work for this book.

Woman Contemplating Red was one of the first of six or seven pieces made over a one-year period using the same materials and basic premise. Most of the subsequent pieces utilized the underlying magazine collage in a more fractured and asymmetric way than this example and with a more specific topical cultural event (Vietnam, etc.). In *Woman Contemplating Red* the figure image in the film overlay tends to create an "accurate" silhouette rather than mixing with a conflicting magazine collage silhouette.

The four more-or-less horizontal bands correspond approximately to identifiable sections/parts of the figure and were selected to be read to represent clothing, anatomy, viscera or skin or, hopefully, combinations of these. My own exact motives for subject choices of the collage material are now rather vague—however, they are clearly symbols connoting fine, smooth texture (hair); pliable, glistening, sensual (raw meat, I think); hot, smoldering (charcoal coals); and clean, slippery, tactile (soap suds). As I write this, I realize that all are highly tactile and/or touch conscious. I also suspect that each surface could be used in any section with similar results—but, of course, different subjective associations would form.

The title was ideated after the piece was completed and is based on the downward gaze of the model, which I took to represent more simply overrational or self-awareness and, of course, the dominant color of reds. During this period I typically used titles which lead the viewer into a rather literary interpretation or association.

One final note—the negative used to make the film overlay was purchased from a mail-order catalog outfit in Los Angeles which provided images on undeveloped film (to keep the operation legal) by description but are unseen until developed by the purchaser. In this instance, the description might have been: #627 World War II type pin-up poses, frontal nudity, full figure, head looking down, Caucasian, Candy McLaughlin, one 120 roll, black and white, 12 different exposures, $6.00. This idea intrigued me because the figurative image is just another "found object" in the spirit of Dada like the magazine collage material. It is authentic and societal rather than subjective and personal, and of course it was less complicated than getting a friend and cheaper than hiring a professional model.

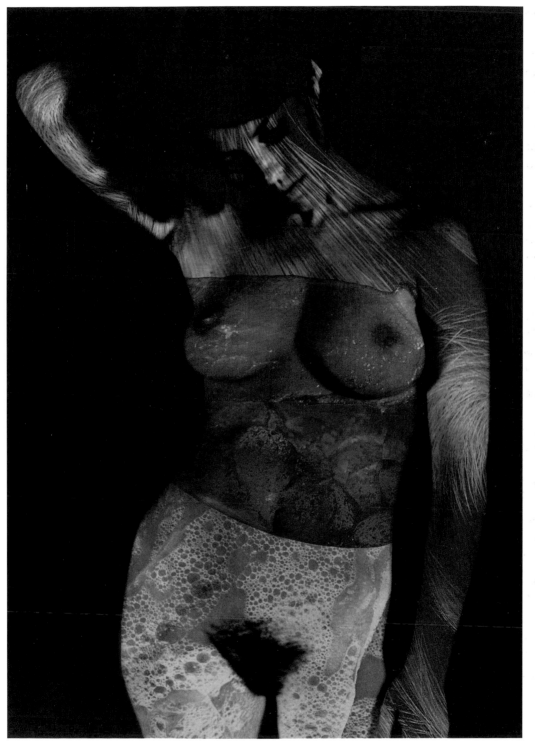

Woman Contemplating Red, 1966

Unique print (black-and-white film transparency over magazine collage), 17⅞ x 13 inches
The Family of Alice R. and Sol B. Frank

Eliot Porter
American, 1901–1990

Since taking his first photographs at the age of thirteen, Porter has become one of the most celebrated nature photographers of our time, and is credited with developing new methods of photographing wildlife. After pursuing a medical career, he turned his full attention to photography in 1939. In 1940, he began working in color in order to capture the subtleties of pigment in the plummage and leaves of his subjects. In 1979, Porter's images became the first color photographs to be shown at the Metropolitan Museum of Art; this text is taken from the catalog for that exhibition entitled *Intimate Landscapes*:

Though it is generally accepted that abstract art refers to those works inspired by the imagination of the artist rather than by objective reality, in photography, in which images are produced by the lens, this distinction is difficult to sustain. In the broadest sense of the term, an optical image is an abstraction from the natural world—a selected and isolated fragment of what stands before the camera. When the selected image is self-explanatory and does not imply more than what lies within its area it is usually referred to as abstract, that is, independent of its surroundings—a pattern of rock, for example, or lichens, or grasses. On the other hand, in the wider scenic view common in most landscape photography, the selected image implies a world outside the limits encompassed by the lens.

Photography of nature tends to be either centripetal or centrifugal. In the former, all elements of the picture converge toward a central point of interest to which the eye is repeatedly drawn. The centrifugal photograph is a more lively composition, like a sunburst, in which the eye is led to the corners and edges of the picture: the observer is thereby forced to consider what the photographer excluded in his selection.

I do not photograph for ulterior purposes. I photograph for the thing itself—for the photograph—without consideration of how it may be used. Some critics suggest that I make photographs primarily to promote conservation, but this allegation is far from the truth. Although my photographs may be used in this way, it is incidental to my original motive for making them which is first of all for personal aesthetic satisfaction....

Ultimately, to be successful as a work of art, a photograph must be both pleasing and convincing. It must not leave the viewer in doubt about the validity of its subject, whether representational or imaginary. Every part must contribute to the unity of the image from corner to corner—no discordant note should be permitted.

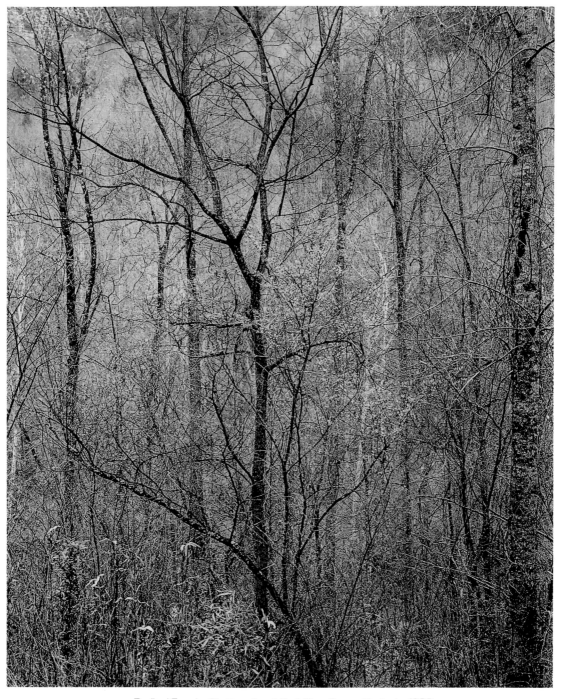

Redbud Tree in Bottom Land, Red River Gorge, Kentucky, 1968

Dye transfer print, 16 x 13½ inches
Horace W. Goldsmith Fund, 87.332

Larry Burrows
English, 1926–1971

While Burrows covered many arenas of war in his lifetime, he is perhaps best remembered for the painterly compositions of mass, light, and shade that he made over a period of nine years in Vietnam. Although he lived and worked in the field for stretches of time, Burrows planned his images, carrying heavy loads of equipment and setting up elaborate compositions. At times troubled by the horror depicted in his often hauntingly beautiful photographs, Burrows nonetheless felt compelled to record these scenes in order to combat indifference towards and ignorance of the war's devastation. He was a staff photographer for *Life* until his death in a helicopter crash in Laos. The following statement is from a 1969 BBC-TV film on Burrows entitled *Beautiful, Beautiful:*

Do I have the right to carry on working and leave a man suffering? To my mind, the answer is no, you have got to help him....

You cannot go through these elements without, obviously feeling something yourself—you cannot be mercenary in this way because it will make you less of a photographer....

There have been moments—yes—when your lips go dry, and...anybody who does not, does not have any fear, then he is a complete idiot....

You can't go out, as you see people. A hill near the DMZ, not so long ago, when suddenly, it was just after five o'clock as a matter of fact, in came some 122 rockets. People that you had seen alive just a few minutes ago, suddenly were dead; and you realize that it could have been you....

There was one particular story which was called "One Ride with Yankee Papa 13," which involved 17 helicopters, four of which were shot down, and quite a lot of people were killed and wounded.

We tried to rescue a pilot off a ship, and we were trapped between these two 30-caliber machine guns. The VC were on the tail of the downed helicopter. We landed alongside, the co-pilot from this downed ship, wounded, climbed on aboard.

The pilot on our ship gave word for Farley, who was the crew chief, to go and rescue the pilot—who was slumped over the controls. We could see him. Farley ran across, I ran after him, and

visually—the sound of gunfire, and with all that was happening—but trying to do it visually it was extremely difficult. It looked documentary. It was frustrating. But rather than go into a long story about that; the co-pilot who had climbed on to our ship had two bullet holes. One in the arm and one in the leg, and one we hadn't noticed, which was a third one, which was just under the armpit. And he died. The story came out in *Life* the following week. Some eighteen months later, the mother wrote to me. She said she had just seen another story which I did for the magazine. And she didn't really understand what I was trying to do or what I was trying to say—to be able to photograph death, to photograph the suffering. She said: "now, I understand, because of this last particular story which ran." And she said, "I want to thank you for whatever help you gave to my son, Jim, during the last moments of his life."

It was a very sad moment, a very touching moment, when our crew chief broke down—cried. Everybody was very tense, because everyone had suffered through it. And so often I wonder whether it is my right to capitalize, as I feel, so often, on the grief of others. But then I justify, in my own particular thoughts, by feeling that if I can contribute a little to the understanding of what others are going through, then there is a reason for doing it.

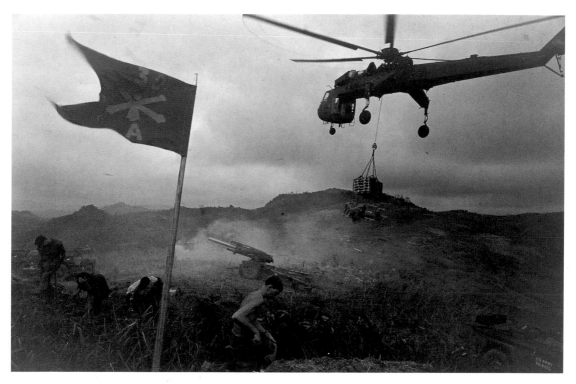

Ammunition Airlift into Besieged Khe Sahn, 1968

Dye transfer print, 1985, 11¾ x 18 inches
Horace W. Goldsmith and Art Purchase Funds, 86.76

Ernest C. Withers
American, 1922–

Enduring great personal risk, Withers became one of the most significant photographers of the Civil Rights movement. Working as a freelance photographer he sold his photographs to African-American newspapers around the United States. These images helped to make the battles of the movement known. His work includes players in the Negro Baseball League and the post-World War II burgeoning music scene along Beale Street in Memphis. Here he talks about his philosophy and specifically about his role during the sanitation workers strike that resulted in his iconic photograph *I Am A Man*.

I remember that G.C. Brown, myself, and one other fellow named Reverend Grant Harvey were the men that Revered Jackson sent down on Bellevue to rent a saw to cut the sticks for those signs. And G.C. Brown printed those "I AM A MAN" signs right over there at the Minimum Salary Building. I had a car and it was snowing, so we went and rented the saw and came back that night and cut the sticks. We cut them and nailed those "I AM A MAN" signs on them....

My mission as an African-American photographer was servicing all the Negro newspapers, in the country, some 10 to 15 papers give or take. Namely, the *Tri-State Defender* was my main thrust out of Memphis, *Atlanta Daily World*, *The New York Amsterdam News*, the *Cleveland Colored Post*, the *Afro-American* from Baltimore, *Jet* magazine. All of these people didn't get serviced by the wire services so they went in search for pictures....

I think my life really was shaped by the influences of men who came in those times and demanded service from me. I can think of 25 ministers, about 50 teachers, a number of people that were senior people in my church. I mean, my daddy didn't send me out to find role models. My dad was somewhat of a role model for me himself, but he always said look forward to a brighter day. Not as a photographer because one of the most disgusting things to my father was when I was a photographer. He wanted me to have a career as a postal worker, work my career, and retire. If I had done what he wanted...I would have worked my career in the post office and I'd be dead...so I think that just choosing this vocation gives me an inspiration to live.... I just use it as in a sense, to having a nose, ears, and eyes for living. Mr. Wilson [L. Alex Wilson of the *Tri-State Defender*] told me that the pledge of photography was "Is it true? Does it hurt? What good does it do?" I was not trained to be a junk photographer, but I had to shoot a lot of stuff that was unnecessarily hurting people. I never looked for the stinks of life. I always looked for a better life. I didn't have any idea 40 or 50 years ago that it would emerge to be what it has emerged to be. It was just being exploited by people, so many people exploited me out of the works that I had done. But it so happens that they usurped the image, used it, and faded away because it wasn't theirs. As I look through the magazines that I have, there comes a proud moment, one proud moment behind the other.

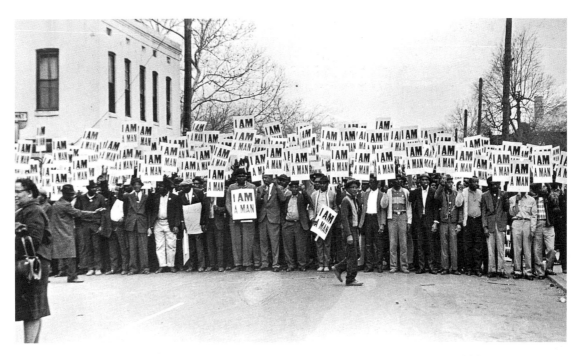

I Am A Man, Sanitation Workers Strike, Memphis, Tennessee, March 28, 1968

Gelatin-silver print, 1994, 10¾ x 18½ inches
Purchase, in memory of Alice R. and Sol B. Frank, and the Art Purchase Fund, 97.21.1

Larry Clark
American, 1943–

After working for his family's portrait business in Oklahoma from 1956 to 1961, Clark relocated to New York where he works as a photographer, artist, and filmmaker. His 1971 book, *Tulsa*, chronicled the lives of his Oklahoma friends in a world of depravation dictated by drugs, sex, and guns. In these images Clark is not a moralizing observer, but rather an active participant. For Clark the pictures are a form of autobiography. The following interview was published in the May/June 1992 issue of *Flash Art*:

I've been a photographer since I was a teenager. My mother was a baby photographer, going door to door. I always had my Rolleiflex and strobe with me because I was working for my parents. I never thought about photography in other terms, as art or anything. But then I went to a commercial photography school which happened to be in an art school. So I was exposed to kids who were doing art and to a lot of the documentary photography from the old *Life* magazine of the fifties when they were doing those great photo essays. Eugene Smith had quit *Life* because they wouldn't give him enough time to do the assignments. He was always writing these diatribes about the truth, and how he wanted to tell the truth, the truth, the truth. It was a real rebel position. It was kind of like a teenager's position: why can't things be like they should be? Why can't I do what I want? I latched on to that philosophy. One day I snapped, hey, you know, I know a story that no one's ever told, never seen, and I've lived it. It's my own story and my friends' story. I would go back to Oklahoma and start photographing my friends. That's when it snapped—I wanted to be a storyteller, tell a story. Which I hate even to admit to now, because I hate photojournalism so badly.

In the beginning, I was just trying to make photographs. Someone would come in and I'd see a light and shadow and recognize things that were dramatic. First of all, I was trained as a portrait photographer. And you've got to make people look good or you don't get your $10.95. Second, they're my friends and they're seeing the photographs as we go along. If you're coming back and showing them pictures where they don't look good, they're not going to want you to take their pictures anymore. Many photographers and photojournalists are great at grabbing the picture, being quick and focused and framing the composition, but they don't care what the people look like. I did. I could do all that plus get the person to look like I would like them to look, or they would like to look.

The shot of Billy on the bed with a gun, I always looked at that as like a baby picture. If you looked at some of the baby pictures my mother or I took, it could have been that pose. I didn't get it at first, but I knew it was great. It was a natural picture. With the white sheet in the background it could be a studio picture. I was able to get that quality when it was actually happening, that quality of looking set up. People often ask if I set these pictures up and then say, "No you couldn't have, but how did you get them to look like that?"

It [*Tulsa*] came out right after I finished it in 1971. The first section is 1963, the middle section is 1968, and then the last section is 1971. About half of the book is 1971. I went to Tulsa and did all those pictures in a matter of months. I knew every aspect of the life and knew what was missing from the book. I went back and was almost…waiting for those photographs to happen. I didn't know how they would happen but I knew I would be ready. It was a real hot period.

Billy Mann, Dead 1970, 1968, from *Tulsa*, 1971

Gelatin-silver print, 1980s, 12½ x 8¼ inches
Gift of Robert W. Pleasant, 86.386.34

Garry Winogrand
American, 1928–1984

Winogrand's quick and intricate observations of the social landscape and eloquent elaborations on the snapshot aesthetic prompted Museum of Modern Art (MOMA) curator John Szarkowski to label him "the central photographer of his generation." Winogrand's fundamental principle—"I photograph to find out what the world looks like photographed"—led him to make pictures at an astounding rate; when he died he left behind more than 300,000 unedited exposures. In 1963 Winogrand had the first of several solo exhibitions at MOMA, including a large-scale posthumous retrospective in 1988; he was also included in that museum's 1967 exhibition, *New Documents* with Diane Arbus and Lee Friedlander. In 1974 Winogrand wrote the following essay about his work, entitled "Understanding Still Photographs":

There is nothing as mysterious as a fact clearly described. What I write here is a description of what I have come to understand about photography, from photographing and from looking at photographs.

A work of art is that thing whose form and content are organic to the tools and materials that made it. Still photography is a chemical, mechanical process. Literal description, or the illusion of literal description, is what the tools and materials of still photography do better than any other graphic medium. A still photograph is the illusion of a literal description of how a camera saw a piece of time and space. Understanding this, one can postulate the following theorem: Anything and all things are photographable.

A photograph can only look like how the camera saw what was photographed. Or, how the camera saw the piece of time and space is responsible for how the photograph looks. Therefore, a photograph can look any way. Or there's no way a photograph has to look (beyond being an illusion of a literal description). Or, there are no external or abstract or preconceived rules of design that can apply to still photographs.

I like to think of photographing as a two-way act of respect. Respect for the medium, by letting it do what it does best, describe. And respect for the subject, by describing it as it is. A photograph must be responsible to both.

I photograph to see what things look like photographed.

Woman with Ice Cream Cone, New York City, 1968

Gelatin-silver print, 8¾ x 13¼ inches
The Family of Alice R. and Sol B. Frank

Robert Adams
American, 1937–

In both his writings on photography and his gently persuasive images of man-altered western American landscapes, Adams manifests an acute awareness of, and desire for, beauty in the face of change. His work, along with that of Lewis Baltz, Frank Gohlke, and others was included in the important 1975 exhibition *New Topographics* at the George Eastman House, a show that explored the transformative effects of human culture on nature. In his 1974 monograph, *The New West*, Adams explained his peculiar approach to photographing the landscape.

Many have asked, pointing incredulously toward a sweep of tract homes and billboards, why picture that? The question sounds simple, but it implies a difficult issue—why open our eyes anywhere but in undamaged places like national parks?

One reason is, of course, that we do not live in parks, that we need to improve things at home, and that to do it we have to see the facts without blinking. We need to watch, for example, as an old woman, alone, is forced to carry her groceries in August heat over a fifty acre parking lot; then we know, safe from the comforting lies of profiteers, that we must begin again....

The subject of these pictures is, in this sense, not tract homes or freeways but the source of all form, light. The Front Range is astonishing because it is overspread with light of such richness that banality is impossible. Even subdivisions, which we hate for the obscenity of the speculator's greed, are at certain times of day transformed to a dry, cold brilliance.

Towns, many now suggest, are intrusions on sacred landscapes, and who can deny it, looking at the squalor we have laid across America? But even as we see the harm of our work and determine to correct it, we also see that nothing can, in the last analysis, intrude. Nothing permanently diminishes the affirmation of the sun.

Along Interstate 25, 1968

Gelatin-silver print, 5½ x 6 inches
The Family of Alice R. and Sol B. Frank

Lee Friedlander
American, 1934–

Friedlander's photographs of cityscapes, monuments, vegetation, social events, and industrial sites reveal a highly sophisticated vision presented in a seemingly haphazard fashion. He also has substantial bodies of work covering nudes, jazz musicians, and self-portraits. His work appeared in the important *New Documents* show at the Museum of Modern Art in 1967 (with Garry Winogrand and Diane Arbus), helping to define the new photographic genre of social landscape. Friedlander was also responsible for saving and printing the work of the New Orleans photographer E.J. Bellocq in 1968. In the introduction to his 1970 monograph *Self Portrait*, he writes:

I suspect it is for one's self-interest that one looks at one's surroundings and one's self. This search is personally born and is indeed my reason and motive for making photographs. The camera is not merely a reflecting pool and the photographs are not exactly the mirror, mirror on the wall that speaks with a twisted tongue. Witness is borne and puzzles come together at the photographic moment which is very simple and complete. The mind-finger presses the release on the silly machine and it stops time and holds what its jaw can encompass and what the light will stain. That moment when the landscape speaks to the observer.

Knoxville, 1971

Gelatin-silver print, 7 x 11 inches
The Family of Alice R. and Sol B. Frank

Jun Shiraoka
Japanese, 1944–

Shiraoka became interested in photography while working as a physics lecturer in Japan. In the 1970s, he went to New York for further photographic study, and in 1980 moved to Paris where he still lives today. While Shiraoka's photographs contain elements of both French and American sensibilities, his strongest influences are the art and Zen philosophy of Japan. His dark, ambiguous images force the viewer to look carefully in order to discern their contents. This statement comes from the catalogue of Shiraoka's first American solo exhibition in 1988. In it, Shiraoka comments on the personal nature of his images:

Ambiguity, uncertainty, clearness. Look, only look. To see, to see oneself, to be seen, what does it mean...?

I grew up in Japan, so my pictures may be Japanese in a way, even the pictures which I took outside of Japan. For instance, the weather in Japan is different from elsewhere. Perceptions are different in the West and in the East. The moon is a very important object in Japanese literature, but not in English literature. In painting, some Western painters paint the shadow, and some Oriental painters paint the mist. And the ways of painting perspective in two dimensions have been different in Japan and the West. But I want to see and look for a Universal image in the photograph, which not only means the same image in the West and in the East, but also that the image should be an eternal image which will not go out of fashion. I think that this is the reality which I am seeking.

I don't care about the composition of a picture. I just take a picture of a subject as I see it in front of me. I don't intend to explain a subject by its photograph, nor do I intend to give information about a subject by its photograph. Before I take a photograph, I never think what, how or why I am going to take a picture. I always carry a 35mm camera. And just when I feel something in what I am seeing in front of me, I try to capture an image of it on film. I want to capture on film the feeling which I feel, for example, when a light breeze blows on the beach at the end of summer. What does not exist for the senses, does not exist in the intellect.... I shoot when I see myself in an image and the image in myself. To take a photograph to me is to objectify myself in the photograph. I take photographs to fill an emptiness in my life. I will never fill the emptiness. I will just go on taking pictures. These images might be my personal illusions, and they might be my personal obsessions.

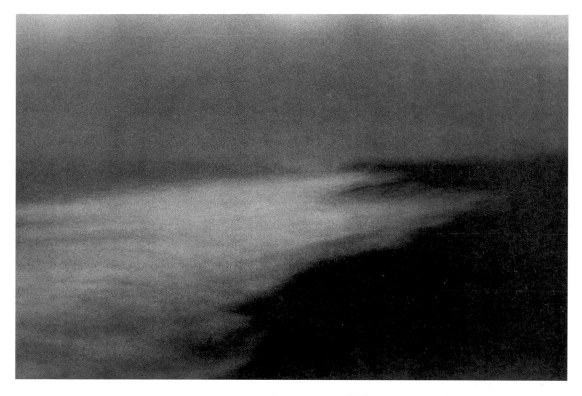

Shimizu, Japan, summer 1969

Gelatin-silver print, 1987, 9½ x 14¼ inches
Horace W. Goldsmith Fund, 86.391

Josef Sudek
Czechoslovakian, 1896–1976

Sudek's lyrical images, simple and intimate renderings of small details and private moments, have earned him the title "the Poet of Prague." After 1926, Sudek never traveled outside of Czechoslovakia. His work was shown in a major 1936 exhibition in Prague with that of Moholy-Nagy, Man Ray, John Heartfield and Aleksandr Rodchenko; in 1961 he was the first photographer honored by the Czech government as an "Artist of Merit." Two of his major bodies of work are series called *Windows* and *Magic Gardens*. This statement is from the book, *Sudek*.

I print my photographs exactly the way a graphic artist prints the engraving or the etching on his printing press. I want nothing else but that the camera with its lens delivers what I myself put in front of it....

I have no particular leaning toward...the all too-clearly defined; I prefer the living, the vital, and life is very different from geometry; simplified security has no place in life.

Everything around us, dead or alive, in the eyes of a crazy photographer mysteriously takes on many variations, so that a seemingly dead object comes to life through light or by its surrounding. And if the photographer has a bit of sense in his head maybe he is able to capture some of this—and I suppose that's lyricism.

When a person likes his profession and tries hard to overcome the difficulties that are connected with it, then he is glad if at least something of what he tried to do succeeds. I think that is enough for a lifetime. And while you're at it you work up a real sweat and that's a bonus....

I never cease to be surprised at young people's interest in my pictures. I can only explain it in the context of a certain longing for romanticism, for good old craftsmanship. But that will pass, and in a few years their interest will lie somewhere different. But prophesies are always risky. The critics of my generation never visualized photography as an independent branch of art; today this is accepted as a matter of course.

I don't like the discussions about whether photography is an art. Even though I think that if it would be just a craft I would not have stayed with it all my life....

This profession does not have a long tradition. A hundred years? What is that? A lot depends on skill. Until now it is not possible to photograph with the eyes only. When I want to accomplish something I do it all alone. That's why I don't go into color photography, that is a complicated profession that I don't know. To have one's material developed elsewhere, that would bother me....

I believe a lot in instinct. One should never dull it by wanting to know everything.

One shouldn't ask too many questions but do what one does properly, never rush, and never torment oneself.

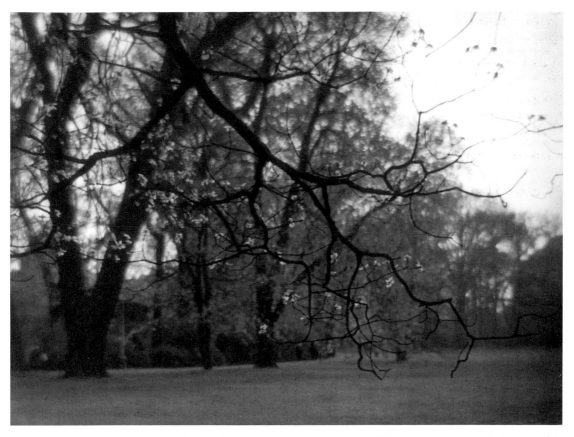

View of Trees from the Beautiful Park, 1971

Gelatin-silver print, 6¾ x 9¼ inches
The Family of Alice R. and Sol B. Frank

Paul Caponigro
American, 1932–

Caponigro's ongoing love for music can be sensed in his mystical, poetic photographs of nature. He depicts both details and the wider landscape in masterful black-and-white prints. Minor White, his major influence, published many of Caponigro's photographs in *Aperture* magazine in the 1960s. Caponigro is also widely experienced as a teacher, having led courses at Yale, Princeton, Boston University, and New York University. This statement is from the preface to his 1983 book *The Wise Silence*.

In my years of Photography I have learned that many things can be sensed, seen, shaped, or resolved in a realm of quiet, well in advance of, or between, the actual clicking of shutters and the sloshing of films and papers in chemical solutions. I work to attain a "state of heart," a gentle space offering inspirational substance that could purify one's vision. Photography, like music, must be born in the unmanifest world of spirit.

For me, intellectual manipulations, forced combining elements in the name of design, even the best arrangements of the mind are of limited value in this realm of beauty. I strive to undo my reactions to civilization's syncopated demands and hope that inner peace, quiet, and lack of concern for specific results may enable a stance of gratitude and balance—a receptiveness that will allow the participation of grace. This meditative form of inaction has been my true realm of creative action. A dynamic and vital seeing is my aim.

I do not necessarily visualize complete images, but rather, my intent is to sense an emotional shape or grasp some inner visitation. My wish is to partake of the "hush" experienced on first glimpse of the Unicorn in the wood. The stuff of mythology and the substance of earth's atmosphere are of the intangible. The magic brought forth by such images as the Unicorn is also available in that solid place we refer to as the real world. It is my conviction that the earth and all its manifestations contain this magic. Who has not, at certain times and in certain terrain, felt the stillness of atmosphere that places a hush on the land? And who has not been affected by that unique agitation generated by the light of the full moon? Permeating the arid deserts and attending the cyclic lappings of water at the shores of seas and lakes is the pulse and breath of earth itself. Even as I have passed through museum halls lined with the efforts of artists and craftsmen from many ages, I have felt that same thrill of vital life emanate from a truly great work of art. Achieve the mystery of stillness, and you can experience a dynamic interaction with the life force that goes far beyond intellectual thought and touches the deepest wells of existence.

I would like to think that I am approximately, in my middle years of working as a photographer and that I have time to continue. I am most grateful for the discovery and conviction that the real working is internal. Calm and inner stillness are for me essential companions to the activity of my craft.

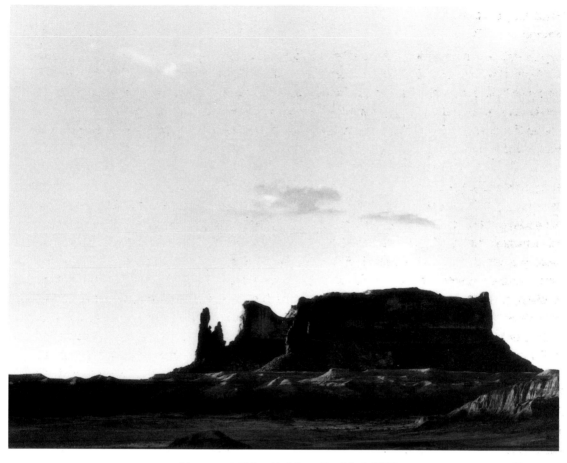

Monument Valley, Utah from *Portfolio II*, 1970

Gelatin-silver print, 6¾ x 8½ inches
The Family of Alice R. and Sol B. Frank

William Clift
American, 1944–

Through extremely fine black-and-white printing techniques, Clift depicts western American land-scapes suffused with a romantic, nostalgic atmosphere that has immediate tangibility and emotional impact. Though he is primarily self-taught, he was influenced by the work of Paul Caponigro. Clift is also noted for his architectural photography; in 1975–1976 he was commissioned to participate in a bicentennial documentation of American court houses. In contrast to the image reproduced here, his usual manner of working compels him to spend extended periods of time studying a sub-ject before photographing it. Clift wrote the following statement in November 1986, for inclusion in this book.

I took this picture during a trip into Southern Colorado in 1975. That year I was very much con-centrated on photographing American county courthouses for the Joseph Seagram Bicentennial Project. Thus, I was on my way along a dirt road towards a fairly small town in the mountains named Lake City, the county seat of Hinsdale County, Colorado. As was not my custom at the time, I stopped along the way and made this pic-ture. I was struck by this view, which must have similarly impressed many others who passed before and after me. For some reason or other, this rather straightforward photograph has continued to inter-est me over the past ten or so years.

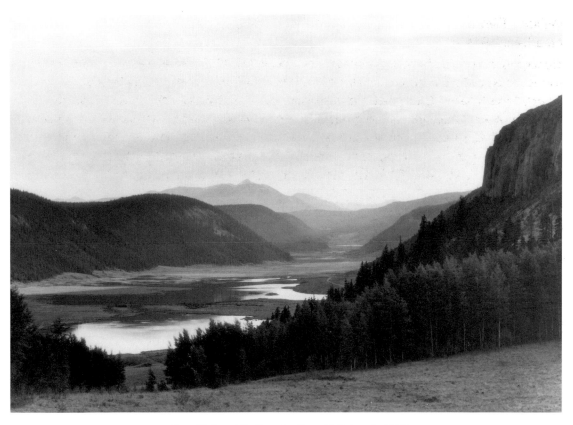

Trout Rising, Rio Grande, Pyramid, Colorado, 1975

Gelatin-silver print, 6¾ x 9½ inches
The Family of Alice R. and Sol B. Frank

William Wegman
American, 1943–

Wegman's decision to name his much-documented pet Weimaraner "Man Ray" is an apt indication of the wit and art-historical reflexivity of Wegman's work. Like the earlier artist, Wegman fluidly switches media, creating drawings and video performance pieces as well as photographs. His imaginative and whimsical portraits of humans and canines were among the first conceptualist-influenced artworks to cross over into the largely formalist photography of the early 1970s and were included in the important 1975 exhibition *The Extended Document* at the George Eastman House. He has continued to photograph Weimaraners in various absurd and provocative situations. In a statement prepared for this book, Wegman says:

I liked to photograph Man Ray on the blue couch we shared from 1970 to 1982. It was also a reoccurring prop in many video pieces throughout this period. He always seemed comfortable there.

Watchful as always while working, I placed a large white museum board against him thinking I would draw or write something on it after. I liked that his fur overlapped the card breaking the illusion that its blankness was "trick photography"—but also playing with the notion.

Nothing became of this picture until after Ray died and I began to look at all the prints and negatives. The thought occurred to make a double portrait with this and another image. After trial and error, the youthful, early-70s, three-quarter portrait was selected and *Double Portrait* was made.

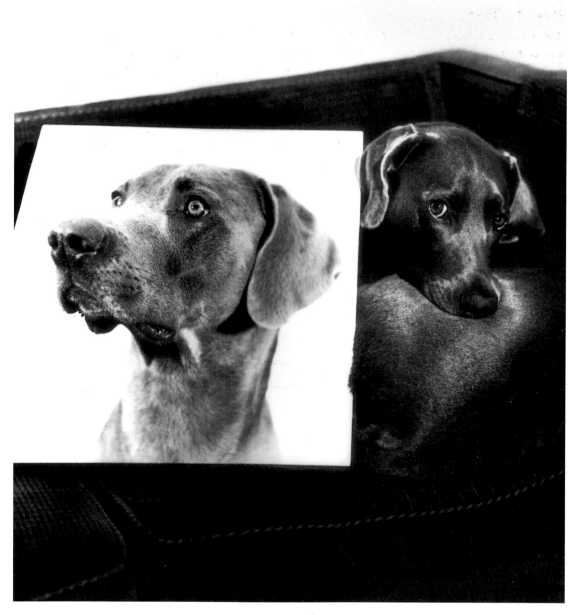

Double Portrait, Plate 7 from *Man Ray* portfolio, 1973–81

Gelatin-silver print, 7¼ x 7 inches
The Family of Alice R. and Sol B. Frank

Robert Cumming
American, 1943–

A highly influential teacher and visual arts theorist in the 1970s, Cumming is widely recognized for his painting and sculpture as well as his photography. His work often uses the diptych form, conveying through pairs of manipulated images a series of questions that challenge how one decodes information through photographs. Cumming often draws on facts of science, engineering, and comparative analysis to validate his fictive, conceptual descriptions of photographic transformations. Cumming submitted this statement for publication in this book:

As an Easterner and newcomer to Southern California in 1970 I was unfamiliar with the level of illusionism in the environment. *It Was Around Dinner When The Ball Went Through The Screen* was one in a series of photo-sculptural works that began to register my thoughts on this subject. Between roughly 1973 and 1978, I produced many such pieces that resembled the vacant set photographs I'd been digging up in the movie still shops in Hollywood.

In this instance, the wood clapboard and window are a half-sized facade, a generic suburban front I'd built to function as backdrop for a number of pieces. The person and interior are a slide projection of a photo I'd taken of artist and friend Bill Wegman in Chicago five years earlier. The ball is of styrofoam and stuck on a piece of wire anchored in the window frame and the window screen is a hand-drawn grid made by scratching the large eight by ten inch negative with a needle.

It was one of a dozen similar "accident" photo tableaus woven into a broader fictional setting in 1975 in *Discourse on Domestic Disorder* (self-published, Anaheim, California).

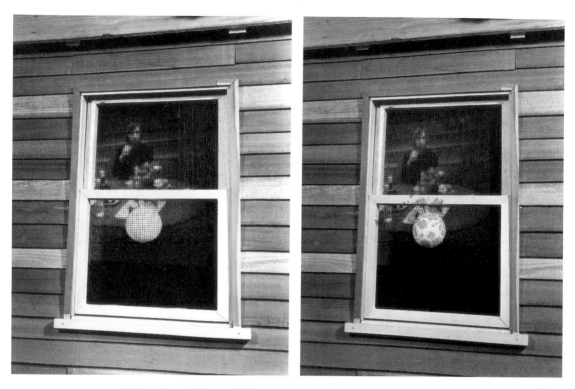

It Was Around Dinner When the Ball Went Through the Screen, 1974

Gelatin-silver prints, 9⅝ x 7⅝ inches each
The Family of Alice R. and Sol B. Frank

Duane Michals
American, 1932–

The principal concern of Michals's work is expanding the narrative capacity of photography. Drawing from Surrealism, Magritte, and Zen Buddhism, Michals stages events which allow, through captions and/or sequenced images, a mixture of mundane and fantastic elements to communicate psycho-dramatic stories. Along with Friedlander, Winogrand, and Davidson, Michals's work was included in the important 1966 exhibition "Toward a Social Landscape" at the George Eastman House. For this book, Michals wrote the following:

I really don't care what my father looked like, and I'm sure you don't very much either. What is important however, is what did or did not transpire between us. That lack of communication, love, conflict is my legacy, my history. This is what matters to me, and this is what I want to share with you. I write with this photograph not to tell you what you can see, rather to express what is invisible. I write to express these feelings. We are our feelings. Photography deals exquisitely with appearances, but nothing is what it appears to be.

A LETTER FROM MY FATHER

As long as I can remember, my father always said that one day he would write me a very special letter. But he never mentioned what the letter would be about. I used to try to guess what family secret the two of us would at last share, what intimacy, what mystery could now

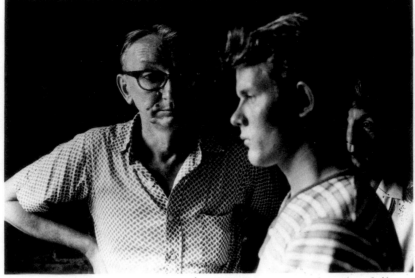

be revealed. I know what I hoped would be in the letter. I wanted him to tell me where he had hidden his affections. But then he died, and the letter never did arrive. And I never found that place where he had hidden his love.

A Letter From My Father, 1960–75

Gelatin-silver print with text, 8 x 10 inches
The Family of Alice R. and Sol B. Frank

Irving Penn
American, 1917–

Penn's elegant, graphically reduced fashion, celebrity, and still life photographs have, since the mid-1940s, defined the peak of high-style image-making. Penn has also extended his formal vision to informal subjects, treating fringe characters, cast-off objects, nudes, and ethnographic studies with the cool distance, descriptive use of white space and exquisite prints characteristic of his work for *Vogue*. This statement was selected by Penn for inclusion in this book and is from his introduction to *Worlds In a Small Room*, 1974.

I share with many people the feeling that there is a sweetness and constancy to light that falls into a studio from the north sky that sets it beyond any other illumination. It is a fight of such penetrating clarity that even a simple object lying by chance in such a light takes on an inner glow, almost a voluptuousness. This cold north light has a quality which painters have always admired, and which the early studio photographers made the fullest use of. It is this light that makes some of these early studio portraits sing with an intensity not bettered by later photographers with more sophisticated means at hand. Electric lights are a convenience but they are used, I believe, at the expense of that simple three-dimensional clarity, that absolute existence that a subject has standing before a camera in a north-light studio.

Mud Glove, December 1975

Platinum/palladium print, 29 x 21 inches
The Family of Alice R. and Sol B. Frank

Robert Mapplethorpe
American, 1947–1989

Mapplethorpe studied drawing and painting before experimenting with a Polaroid camera in the early 1970s. Many of his first photographs, which are portraits of his artist and socialite friends, were taken in a style similar to that of Andy Warhol whose work he admired. His attention to the formal elements of composition and contrast is evident in his flower arrangements and nudes, as well as in his more confrontational depictions of eroticism and male sexuality. These statements, from a 1987 interview, reveal Mapplethorpe's concerns with approach and style:

I think the pictures I take dealing with sexuality are probably the most potent of pictures that I have ever taken. They are the pictures that people remember more because they are unique. They also stand out from the rest because they somehow reflect the impact of an inner feeling of sexuality. They are more intense, though I don't think they're any more important than my other pictures. Sometimes, though, they are the only ones people remember....

The way I approach art in general—I take it as it is. I don't come to it with prejudice. It's like when I photograph celebrities. I often don't know who these people are until the moment I meet them. I don't have this pedestal notion that I think a lot of photographers have when they photograph celebrities. They go in thinking how important it is that they are photographing so and so. I often don't know who these people are. It's not that important to me and I think it is a great advantage to approach things that way. I think it's given me access to a lot of people because I'm not in awe of anybody and I never have been. I'm just not the kind of person who has heroes. I never had heroes....

Remember I knew nothing about the history of photography at that point [when he started photographing]. It's interesting because my style was developed even before I knew who Steichen or Stieglitz was. It was like, I had a way of seeing and that was it. That's not to say that over the years having studied has not helped me define what my photography is about. I think that it was a great advantage to go into photography not knowing much about it. Not thinking. I think one of the problems with many photographers today is that they never see for themselves, but just like everybody else....

Photographers are usually terrible about editing. But it's part of being an artist. It's one of the objections I have to these young painters. Every doodle they do they put out there. I think I could do your portrait and maybe choose the two best pictures and convince you in the end that they are the right ones. They may not be the prettiest of pictures, but there is a certain kind of thing that comes out of them....

I believe in certain kinds of magic. Sort of an abstract energy concept. I think there's a magic that can invest in photography sessions. It's not about the fact that I know more about photography, but that I can muster up this certain kind of thing that makes a great picture. Even when my assistants do virtually all the work the picture still has me in it.

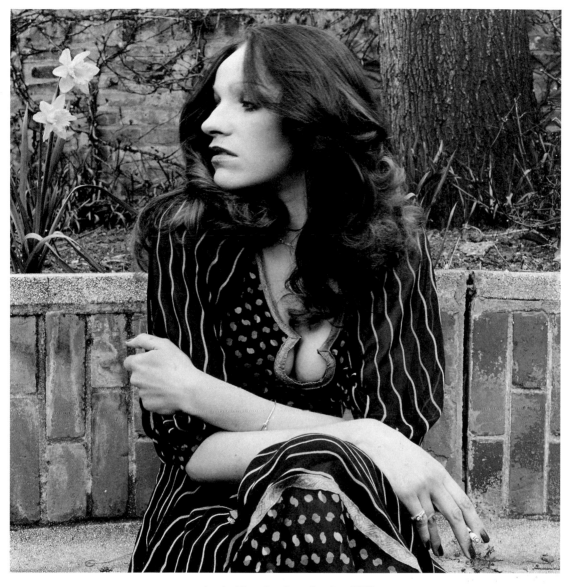

Lady Rose Lambton, London, 1976

Gelatin-silver print, 13⅞ x 13⅞ inches
Gift of the artist, 78.418b

William Eggleston
American, 1939–

Eggleston's 1976 solo exhibition at New York's Museum of Modern Art and the publication of *William Eggleston's Guide* established him as *the* seminal color photographer. Using a snapshot aesthetic associated with the amateur photographer, Eggleston focused attention on the banal emptiness of American culture as expressed in its architecture and environment. With well-composed views and prints with saturated, beautiful color, he elevated the ordinary to a higher standard. Recently, Eggleston has exhibited black-and-white photography, displaying the same kind of vision even without the use of color. This text is drawn from his book *The Democratic Forest*.

I was having dinner with some friends, writers from around Oxford, or maybe at the bar of the Holiday Inn, [and] someone said, "What have you been photographing here today, Eggleston?"

"Well, I've been photographing democratically," I replied.

"But what have you been taking pictures of?"

"I've been outdoors, nowhere, in nothing."

"What do you mean?"

"Well, just woods and dirt, a little asphalt here and there."

I was treating things democratically, which of course didn't mean a thing to the people I was talking to. I already had different, massive series. I had been to Berlin and to Pittsburgh and completed huge bodies of work. From that moment everything from the boxes of thousands of prints made cohesive sense for the first time. All the work from this period from 1983 to 1986 was unified by the democracy. Friends would ask what I was doing and I would tell them that I was working on a project with several thousand prints. They would laugh but I would be dead serious. At least I had found a friend in that title, *The Democratic Forest*, that would look over me. It was not much different from Cartier-Bresson bringing the whole world from America to China to *The Decisive Moment*.

I had picked up *The Decisive Moment* years ago when I was already making prints, so the first thing I noticed was the tonal quality of the black and white. There were no shadow areas that were totally black, where you couldn't make out what was in them, and there were no totally white areas. It was only later that I was struck by the wonderful, correct, composition and framing. This was apparent through the tones of the printed book. I later found some actual prints of the same pictures in New York. They were nothing—just ordinary looking photographs, but they were the same pictures I had worshipped and idolized, yet I wouldn't have given ten cents for them. I still go back to the book every couple of years and I know it is the tones that make the composition come across.

I am afraid that there are more people than I can imagine who can go no further than appreciating a picture that is a rectangle with an object in the middle of it, which they can identify. They don't care what is around the object as long as nothing interferes with the object itself, right in the centre. Even after the lessons of Winogrand and Friedlander, they don't get it. They respect their work because they are told by respectable institutions that they are important artists, but what they really want to see is a picture with a figure or an object in the middle of it. They want something obvious. The blindness is apparent when someone lets slip the word "snapshot." Ignorance can always be covered by "snapshot." The word has never had any meaning. I am at war with the obvious.

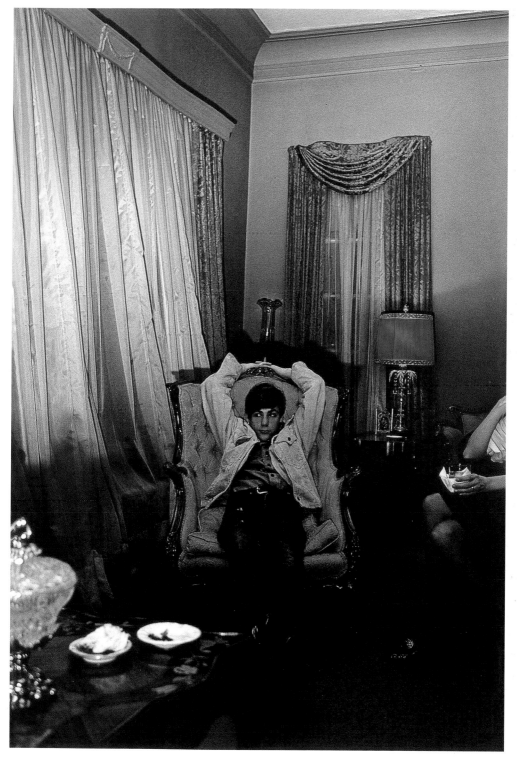

Sumner, Mississippi, ca. 1972

Dye transfer print, 24¾ x 18½ inches
Purchase and National Endowment for the Arts Grant, 89.88

Olivia Parker
American, 1941–

Emerging from a background as a painter, Parker began in 1970 to use traditional photographic materials and processes (large-format negatives, toned contact prints) to convey images of found object assemblages. Through her photographs, executed in both black and white and color, Parker creates mythic frames for symbol and allusion. This statement, written in 1984, was submitted by Parker for this book.

For ten years I have been investigating the human implications of objects and the visual mental structures people have devised at various times in order to attempt an understanding of the unknown.

To explore the human implications of objects, texts, markings and other possible indicators I must find ways of changing the obvious references of subjects. My intention is not to document objects but to see them in a new context where they take on a presence dependent on the world of each photograph. Often I use old objects, for as the Polish artist Magdalena Abakanowicz said: "I am much more interested in an old piece of burlap than a new one, for the beauty of an object is to me, in the quantity of information I can get from it, the stories it has to tell." If I use new or organic materials, they only become interesting in context; a flower and a machine part must act on each other....

I have mentioned my interests. My means are photographic. I do not save my constructions as permanent pieces, because their wholeness is too dependent on light and the nature of my photographic materials. By working in both black and white and color, I have a range suited to the subtleties I seek to explore. Also, although we think of photography as more "real" than the other visual arts, it allows for transformation of objects in ways I find especially interesting. The substance of an object can be altered by removing it part ways through an exposure. Light can change forms and structure. Objects or figures can exist as shadows yielding only some of their information to a piece. Color can be the color of an object as we think of it, the color of light around an object, or a new color caused by filtration, additional projected colored light, or the peculiar way a certain film and print material see color. Although my work may move close to the other visual arts in that I make what I photograph, it remains purely photographic in its final form.

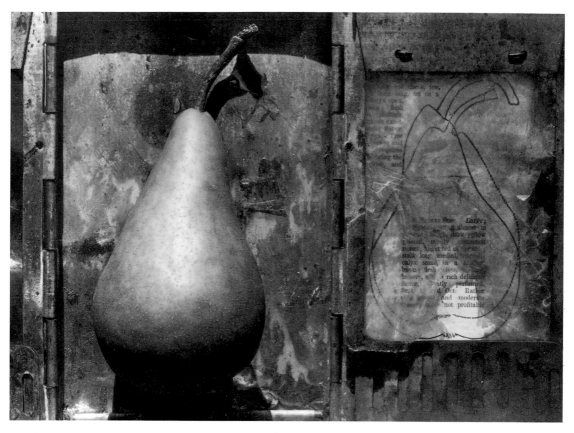

Bosc, 1977

Selenium-toned gelatin-silver print, 4¾ x 6⅝ inches
The Family of Alice R. and Sol B. Frank

Jan Groover
American, 1943–

In her ongoing exploration of photography's formal conventions and limitations Groover, who worked in painting and drawing during the 1960s, has utilized numerous techniques and experimented with a variety of subjects. Her work in the early 1970s involved color triptychs of architectural details and urban scenes; subsequently she made color images of intricate kitchen utensil still lifes, platinum prints of cityscapes, close-up portraits and table-top arrangements of found objects. In each project, Groover seeks to ascertain the ideal balance between style and substance in the print. This statement is taken from an interview originally published in the Akron Art Institute's *Dialogue*, 1979.

I was fortunate to have the understanding of the silverware business when I did. It's such wonderful stuff. It reflects everything all the time. It's so liquid in terms of its ability to pick things up. It's so transformable; a knife can be a knife and a color too. It can be a silver knife next to a silver bowl, and another knife next to it can be pink. I like that kind of visual switch.

How do I get the different colors? I have a very funny lowered ceiling right over my still-life table. Generally to get enough light on the still life you have to bounce light off all kinds of things. You can't use direct light because direct light on the silverware makes an ugly glare.... I found you can position certain colored cloths, or plants, or whatever out there so that you can make the color in them reflect on one thing and not another, or on all things except one by having different tilts and angles of reflection. I bounce the light off the color and position the color exactly where I want it to hit on a reflected surface. It's using them like mirrors....

The activity of looking at a photograph is that you are looking at something; it's like looking at a tree or looking at a painting. I care about how something looks and I make pictures that show that care in some way or another.

I think one of the things that has irritated me about Photography is the intellectual lack of wanting to talk about pictures as pictures instead of all this talk about subject matter. I think a lot of photographers are pictorially illiterate.... When people ask about a painting they don't necessarily say it is about a house; yet, in photography, that is the general usage and I don't like that because it is so limited....

One of the hardest things in life and art is to know what you want. It seems to me that the business of making art is to push toward—I always feel weak saying it, although I know it is the truth when I think about it—is that you are always pushing to find out what you want out of a situation, and it is not anything knowable until you know it.

You can't have a game plan except in working. Photography is a fluid activity; it's not a football game.

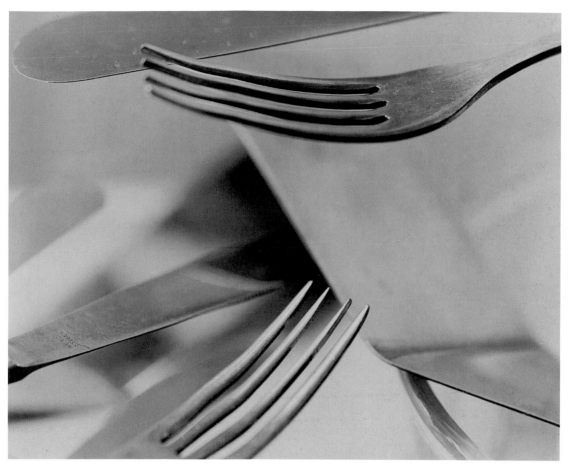

Untitled, 1978

Chromogenic print, 14¾ x 18¾ inches
The Family of Alice R. and Sol B. Frank

Joel Sternfeld
American, 1944–

Using an 8-x-10-inch view camera, Sternfeld photographs the meeting places of humans and nature, capturing the effects of technology on the landscape, and the ways in which landscape has influenced the advance of civilization. Often his images are filled with irony and surprise as he explores aspects of ordinary life. In this exploration Sternfeld also looked back to the photographic documents of 1930s America taken by artists such as Walker Evans. Sternfeld's photographs allow us to see the beauty of our landscape while acknowledging the price we pay for technology. The following statement was selected by the artist for this book:

In the spring of 1978 I received a Guggenheim Fellowship to continue a series of street photographs. But the award and the possibilities it created encouraged a change in my work.

All at once it seemed as if the entire continent, every region, every season, and every photographic means were within reach.

In time the thematic structure of a new body of work emerged.

Although I was only thirty-three years old, I had the sense of having been born in one era and surviving to another. The photographs which I made represent the efforts of someone who grew up with a vision of classical regional America and the order it seemed to contain, to find beauty and harmony in an increasingly uniform, technological and disturbing America.

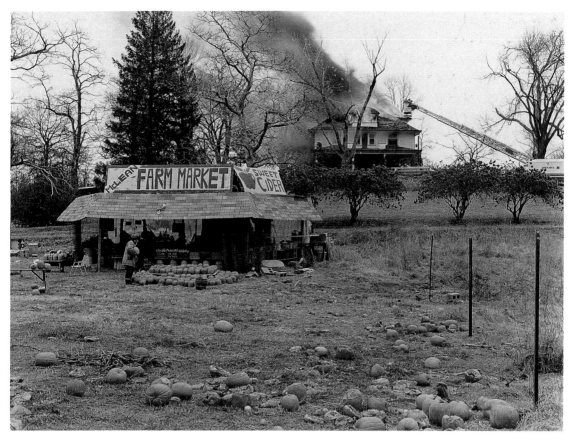

McLean, Virginia, December 4, 1978

Dye transfer print, 15 x 19½ inches
Horace W. Goldsmith Fund, 84.270

George Tice
American, 1938–

A self-taught photographer, Tice has been working in photography since he was fourteen years old. A master technician, he frequently uses the 8-x-10-inch view camera and is largely responsible for the resurgence of interest in the platinum printing process. Tice works with the extended photo-essay and has published more than a dozen books of his photographs, including *Fields of Peace: A Pennsylvania German Album* (1970), *Paterson* (1972), *Urban Landscapes: A New Jersey Portrait* (1975), and *Hometowns: An American Pilgrimage* (1988). Tice submitted this statement about the creation of *From the Chrysler Building*:

My photograph *From the Chrysler Building* resulted from a commission I received from the Association for a Better New York. It was their purpose to create and publish a series of posters on the theme—"New York, New York." I was free to present my own concept of the city. Because of the official nature of my commission, I thought I might gain access to vantage points that I could not on my own.

I started thinking about photographing the city from a skyscraper and that idea brought to mind a 1934 photograph by Oscar Grauber of Margaret Bourke-White perched atop a gargoyle jutting off the 61st floor of the Chrysler Building. She is depicted aiming her Graflex camera at something higher.

I informed the Association of my idea to photograph from the Chrysler Building, and they paved the way and obtained the permission needed. They also took out an insurance policy on my life. I remember photographing with the policy sticking out my back pocket.

To approach the gargoyles I had to climb out an office window with my view camera to a walkway. Once up there, I realized I had a larger choice of eagles than I had thought. Instead of the four I anticipated, there were eight. Juxtaposed against the city, each provided different views. I passed several hours of a sunny June day studying the various compositions presented by each gargoyle as the light changed. Finally, I selected a view looking past the Lincoln building toward New Jersey, whereby I could include the people and traffic on the streets below.

After developing my film, I was pleased with the composition, but I did not like the harsh effects produced by direct sunlight. A week later, on a grey day, I returned to the Chrysler Building's 61st floor and took it again.

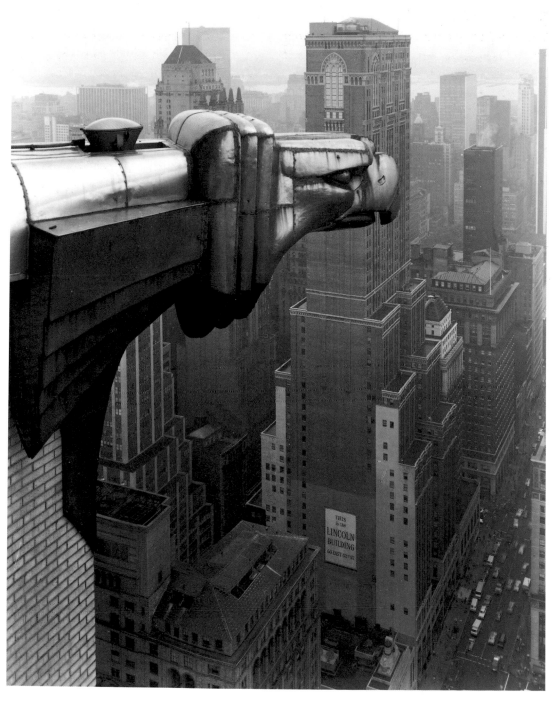

From the Chrysler Building, New York, 1978

Gelatin-silver print, 19⅜ x 15⅜ inches
Purchase, 86.203

John Pfahl
American, 1939–

Pfahl's photographic projects combine the conceptual and the pictorial in an effort to understand the effects of human intervention on nature; this is especially true of *Altered Landscapes,* his first body of substantial work made in the mid-1970s. His series entitled *Picture Windows,* taken between 1978 and 1981, continues Pfahl's exploration of the nature of perception by creating pictures within pictures, using views of "picture window" themes seen through the frames that surround them. Pfahl's work—including later series such as *Power Places* and *Smoke*—offers provocative views of contemporary landscape which challenge traditional portrayals. Pfahl's statement for this book addresses his technique of creating frames from existing structures:

While making my *Picture Window* photographs, I came to think that every room was like a gigantic camera forever pointed at the same view. In the dictionary, of course, the word camera in Latin means chamber or room.

I searched the country for these cameras and their views: the more unusual or picturesque, the better. It was hard to tell from the outside what could be seen from the inside, so I was usually surprised when I discovered a scene in its new context.

Strangers with puzzled looks were amazingly cooperative in letting me into their rooms with my photographic gear. They let me take down the curtains, wash the windows, and rearrange the furniture. Often, too, they expressed their desire to share their view with others, as if it were a nondepletable treasure.

I liked the idea that my photographic vantage points were not solely determined by myself. They were predetermined by others and patiently waited for me to discover them.

This scene was photographed along a boating canal in Coral Gables, Florida. The glass louvers reflect my wife in a bikini sunbathing on the balcony, superimposing a second, more fragmented image on the sunny view.

1390 S. Dixie Highway, Coral Gables, Florida, 1979

Chromogenic print, 15⅞ x 19⅞ inches
Purchase, 81.25

Michael Spano
American, 1949–

Through the use of unusual equipment—wide-view and sequence-exposure cameras—and non-standard darkroom techniques, including negative solarization and photograms, Spano seeks alternative ways of representing the New York urban experience. His techniques expand upon the familiar genre of street photography to suggest the medium's potential for insight and reflection. In his portraits and nude studies he further enlarges our visual perception. Spano describes his work:

The picture reproduced here was made with a panoramic camera where the lens pans on a curved film plane while the exposure is being made, capturing 140 degrees of space at different moments on one piece of film.

A photograph representing a duration of time.

These photographs are pictures primarily of urban man. They are portraits of a people who demand a space for themselves in the territory of their experience, a domain that is both public and private. By acknowledging their territory, I establish an intimate, immediate relation with them taking the freedom to create a work of art.

Organizing a picture which depicts 140 degrees of space in the city where people are actively represented brings to bare the complex idea of grouping figures.

My figures are placed in a multi-facade deep space, with air and atmosphere around them while they move and turn. Gestures and detail are given a heightened significance pulling the composition into accord.

At the same time my awareness to the history of panoramic photography is operating. To advance the idea of this type of picture making is my challenge.

Street Scene, 1980

Gelatin-silver print, 7 ¼ x 17 ¼ inches
The Family of Alice R. and Sol B. Frank

Chuck Close
American, 1940–

Dissatisfied with his work after completing graduate studies at Yale University in the late 1960s, Close began using photographs as foundations for his paintings. Using himself and his friends as subjects, Close made a series of large-scale portraits based on photographic guides; the over life-sized heads are tightly cropped and display almost hyperreal detail. He later worked with acrylic and airbrush to simulate the process of color separation through which a printing press reproduces color photographs. In this interview, Close explains that becoming a photographer was not something he had originally intended:

The main reason I started making photographs was that I knew that I wanted to do very sustained paintings. I wanted to work for literally months on a piece and I didn't want to have the model around, and I didn't want the condition to keep changing, that is, you know the model gains weight and loses weight; their hair grows long or becomes bald; they're asleep, or they're awake, and the painting becomes a kind of the average of all of those. You keep responding to them differently because they're there. So I wanted something that was a frozen moment in time that would have some of the urgency of a split second even though I was going to spend in some cases up to twelve to fourteen months working on one picture. I wanted the paintings to look like they just happened. It didn't look labored, or I didn't want people to think about, "Oh my God, look at all that work this guy did." So I thought that this was some way to keep a kind of clone-like cross section of time, a quick moment, while I worked in a much more novelistic time frame, an incremental way, very much the way a writer pieces together a work....

At first I never thought of my photographs as end products, at least I didn't consider myself a photographer because the thing I was making was a painting; therefore, while the photographs were an essential ingredient in the process, they had a souvenir or by-product status: something that was necessary without which the final product, the painting, could not be made. But, they had no particular object status for me other than as souvenirs. I often gave them away to friends. I remember trading one for a couple of kitchen chairs. So I didn't think of myself as a photographer. I have very narrow expertise in photography. That is, I learned to do what it is that I need to do, and I know very little about other aspects of the photographic process. I always did my own darkroom work. In every black-and-white print I would spend long hours in the darkroom dodging and burning and building into the photograph those things that I wanted to work from....

Now at a certain point, around the mid-70s, I was invited to work in Polaroid. Prior to working with Polaroid, if I took a photograph I had no idea what I had until I developed the film. So I tended to take the same photograph over and over, just bracket the shot just to make sure I had the right exposure. The minute I started working with Polaroid I realized that as soon as I got a print that I thought I wanted to work from, there was no reason to make more versions. I began to take photographs that I had really no intention of making a painting from. So I reluctantly began to accept the fact that if I'm making photographs in no life other than that of a photograph, then golly, I must be a photographer. So I sort of backed into it. Thinking about myself as a photographer—it's still something I'm not totally comfortable with.

Gwynne, 1980

Gelatin-silver print, ink, and tape, 30 x 20 inches
Purchase and National Endowment for the Arts, 89.100

Emmet Gowin
American, 1941–

While living in his hometown of Danville, Virginia, Gowin first received recognition for his extended series of introspective, ethereal portraits of his wife and children providing an intimate yet public view of private experiences. Having studied with Harry Callahan at the Rhode Island School of Design in the mid-1960s, Gowin proceeded to employ wide-angle lenses and expressive prints to dramatically enhance straight photographic descriptions of his subjects. In addition to his black-and-white work with his family, Gowin has also explored landscape photography, and color imagery with Polaroid films. His more recent concerns are aerial views of the man-made scars on the earth caused by such things as toxic waste dumps, strip mines, and agricultural projects. This statement, written in 1983, was submitted by Gowin for this project. It is entitled "Little Lamb and the Average Man."

During the winter of 1980, five photographers were selected by the Seattle Arts Commission to photograph in Washington State. The whole state, we were told, was ours for a subject. My thoughts began to fill with visions of city life and rain forests, agriculture and forestry, as I waited for June and July. On May 18, 1980, Mount St. Helens erupted. Looking back, it seems to me another instance of a subject extending itself towards me. I wonder if I would have traveled to Mount St. Helens on my own. But many things beyond our control work together on our behalf, chance and choice and human action combine and contribute to the quality of our lives.

By a second chance, the head of the Photographic Section of the U.S. Forest Service, William Hauser, was waiting in the same office lobby of the Gifford Pinchot Forest the morning I explained my desire to land and photograph in the tightly guarded "Red Zone" of the still very dangerous volcano. Although he was himself a visitor in that office, a bystander, he entered our conversation, "I like your description," he said, "I'd like to help you acquire the permission you need." He then spent much of the next two days working on behalf of someone he did not know and whose aims he knew only through an impulse. Life builds when we trust our feelings; individual acts of thoughtfulness form the bonds that bring us together.

During the years 1788–94, the great English poet William Blake wrote a cycle of poems, *The Songs of Innocence*. It is fascinating to consider that these youthful poems of openness were written at a moment in England's history, when the Industrial Revolution, "England's dark and satanic mills" as Blake called them, had already worked a seemingly irreversible change in the life of the average man. To such a man, nature was either something he owned and was free to exploit, or nature was a place he could seldom go, perhaps only on his vacation.

In a poem on spring, Blake wrote the deceptively simple lines, "Little Lamb, Here I Am." Rightly, in our time, we have become acutely aware of the destructive forces in nature and we do not find it possible to exclude man from our picture. "Little Lamb, Here I Am," conveys the openness with which the complex man may in some moments stand before the rigor of nature. We may even glimpse the means with which to accept ourselves. Before nature, what I see does not truly belong to anyone; I know that I cannot have it, in fact, I am not sure what I am seeing. May we, nonetheless, learn to value this Earth more.

To stand before nature is as imaginative as real and a state of mind is the limit of what we can see. Perceiving forces is a working problem in scale, and our position determines that scale. The two realities: the Little Lamb and the Average Man, suggest a condition far apart. Our survival and the poetic imagination require us to bring the two together.

Area of Mount St. Helens, 1980

Gelatin-silver print, 9¾ x 9¾ inches
The Family of Alice R. and Sol B. Frank

Sheila Metzner
American, 1939–

Metzner worked as an art director for a major advertising firm before devoting herself full-time to photography in 1968. The pictorializing effects of her early black-and-white still lifes and nudes are evident in her later color photographs, which are printed using the turn-of-the-century Fresson process. Seeking the perfection of form through color and texture, Metzner's soft focus photographs have been described as blending a timeless intimacy with modern elegance. The following introspective statement, selected by the artist, was printed in *The International Annual of Photography:*

Photography in its most basic form is magic. A figure, an object is before the box with a hole in it. A sensitized film, absorbs the light passing through the aperture in the box. In the box is darkness. It is developed in darkness. The image is fixed on the film. The image is in reverse of reality. Then, either by contact print or enlargement, the image, passed through light again is transferred onto another sensitized paper. Again, in darkness. The paper is set in a chemical bath which causes it to appear slowly in positive form. What we saw in nature is now two dimensional and can be lifted, fixed, washed, dried and held in my hands. I can carry this portrait, landscape, still life from room to room, set it on a table and look at it whenever I wish to. This image, caught in my trap, my box of darkness can live. It is eternal, immortal. The child in the image will not age as the living child will. This is magic.

What then, having this power, to stop time, as a God does, to create immortality, to trap a moment in life, what, is my responsibility? What am I looking for? What do I want to preserve, worship, retain, present as my legacy to the world at large, for myself, my family, my friends?

All of the above words when read, silently, or aloud create in me images, which reflect, which mirror, my inner life. My deepest, darkest, brightest thoughts and feelings. They inspire my intellect, what is finer in me. They inspire a search, a journey, a wish for contact with the divine. They inspire intimate contact with my surroundings. I am magnetized, pulled into contact with a face, a body, a body in a certain light, toward a relationship which is true.

The energy for this work must be fed. The impressions themselves are my food. I am stronger when I am conscious of myself in relation to what I am photographing. The journey, the work, the process includes me. The work, the photograph is a reflection, a mirror of my being.

Therefore, my transformation, my well being is essential to the life of the photograph. So photography is a reciprocal relationship. We nourish one another.... All at once the image reveals itself to me. It is my gift. A gift for the effort I am making to go into the unknown.

Into the question. Into not knowing why I am there, what I am doing. I push the button. Standing or kneeling, or sitting, terrified or laughing, serious or thrilled. I pray that the image was caught, captured in the darkness of the little black box. I am the genie, holding the bottle. Inside swirling is the storm, or the face, or the flower, or the ice, or the stone.

The photograph is something, in its highest form that I am given for my effort. It is not something that I take. And then after I bring it back, develop it, print it, look at it, experience it again, I submit my experience to life. I give it back to the world, it came from. Light into darkness. Darkness into Light.

Calla Lily, 1980

Fresson print, 19⅛ x 12⅞ inches
Purchase, 81.22

Robert Glenn Ketchum
American, 1947–

With his photographs, environmental activist Ketchum captures images of nature's beauty with respect and compassion while at the same time informing the public of the danger in our assault on her resources. He has also published several books, including *The Hudson River and the Highlands* (1982). His book *The Tongass: Alaska's Vanishing Rain Forest* (1987), led to a Congressional vote of protection for that area. In the following, Ketchum describes his photographic series *Order from Chaos:*

Begun in the early '70s and published as two portfolios in 1983, the eighteen color prints in this series were a formal exercise on my part to explore the rectangle of the print as a whole. I wanted to shift the hierarchy of the photograph from the subject depicted, to the print itself. I also wanted to explore identifiable landscapes in an abstract manner, without resorting to manipulation, or reducing the subject to just a partial detail of the whole.

My intent was to reject the intentionally descriptive viewpoint expressed in much of the historical tradition of landscape photography, while still retaining a perspective the viewer would believe to be "as the eyes would see it." Using a four-by-five-inch view camera to record every minute detail, I found the complex diversity and unbelievable seasonal colors of the eastern deciduous forests best suited to my purpose. In complicated, layered compositions, I confused obvious orientation by camera angle, and destroyed spatial perception through the use of line, color, and form in uncountable layers. The great depth-of-field available to view cameras allowed me to maintain overall sharpness in extremely complex circumstances, making every individual plant, bush and tree equally important to the overall pattern of the composition. This visual democracy only furthered the sense within the print of the connectedness of all the living things I had photographed.

Constructed very precisely in camera, these images were also printed full-frame, and the large scale of the prints was purposeful, to further enhance the viewer's experience of being engulfed by the hyperactive pattern forms and intense detail.

I also chose to reject the traditional site-specific titles commonly associated with landscape photography at the time. I have always felt that such titles rob the subject of its metaphorical potential, and surely would have impaired the very abstract sense my pictures were trying to evoke. I borrowed from the writings about Jackson Pollock when I called the collective series, *Order from Chaos.* When asked facetiously how he knew when his paintings were finished, he replied that a certain rhythm—an order—arose from the chaos, signaling to him the painting's conclusion. I felt similarly about the process I used to extract my compositions from the skein of the forest.

Individual picture titles were another story entirely. They were all whimsical, and often referred to lines or titles from literature I was reading, or songs I was listening to while working on the prints. Each title has a reference, but the references are obscure, and I do not expect viewers to necessarily understand exactly what those titles mean without asking. In the case of the image selected here, *And Gravity Lets You Down*, it is a line from a song by a band, Talking Heads. Because the viewer's perspective in my photograph is somewhat elevated—above the tree and looking down through it to the ground—the idea that "gravity lets you down" seemed to fit. This isn't romanticism, it is humor.

And Gravity Lets You Down, 1981

Dye bleach print, 30 x 38¼ inches
Horace W. Goldsmith Fund, 87.113

William Christenberry
American, 1936–

A sculptor and painter, Christenberry was drawn to photography in 1959 when he stumbled upon the photographs of Walker Evans in James Agee's *Let Us Now Praise Famous Men*. The subjects of Evans's images of the South were familiar to the native Alabaman, and inspired Christenberry to take his own photographs of this region, primarily in Hale County where he was raised. He is particularly attracted to the simple forms of vernacular architecture and their relationship with the landscape they inhabit. Christenberry, who lives and teaches in Washington, D.C., explains the importance of photography to his artistic work:

When I first began making photographs in the late 1950s, I used a Brownie camera. I had been making these photographs over the years just for myself, and they were color references for my paintings of the Alabama landscape. These small photographs are probably among the most natural things I've done, for I did not think of them as art.

In 1977 I started using an eight-by-ten-inch view camera and since that time have concentrated my efforts on it.

Photography has always been a part of my artistic activity, which also involves painting and sculpture. I use these media to express the many concerns and feelings in my life and about my background. It is the relationship of all these means of expression and their totality that best exemplify my work.

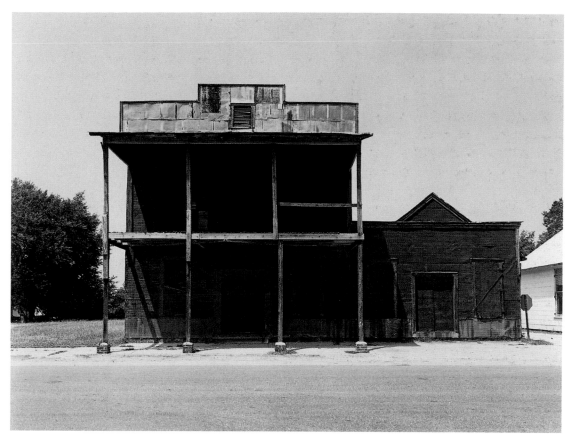

Facade of Warehouse, Newbern, Alabama, 1981

Dye transfer print, 17 x 21¾ inches
Purchase, 82.19

David Hockney
English, 1937–

Working first with Polaroid images, then with borderless 35mm prints, between 1981 and 1983 Hockney created hundreds of photographic collages. Internationally recognized as a painter, print-maker, and stage designer, he first made photographs as sketches for his work. Although frustrated by the visual limitations of the single image, he realized that joining many photographs together could provide a multi-perspective redefinition of a place and incorporate elements of time and spatial manipulation absent from straight photography. In a November 1993 lecture at the Victoria and Albert Museum, Hockney elucidated his approach to photography.

Cubism was about the destruction of a fixed way of looking. A fixed position implies we are standing still, that even the eye is still. Yet we all know our eyes move constantly, and the only time they stop moving is when we're dead—or when we're staring. And if we're staring, we're not really looking. That is the problem with the single frame photograph: all you can actually do is stare at it. Your eyes cannot wander around in it, because of its inherent lack of time. When I realized that my new conception of photography was related to cubism, I made two deliberate pastiches of a cubist still life—I set up a guitar, tobacco can, wooden table, and so on—all the elements of a cubist still life. I thought the result told you far more about the presence of objects in the world than one single picture would....

It made me look at cubism in another way: I saw new worlds of perception, still unexplored. It dawned on me that what we call realist painting has not [been] able to deal with cubism. It always tends to go back to the one-point perspective idea, or into a kind of fluid fantasy that was nonetheless based on one-point perspective. But to deal with the reality of what's around us has been a very hard thing for painters, outside of Picasso, Braque or Gris. There's not that much been done. The originators of cubism had done great things with it. And I disagree with the belief that Picasso abandoned cubism; I believe he was a cubist painter all his life. Of course, the modern idea is that cubism leads to abstraction. It appears to, and does in one sense, but cubism wasn't about abstraction, it was about the visible world, the world around us. Cubism tends to deal with things very close to us. The closer we get to anything the more the view shifts. Cézanne pointed this out—that as the thing got closer he had more and more doubts, I discovered in photography that as things get closer to you, it gets more difficult to piece together. It made me believe that the most interesting and mystical space we have is here, close to us, and not in outer space.

Almost all cubist pictures are about things close to us. They don't jump off the wall at you. You have to go to them, and look, and look. The camera does not bring anything close to you; it's only more of the same void that we see. This is also true of television, and the movies. Between you and the screen there's a window, you're simply looking through a window. Cubism is a much more involved form of vision. It's a better way of depicting reality, and I think it's a truer way. It's harder for us to see because it seems to contradict what we believe to be true. People complain that when they see a portrait of Picasso where, for instance, somebody has three eyes! It's much simpler than that. It's not that the person had three eyes, it's that one of the eyes was seen twice. This reads the same way in my photographs. The fact that people can read photographs in this way made me think we've been deceived by the single photograph—by this image of one split second, in one fixed spot. I now see this fault in all photographs, and I can tell when drawings or paintings have been made from photographs. You can sense when the picture is not felt through space.

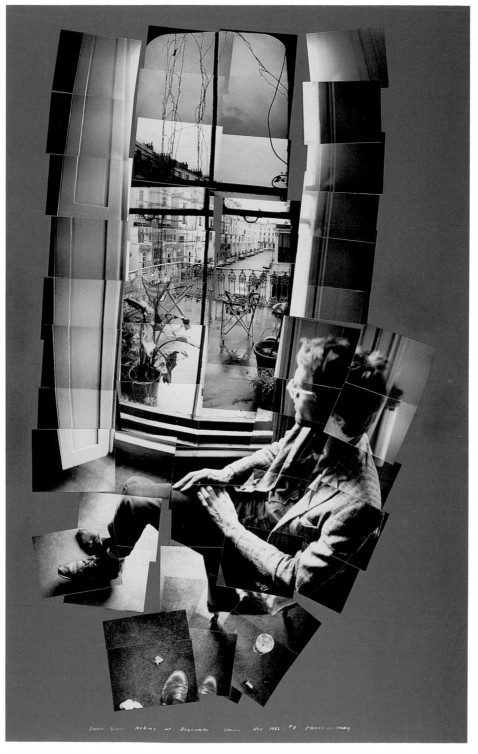

David Graves Looking at Bayswater London, November 1982

Chromogenic print collage, 42½ x 25½ inches
The Family of Alice R. and Sol B. Frank

Nancy Burson (with Richard Carling and David Kramlich)
American, 1948–

Since 1982, Burson has collaborated with computer scientists David Kramlich and Richard Carling in designing unique software that she uses to create composite portraits. Modern technology enables her to scan images into the computer, stack the faces on top of one another, and then manipulate them to produce portraits that are often politically motivated, and always provocative. An aging program developed by Burson in the late 1970s has been used by the Federal Bureau of Investigation to "age" missing persons and to construct suspect sketches. Burson, who lives and works in New York, provided the following brief but insightful commentary for this book:

All of my early images were really visual experiments to me. They were an attempt to answer unasked questions like, what happens if you put images of six men and six women together, or if we combined a monkey's image with a human, would the result approximate an image of early man?

Three Major Races was inspired by Ursula LeGuin's *Lathe of Heaven*, in which all the races meld together to form one grey race. It is a photo of no one and everyone.

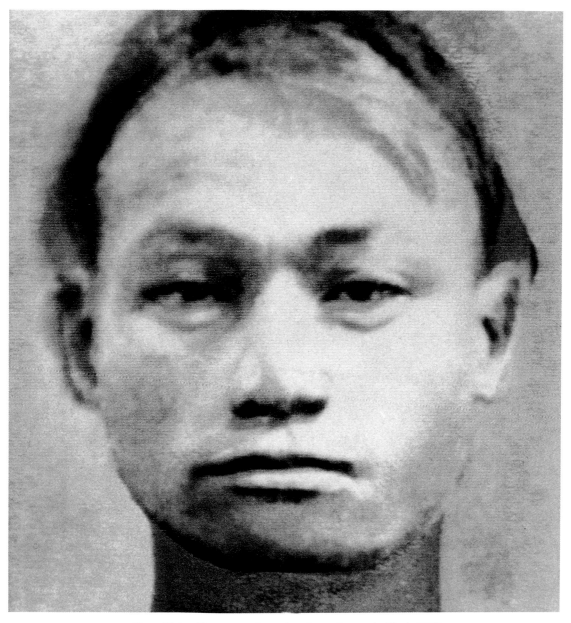

Three Major Races, An Oriental, a Caucasian, and a Black, 1982

Gelatin-silver digital print, 1995, 9 x 8¼ inches
Gift of Decipher, Inc., 95.5

Zeke Berman
American, 1951—

Originally trained as a sculptor, Berman began to experiment with photography in the late 1970s employing his own constructions as subject matter. Berman's work challenges the viewer's perception through optical illusion and paradox: His images suggest dimensions, but exist on a planar level. Committed to conceptual modes of art-making, the photographer transforms the physicality of his subject matter into abstract ideas. The following statements are taken from written text and a conversation with Berman:

In this image I used the device of placing material on the studio floor, that when seen from the one point of view of the camera read back as a standing table that looks, somewhat, maybe, different than two-dimensional. It seems to be hovering on the picture plane, the photo's surface, but of course it is actually laid out on the studio's floor. It's a device that at some point became exhausted. This is the last picture I associate as being at the end of one body of work and the beginning of something else. It's a sort of setting sun kind of thing.

I originally made sculpture but became attracted to placing a camera between myself and what I make. This results in an isolation and distancing that changes a physical construction into an optical one.

Test the characteristics of one medium against another. Test the characteristics of one system of knowledge against another.

For me, the studio was first a safe haven, then a cave, then a laboratory.

In 1983 I started really looking at the paintings of Jasper Johns. It's been quite an education.

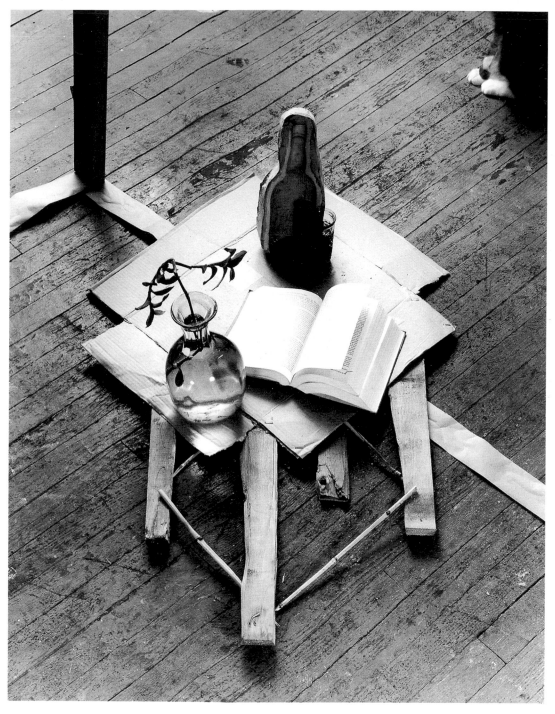

Interior, 1983

Gelatin-silver print, 19 x 15 inches
Horace W. Goldsmith and Art Purchase Funds, 85.151

Mary Ellen Mark
American, 1940–

A leading documentary photographer, Mark has traveled all over the world on assignments for *National Geographic*, *Life*, and the *New York Times Sunday Magazine*. She frequently chooses people on the fringes of society as her subjects, evoking a strong emotional reaction from the viewer through the sensitivity and compassion of her approach. Mark's projects have resulted in the publication of several books, including *Falkland Road* (1981), which portrays the existence of prostitutes in Bombay, *Streetwise* (1988), an exploration of life for young runaways on the streets of Seattle, and most recently, *Twins* (2003), which presents her large-format black-and-white Polaroid portraits of twins. Mark prepared the following statement for this book:

This is a portrait of Erin Blackwell. Her street name is Tiny. In 1983 I traveled to Seattle to do a story about runaway kids for *Life* magazine. Tiny was then a thirteen-year-old street child. The first time I saw her was in a parking lot. She was wearing a tight sweater, tight jeans, high heels and lots of make-up. She looked like a little girl playing "dress up." I approached her, introduced myself and asked if I could spend time with her. I spent the remaining weeks photographing her.

Several months later I returned to Seattle with my husband Martin Bell who made the documentary film *Streetwise*. Tiny was the main character in that film. This photograph was taken on October 31, 1983. I remember the date because it was Halloween and the last day of shooting on the documentary film. Tiny was on her way to a party at a social center for street kids. She put her costume together out of old secondhand "give away" clothes. She told me that she wanted to dress like a French prostitute. She was, as always, the little girl playing "dress up."

Since 1983 I have kept in constant contact with her. She is now 34 years old and has eight children. She has seen good times and very bad times. Life has taken its toll on her physically, but she still has that amazing candid vulnerability that I am drawn to. I hope to continue to know her and photograph her throughout my life.

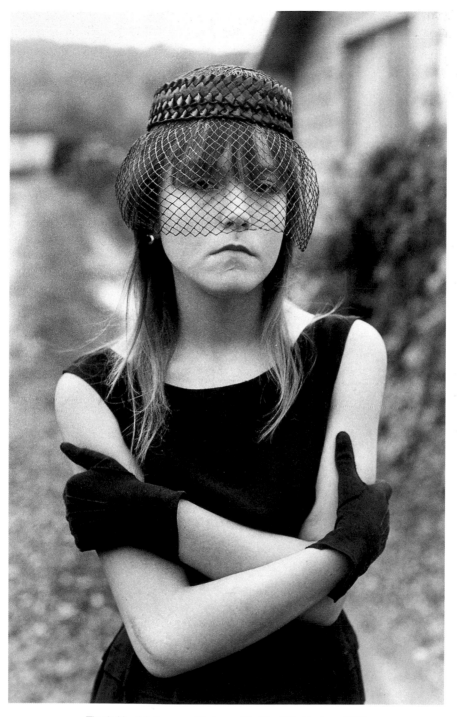

Tiny in Her Halloween Costume, Seattle, Washington, 1983

Gelatin-silver print, 1995, 13¼ x 8¾ inches
Gift of Suzanne and Jack Jacobson, 95.16

Cindy Sherman
American, 1954–

Sherman first gained recognition for her carefully staged portraits in which the artist herself acts as subject. Revealing close attention to details of lighting, mise en scène, make-up, costuming, and pose, the images put forth an extended thesis about cultural stereotypes, role-playing, mythical narratives, and photographic representation. In the late 1980s she continued this style of fabricating for the camera, but did not appear as subject in all of the pictures. Her work has been exhibited internationally and has garnered tremendous critical and public acclaim. This statement is from the *Documenta 7* exhibition catalog, 1982.

I want that choked-up feeling in your throat which maybe comes from despair or teary-eyed sentimentality: conveying intangible emotions.

A photograph should transcend itself, the image, its medium, in order to have its own presence.

These are pictures of emotions personified, entirely of themselves with their own presence— not of me. The issue of the identity of the model is no more interesting than the possible symbolism of any other detail.

When I prepare each character I have to consider what I'm working against; that people are going to look under the make-up and wigs for that common denominator, the recognizable. I'm trying to make other people recognize something of themselves rather than me.

I have this enormous fear of being misinterpreted, of people thinking the photos are about me, that I'm really vain and narcissistic. Then sometimes I wonder how it is I'm fooling so many people. I'm doing one of the most stupid things in the world which I can't even explain, dressing up like a child and posing in front of a camera trying to make beautiful pictures. And people seem to fall for it. (My instincts tell me it must not be very challenging then.)

Believing in one's own art becomes harder and harder when the public response grows fonder.

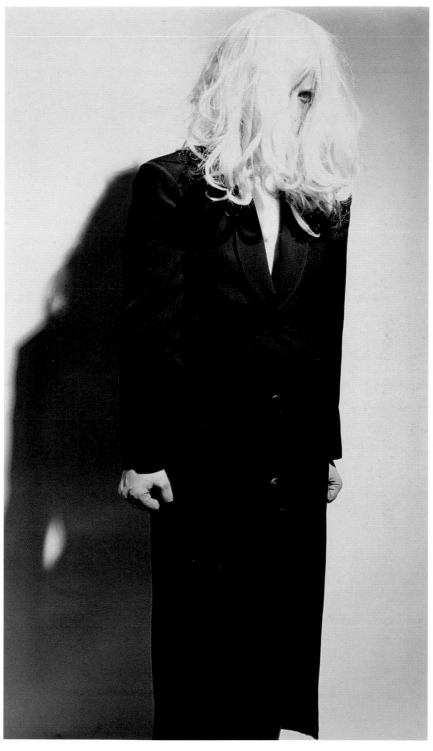

Untitled, 1983

Chromogenic print, 34½ x 20½ inches
The Family of Alice R. and Sol B. Frank

Lucas Samaras
American (b. Greece), 1936–

A versatile photographer, painter, and sculptor, Samaras began using Polaroid materials in 1969 and has expanded the descriptive ability of the instant photography medium. Through controlled colored lighting, lengthy exposures, manipulating the emulsion during its development process, and cutting apart then reassembling prints, Samaras invests with artistic value materials generally employed for snapshot imagery. His descriptions of light and movement reflect an aesthetic that could only be realized in photography. He consistently uses his own image to explore the themes of sexuality, terror, mortality, and transformation. This statement is from an interview, originally published in *ARTnews*, April 1976.

I have found for myself an uncultivated field to which I can go and do my stuff. That uncultivated field is the self. Most of us have evaded the body. There is a certain word which has negative connotations: narcissism. You know…[d]on't look in the mirror! Well, when you live alone, you don't have people saying "Don't do this" and "Don't do that." You can do whatever the hell you like, and if you want to look in the mirror, it's not all that dangerous, and not even all that erotic. For me, looking in the mirror produces a sense of wonder. I say, "Who is that?" I look at my hand or at my rear-end and say, "What is that?" The idea of the mirror being an area of erotic conflict is an idea for those who don't look into mirrors.

And so, I started photographing myself, and found that I could see portions of myself that I had never seen before. Since I face just my face in the mirror, I know pretty much what it's like. When I see a side-view, I'm not used to it, and find it peculiar. Or the back of my head—it's very strange to see it. So, photographing myself and discovering unknown territories of my surface self, causes an interesting psychological confrontation. You face certain facts about yourself. Although we all live in fantasies, and we all know that we will die someday, we have to come to terms with other unknown facts about us. At any rate, when I began photographing myself, I could place myself in poses that had not been investigated by other artists. It was an area other artists hadn't touched. Then, I went on from there. I manipulated my image—distorting it, brutalizing it. People thought I was mad, but I felt I had to tell these things. It gave me a kind of excitement....

But an artist must have an involvement with everything that is in front of him, whether it's a woman, a man, a cup, a dog, a string or a tree. If an artist does not have an erotic involvement with everything that he sees, he may as well give up. To be a human being may be a very messy thing, but to be an artist is something else entirely, because art is religion, art is sex, art is society. Art is everything.

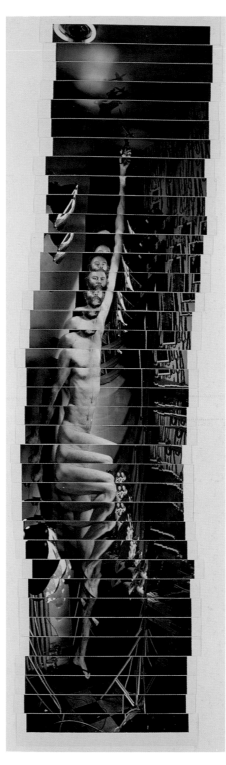

Self Portrait, March 2, 1983

Polacolor II assemblage, 33⅞ x 9 inches
The Family of Alice R. and Sol B. Frank

Len Jenshel
American, 1949–

Considered one of the leading photographers of the American landscape, Jenshel creates haunting, surreal images of backroads and empty spaces. His depiction of color is almost ethereal, and plays on the viewer's emotions as does the often striking quality of light. Like Joel Sternfeld and Robert Glenn Ketchum, Jenshel frequently captures scenes juxtaposing the beauty of nature with the effects of encroaching civilization. In the following statement, he describes his experiences while working on the set of David Byrne's *True Stories:*

I arrived in Dallas, Texas, in October of 1985 to participate in one of the strangest and most interesting commissions I had ever received. David Byrne, the avant-garde artist and lead singer of the Talking Heads musical group, was making his first Hollywood movie.

David had commissioned William Eggleston and myself to come down for ten days of filming to make pictures about anything we wanted—on the set, off the set—no restrictions. The resulting bodies of work would be published in a book that might be about the making of the movie, and then again, might not—no one really knew yet.

Loosely described, the movie, *True Stories*, was a tongue in cheek comedy with characters inspired by the tabloids. It would be a great portrait of middle-America suburbia, among other things—but for me, it was about the blurring of real and unreal.

Perhaps my favorite line in the film is recited by the "lazy woman," who has not been out of bed for years. She sits in bed with the remote control, channel surfing, and blurting out repetitiously, "commercial or video, commercial or video." With this as inspiration, I decided to split my time on the movie set and in the "real" world. As I traveled and photographed around suburban Dallas, I could hear myself saying, "commercial or video;" "Hollywood or Dallas;" "real or unreal." Consciously and playfully, I sought to blur that very fine line between worlds—for isn't that what photography does so well?

The photograph reproduced here, *Dallas, Texas* was made on the movie set—then again, maybe it was not.

Dallas, Texas, 1985

Chromogenic print, 12¾ x 19 inches
Purchase, 87.328

Sally Mann
American, 1952–

Mann lives and works in her hometown of Lexington, Virginia, and first came to prominence for photographs portraying the beauty and individuality of her three children. Those images, collected in the book *Immediate Family* (1992), convey a sense of the children's daily struggles and reactions to ordinary and extraordinary events while chronicling the changes in their minds and bodies as they grow. Since then Mann has created ethereal landscapes of the American South and Civil War battlefields. Her most recent body of work, a meditation on mortality, was published in 2003 as *What Remains*. Other publications by Mann include: *Second Sight* (1984), *At Twelve* (1988), and *Still Time* (1994). She reflects on her art in the following statement:

I photograph my children growing up in the same town I did. Many of the pictures are intimate, some are fictions and some are fantastic but most are of ordinary things every mother has seen; a wet bed, bloody nose, candy cigarettes. They dress up, they pout and posture, they paint their bodies, they dive like otters in the dark river.

They have been involved in the creative process since infancy. At times, it is difficult to say exactly who makes the pictures. Some are gifts to me from my children: gifts that come in a moment so fleeting as to resemble the touch of an angel's wing. I pray for that angel to come to us when I set the camera up, knowing that there is not one good picture in five hot acres. We put ourselves into a state of grace we hope is deserving of reward and it is a state of grace with the Angel of Chance.

When the good pictures come, we hope they tell truths, but truths "told slant," just as Emily Dickinson commanded. We are spinning a story of what it is to grow up. It is a complicated story and sometimes we try to take on the grand themes: anger, love, death, sensuality and beauty. But we tell it all without fear and without shame.

Memory is the primary instrument, the inexhaustible nutrient source; these photographs open doors into the past but they also allow a look into the future. In Beckett's *Endgame*, Hamm tells a story about visiting a madman in his cell. Hamm dragged him to the window and exhorted: "Look! There! All that rising corn! And there! Look! The sails of the herring fleet! All that loveliness!"

But the madman turned away. All he'd seen was ashes.

There's the paradox; we see the beauty and we see the dark side of things; the cornfields, the full sails, but the ashes, as well. The Japanese have a word for this dual perception; *mono no aware.* It means something like "beauty tinged with sadness." How is it that we must hold what we love tight to us, against our very bones, knowing we must also, when the time comes, let it go?

For me, those pointed lessons of impermanence are softened by the unchanging scape of my life, the durable realities. This conflict produces an odd kind of vitality, just as the madman's despair reveals a beguiling discovery. I find contained within the vertiginous deceit of time its vexing opportunities and sweet human persistence.

In this confluence of past and future, reality and symbol, are Emmett, Jessie and Virginia. Their strength and confidence, there to be seen in their eyes, is compelling; nothing is so seductive as a gift casually possessed. They are substantial; their green present is irreducibly complex. The withering perspective of the past, the predictable treacheries of the future; for this moment, those familiar complications of time all play harmlessly around them as dancing shadows beneath the great oak.

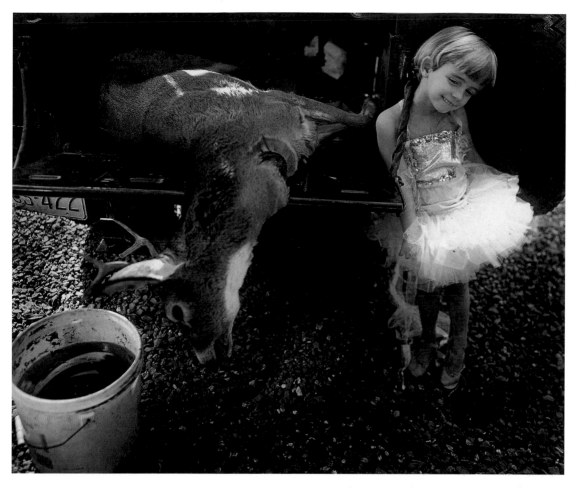

Jessie and the Deer, 1985

Gelatin-silver print, 19¾ x 23⅝ inches
Horace W. Goldsmith Fund, 87.329

Sal Lopes
American, 1943–

On the day of its dedication in 1982, Lopes began documenting visitors to the Vietnam Veterans Memorial in Washington, D.C. Without sensationalism, he captured the effects of the Wall's power on those who had lost loved ones in the Vietnam War. Many of these photographs were published in the 1987 book *The Wall: Images and Offerings from the Vietnam Veterans War Memorial.* His 1994 monograph, *Living With AIDS,* presents a moving photographic journal of those affected by AIDS. Lopes, who works in Boston, prepared the following comments regarding the bittersweet nature of his work for this book:

This is a photograph of Keefer, one of the many reluctant warriors I photographed at the Vietnam Veterans Memorial in Washington. The memorial is a place of national healing honoring those who died and more importantly, those who have survived. It has become a shrine where people leave offerings, and communicate with the dead. It is easy to forget that no one is buried there. Over time, I have photographed people sharing grief, guilt, love, and celebration.

Much of my work during the past ten years has dealt with loss and memory. Using the portrait, I photograph people of integrity, courage and dignity—pictures of survivors who show pride, pain, and love. I can't be the detached photographer the profession seems to demand. I gain the trust of the people I photograph by allowing myself to feel their pain and by working close with short lenses.

I photograph issues that concern and move me. I am successful when my work takes on a life of its own, when it forces people to confront their emotions, when it allows a viewer to make their own judgements, when it shows the true cost of abstractions such as war.

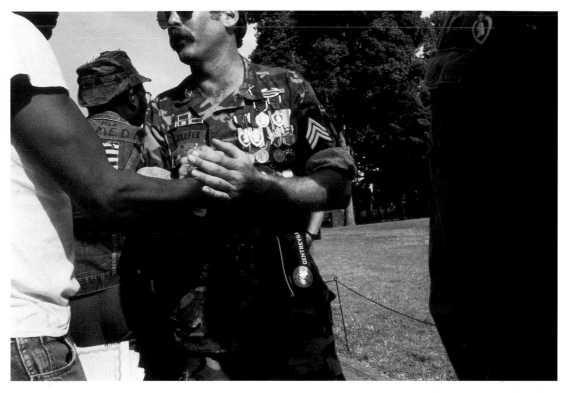

The Vietnam Veterans Memorial, November 1986

Dye bleach print, 8½ x 12¾ inches
Horace W. Goldsmith Fund, 87.359

Burk Uzzle
American, 1938–

Self-taught, Uzzle began his career in photography on the staff of the *Raleigh News and Observer*, and in 1962, worked as a contract photographer for *Life* magazine. He joined Magnum Photos in 1967, and was president from 1969 to 1970. His 1984 book *All American* was a humorous, straightforward look at America. The work represented here employs multiple exposures made in the camera to express more complex issues than can be revealed in a straight documentary photograph. This statement was published in a 1992 exhibition catalogue entitled *A Progress Report on Civilization*:

After all those years of wandering around as a street photographer and as a journalist, I decided that this world is such a curious, screwed-up place so full of contradictions…that I couldn't look at it anymore in the raw form without trying to find some way of balancing it in a more philosophical context—less in a repertorial manner and more in an artistic one. And I like to think of these pictures as visual music—the theme of which has more to do with philosophy then sociology. You just have to take an attitude about life: I'm going to get through this. It may be difficult, but in the end it can balance and work. So that's why these pictures started coming about this way.

This [*My Precious*] started out as a photograph of American symbols: jeans, the Statue of Liberty, and the violence which so characterizes our country now and the hope of children too, to transcend it all. So you have the affirmation of a father holding a happy child and his brother and what the country's always believed in which is liberty and the violence of the gun which is both—I'm sorry to say—probably a necessary attribute of our culture for survival for an awful lot of people.

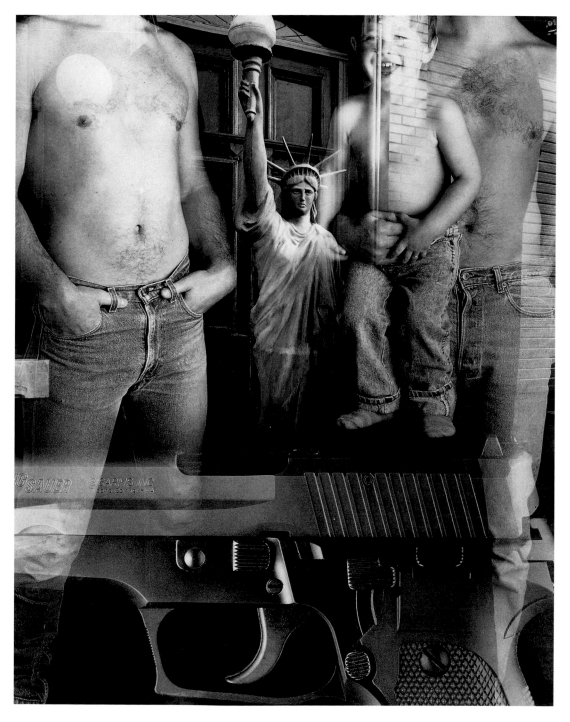

My Precious, 1988

Gelatin-silver print, 23¼ x 18¼ inches
Gift of the Artist, 92.23.2

Robin Schwartz
American, 1957–

Schwartz began her series of primate portraits in 1987. With this project she desired to capture the individual personalities of her subjects; however, by photographing the animals in their adopted homes, she demonstrated their instinctual need to take on the characteristics of their human owners. A selection of these images published in *Like Us: Primate Portraits*, illustrates the results of these relationships. This text combines the introductions to her books *Like Us* (1993) and *Dog Watching* (1995):

Animals are the passion and obsession that fuel my imagination. The boundary line separating people and animals has always been blurred for me, and perhaps because of that, I try to develop a dialogue with my subjects, whatever their species.

I always attempt to make friends with the animals so that I will be remembered on the next visit. Our interaction was essential, for without the primates' consciousness of me I would not have been able to capture the intensity of eye contact. When I began this project, my goal was to reveal the primates' personalities. Then, thinking of fantasy images from children's books, I tried to direct the primates, but mostly I photographed by instinct, having the flash freeze the image of my rapidly moving subjects. I usually photographed within three feet, with a 35mm lens, never through bars or Plexiglas cages.

Although I was able to photograph many species, what you see is a fictional world of primates. I sought photographs that do not represent the everyday world of monkeys and apes in captivity. It is not my intention to encourage primate pet ownership, but to show a side of its existence, to present each primate as a unique individual, and to share my photographic fantasies.

I believe that animals, kept as pets, offer us a unique glimpse into the heart of the human culture that surround them. How a society treats its animals is a reflection of its humanity. The relationship of pet and owner cuts across economic classes, and reveals much about a cultures' compassion. My connection with animals has guided my work and life. I have found great humanity, love, respect, adventure, and comfort in their company.

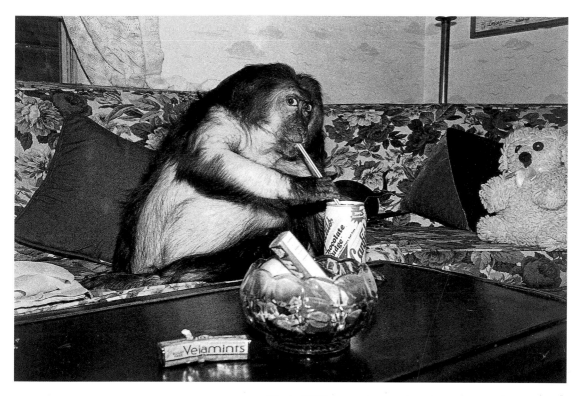

Minnie, 1989

Gelatin-silver print, 12⅛ x 18⅛ inches
Gift of the Artist, 93.29

Patrick Nagatani
American, 1945–

Andrée Tracey
American, 1948–

For a six-year period in the 1980s, Nagatani and Tracey collaborated on constructing elaborate, life-sized sets incorporating photographic cutouts, painted backdrops, complicated props, and live figures. Their large-format Polaroids of these scenes are characterized by glowing oranges, reds, and greens, alluding to the main issues addressed in this work: the dangers of nuclear testing and infatuation with technology, and the resulting effects on the earth. Nagatani comments on creating *Alamogordo Blues* in the following passage:

Andrée Tracey and I were invited to use the Polaroid twenty-by-twenty-four-inch camera and have an exhibition in Frankfurt, Germany, at FotoForum Gallery. A primary goal was to direct the new work from some of the humorous images that we had accomplished in the past towards images that had a more direct "black humor" ingested with irony. Throughout our collaboration we worked with and were informed by issues that Spencer R. Weart focused on in his book *Nuclear Fear, A History of Images.*

The source for this work was the well-known image of goggled observers, seated in Adirondack chairs witnessing an atomic detonation in 1951. The picture, entitled *Observers, Operation Greenhouse,* was from the files of the U.S. Department of Defense.

I had read somewhere that most of the military personnel in the image had acquired cancer or some fatal disease as a result of the radiation exposure. It was during this time that military personnel were either intentionally or unwittingly exposed to large amounts of radiation as a result of government stupidity and/or experimentation. The image is full of irony as its implications are understood forty-four years later. Our intent with *Alamogordo Blues* was to layer an image with further information in an effort to direct further ironic juxtaposition.

We constructed an adirondack chair and we took large format pictures of Japanese-American friends (both my brothers are models) with ties strung up on monofilament and with hair greased back (to give the appearance of the nuclear wind blast). We

printed the black-and-white negatives on large gelatin-silver mural paper and mounted the resultant figures on foamcore board. The figures were hand-colored and accurately cut out. The prints spewing out of the Polaroid SX-70 cameras were hand made in various sizes to perceptively force a greater illusion of distance. I posed in the image after Andrée had applied blue theatrical make-up with white shirt, goggles, tie, and SX-70 camera. Our desire to use a "real" figure in the representation installation was to heighten the sense of scale of the installation. The canvas background of an area in Alamogordo, New Mexico, (the historical and contemporary nuclear landscape of American nuclear weapons development) was painted by Andrée in oils. As in our previous collaborative work, the sense of illusion was the main reason to combine the painted "metaphorical mark" with the sharp, informationally loaded photographs. All of the props in the installation were hung with monofilament suspended from a scaffolding that we designed and transported to Germany for the "shoot."

If we were writing about any one of many other Nagatani/Tracey images, there would certainly be a great deal more text on the construction intricacies of the set and the work intensive set-up. *Alamogordo Blues* was a relatively "easy" installation to arrange for the camera. We think that its success rests with the seamless flow from concept to final photographic object. To this day, we feel that *Alamogordo Blues* is one of our strongest images from the collaboration.

Alamogordo Blues, 1989

Dye transfer print, 18¼ x 28¼ inches
Purchase, gift of the Photography Alliance of The Chrysler Museum, 91.14

Maria Martinez-Cañas
American (b. Cuba), 1960–

Although born in Cuba, Martinez-Cañas left the island when she was only three months old. Through her photography, she searches for her Cuban heritage by using the fragments of family pictures and stories as inspiration for ideas. Photographing since the age of ten, Martinez-Cañas contact-prints her negatives after cutting and shaping them to create designs based on Caribbean vegetation, old documents, and maps of Cuba. Her work conveys a multi-layered language of personal symbols and references through formal, often abstract presentations. This statement about *Tormenta de Imágenes* is from a 1992 interview:

I feel very strongly about this piece. I think to me this is one of the most unique images that I have made. This piece is a combination of a lot of forms and shapes that have interested me for many years. The title *Tormenta de Imágenes* relates to a storm of images because we're confronted with all these images. This is really the photographer talking much more than the Cuban talking.

I wanted the piece to be totally packed with images that would in a way be very difficult for you to really pinpoint what it is you're looking for. Also if you look at it carefully you realize the line from the bullfight, a line that is out of focus, a line from buildings, and we start again with the bullfight.

There is a kind of movement or rhythm visually that happens on the piece. If you look really carefully you may not necessarily see that. Also a kind of almost claw shape inside the oval shape is the one that has the more organic element and then the female body in the center....

To me this piece was a very feminine piece. I felt that the male had to be there and I felt that it was not for any specific reason you would think. I felt very much that this was a very female-oriented piece. For that reason it had to have the female body at some point on the piece.

The idea of power. The idea of animal and male power more than anything. I've always been

fascinated with bullfights. Not necessarily that I do not dislike them. To tell you the truth, I like them very much. I think they're wonderful. I don't want to call it a sport because to them it's much more than a sport. It's an art form. This idea of the duality of male power and animal power. I think that each one of us do also have the type of duality of male and female in us. And it depends on which one we develop more than the other....

The idea of the repetition of the negative and inverted negatives and flipped negatives that I use is because I wanted to recreate a different sense of space. Recreate a reality that in reality doesn't exist because there is no way this can exist the way I put it in. I wanted to be with that sense of almost dislocation or location that in reality does not exist. Because to me a lot of the time the way I work specifically with a piece like this, this shape may not necessarily make any sense with the rest of the piece. Like this shape inside the oval may not necessarily make any sense and you'll wonder why is this here? What connection does this have with this? It may not necessarily have any kind of connection but I think that our lives in general are very much that way. We're built out of this fragmentation that in some cases has no connection with anything else. I frequently deal with these types of issues.

Tormenta de Imágenes (Storm of Images), 1990

Gelatin-silver print, 41 x 41 inches
Purchase, gift of the Photography Alliance of The Chrysler Museum, 92.18

Christian Boltanski
French, 1944–

One of the most important French contemporary artists, Boltanski has worked with books, photographs, and films, but is best known for his powerful mixed-media installations. Reminiscent of monuments or altarpieces in their presentation, his works incorporate anonymous photographic portraits and other vernacular materials such as biscuit tins, discarded clothing, and desk lamps. In this statement he talks about his mission as an artist and specifically about the connotations of his materials.

No, I never take photographs myself. I don't feel like a photographer, more like a recycler. When we look at a photo we always believe that it's real; it's not real but it has a close connection with reality. If you paint a portrait, that connection is not so close. With a photo you really feel that the people were "there...."

A good work of art can never be read in one way. My work is full of contradictions. An artwork is open—it is the spectators looking at the work who make the piece, using their own background. A lamp in my work might make you think of a police interrogation, but it's also religious, like a candle. At the same time it alludes to a precious painting, with a single light shining on it. There are many ways of looking at the work. It has to be "unfocused" somehow so that everyone can recognize something of their own self when viewing it.... I always try to use forms that people can recognize. Take the biscuit tins for example. I use them because they are minimal objects, but also because I know that my generation can recognize them. We have all kept our small treasures in biscuit tins. It also reminds some people of the metal urns where ashes are kept. I suppose I want my art to be more about recognition than discovery....

Ideally I want to touch people, and I think that my art is for a large public—it's not to be viewed by some exclusive crowd. I try to make my art viewed as if it were life, so that people can speak about my art as if it were something they know. This is why I use photos, since everyone can relate to them, and also why I talk about issues like death, which is important to everyone. It's like people who are really moved when they see the film: they might cry watching the film and then later talk about it and criticize it in a more detached way. That's what I try to do, touch people in a direct way. It's true that sometimes I use very heavy things to do this—and the *Dead Swiss* is a good example. But, then again, it is a way of speaking to people. I chose the Swiss because they have no history. It would be awful and disgusting to make a piece using dead Jews— or dead Germans for that matter. But the Swiss have no reason to die, so they could be anyone and everyone, which is why they're universal.... I don't think it's about Jewish history. I often get this kind of misunderstanding with my work. Of course it is post-Holocaust art, but that is not the same as saying that it is Jewish art. I hope my work is general. I'm not a philosopher; I'm an artist.

Reserve of Dead Swiss, 1990

Mixed media installation, 116 x 37 x 13½ inches
Purchase, gift of Helen Gifford, Suzanne and Jack Jacobson, Lee and Bernard Jaffe, Lance A. Lavenstein,
Dr. and Mrs. Robert M. Rubin, Gerald Sprayregen, and the Art Purchase Fund, 96.30

Gwen Akin
American, 1950–

Allan Ludwig
American, 1933–

Akin and Ludwig began collaborating in 1982 to learn platinum printing techniques. This resulted in a series of *tableau morte* photographs, contrasting the exquisite physical beauty of the platinum print with difficult subject matter, primarily from the Mutter Medical Museum. Evoking a mixture of fascination, awe, and terror, these photographs relied on the aesthetics of attraction and repulsion, which was so much a part of eighteenth century art and thought. In 1992, they began appropriating found portraits of women. Re-photographing only the facial features these images were inserted into 233 various-sized oval frames and arranged at random. First exhibited in 1993 at The New Museum in New York City the installation has since been shown in nine venues. This statement was written for this book.

The Women Series was certainly the most popular project we ever undertook. Audiences had a lot of fun trying to identify the more notable women on view shoulder by shoulder with others who were unknown. Amazingly enough the unknowns held their own in the company of more recognizable faces such as those of Greta Garbo, Angela Davis, Georgia O'Keefe, Queen Elizabeth, and the first American transsexual, Christine Jorgensen.

We found the original photographs in yard sales and junk shops, in flea markets and photo fairs. We used photos of our own mothers and grandmothers. As the project progressed, friends contributed snapshots of their own relatives from old family albums.

We had originally conceived the piece to be made up of faces of both men and women from the past and present, but we found most of the older portraits of men to lack expressive qualities. When we isolated just their faces and placed them in oval frames, they appeared wooden in the extreme. Had we done a *Men* series it would have been a flop. Why this should be true remains something of a mystery to us. After all, male movie stars from Valentino to Brad Pitt have dazzled us with their photogenic star power. Perhaps in the early days of still photography men were more self-conscious than women before the camera's gaze.

In the early 1990s, artists' use of works not of their own creation was a topic much under discussion by artists, viewers, critics, curators, and lawyers. Once, when *The Women Series* was shown in Los Angeles, a viewer become irate; he told us in no uncertain terms that we had blighted the work of some great Hollywood photographers. He felt that the original creators had a right to have their work shown the way they had originally conceived and not as some badly printed and cropped copies. We felt the man had a point but we told him that it was not our intention to demean anybody's work. What was and still remains interesting to us is that when works are presented in a different context in a different time in history, reactions to these images are altered.

We told him that artists had probably been doing this sort thing since they first scratched images on the walls of their caves and certainly since Braque, Picasso, Dali, Duchamp, Lichtenstein, Warhol, Koons, Sherrie Levine, etc. appropriated others' work. Like compulsive gamblers, we are helpless to stop ourselves, even in the face of public indignation and lawsuits.

The Women Series, 1992–96 (detail)

233 framed gelatin-silver prints, dimensions vary
Anonymous Gift, 96.16

Rineke Dijkstra
Dutch, 1959–

Rineke Dijkstra is an internationally renowned Dutch photographer who makes life-size, color documentary photographs of people with a quiet, intense concentration. Her photographs focus on humans in transition, revealed moments of vulnerability. The photograph here is set in a verdant park and pine forest in Nida, Lithuania. Brigita, a pubescent girl about twelve years old, gazes directly at us, engaging the viewer with a slightly self-conscious, awkward pose. She is rendered in a moment of transition, half-teenager in her dress, while still child-like with her long braids and undeveloped body.

In my portraits, I try to capture something universal, but something personal at the same time. I look for specific things that set my sitters apart— little details, like a certain gesture or gaze, which makes them different than other people.

I go to my subjects where they are in their own reality, rather than photographing them in the studio. I like to photograph them in their natural circumstances.

As a photographer you enlarge or emphasize a certain moment, making it another reality. In the photograph you can scrutinize all kinds of details, you can see things you normally would not pay so much attention to.

Nida, Lithuania: I photographed this girl in the summer of 2000 in the woods of Lithuania, where she was playing with her friends. A forest is a fairy tale kind of place, connected with all kinds of stories and fantasies. The way the light plays with the leaves of the trees and shines through them is beautiful and mysterious.

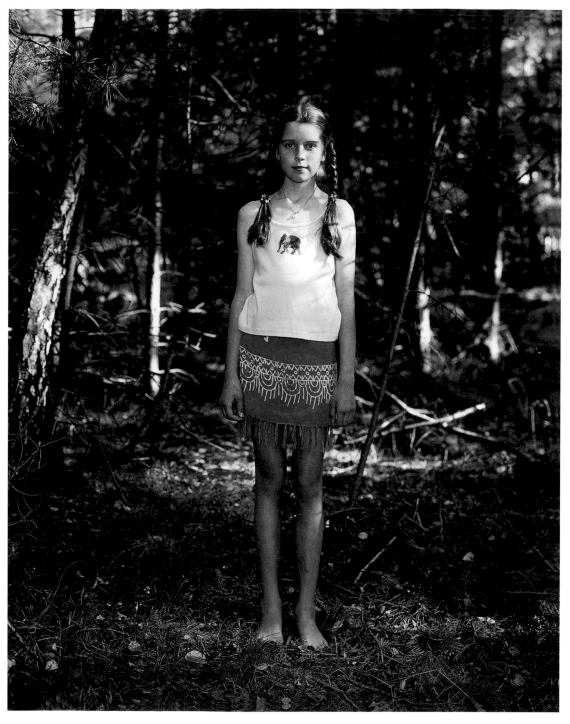

Nida, Lithuania (Brigita), July 30, 2000

Chromogenic print, 59⅛ x 50⅜ inches
Purchase, Walter P. Chrysler, Jr. Fund and in memory of Alice R. and Sol B. Frank, 2002.12

Luc Delahaye
French, 1962–

Delahaye's work spans the worlds of journalism and art. A member of Magnum, he makes his living as a photojournalist. His occupation takes him to such dangerous, war-torn places as Iraq, Lebanon, Israel, Rwanda, Chechnya, Bosnia, and Afghanistan. His fifth and most recent book entitled *History*, suggests that he wants his work to be considered within the genre of history painting. This dramatic image, with its large-scale and panoramic sweep, conveys the gravity of the event in a way that a small image could not. This picture depicts a Taliban fighter during the American invasion of Afghanistan in 2001, shortly after the tragedy of 9/11. Delahaye's Taliban photograph derives remarkable grace from the posture of the figure in a pose that is frequently seen in paintings of the dead Christ or martyred saints. This statement was submitted for this book.

About ten years ago I asked myself extremely simple questions: What is photography? What is a camera exactly? What happens when it is left on its own? This led me to do some experiments. I used photo booths to take pictures of homeless people: my act as a photographer was to put the coin in the slot. Then, I took a hidden camera into the subway and photographed people sitting opposite of me with a strict protocol, very systematically, trying to be nothing more than the machine my camera was. These experiences confirmed what is already known: that the recording process is a magical process (but I wanted the evidence, so I could move on).

I consider the act of taking pictures as an artistic performance in itself: a sum of movements, which have no other finality than their own perfection. I am the only viewer of this part. The consequence is "being there," fully and simply, without affects or emotions.

I am now photographing the events of the world that make history. I am very much distant from what I see, this is my nature. I am looking for clarity, precision, detachment, trying to record as much detail as I can. This work is produced in large prints. I am trying to make "tableaux," to make images which have density, harmony and mystery, a certain quality that takes you and resists you at the same time.

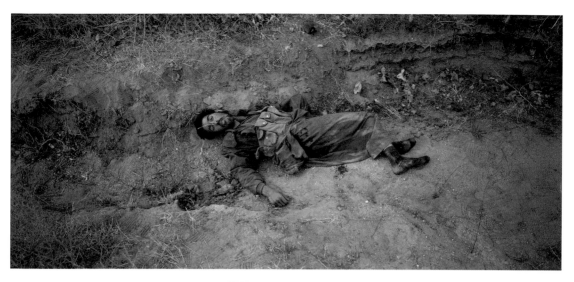

Taliban, Afghanistan, 2001

Chromogenic print, 43 x 93 inches
Gift of the Chrysler Contemporaries, 2003.8

Thomas Struth
German, 1954–

Emerging from the Kunstakademie Düsseldorf in the 1970s, Struth fell under the influence of
Joseph Beuys and studied directly with Bernd Becher and Gerhard Richter. Working in a formal
and precise manner, his pristine images have placed him in the vanguard of photographers using
large-scale color photography. Creating images that bridge the gap between traditional realms of art
and photography, his work lends the medium a presence that could be compared with painting.
Although this statement comes from a 1994 interview, it clearly explains the thought processes that
have carried Struth to the present day.

My whole idea of working has a lot to do with
how humans live. How we live, how I live, how
humans live together—human collectivity. That is
my core value: what it is to be human. That is
everything I believe in. I do not believe in current
ideas of post-humanity.... For me the most impor-
tant phenomena are those that bring forth changes
in societies or in history. These changes used to be
noticeable in the physical world immediately.
Today this is not so clear anymore. Today's changes
through new computers, sundry inventions in gene
technology and new technological systems are not
as visible as they once were in the street.

If I look at my work from the beginning it is
more the idea of trying to establish a kind of mater-
ial that one can work with for the future, rather
than making nostalgic images to record something
that later will become lost.... What fascinates me
is the sort of insight and information that I receive
from the nature of the space, and this has to be the
case before I am able to say anything about this
space.... These spaces are those of a specific place.
The everyday streets are in a funny way more truly
monumental as witnesses to the everyday life of
people. Also, it makes things much easier to read
than if I used images of famous sites.... [I]n gen-
eral, my work is less about expanding the
possibilities of photography than about re-investing
it with a truer perception of things by returning to
a simple method, one that photography has had

from the beginning of its existence.... For I do
believe that in photographs like those of the nine-
teenth-century English photographer Thomas
Annan or Eugène Atget, you can read the motiva-
tion of the person who made the image in them;
the psychological, emotional or intellectual scaffold-
ing that the person saw in the environment. And
there is the matter of how we can retrieve that or
read it from the surface of the image. My belief in
the psychology of that situation is very strong..... I
believe that if I asked five students to take a photo-
graph of the same street or building in the city, one
would be able to see which of them was really
interested in the street or building and which was
not.... Why this happens interests me very much.
You forget that by now this is clearly accepted in
painting, but in photography this level of sophisti-
cated reading remains under disguise. For what
matters is how much of yourself you put into your
work. If you have a real relationship with a particu-
lar building, landscape or person, as in a portrait, it
will show in the picture.

[When] I am taking a photograph, I am con-
scious that I am constructing images rather than
taking snapshots. Since I do not take rapid photo-
graphs it is in this respect like a painting which
takes a long time where you are very aware of what
you are doing in the process. Exposure is only the
final act of making the image as a photograph.

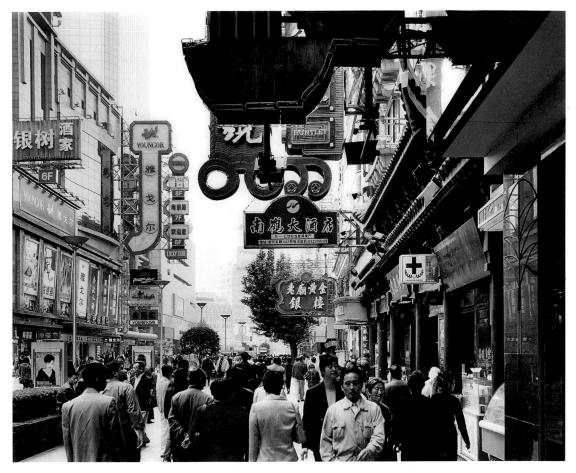

Nanjing Xi Lu 3, Shanghai, 2002

Chromogenic print, 53⅛ x 61¾ inches
Purchase, in memory of Alice R. and Sol B. Frank, 2003.17

Gabriel Orozco
Mexican, 1962–

With equal eclecticism, Orozco works with photography, sculpture, performance, video, installation, and conceptual art. Moving to the forefront of international artists he has redefined the use of photography in imaginative ways. Some of his photographs record naturally occurring situations that contemplate the beauty of simple actions and moments. More often he uses it to document his own ephemeral sculptures and installations, thus giving them a longer life and a wider audience. In this text he considers how he uses photography in relation to other media.

I prefer to start with my own relation to photography and sculpture. In a way I think I started more through photography than through sculpture. I got a very classical education as a painter in an academy—painting, drawing, etching—but not sculpture at all (less photography). I learned photography in Mexico by looking, and after by doing some actions outside. Through photography I could record, transport and keep these actions. When I started to do these works, it was impossible to show them…. I never trusted in photography completely. I never thought that photography was capable of transporting all the ideas I needed to realize, to activate the space…. I was using photography at the same time that I was exploring materials and objects that were around me, without thinking about photography as a specific conceptual solution.

I cannot separate photography from my sculptural practice. I don't know in advance whether I will need to use photography or whether it will, at the end, become an object. What I am doing, how it ends up as a sign, is all about language, but sometimes it becomes a physical thing, sometimes it is just photography…. [F]our people saw [my 1991 installation entitled Turista Maluco]. That was the action. But then the work really starts to function as a sign in more general terms, and circulating to more people through photography. So maybe we

have to ask whether four people were enough to name it a "work?" But then, when a thousand people have seen the photograph, is that something else, like the news in the newspaper?

The sculpture is not the photograph, that, I'm sure of. I reduce the size of my photographs to the minimum, they are all the same size. I'm not interested in any physical, objectual photography. I don't believe that photography is sculptural like that…. If it's just a question of recording a perception, the sculptural object is not necessary. For me the size doesn't matter—of course it's important, the size, how it's framed, how it's put up, how photography tries to become an object—which also became a very important issue in the eighties, but not for me. I was not very interested in the frame or the size, so I just economized as much as possible: one size, a very conventional frame. I would call it "the space of the window" or, even more, a box in which you transport a space that happens before…. I always think of my photography like a shoe box, and in that sense I really think it's irrelevant if it's a huge photo mural or if it's a small place. You can travel through space and time, be transported; the size doesn't matter. I don't see any sculptural attributes to photography. These attributes are in relation with what is happening and if the idea is strong enough in terms of time and space.

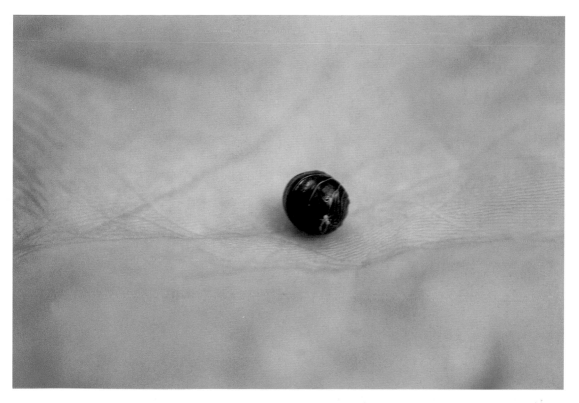

Rolling Life's Hand Line, 2003

Chromogenic print, 16 x 20 inches
Purchase, in memory of Alice R. and Sol B. Frank, 2003.16

BIBLIOGRAPHY

Abbe, James E. *I Photograph Russia*. New York: R.M. McBride & Company, 1934; London, 1935.

Abbott, Berenice. *Changing New York*. New York: Dutton, 1939.

Adams, Ansel. *Ansel Adams: An Autobiography*. Boston: Little, Brown and Company, 1985.

Adams, Robert. *The New West*. Boulder: Colorado Associated University Press, 1974.

Arbus, Diane. *Diane Arbus*. Edited by Doon Arbus and Marvin Israel. New York: Aperture, Inc., 1972.

Atget, Eugene. See Leroy, *Atget*.

Atkins, Anna. *Sun Gardens: Victorian Photograms by Anna Atkins*. New York: Aperture, Inc., 1985.

Bell, William. "Photography in the Grand Gulch of the Colorado River." *The Philadelphia Photographer* 10 (1873): 10.

Bellmer, Hans. See Peppiatt, "Balthus, Klossowski, Bellmer."

Bing, Ilse. *The Camera as My Artistic Tool* (unpublished manuscript).

Boltanski, Christian. See Semin, *Christian Boltanski*.

Borcoman, James. "The Midi de la Photographed." *Charles Nègre 1820–1880*. Ottawa: The National Gallery of Canada, 1976.

Bourke-White, Margaret. *Portrait of Myself: Margaret Bourke-White*. New York: Simon and Schuster Inc., 1963.

Brady, Mathew. See Townsend, "Brady."

Brandt, Bill. *Camera in London*. London: The Focal Press, 1948.

Brassaï. *The Secret Paris of The 30s*. Translated by Richard Miller. New York: Random House, Inc., 1976.

Braun, Adolphe. Letter to Paul de St. Victor. Undated. Translated by Marie-Jose Bodi. From the collection of Naomi Rosenblum.

———. Letter to Paul de St. Victor. October 12, 1871. Translated by Marie-Jose Bodi. From the collection of Naomi Rosenblum.

Brigman, Anne W. "What 291 Means to Me." *Camera Work*, no. 47, July 1914.

Bruguière, Francis J. "Creative Photography." *Modern Photography Annual* (1935–36): 9–14. Reprint. *Photographers on Photography*. Edited by Nathan Lyons. Englewood Cliffs Prentice-Hall, Inc., 1966.

Bullaty, Sonja. *Sudek*. New York: Clarkson N. Potter, 1978.

Bullock, Wynn. *Photographing The Nude*. Edited by Barbara Bullock-Wilson and Edna Bullock. Salt Lake City: Gibbs M. Smith, Inc. 1984.

Burrows, Larry. See Irvin, *Beautiful, Beautiful*.

Callahan, Harry. *Harry Callahan: Eleanor and Barbara*. New York: The Checkerboard Foundation, 1983. Film.

Cameron, Julia Margaret. "The Annals of My Glass House." 1874. (First published in *Photo Beacon* 2 (1890): 157–60.) Reprint. *Photography: Essays & Images: Illustrated Readings in the History of Photography*. Edited by Beaumont Newhall. New York: The Museum of Modern Art, 1980.

Caponigro, Paul. *The Wise Silence: Photographs by Paul Caponigro*. Boston: Little, Brown and Company, 1985.

Carjat, Étienne. "Le Lamento du Photographe." *Artiste et Citoyen*. Translated by Marie-Jose Bodi. Paris: Tresse Éditeur, 1883.

Carr, Carolyn. "Jan Groover Photographs, An Interview." Dialogue, Akron Art Institute, September, 1979.

Carroll, Lewis. See Gernsheim, *Lewis Carroll*.

Cartier-Bresson, Henri. *The Decisive Moment*. New York: Simon and Schuster, 1952.

Clark, Larry. See Kelley, "In Youth is Pleasure."

Claudet, Antoine François. "On Photography in its Relations to the Fine Arts." *Humphrey's Journal of Photography and the Allied Arts and Sciences* 12, no. 7 (August 1860): 108–110.

Close, Chuck. Interview with author. May 23, 1995.

Coburn, Alvin Langdon. "The Relation of Time to Art." *Camera Work*, no. 36, 1911.

Content, Marjorie. Journal entry. November 18, 1936. Marjorie Content Estate.

Cunningham, Imogen. "Portraits, Ideas, and Design." Interview with Edna Tartaul Daniel, 1961. Oral History Project, Bancroft Library, University of California, Berkeley.

Curtis, Edward S. Untitled, unattributed, and undated typescript from the Edmond S. Meany papers at the University of Washington Libraries' Manuscripts and University Archives. Cited in *History of Photography* 2, no. 4 (October 1978): 349–353. Taylor and Francis Journals <http://tandf.co.uk/journals>

Cuvelier, Adalbert. Letter to Charles Chevalier. Translated by Marie-Jose Bodi. February 12, 1854. *Guide du Photographie*. Paris: Charles Chevalier, 1854.

Davidson, Bruce. *Bruce Davidson's Photographs*. New York: Agrinde Publications Ltd., 1978.

Dewan, Janet. Linnaeus Tripe, correspondence to author. April 12, 1995.

Dewan, Janet and Maia-Mari Sutnik. *Linnaeus Tripe: Photographer of British India 1854–1870*. Ontario: Art Gallery of Ontario, 1986.

Documenta 7. Exhibition catalog. Kassel: P. Dierichs, 1982.

DuCamp, Maxime. See Flaubert, *Flaubert in Egypt.*

Duchenne, Guillaume-Benjamin. *The Mechanism of Human Facial Expression,* 1862. Edited and translated by R. Andrew Cuthbertson. London: Cambridge University Press; Paris: Editions de la Maison des Sciences de l'Homme, 1990.

Eakins, Thomas. See Goodrich, *Thomas Eakins.*

Eggleston, William. *The Democratic Forest.* New York: Doubleday, 1989: 171–73.

Emerson, Peter Henry. *Naturalistic Photography for Students of the Art.* London: Sampson Low, Marston, Searle and Rivington Limited, 1889. Reprint. New York: Arno Press, 1973.

Evans, Frederick. *The Photographic Journal 59* (April 30, 1900): 236–41.

Evans, Walker. See Katz, "An Interview with Walker Evans."

Fenton, Roger. *Roger Fenton Photographer of The Crimean War: His Photographs and His Letters from The Crimea.* New York: Arno Press, 1973.

Flaubert, Gustave. *Flaubert in Egypt: A Sensibility on Tour.* Translated and edited by Francis Steegmuller. Boston: Little, Brown and Company, 1972.

Frank, Robert. *U.S. Camera Annual 1958.* New York: U.S. Camera Publishing Corp., 1957.

Friedlander, Lee. *Self Portrait.* New York: Haywire Press, 1970.

Frith, Francis. "Egypt and Palestine." *British Journal of Photography* (February 1860): 32–33.

Gardner, Alexander. *Gardner's Photographic Sketch Book of the War,* vol. 1. Washington, D.C.: Philp & Solomons, 1866.

Gernsheim, Helmut. *Lewis Carroll: Photographer.* New York: Chanticleer Press Inc., 1949.

Gilpin, Laura. "The Fine Art of Photography." Ninety-Eight-Six (May 24,1928): 7.

Goodrich, Lloyd. *Thomas Eakins: His Life and Work.* New York: The Whitney Museum of American Art, 1933, pp. 17–18

Groover, Jan. See Carr, "Jan Groover Photographs, An Interview."

Gruen, John. "The Apocalyptic Disguises of Lucas Samaras." *ARTnews,* vol. 75, no. 4, April 1976.

Gutmann, John. See Sutnik, *Gutmann.*

——. See Thomas, *The Restless Decade.*

Halsman, Philippe. *Halsman Sight and Insight.* Garden City: Doubleday & Company, Inc., 1972.

Hambourg, Maria Morris, et al. *Nadar.* New York: The Metropolitan Museum of Art, 1995.

Haskins, Jim. *James VanDerZee: The Picture-Takin' Man.* Trenton: Africa World Press, Inc., 1991.

Haynes, Frank J. See Tilden, *Following the Frontier with F. Jay Haynes.*

Hill, Paul, and Thomas Cooper. *Dialogue with Photography.* New York: Farrar, Straus and Giroux, Inc., 1979.

Hill, David Octavius. See Stevenson, *The Personal Art of David Octavius Hill.*

Hine, Lewis. "Social Photography, How the Camera May Help in the Social Uplift." Proceedings, National Conference of Charities and Corrections (June 1909).

Hockney, David. *David Hockney on Photography: Lecture at the Victoria and Albert Museum.* New York: André Emmerich Gallery, 1983.

Horton, Anne. *Robert Mapplethorpe.* Exhibition catalogue. Berlin: Raab Galerie, 1986.

Hosoe, Eikoh. Photographer's note from *Barakei* [Ordeal by Roses]. New York: Aperture Foundation, Inc., 1985.

Hurley, F. Jack; Brooks Johnson; and Daniel J. Wolff. *Pictures Tell the Story: Ernest C. Withers.* Norfolk: Chrysler Museum of Art, 2000.

Irvin, John. *Beautiful, Beautiful.* London: BBC-TV, 1969. Film.

Jackson, William Henry. *Time Exposure: The Autobiography of William Henry Jackson.* New York: Van Rees Press, 1940. Reprint. Albuquerque: University of New Mexico Press, 1986.

Johnson, Brooks. *A Progress Report on Civilization.* Exhibition catalogue. Norfolk: The Chrysler Museum, 1992.

——. *Jun Shiraoka.* Exhibition catalogue. Norfolk: The Chrysler Museum, 1988.

——. *Mountaineers to Main Streets: The Old Dominion as seen through the Farm Security Administration Photographs.* Exhibition catalogue. Norfolk: The Chrysler Museum, 1985.

Käsebier, Gertrude. "Studies in Photography." *The Photographic Times* 30, no. 6 (June 1898): 262–272. Reprint. *A Photographic Vision: Pictorial Photography,* 1889–1923, Salt Lake City: Peregrine Smith, Inc., 1980.

Katz, Leslie. "An Interview with Walker Evans." *Art in America,* March–April, 1971.

Kelley, Mike. "In Youth is Pleasure." Interview with Larry Clark. *Flash Art 25,* no. 164 (May/June 1992): 82–84.

Kertész, André. Interview with Brooks Johnson, New York, May 11, 1982.

Klein, William. *Rome: The City and Its People.* New York: Viking Penguin, Inc., 1960.

Krull, Germaine. See Mac Orlan, *Photographes Nouveaux.*

Lange, Dorothea with Daniel Dixon. "Photographing the Familiar." *Aperture* 1, no. 2 (1952): 4–15.

Langenheim, William and Frederick. "The Daguerreotype." *Pennyslvania Arts and Sciences* 4, no. 1 (1939): 21–22.

Laughlin, Clarence John. *Clarence John Laughlin: The Personal Eye.* New York: Aperture, Inc., 1973.

Le Gray, Gustave. *A Practical Treatise on Photography, Upon Paper and Glass.* Translated by Thomas Cousins. London: T. & R. Willats, 1850.

Leroy, Jean. *Atget: magicien du Vieux Paris.* Translated by Jefferson C. Harrison. Joinville Le Pont: Pierre-Jean Balbo, 1975.

Mac Orlan, Pierre. *Photographes Nouveaux: Germaine Krull.* Translated by Jill Quasha. Librairie Gallimard, 1931.

Magritte, René. "La Voix du Mystère," *Rhétorique* 4 (January 1962): 1. Reprint. *Magritte: Ideas and Images.* Translated by Richard Miller. New York: Harry N. Abrams, Inc., 1977.

———. Notes written at the Gladstone Hotel, New York, New York, December 16, 1965. Reprint. *Magritte: Ideas and Images.* Translated by Richard Miller. New York: Harry N. Abrams, Inc., 1977.

Mapplethorpe, Robert. See Horton, *Robert Mapplethorpe.*

Martinez-Cañas, Maria. Interview with author. April 17, 1992.

Meatyard, Ralph Eugene. *Photographs.* Exhibition catalogue. Carl Siembab Gallery, Boston, Massachusetts, November 1962.

Mellor, David, ed. *Germany: The New Photography 1927–1933.* London: Arts Council of Great Britian, 1978.

Metzker, Ray. See Tucker, *Unknown Territory.*

Metzner, Sheila. *Graphis Photo: The International Annual of Photography.* Zurich: Graphis Press Corp., 1994.

Misonne, Léonard. *Léonard Misonne,* Vienna: Edition die Gallerie, [1934?].

Model, Lisette. "Pictures as Art." *The New York Times,* December 9, 1951, 21.

Moholy-Nagy, László. "From Pigment to Light." *Telehor,* vol. 1, no. 2, 1936.

Morgan, Barbara. "Dance Photography." *U. S. Camera* 8 (February–March 1940): 52–64.

Muybridge, Eadweard. *Animals in Motion.* Edited by Lewis S. Brown. New York: Dover Publications, Inc., 1957.

———. *Animal Locomotion.* Philadelphia, J.B. Lippincott, 1887.

Nadar. *Quand J'Étais Photographie* (When I was a Photographer). Paris: E. Flammarion, 1899. Reprint. New York: Arno Press, 1979.

———. See Hambourg, *Nadar.*

Nègre, Charles. See Borcoman, "The Midi de la Photographed."

Orozco, Gabriel. *Clinton is Innocent.* Interview with Benjamin Buchloh. Paris: Paris Musées, ca. 1998. Published in conjunction with an exhibition held at the Musée d'Art Moderne de la Ville de Paris, May 28–September 13, 1998.

O'Sullivan, Timothy. See Samson, "Photographs from the High Rockies."

Outerbridge, Paul. *Photographing in Color.* New York: Random House, Inc., 1940.

Parks, Gordon. *Moments Without Proper Names.* New York: The Viking Press, Inc., 1975, p. 7.

Penn, Irving. *Worlds in a Small Room.* New York: Grossman, 1974.

Peppiatt, Michael. "Balthus, Klossowski, Bellmer: Three Approaches to the Flesh." *Art International,* vol. 17, no. 8, October 1973.

Porter, Eliot. *Intimate Landscapes, Photographs by Eliot Porter.* The Metropolitan Museum of Art. New York: E. P. Dutton, 1979.

Ray, Man. *Man Ray Photographs.* Paris: Philippe Sers, 1981. New York: Thames and Hudson Inc., 1982.

Renger-Patzsch, Albert. "Photographie und Kunst." *Das Deutsche Lichtbild,* 1929.

———. See Mellor, *Germany.*

Robinson, Henry Peach. *The Elements of a Pictorial Photograph,* Bradford: Percy Lund & Co., Ltd.; The Country Press and London: Memorial Hall, Ludgate Circus, E.C., 1896; New York: Arno Press, Inc., 1973.

Roche, Thomas C. "Landscape and Architectural Photography," *The Philadelphia Photographer* 10 (September 1873): 340–348.

Rodchenko, Aleksandr. *Rodchenko: The Complete Work.* Edited by Vieri Quilici. London: Thames and Hudson Ltd., 1986; Milan: Idea Books Edizioni, 1986.

Rodger, Thomas. "The Collodion Process." *The Photographic and Fine Art Journal* (July 1857): 212.

Rothstein, Arthur. See Johnson, *Mountaineers to Main Streets.*

Samaras, Lucas. See Gruen, "The Apocalyptic Disguises of Lucas Samaras."

Samson, John [Timothy O'Sullivan]. "Photographs from the High Rockies." *Harper's New Monthly Magazine,* (September 1869), 465.

Sander, August. *August Sander: Photographs of an Epoch 1904–1959.* New York: Aperture, Inc., 1980.

Schwartz, Robin. *Dog Watching.* New York: Takarajima Books, 1995.

——. *Like Us: Primate Portraits.* New York: W. W. Norton & Company, 1993.

Semin, Didier, Garb, Tamar, and Donald Kuspit. *Christian Boltanski.* (Tamar Garb in conversation with Christian Boltanski, first published 1997.) Reprinted 1999, 2001: Phaidon Press Limited, pp. 6–43.

Sherman, Cindy. See *Documenta 7.*

Shiraoka, Jun. See Johnson, *Jun Shiraoka.*

Siskind, Aaron. *Aaron Siskind: Photographer.* Edited by Nathan Lyons. Rochester, New York: The George Eastman House, 1965.

Smith, W. Eugene. "The World's 10 Greatest Photographers." *Popular Photography*, vol. 42, no. 5, May 1958.

Southworth, Albert S. "An Address to the National Photographic Association," 1870. First published in *Philadelphia Photographer* (October 1871) Reprint. *Secrets of the Dark Chamber: The Art of the American Daguerreotype.* Foresta, Merry A. and John Wood. Washington, D.C.: Smithsonian Institution Press, 1995.

Steichen, Edward. *A Life in Photography: Edward Steichen.* New York: Bonanza Books, 1984.

Stevenson, Sara. *The Personal Art of David Octavius Hill.* New Haven: Yale University Press, 1981.

Stieglitz, Alfred. Exhibition catalog. New York: Anderson Galleries, 1921.

Strand, Paul. "Photography." *Seven Arts* (Aug. 1917): 524–26.

Struth, Thomas. Discussion of silence, society, and the self with Mark Gisbourne. *Art Monthly*, May 1994.

Sudek, Josef. See Bullaty, *Sudek.*

Sutcliffe, Frank Meadow. "How to Look at Photographs." *The Photographic Times* 22 (September 1892): 477–479.

Sutnik, Maia-Mari. *Gutmann.* Toronto: Art Gallery of Ontario, 1985.

Talbot, William Henry Fox. *The Pencil of Nature.* London: Longman, Brown, Green and Longmans, 1844. Reprint. New York: Da Capo Press, 1969.

Teynard, Felix. *Égypte Et Nubie: Sites et Monuments.* Translated by Catharine H. Roehrig, 1858. Reprint. *Félix Teynard: Calotypes of Egypt.* New York: Hans P. Kraus, Jr., Inc.; London: Robert Hershkowitz Ltd.; Carmel: Weston Gallery Inc., 1992.

Thomas, Lew. *The Restless Decade, John Gutmann's Photographs of the Thirties.* New York: Harry N. Abrams, Inc., 1984.

Tilden, Freeman. *Following the Frontier with F. Jay Haynes: Pioneer Photographer of the Old West.* New York: Alfred A. Knopf, 1964.

Townsend, George Alfred. "[Mathew] Brady, The Grand Old Man of American Photography." *The World,* April 12, 1891, p. 26. Reprint. *Photography: Essays & Images.* Edited by Beaumont Newhall. New York: The Museum of Modern Art, 1980.

Tripe, Linnaeus. See Dewan, *Linnaeus Tripe.*

Tucker, Anne Wilkes. *Unknown Territory: Photographs by Ray K. Metzker.* New York: Aperture, 1984.

Ulmann, Doris. See Warren, *Doris Ulmann.*

Uzzle, Burk. See Johnson, *A Progress Report on Civilization.*

VanDerZee, James. See Haskins, *James VanDerZee.*

Vishniac, Roman. *A Vanished World: Roman Vishniac.* Schocken Books Inc., 1947. Reprinted 1969, 1973, 1975, 1983. New York: Farrar, Straus & Giroux.

Vroman, Adam Clark. "Photo Era." *The American Journal of Photography* 6 (February 1901): 269–270.

Warren, Dale. "Doris Ulmann: Photographer-in-Waiting." *The Bookman* (October 1930): 72, 129–144.

Watkins, Carleton E. Watkins Letters 1880–90. Bancroft Library, University of California, Berkeley.

Watkins, Margaret. "Advertising and Photography." *Pictorial Photography in America* 4. New York: The Pictorial Photographers of America, 1926.

Weston, Brett. See Hill, *Dialogue with Photography.*

Weston, Edward. *Daybooks.* Center for Creative Photography, University of Arizona, Tuscon.

Weegee. *Weegee by Weegee: An Autobiography.* New York: Ziff-Davis Publishing Company, 1961.

——. *My Camera on Point Lobos.* Edited by Virginia Adams. Boston: Houghton Mifflin Company, 1950.

White, Clarence H. "The Progress of Pictorial Photography." Interview with Henry Hoyt Moore. *Annual Report of the Pictorial Photographers of America.* New York: The Pictorial Photographers of America, 1918.

White, Minor. *Minor White: Rites and Passages.* New York: Aperture, Inc., 1978.

Withers, Ernest C. Interview with author. August 4–5, 1999.

——. See Hurley, *Pictures Tell the Story.*

Wolcott, Marion Post. "Keynote Address" paper read at Women in Photography conference, October 10–12, 1986 at Syracuse, New York.

INDEX

Abbe, James E., 152

Abbott, Berenice, 170

Adams, Ansel, 122

Adams, Robert, 230

Adamson, Robert, 24

Akin, Gwen, 304

Akin and Ludwig, 304

Arbus, Diane, 206

Atget, Eugène, 86

Atkins, Anna, 26

Bell, William, 58

Bellmer, Hans, 156

Berman, Zeke, 280

Bing, Ilse, 168

Boltanski, Christian, 302

Bourke-White, Margaret, 166

Brady, Mathew, 18

Brandt, Bill, 150

Brassaï, 146

Braun, Adolphe, 46

Brigman, Anne W., 100

Bruguière, Francis J., 132

Bullock, Wynn, 188

Burrows, Larry, 222

Burson, Nancy, 278

Callahan, Harry, 186

Cameron, Julia Margaret, 66

Caponigro, Paul, 238

Carjat, Étienne, 70

Carling, Richard, 278

Carroll, Lewis, 68

Cartier-Bresson, Henri, 148

Christenberry, William, 274

Clark, Larry, 226

Claudet, Antoine François, 20

Clift, William, 240

Close, Chuck, 266

Coburn, Alvin Langdon, 98

Content, Marjorie, 116

Cumming, Robert, 244

Cunningham, Imogen, 120

Curtis, Edward S., 84

Cuvelier, Adalbert, 48

Cuvelier, Eugène, 48

Davidson, Bruce, 204

Delahaye, Luc, 308

Dijkstra, Rineke, 306

Dodgson, Charles Ludwidge, 68

DuCamp, Maxime, 36

Duchenne, Guillaume-Benjamin, 32

Eakins, Thomas, 80

Eggleston, William, 252

Emerson, Peter Henry, 74

Evans, Frederick, 88

Evans, Walker, 140

Fellig, Usher, H. 176

Fenton, Roger, 34

Frank, Robert, 202

Friedlander, Lee, 232

Frith, Francis, 40

Gardner, Alexander, 52

Gilpin, Laura, 130

Groover, Jan, 256

Gowin, Emmet, 268

Gutmann, John, 158

Halász, Gyula, 146

Halsman, Philippe, 180

Hawes, Josiah Johnson, 14

Haynes, Frank Jay, 64

Heinecken, Robert F., 218

Hill, David Octavius, 24

Hill and Adamson, 24

Hine, Lewis Wickes, 106

Hockney, David, 276

Hosoe, Eikoh, 214

Jackson, William Henry, 60

Jenshel, Len, 288

Käsebier, Gertrude, 94

Kertész, André, 114

Ketchum, Robert Glenn, 272

Klein, William, 200

Kramlich, David, 278

Krull, Germaine, 138

Lange, Dorothea, 160

Langenheim, Frederick, 16

Langenheim, William, 16

Laughlin, Clarence John, 182

Le Gray, Gustave, 44

Lerner, Bob, 198

Levitt, Helen, 174

Lopes, Sal, 292

Ludwig, Allan, 304

Magritte, René, 118

Man Ray, 134

Mann, Sally, 290

Mapplethorpe, Robert, 250

Mark, Mary Ellen, 282

Martinez-Cañas, Maria, 300

Meatyard, Ralph Eugene, 208

Metzker, Ray K., 210

Metzner, Sheila, 270

Michals, Duane, 246

Misonne, Léonard, 90

Model, Lisette, 178

Moholy-Nagy, László, 136

Morgan, Barbara, 172

Muybridge, Eadweard, 78

Nadar, 30

Nagatani, Patrick, 298

Nègre, Charles, 50

Orozco, Gabriel, 312

O'Sullivan, Timothy H., 62

Outerbridge, Paul, 110

Parker, Olivia, 254

Parks, Gordon, 216

Penn, Irving, 248

Pfahl, John, 262

Porter, Eliot, 220

Radnitsky, Emmanuel, 134

Ray, Man, 134

Renger-Patzsch, Albert, 190

Robinson, Henry Peach, 76

Roche, Thomas, 54

Rodchenko, Aleksandr, 112

Rodger, Thomas, 28

Rothstein, Arthur, 162

Samaras, Lucas, 286

Sander, August, 144

Schwartz, Robin, 296

Sherman, Cindy, 284

Shiraoka, Jun, 234

Siskind, Aaron, 184

Smith, Eugene W., 176

Sommer, Frederick, 126

Southworth, Albert Sands, 14

Southworth and Hawes, 14

Spano, Michael, 264

Steichen, Edward, 92

Sternfeld, Joel, 258

Stieglitz, Alfred, 96

Strand, Paul, 128

Struth, Thomas, 310

Sudek, Josef, 236

Sutcliffe, Frank Meadow, 72

Talbot, William Henry Fox, 22

Teynard, Félix, 38

Tice, George, 260

Tournachon, Gaspard-Félix, 30

Tournachon, Adrien, 32

Tracey, Andrée, 298

Tripe, Linnaeus, 42

Uelsmann, Jerry N., 212

Ulmann, Doris, 142

Uzzle, Burk, 294

VanDerZee, James, 104

Vishniac, Roman, 154

Vroman, Adam Clark, 82

Watkins, Carleton E., 56

Watkins, Margaret, 108

Weegee, 176

Wegman, William, 242

Weston, Brett, 192

Weston, Edward, 124

White, Clarence H., 102

White, Minor, 194

Winogrand, Garry, 228

Withers, Ernest C., 224

Wolcott, Marion Post, 164

In addition to all other copyrights and reservations pertaining to the works published in this book and held by living artists, their estates, publications and/or foundations, the following are mentioned:

Joseph Stalin in the Kremlin, James Abbe © 2004 Tilly Abbe

Ansel Adams: An Autobiography by Ansel Adams © 1985 the Ansel Adams Publishing Rights Trust. By permission of Little, Brown and Company, (Inc.)

Mount Brewer and Bullfrog Lake, Kings Canyon National Park by Ansel Adams used with permission of the Trustees of The Ansel Adams Publishing Rights Trust. All Rights Reserved.

Diane Arbus: An Aperture Monograph © 1972 the Estate of Diane Arbus

The Human Pincushion © 1962 the Estate of Diane Arbus

Hans Bellmer, *La Poupée* © 2004 Artists Rights Society (ARS), New York/ADAGP, Paris

New York, The Elevated, and Me, 1936 © the Estate of Ilse Bing, courtesy Edwynn Houk Gallery, New York

Portrait of Myself: Margaret Bourke-White © 1963 Margaret Bourke-White. Reprinted by permission of the Estate of Margaret Bourke-White.

Camera in London © 1948 Estate of Bill Brandt, courtesy of Noya Brandt

Parlormaid and Under-Parlormaid Ready to Serve Dinner © Estate of Bill Brandt, courtesy Noya Brandt and Edwynn Houk Gallery

The Secret Paris of The 30's © 1976 Random House, Inc. and Thames & Hudson, Ltd., by permission of Pantheon Books, a division of Random House, Inc.

Une Fille de Joie © Gilberte Brassaï, courtesy Edwynn Houk Gallery

The Source by Anne W. Brigman courtesy Mrs. Willard Nott

Wynn Bullock, *Nude Behind Cobwebbed Window* © 1955/2003 Bullock Family Photography LLC, all rights reserved, courtesy Laurence Miller Gallery, NY

Ammunition Airlift into Besieged Khe Sahn, 1968, Larry Burrows, Life © 1968 Time Inc. Reprinted by permission of the Estate of Larry Burrows.

Harry Callahan, *Eleanor*, Chicago, 1953 © the Estate of Harry Callahan, courtesy Pace/MacGill Gallery, New York

The Wise Silence: Photographs by Paul Caponigro © 1983 George Eastman House, a New York Graphic Society book, by permission of Paul Caponigro

Seville, Spain © Henri Cartier-Bresson/ Magnum Photos

Henri Cartier-Bresson statement reprinted with permission of Simon & Schuster Adult Publishing Group from *The Decisive Moment* by Henri Cartier-Bresson (New York: Simon & Schuster, 1952).

Triangles © 1970 the Imogen Cunningham Trust

Imogen Cunningham text courtesy the Bancroft Library, University of California, Berkeley

Bruce Davidson Photographs © 1978 Bruce Davidson

Flaubert in Egypt: A Sensibility on Tour © 1972 by Francis Steegmuller. Reprinted with the permission of McIntosh and Otis, Inc.

The Mechanism of Human Facial Expression, 1862 G. B. Duchenne. Edited and translated by R. Andrew Cuthbertson © 1990 Cambridge University Press. Reprinted with the permission of Cambridge University Press

Sumner, Mississippi © William Eggleston, courtesy Cheim & Read Gallery

Le Puy, Church of St. Michael D'Aiguilla by Frederick Evans/Country Life Picture Library

Untitled, ca. 1930 © Walker Evans Archive, The Metropolitan Museum of Art

Text by Robert Frank, from *The Americans* courtesy and © Pace/MacGill Gallery, New York

Laura Gilpin, *Bryce Canyon #2* © 1979 Amon Carter Museum, Fort Worth, Texas

Omen, San Francisco, 1934 by John Gutmann © 1998 Center for Creative Photography, Arizona Board of Regents, courtesy Center for Creative Photography, The University of Arizona.

Albert Einstein, 1947, Philippe Halsman © by Halsman Estate

Sight and Insight © 1972 by Halsman Estate

David Graves Looking at Bayswater, London, Nov. 1982, collage, Edition: 20, 48½ x 31 inches © David Hockney Photographic

Pipe and Glasses, 1926 by André Kertész courtesy the Estate of André Kertész

White Angel Breadline, San Francisco, 1932 © Dorothea Lange Collection, Oakland Museum of California, City of Oakland. Gift of Paul S. Taylor

The Masks Grow To Us, Clarence John Laughlin © The Historic New Orleans Collection

Untitled © 1982 Helen Levitt, courtesy Laurence Miller Gallery and Jeffrey Fraenkel Gallery

René Magritte, *Tableau* © 2004 C. Herscovici, Brussels/Artists Rights Society (ARS), New York

Photograph and text by Ralph Eugene Meatyard courtesy the Estate of Ralph Eugene Meatyard

Unknown Territory: Photographs by Ray K. Metzker © 1984 the Museum of Fine Arts, Houston and Ray K. Metzker, all rights reserved

Léonard Misonne, Untitled, Bruges © 2004 Artists Rights Society (ARS), New York/ADAGP, Paris

Mud Glove © 1975 by Irving Penn

Text by Nadar © Metropolitan Museum of Art, reprinted by permission

Eliot Porter, *Redbud Tree in Bottom Land*, Red River Gorge, Kentucky, April 17, 1968 © 1990 Amon Carter Museum, Fort Worth, Texas, Bequest of the artist

Intimate Landscapes 1979 by permission of the Estate of Eliot Porter

Man Ray, *Le Soufflé* © 2004 Man Ray Trust/ Artists Rights Society (ARS), NY/ADAGP, Paris

Albert Renger-Patzsch, *Zierlen* © 2004 Albert Renger-Patzsch Archiv/Ann u. Jürgen Wilde, Zülpich/Artists Rights Society (ARS), New York

Self-Portrait, March 2, 1983 © Lucas Samaras, courtesy Pace/MacGill Gallery, New York

August Sander, *Commercial Traveler* © 2004 Die Photographische Sammlung/SK Stiftung Kultur-August Sander Archiv, Cologne/ARS, NY

Aaron Siskind: Photographer © 1965 George Eastman House

Frederick Sommer, *Jack Rabbit* © Frederick & Frances Sommer Foundation

Iris © 1971, Aperture Foundation, Inc., Paul Strand Archive

"Photography," *Seven Arts* © Aperture Foundation, Inc. Paul Strand Archive

From *Sudek* by Sonja Bullaty and Angelo Lomeo © 1986 by Sonja Bullaty. Used by permission of Clarkson Potter/Publishers, a division of Random House, Inc.

Schoolteachers, Miss Holmes and Harry McGill, James VanDerZee © Donna Mussenden VanDerZee

James VanDerZee: The Picture Takin' Man © 1991 by James Haskins. Reprinted with permission from Donna Mussenden VanDerZee

Carleton E. Watkins text courtesy, The Bancroft Library, University of California, Berkeley

Milk Bottle, 1919, Margaret Watkins © Joseph Mulholland

Brett Weston, *Dialogue with Photography* © 1981 Paul Hill and Thomas Cooper, reprinted by permission of Farrar, Straus and Giroux, Inc., courtesy Brett Weston Archive

Edward Weston, *Pelican*, Point Lobos, 1942 © 1981 Center for Creative Photography, Arizona Board of Regents

Quotation from Minor White © 1987, Trustees of Princeton University, reprinted with permission, The Minor White Archive, Princeton University

Moencopi Strata © 1987 Trustees of Princeton University, reproduced courtesy The Minor White Archive, Princeton University

Woman with Ice Cream Cone, New York City, 1968 © The Estate of Garry Winogrand, courtesy Fraenkel Gallery

I Am a Man © 2003 Ernest C. Withers, Courtesy Panopticon, Inc.